GREAT
PAINTINGS
OF THE
WESTERN
WORLD

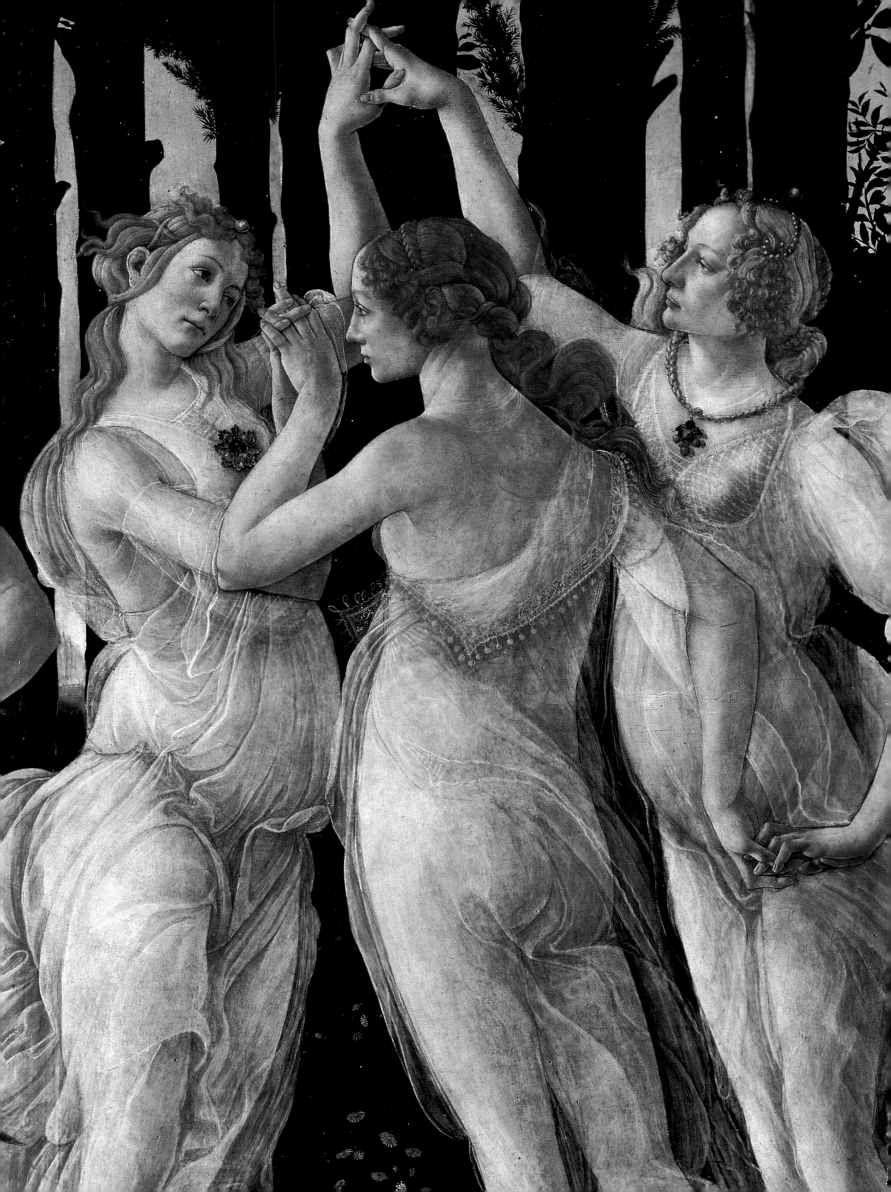

GREAT PAINTINGS

OF THE

WESTERN

WORLD

by Alison Gallup, Gerhard Gruitrooy,
and Elizabeth M. Weisberg

BEAUX
ARTS
EDITIONS

Copyright © 1997 Hugh Lauter Levin Associates, Inc.

 All photographs courtesy of Art Resource, New York.

Designer: Philip Grushkin
Production Coordinator: Jan Halper Scaglia

Printed in China
ISBN 0-88363-259-4

frontispiece: Sandro Botticelli. *Primavera.* (detail) c. 1477–78.
Panel. 80 1/4 x 124 in. (203 x 3314 cm). Galleria degli Uffizi, Florence.

CONTENTS

GREAT
PAINTINGS
OF THE
WESTERN
WORLD

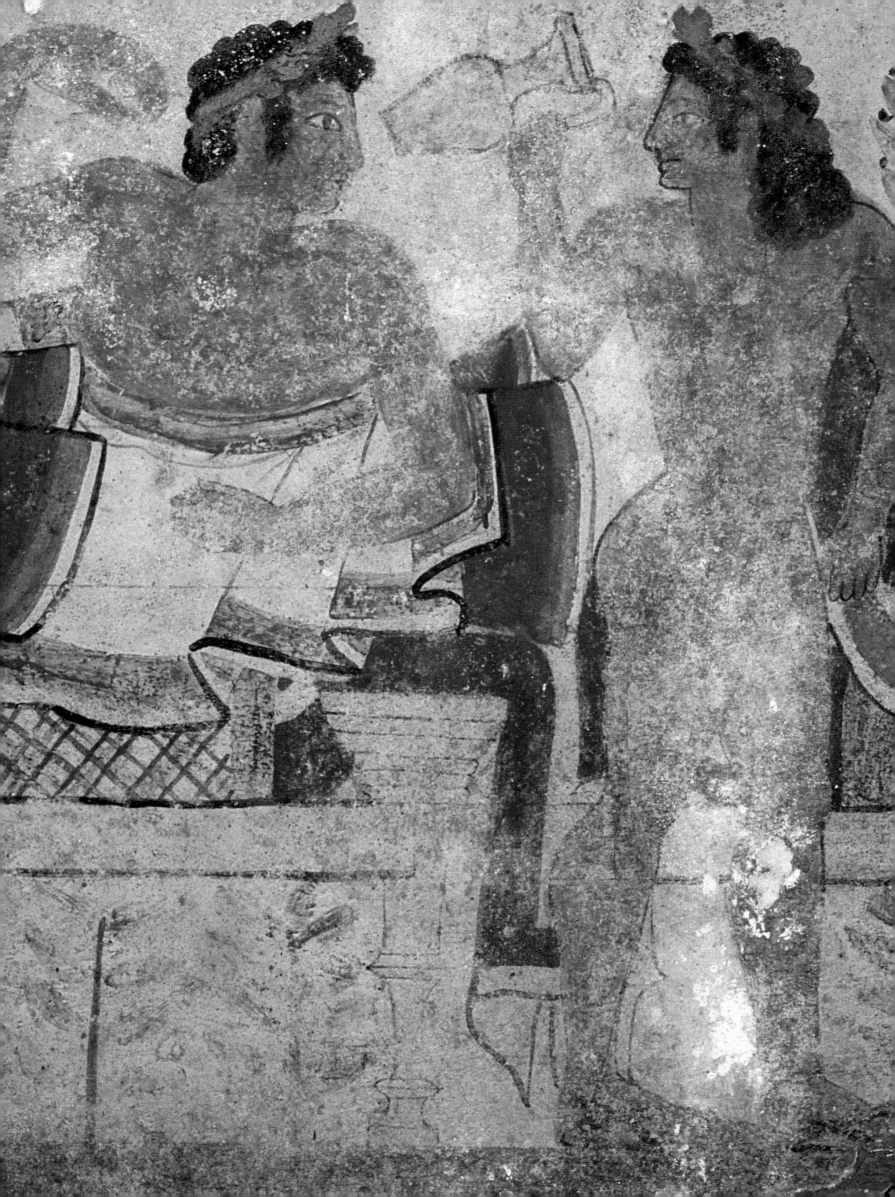

The Ancient World

From Ritual to Rationalism

CAVE PAINTING

THE HISTORY OF WESTERN PAINTING begins approximately thirty thousand years ago, with prehistoric depictions of animals, various shapes and symbols, and human beings on the walls of caves. Some of the best examples of Cro-Magnon painting are the Paleolithic paintings found in the caves at Altamira in northern Spain and Lascaux in the Dordogne region of France. ("Paleolithic," made up of the Greek words *paleo*, meaning "old," and *lithos*, meaning "stone," is a term used by scholars to describe the early Stone Age, from c. 40,000 to 8000 B.C.E.) The creators of these pictures used crushed minerals mixed with water and saliva as paints; "brushes" were most likely made of chewed twigs, but pigments were probably more commonly applied with the hand or by spitting them from the mouth or through tubes made of bone or reed. The resulting earth-toned images tend to be rather blurry. Given the undefined space and the uneven, rough surface of the ceilings and walls of the caves, these images appear to be positioned somewhat haphazardly, without groundlines (baselines indicating the ground on which figures stand) or background settings, and only rarely combined to suggest a narrative.

The caves at Altamira were first found by a hunter in 1868; in 1879, Maria, the young daughter of the Marquis Marcellino de Sautuola, an amateur archaeologist studying portable prehistoric artifacts, noticed the paintings by accident. Many of the marquis's late nineteenth-century colleagues would have thought the function of the painted images that adorn the vast walls and ceilings of prehistoric caves to be purely aesthetic. Clearly, those commentators might have mused, the desire to be surrounded by beauty has been inherent in human nature since the beginning.

The fact that animals are overwhelmingly the main subject of cave paintings may point to a more practical, less romantic interpretation. Paleolithic peoples were hunters—animals were essential to their survival. Given that the pictures for the most part do not seem to be composed narratively, as if recording an

Funeral Banquet. c. 480–470 B.C.E.
Detail of Etruscan mural paintings in the Tomb of the Leopards, Tarquinia.

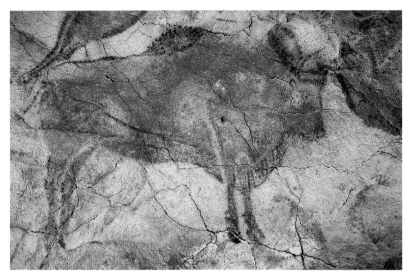

Bison. c. 12,000 B.C.E. Altamira cave, Santander, Spain. Paint on limestone.

actual episode, their purpose was more likely conjuration. Painting animals on cave walls might also have been an equally magical way to ensure their continued reproduction. In a few instances, animals are depicted as if wounded, suggesting that a ritual injuring or killing of an animal rendered in paint perhaps guaranteed a successful hunt in real life. The frequent overlapping of imagery and the fact that entire cave surfaces appear to have been repainted many times suggest that the act of painting was more important than the pictures produced. This supports the interpretation that these images had a magical function, that they represented attempts to control the animal kingdom and thereby assure the survival of the human group.

The animals painted on the surface of prehistoric caves are depicted remarkably accurately; in some examples, the artists even suggest muscular bulk through deft shading. By comparison, the rarely found representations of humans are very schematic, often resembling stick figures. Added to this fact, the sheer number and the wide variety of animals portrayed—including horses, bison, mammoths, bears, ibexes, aurochs, and deer—suggest the great significance of animals to Paleolithic society. We will never know for certain what functions prehistoric cave paintings served. The various interpretations necessarily reflect more the interpreters' theoretical frameworks than any verifiable reality: lacking a written language, the prehistoric people of the caves left no verbal records to help further our knowledge.

THE ANCIENT NEAR EAST

Paleolithic people led an unsettled life; this nomadic society of hunters and gatherers had little control over its food supply. Beginning around 8000 B.C.E, however, people began to grow their own food, raise their own animals, and organize into permanent communities. Although, like their Paleolithic predecessors, the Neolithic peoples (from *neos*, meaning "new" in Greek) used stone to make basic weapons and tools, organized agriculture and animal husbandry left more time and labor for other activities, including the production of clay vessels. Since their size and weight made them difficult to carry, clay vessels are characteristic of stationary communities.

Neolithic villages made their first appearance in the Near East, an area consisting roughly of modern-day Turkey, Iraq, and Iran. A late example of Neolithic painted pottery from this region is a beaker from Susa (present-day Shush in Iran) dating to c. 4000 B.C.E. The highly abstracted animal forms contained within patterned borders are common to many works of art from this area. Decoration takes precedence over naturalism to create designs with beautiful stylized animals, such as the thin band of elongated dogs beneath a frieze of graceful long-necked birds around the top of the beaker, and the marvelous ibex with circular horns, its body composed of two curved triangles, that dominates the large

central portion. In contrast with Paleolithic depictions of animals, which may represent attempts to control the animal kingdom, animals, now domesticated, seem simply to decorate this Neolithic vase.

The early Neolithic agricultural communities gradually evolved into more complex societies, with systems of government, law, formal religion, and, perhaps most importantly, the first appearance of writing, thus marking the end of prehistory and the beginning of recorded history. The political structures alternated between conglomerations of independently ruled city-states and centralized governments under a single leader.

The city-states of the Near East frequently fought one another. In addition, the lack of natural barriers made the area particularly vulnerable to invasion. This almost constant warfare was a frequent subject of art. A further destabilizing factor was the unpredictable climate; floods, drought, storms, and the like plagued the inhabitants of this region. Thus, they understandably tended to worry considerably about survival in this world—a world of invasions, political instability, and natural catastrophes.

From about the fourth millennium B.C.E., the Sumerians inhabited southern Mesopotamia, a Greek place name meaning "the land between the rivers," that is, the Tigris and Euphrates rivers. They invented the wheel and a form of writing in which a stylus, usually a length of reed cut at an angle, was used to impress characters into wet clay. Cuneiform, meaning "wedge-shaped," which aptly describes the appearance of this writing, has been deciphered; our ability to read ancient Mesopotamian texts makes the ancient art of the region more accessible to the twentieth-century viewer than the art of prehistoric societies. Ancient Near Eastern images usually have clearly structured compositions, groundlines, and readable narratives emphasizing human beings, their history, and their relation to their gods and goddesses. All of these characteristics enable us to interpret the art more easily than the more elusive prehistoric cave paintings discussed earlier.

The various city-states that comprised ancient Sumer were often at war with one another. The so-called Standard of Ur is a box, the function of which is not known, that was found in a royal cemetery among daggers, helmets, and other military regalia. The box displays scenes of both war and peace, probably episodes of a specific historic event. Stylistically, the depictions of human form in the Standard of Ur resemble those we will see in other ancient cultures. Frontal and profile views are combined in a single figure, emphasizing the conceptual over the illusionistic, and the size of a figure directly corresponds to his importance; on the Standard of Ur, the seated, regal figure in the top row is bigger than those standing before him. Also typical is the arrangement of figures in bands. There is little overlapping of forms, or any indication of a setting, resulting in a very two-dimensional image. This straightforward, regimented presentation of figures contrasts markedly with the informal arrangement of imagery in prehistoric caves.

A fragment of a wall painting from the palace of Zimri-Lim at Mari (today, Tell Hariri, Iraq)

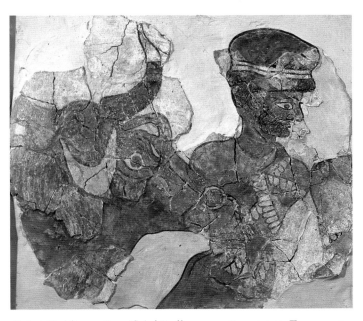

Priest Guiding a Sacrificial Bull. 2040–1870 B.C.E. Fragment of a mural painting from the palace of Zimri-Lim, Mari (modern Tell Hariri, Iraq). National Museum, Aleppo, Syria.

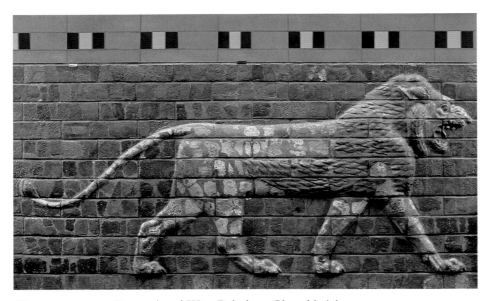

Lion. c. 575 B.C.E. Processional Way, Babylon. Glazed brick.
Height: approx. 38 in. (96.5 cm). Archaeological Museum, Istanbul, Turkey.

shows part of a religious ceremony: a priest leading a bull to sacrifice. Zimri-Lim was a ruler during the Amorite occupation of Mesopotamia. His palace was destroyed by the celebrated Hammurabi (ruled 1792–1750 B.C.E.), author of the famous legal code and a fellow Amorite leader. The fragmented murals of Zimri-Lim's palace are some of the few wall paintings to survive from Mesopotamia.

Among the most famous achievements of the Mesopotamians are the construction and decoration of the Ishtar Gate, originally one of the main entryways to the ancient city of Babylon (Iraq). Babylon had been the political and cultural capital of Mesopotamia under Hammurabi, and, toward the end of the seventh century B.C.E., with the decline of the Assyrians—probably the most powerful people to dominate Mesopotamia and the surrounding regions—the Babylonians reasserted their power. The best-known ruler of this Neo-Babylonian period was Nebuchadnezzar II (ruled 604–562 B.C.E.), the famed leader mentioned in the Old Testament who was responsible for building the Tower of Babel and the Hanging Gardens of Babylon, as well as the Ishtar Gate, now reassembled in Berlin. The Ishtar Gate and the walls lining the Processional Way (the street leading from the Gate) were faced with glazed brick. Sacred animals, also of glazed brick—among them, lions, associated with the goddess Ishtar, and dragons, sacred to Marduk, the patron god of Babylon—and geometric borders ornamented both the Gate and Processional Way. The somewhat stylized forms of these animals, and their rhythmic arrangement within decorative borders, recall the Neolithic vase from Susa, with which we began our discussion of the art of the ancient Near East.

ANCIENT EGYPT

The civilization of ancient Egypt was roughly contemporary with the neighboring cultures in the ancient Near East. While the Mesopotamians were constantly subjected to enemy attacks, however, the fruitful Nile Valley was surrounded by desert and thus not easily reached by invading forces. Furthermore, unlike the politically unstable city-states of the ancient Near East, Egypt remained virtually unchanged for thousands of years under a series of pharaonic dynasties; the term "pharaoh" literally means "palace," but is used to designate the kings of Egypt. The relatively predictable Nile floods are also in contrast with the unpredictable and violent storms and droughts of Mesopotamia. More secure in this life, Egyptians created works of art and architecture that tend to focus on the afterlife.

An Egyptian pharaoh was worshiped as a god not only during his—or very rarely her—lifetime, but after death as well. The Egyptian vision of the afterlife required that the pharaohs, their families, and their privileged officials and attendants be supplied with all the necessities and comforts of this world in

the next. Thus, tombs were stocked with food, wine, clothing, jewelry, games, furniture, weapons, musical instruments, and so on, to provide for the *ka*, or the spirit of the dead person, for all eternity. In addition, nearly every square inch of the walls and ceilings of tombs was elaborately decorated with painted reliefs, hieroglyphs (the Egyptian system of writing, which has been deciphered by modern archaeologists), and wall paintings. It is from tombs, their contents, and decorative programs, that we have acquired most of our knowledge of ancient Egyptian culture; the Egyptians' houses, even palaces and other structures, were often made of perishable materials and so have not survived. Life was short for most ancient Egyptians; their emphasis on the afterlife is revealed by their tombs, which were meant to endure, not the structures for this life.

Many Egyptian tomb wall paintings replicate everyday scenes of the inhabitant's world; pharaohs are shown hunting birds, hippopotami, and other animals, and their underlings are depicted carrying out tasks such as plowing fields

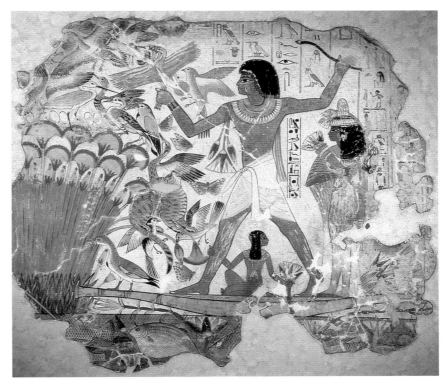

Nebamun Hunting Birds. Dynasty 18, c. 1400–1350 B.C.E. Fragment of a wall painting from the tomb of Nebamun, Thebes. Height: approx. 32 in. (81.3 cm). British Museum, London.

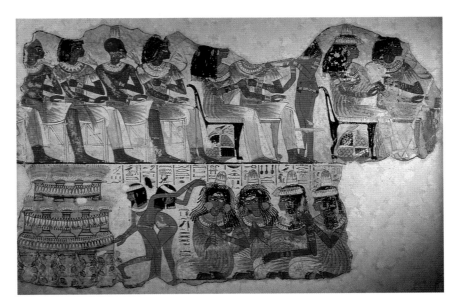

Banquet Scene. Dynasty 18, c. 1400–1350 B.C.E. Fragment of a wall painting from the tomb of Nebamun, Thebes. British Museum, London.

and picking fruit that they performed in the service of the pharaoh and other superiors during this life. While these paintings repeated the cyclical pattern of the seasons for all eternity, others are more specifically religious in subject matter, focusing on the other world. Frequently, pharaohs are shown at their own funerary banquets, presenting offerings to gods and goddesses, and, on occasion, pharaohs are portrayed in their mummified state, attended by Anubis, the jackal-headed god of the dead.

Two-dimensional depictions of royal figures in Egyptian art had long been standardized. Typically, pharaohs, queens, and members of their families and courts are shown with heads, hips, legs, and feet in profile, while their torsos and eyes are depicted as if viewed from the front, like Mesopotamian depictions of the human form. This combination allowed for the most composite view of the human body.

Nonroyal members of Egyptian society, however, are frequently portrayed in more natural poses—as are animals—and often they are shown completely in profile. Royal figures are rarely depicted exerting themselves. Their composite stance does not allow for much movement, and thus they stand immobile and perfect for all eternity. In contrast, farmers, slaves—workers in general—are commonly shown in action. They pick grapes, hunt birds, and plow fields quite energetically. Royal members of Egyptian society, the pharaohs in particular, thus come across as impervious to the world around them. It is important to recall that pharaohs were divine, and their impassiveness is that of transcendent beings. Regardless of class, women tend to have fairer skin, as befitting indoor people, while men, including kings, are darker-skinned from the outdoor life. It is not the pharaohs' individual personalities that are emphasized in painted and sculptural representations, but what might be called their "pharaoh-ness." Pharaohs simply *exist*, while their attendants *perform*. This distinction is maintained, with some exceptions, in many of the works of art created over the course of Egypt's ancient civilization—almost three thousand years.

The discovery of the tomb of King Tutankhamen in 1922 by Howard Carter, a British archaeologist, resulted in some of the most important contributions to our understanding of the ancient Egyptians' civilization in general, and their burial practices in particular. This is especially true since the tomb was found almost intact, unlike the many tombs that have suffered significant damage from plundering over the centuries. The tomb of the Boy King (ruled 1335–1327 B.C.E.) is a treasure trove of Egyptian art and artifacts. The back of Tutankhamen's throne is an exquisite depiction in gold, faience, glass paste, semi-precious stones, and silver of Tut and Queen Ankhesenamen, his sister-wife. The two figures are depicted in a style first associated more with the reign of King Akhenaton, also known as Amenhotep IV, Tut's predecessor, who ruled from 1352 to 1335 B.C.E. During Akhenaton's reign, representations of the human form, while still displaying an emphasis on line, became more relaxed and informal, less rigid and static. The conventional broad shoulders, narrow hips, and toned musculature that we think of in depictions of pharaohs have disappeared. The curvy, fluid, playful lines and the somewhat elongated, elegant, and feminine shapes of Tut and his queen are markedly different from typical Egyptian painted and sculptural representations of royalty, where the human figure is more squarely geometric, compact, and stiff, giving the impression of idealized, rational, dignified, and eternally existing personages—the gods they were. In contrast, the sinuous naturalism of Tut and Ankhesenamen allows them the freedom of potential movement. As a result, they seem more of our world.

Generally speaking, though, Egyptian artists had little interest in modeling or in the depiction of depth. Royal and nonroyal figures alike appear very two-dimensional, made up of flat areas of color, and the frequent inclusion of hieroglyphs in the same space as the figures calls attention to the flatness of the image as a whole.

Egyptian painting is also found in the Books of the Dead. The books of ancient Egypt were actually scrolls made from *papyrus*, the Greek term for the plant that grows plentifully along the Nile and from which the word "paper" derives. Books of the Dead were placed inside the wrappings of a mummified body in its coffin. Consisting of combinations of spells, prayers, and other magical writings tailored to the deceased, they were intended to guide the dead person through the trials of judgment in the afterlife. Most Books of the Dead contain judgment scenes. In some, Osiris, god of the underworld, presides over a ceremony in which the dead person's heart is weighed against an ostrich feather in order to determine whether he or she will merit eternal life.

MINOAN PAINTING

The flowering of the Minoan civilization, centered on the island of Crete in the Aegean Sea, coincided with the New Kingdom in Egypt and the Babylonian period of Hammurabi in Mesopotamia. "Minoan" comes from the name "Minos," the king of Crete in Greek mythology who provided the human-flesh-eating Minotaur, a half-man and half-bull monster, with a constant supply of young men and women from Athens. After the late nineteenth-century discoveries of sites thought to have existed only in the creative mind of Homer, such as Troy in Turkey, and Mycenae on the Greek mainland, the English scholar Sir Arthur Evans set out to discover ancient Crete. Due to the lack of decipherable texts, we know less about Minoan society than we do about ancient Egypt or the ancient Near East, and thus Minoan art remains somewhat mysterious. Furthermore, earthquakes and, apparently, warfare with the Mycenaeans of the Greek mainland resulted in the destruction of many Minoan palaces and works of art.

The surviving Minoan wall paintings come from the ruins of the palace complexes, the best example of which is at Knossos on Crete, excavated and (over-) restored in parts by Sir Arthur Evans in 1900. It is unclear precisely what functions the palaces served. They seem to have been religious, economic, and administrative centers, as well as the rulers' homes. The myth of the Minotaur, son of Minos' queen, Pasiphaë, and a sacred white bull, describes a labyrinth built by the ingenious Daedalus to contain the monster. The palace complexes are themselves labyrinthine, consisting of many open, airy courtyards, private apartments, storage rooms, shrines, and baths. Several wall paintings survive from the palace at Knossos, albeit in a rather ruinous state. Many have been heavily restored, with the lost areas filled in by modern reconstruction. Unfortunately, only a fraction of what originally must have existed remains.

Many Minoan wall paintings reveal the importance of the sea to this island civilization, which had lucrative trading contacts with the Greek mainland, Egypt, and the Near East. The *Young Fisherman with His Catch* is from the site of Akrotiri on the island of Thera—today, Santorini—a Minoan outpost north of Crete. A violent volcanic eruption around 1620 B.C.E. destroyed Thera, but many murals from Akrotiri were fortunately preserved in the volcanic ash. A frieze of boats is also preserved from the same site. The careful attention paid to portraying the different types of boats and the various tasks performed by crew members reveals that the makers of these murals belonged to the seafaring world they depicted.

We know little about the religious practices of the Minoan civilization. The many images of women

Young Fisherman with His Catch. Detail of a fresco in Room 5, West House, Akrotiri, Thera (Santorini). c. 1650 B.C.E. Height: approx. 53 in. (134.6 cm). National Archaeological Museum, Athens.

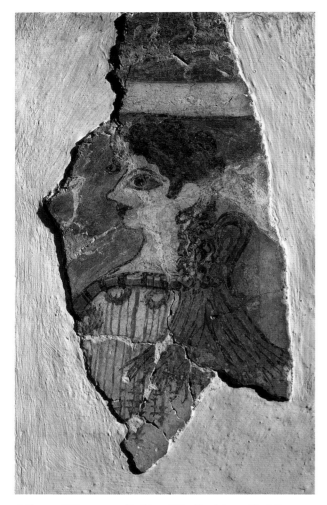

Minoan Woman or Goddess ("La Parisienne"). Minoan, fresco fragment from the palace at Knossos, Crete. c. 1450 B.C.E. Height: approx. 10 in. (25.4 cm). Archaeological Museum, Heraklion, Crete.

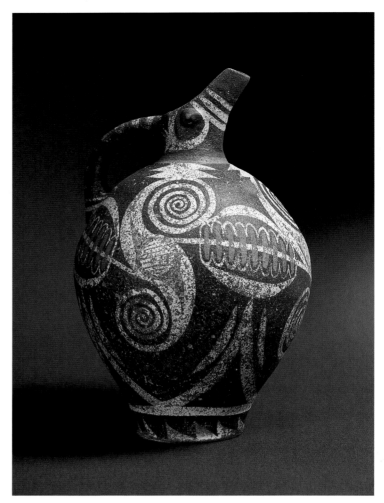

Vase. c. 1900 B.C.E. Phaistos, Crete. Minoan, ceramic. Height: 10 5/8 in. (27 cm). Archaeological Museum, Heraklion, Crete.

found in tombs and shrines suggest that the chief deities may have been goddesses. A wall painting from the palace at Knossos shows an elegant woman, possibly a priestess participating in a religious ceremony. The profile view of her face, combined with the large frontal eye, is similar to the treatment of figures in the ancient Near East and Egypt.

Perhaps the most famous Minoan mural is one called *Bull Jumping*, from the palace at Knossos. It is not clear in what context this activity is taking place, although it may be part of a religious ceremony in which male and female acrobats take turns vaulting over a bull. The thin-waisted, elegant, stylized figures with flowing curls are quite different from any of the figures seen in either Egyptian wall paintings or Mesopotamian figural representations, though, despite their energetic outdoor activity, the females have the conventionally lighter skin color common in Egyptian painting. The weightlessness and playfulness of the bull-jumpers are the antithesis of the timelessly dignified pharaohs adorning Egyptian tombs, while the wonderfully elongated and curved body of the bull, with its long, graceful horns, resembles some of the abstracted animal forms found in paintings and relief sculptures of the ancient Near East. Also of note is the decorative border that frames the scene, serving to complement the rhythmic motion of the bull-jumper.

Several stellar examples of painted Minoan pottery, produced in workshops in the palace complexes, have survived. A vase from Phaistos, Crete, displays bold swirling white and brown patterns on a black background, a less disciplined, more organic design than that found on the beaker from Susa.

ANCIENT GREECE

Around 1100 B.C.E., invaders from northwest of the Balkan Mountains entered what is today the Greek mainland, the islands of the Aegean, and Asia Minor, the western part of Turkey. These invaders mixed with the Bronze Age peoples already inhabiting these areas, forming the civilization of ancient Greece. Organized into city-states, the ancient Greeks shared a common language and religion, but had different governing structures. Often there was fierce rivalry between city-states, although on occasion the Greeks would combine forces against the Persians, who were a constant threat to the Aegean until the fifth century B.C.E. Around the sixth century B.C.E, the city of Athens rose to political, economic, and cultural prominence.

Some of the oldest surviving works of art created by the ancient Greeks are their ceramic vases. Many early vases served as monuments marking graves in cemeteries, thus explaining their large size and the funerary scenes often found adorning their exterior surfaces. One such vase from the Dipylon cemetery in Athens, dating to 750–735 B.C.E., is decorated in the "geometric" style. Unlike the more organic, curvilinear, free-floating designs seen on Minoan vases, geometric-style vases have more rectilinear and programmatic decoration, organized in bands. The torsos of the figures making up the funeral procession in the second register from the top—the deceased himself can be seen laid out on his bier at the far right—consist of triangles, while their arms are composed of long, very thin rectangles. The humanity of these abstracted figures is subordinated to their role as decorative elements in the overall patterned design. The geometrically conceived human figures and patterns alternate and mix together on the surface of this vase, creating a two-dimensional rhythm.

In the seventh century B.C.E., "orientalizing"-style vases were produced in several Greek pottery centers. As the name suggests, the decoration of these ceramic vessels was often influenced by motifs found in the art of the Near East and Egypt. Many of these vases were produced in Corinth, a major port which imported objects from the East. The orientalizing-style oenochos, or wine jar, from Rhodes, another center of pottery production, is decorated with elegantly stylized deer and geese, resembling animals seen in many works from the ancient Near East. Interspersed between these animals are geometric design elements, while a plant motif resembling the lotus bud forms found in Egyptian painting and sculpture adorns the lowest register of the jar.

The flourishing of Athens as a cultural center is attested to by the great quantity and

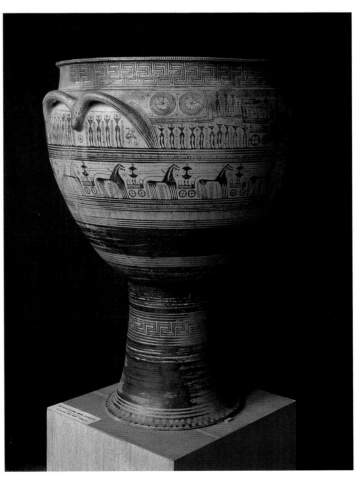

Krater. 750–735 B.C.E. Dipylon Cemetery, Athens. Geometric Style. Height: approx. 40 in. (101.6 cm). National Archaeological Museum, Athens.

high quality of painted vases produced in Attica (the name given to Athens and its surrounding area) from the late seventh century until around 480 B.C.E., known as the Archaic period in Greek art. Archaic Greek vases tend to be smaller than the earlier geometric and orientalizing vases, and many of these utilitarian vessels—kylixes, or drinking cups; amphorae, for storing oil or wine; kraters, for mixing wine and water; and so on—were exquisitely decorated, frequently with narrative scenes that are often mythological in subject. In this period, decorative patterning now functions almost exclusively as a framing element. The human figure, whether mortal or immortal—unlike the hybrid forms of Egyptian and Mesopotamian gods, the immortal gods and goddesses of Greek mythology are entirely human in appearance—becomes the main theme of Greek vase painting. The same humanism inspired artists to start rejecting the composite depiction of the human body, that is, the combined frontal and profile views, and move toward a more realistic rendering of human form in three-dimensional space. In this new art, the musculature is often carefully delineated and figures foreshortened.

A detail from the inside of one kylix shows a depiction of Dionysus, the god of wine, reclining on his boat. The scene represents an episode from a Homeric hymn in which Dionysus, having been abducted by pirates, causes grape vines to sprout from his boat. The pirates jump overboard in fear and are turned into dolphins. The talented artist who painted this wonderful scene is actually known to us by name: Exekias (flourished c. 550–525 B.C.E.). Many Greek vase painters of the Archaic period signed their works—another example of Greek humanistic tendencies—and thus, for the first time, an artist's oeuvre can be documented. An outstanding example of Exekias' sensitivity can be seen in one of his amphorae; he created a simple composition consisting primarily of two figures, Achilles and Ajax, whose curved forms beautifully echo the amphora's rounded contours.

These vases by Exekias are two of the best examples of the black-figured style. In this technique, the figures are painted using a slip—clay mixed with water—that turns black when the vase is fired. The red background is the unslipped area of the ceramic surface. Details of the black figures can be scratched through the slip surface with a stylus; white and reddish-purple glosses were often added over the black. The red-figured technique leaves the unslipped figures to be fired to the reddish color of the clay, while the background is painted in with slip to fire black. The artist can then add detail simply by applying slip to the red figures with a thin paintbrush. Red-figured vases became more popular around the end of the sixth century B.C.E., perhaps because that technique better expressed the developing Greek interest in the physical and psychological natures of individual human beings.

Nonmythological subjects also appear on vases. In one example, a group of women at a fountain appropriately decorates a hydria, or water jug. Several vases have images relating to the Panathenaic games, festivals held in Athens similar to the Olympic games which first took place in 776 B.C.E. (The Olympics were discontinued by the Romans in 394 C.E., only to resume more than fifteen hundred years later, in 1896.) Greek vases often depict actual athletic events, such as footraces. Because they competed nude, athletes were a favorite subject for Greek artists interested in depicting the human body. This type of vase might have been given as a prize to a winning athlete.

The Greeks saw themselves as a rational, civilized, and dignified people, and thus superior to the Persians, whom they considered barbarians. When the Greeks finally succeeded in halting the onslaught of their foes from the East, they embarked on an age of great prosperity, known as the High Classical period, which lasted from about 450 to 400 B.C.E. During this time, the humanistic tendencies of the Greeks came to fruition, and were expressed in all media. The core principle and aesthetic tenet of the

time are best summed up by the Greek philosopher Protagoras (c. 485–410 B.C.E.), who said, "Man is the measure of all things." This interest in humanity, this confidence in human capabilities, is probably best seen, as far as the visual arts are concerned, in Greek sculpture and architecture; it was at this time that the Parthenon was rebuilt, under the famous Athenian statesman Perikles, and decorated with some of the best examples of High Classical sculpture. The human form in art was infused with realism; the musculature was carefully modeled, movement was implied, and drapery fell naturally over the body. This realism encompassed an ideal of humanity that resulted in dignified, confident, emotionally restrained, and rational expressions and postures. Painting at this time also reached great new heights, primarily in the form of wall and panel painting, virtually none of which survives. Vase painting, especially the red-figure style, continued, although it had reached its heyday during the Archaic period. Interestingly, the painters of late fifth-century red-figure vases seem to have been influenced by large-scale painting, with mixed results. The compositions become complex and crowded, better suited to a flat wall or panel, while the Archaic harmony between the painted figures and the curved shapes of the vases is no longer as successfully achieved. Furthermore, vase painting is not conducive to the depiction of light and shadow or to the creation of the illusion of space receding into the distance, both advanced techniques in Greek wall paintings of this period.

It is, however, during the Classical period that white-ground vases became more popular. In this style, either the red-figure or black-figure technique served to decorate a white ground; in addition, artists employed tempera paint. Tempera allowed for a wider range of colors, but the tempera additions, unfortunately, often have not survived, given their tendency to flake off. The lekythos painted with a scene of a warrior taking

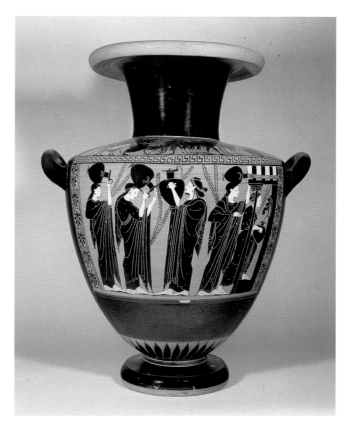

Hydria with Women at the Fountain. 530 B.C.E. Vulci. Museo di Villa Giulia, Rome.

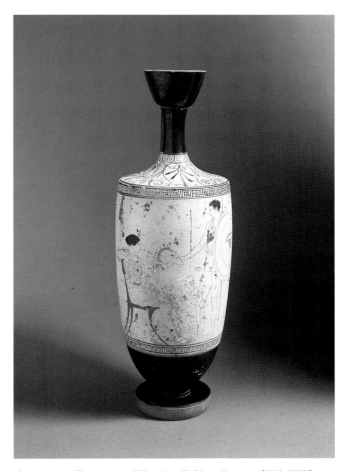

ACHILLES PAINTER. *Warrior Taking Leave of His Wife.* 440 B.C.E. Eretria. Attic white-ground lekythos. Height: approx. 17 in. (43 cm). National Archaeological Museum, Athens.

leave of his wife was probably made to be placed either in or on a tomb. The graceful figures on this vase magnificently display the "noble simplicity and quiet grandeur" that the German scholar Johann Joachim Winckelmann considered to be characteristic of High Classical Greek art.

The Greeks colonized southern Italy, where they were in contact with the indigenous Etruscan culture. An ancient Greek wall painting from the so-called Tomb of the Diver in Paestum, Italy, probably reveals Etruscan influences. The dive taken by the figure could be interpreted as the passage of the deceased into the otherworld. The Greeks did not build large tombs to house their dead; for them, the realm of the dead seems to have been a vaguely defined, mysterious place.

In the fourth century B.C.E., the Greek city-states were dominated by the kings of Macedon, an area to the north of Greece. The most famous of these conquerors was Alexander the Great (356–323 B.C.E.), who also subjugated the Persian Empire and Egypt. In a Roman floor mosaic, based on a Greek painting of the battle between Alexander the Great and the Persian king Darius III, the artist has applied foreshortening and shading techniques to create an effect of three-dimensional space. The emotional and physical intensity of this image—conveyed through the facial expressions of the participants and the depiction of dramatic movement—is probably typical of late Greek wall painting.

ETRUSCAN PAINTING

A people who may have migrated from the eastern Mediterranean, the Etruscans occupied central Italy, including part of Umbria and the area known today as Tuscany (after *Tuscii*, the Latin for "Etruscans") at least as early as the tenth century B.C.E. By the third century B.C.E., their cities had been incorporated by Rome. We know relatively little about the Etruscans, yet apparently, like the Egyptians, they viewed tombs as homes for the dead for eternity. Also like the Egyptians, the Etruscans buried all sorts of objects with their dead, including Greek vases like the Archaic ones discussed earlier, which they vigorously collected. A theme common to tombs throughout the ancient world, the funerary banquet, recurs as well in the so-called Tomb of the Leopards in Tarquinia. A symmetrically balanced pair of leopards at the top brings to mind the animal pairings of the ancient Near East. A fishing and fowling scene painted on the wall of the Tomb of Hunting and Fishing is reminiscent both of playful Minoan aquatic images and a painting from the New Kingdom tomb of Nebaumun depicting the pharaoh hunting birds.

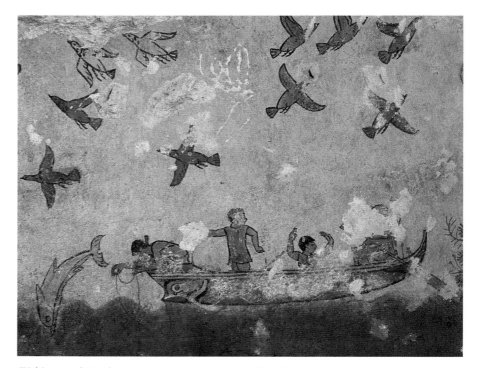

Fishing and Fowling. c. 530–520 B.C.E. Detail of Etruscan mural paintings in the Tomb of Hunting and Fishing, Tarquinia.

THE ROMAN EMPIRE

At its height, in the early second century C.E., the Roman Empire included Britain, Germany, Italy, Sicily, Spain, Macedon, Gaul (modern France), Greece, North Africa, Asia Minor, Syria, Egypt, Palestine, Romania, Armenia, a stretch of the Black Sea coast, Mesopotamia, and the northwest coast of Arabia. Conquering these diverse populations brought the Romans into contact with many different religious, political, and artistic traditions. Remarkably inclusive, the Romans often incorporated, rather than suppressed, these traditions. For example, while the Romans absorbed Greek religion, giving the Greek gods and goddesses Roman names, a number of emperors permitted the cult of the Persian god Mithras, as well as the worship of other deities from the Near East and Egypt.

The Romans were, however, most profoundly influenced by Greek art. They collected it, employed Greek artists, and copied many Greek paintings, statues, and architectural forms. In fact, were it not for Roman copies of Greek works, we would know far less about Greek art than we do. Oddly enough, whereas Greek authors praised individual Greek artists, the Romans thought little of their own contemporary artists, choosing instead to write about the luminaries of the Greek civilization.

In 79 C.E., Mount Vesuvius erupted, burying the entire city of Pompeii and surrounding areas beneath volcanic ash. One outcome of this disaster—which killed about two thousand people—was the fortunate preservation of many magnificent Roman wall paintings, discovered first in the eighteenth century and still being brought to light today. These paintings, which decorated the interior walls of Roman houses and villas, were classified into four styles at the end of the nineteenth century.

First Style Roman wall painting (c. 200–80 B.C.E.) can be seen in the lower portion of the Ixion Room in the House of the Vettii in Pompeii. The goal of this style was to imitate slabs of rich marble paneling in paint. In the Second Style (c. 80–15 B.C.E.), the flat wall surfaces were painted with illusionistic cityscapes, landscapes, and, in the famous walls of Room 5 of the Villa of the Mysteries, for example, figures "performing" in stage-like spaces. The Villa of the Mysteries was so named by archaeologists because its paintings may depict the initiation rites of a Dionysian mystery cult. Only women were members of this cult, which was a Greek import, and initiation may have involved a ritual "marriage" with Dionysus. The various scenes, framed by painted architecture, take up almost all the wall space, and are painted so that the figures appear to enact their rituals on a shallow ledge before a rich "Pompeiian red" background. The effect of three-dimensionality is also achieved through modeling and overlapping forms. The beautiful, lithe figure of the dancing woman in one scene steps away from the viewer into the illusionistic space of the picture, and the skillful shading of the stepping leg enhances the perception of depth.

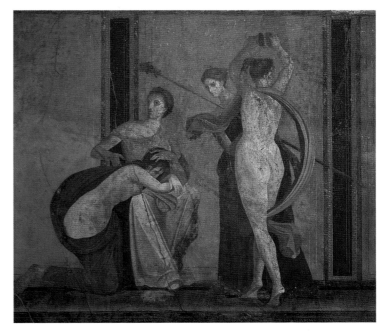

Dionysiac Mystery Frieze. c. 50 B.C.E. Detail of Second Style wall paintings. Height: 64 in. (162.5 cm). Villa of the Mysteries, Pompeii.

Third Style (c. 15 B.C.E–45 C.E.) wall painting is extremely elegant. Paintings in this style consist primarily of flat areas of solid color, with delicate, often attenuated decorative architectural details and small, framed scenes almost like panel paintings. Frequently, the scenes in the center of these panels are not even framed but rather seem to float against their solid-color backgrounds. Interestingly, like First Style paintings, those in the Third Style call attention to the hard, opaque wall surface, rather than denying it, as the Second Style to some extent tried to do with illusionistically receding space.

Between and above the panels of solid red and black on the wall painting in the house of M. Lucretius Fronto are Second Style–like illusionistic architectural paintings, although here the architectural elements lack the extraordinary substantiality and three-dimensionality seen in better examples of Second Style depictions of architecture. The architectural scenes of Second Style Roman paintings typically consist of somewhat fantastic structures crammed into rather shallow spaces, but in some cases the artists successfully employed linear perspective to create the effect of deep recession into space. It is thought that the rather unreal, decorative architecture found in Second Style wall painting may be akin to the architectural backdrops made for Roman theatrical performances.

Second Style works include landscapes, portraits, still lifes, mythological scenes, and historical episodes, as do the framed images of

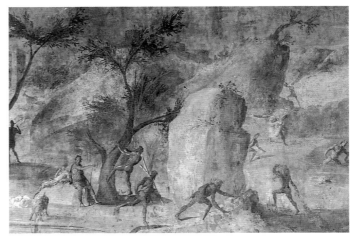

The Laestrygonians Attack Odysseus and His Crew. c. 50–40 B.C.E. Second Style wall painting from a house on the Esquiline Hill, Rome. Height: 5 ft. (152 cm). Vatican Museums, Rome.

Seaside Villas, "Panel Painting." Before 79 C.E. Detail of wall painting in the House of M. Lucretius Fronto, Pompeii.

Third Style wall paintings. These subjects also appear in paintings of the Fourth Style (starting c. 45 C.E.), which basically combines aspects of the three previous styles; however, in the Fourth Style, although perspective has virtually been mastered, painted architectural views seem even more irrational, depicting fragmented, completely fantastic structures.

In some Third Style landscapes, the artists bathed their scenes with light, and atmospherically—that is, by making distant objects blurry to show the effects of haze—created a sense of depth. These impressionistic painted landscapes may have functioned as sunny vistas in the often windowless Roman houses.

A remarkably sensitive portrait of this period shows a young woman deep in thought, holding her stylus to her mouth as if deciding what her next written words should be. During the Roman Empire,

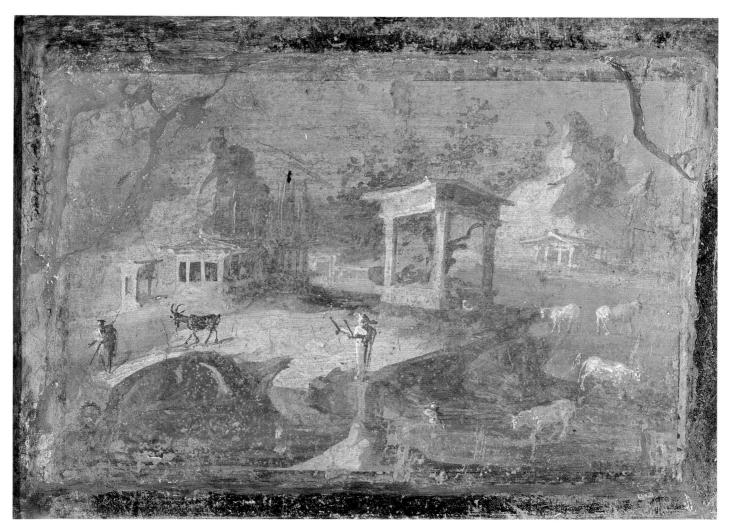

Landscape. 62–79 C.E. Pompeii. Third Style wall painting. Museo Archeològico Nazionale, Naples.

Roman women were increasingly educated, in some cases going on to become businesswomen, doctors, writers, and otherwise participants in the public sphere. Women often had their portraits painted in the act of writing, whether this activity played a significant part in their life or not.

It is important to remember that the Roman wall paintings that we see on museum walls have been removed from their original contexts. This gives the false impression that these images were isolated, framed works of art in the Renaissance tradition that we are used to. In fact, as we have already seen, many of these images were integral parts of large painted programs that could

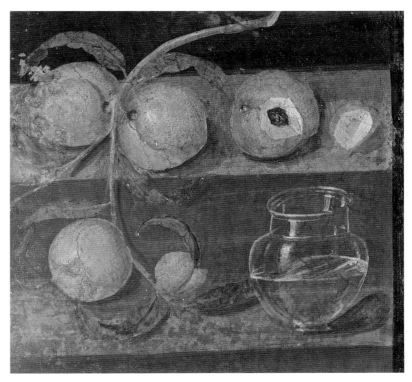

Still Life with Peaches and Glass Jar. Detail of a Fourth Style wall painting from Herculaneum. 62– 79 C.E. Approx. 14 x 13 1/2 in. (35.5 x 34.3 cm). Museo Archeològico Nazionale, Naples.

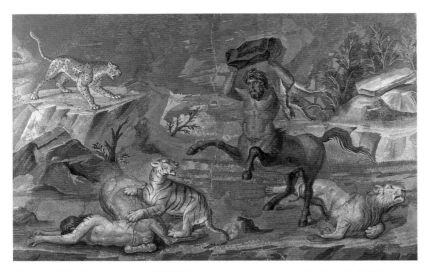

Battle of the Centaurs and Wild Beasts. c. 118–28 c.e. Hadrian's Villa, Tivoli. Mosaic. 23 x 36 in. (58.4 x 91.4 cm). Pergamonmuseum, Berlin.

include the four walls, and often the ceiling, of a room. The *Still Life with Peaches and Glass Jar*, now in the Museo Nazionale in Naples, was originally part of a Fourth Style program from Herculaneum, another town destroyed by the eruption of Vesuvius. Although perhaps not quite as successfully as the seventeenth-century Dutch still-life painters, our Roman artist made a respectable attempt to represent the effects of light on glass, while the shading of their rounded forms, combined with their cast shadows, gives a three-dimensional quality to the peaches.

The floors—and sometimes the walls and ceilings—of Roman city houses, country villas, and public structures were often covered with mosaics. (Mosaic, which is composed of pebbles, or pieces of marble, stone, or glass pressed into a cement-like substance, is both durable and water resistant.) The representational capacity of mosaic work became incredibly refined and elaborate, as mosaicists strove to create illusionistic effects like those in paintings, with a wide variety of colored stone or glass cut into small pieces called "tesserae." In the *Battle of the Centaurs and Wild Beasts*, the artist employed the same foreshortening and shading techniques we saw in Roman paintings to make figures and landscape settings look three-dimensional. Many narrative scenes done in the mosaic technique were rather small and prefabricated in workshops. These scenes were then often set into a predetermined space on a plain or patterned mosaic floor or wall, just as many narrative Roman wall paintings were "framed" and "hung" on the walls of Roman houses.

Rome would hold sway as the cultural and political center of a vast territory until the fourth century c.e., when the emperor Constantine made Constantinople, formerly Byzantium, today Istanbul, the capital of the Roman Empire. At the end of the fourth century, the Empire was permanently divided and while the Eastern, or Byzantine, Empire flourished, the once powerful city of Rome, and much of the Western Empire, was overrun by foreign invaders.

Beaker. c. 4000 B.C.E. Susa (modern Shush, Iran). Ceramic, painted in brown glaze. Height: 11 1/4 in. (28.6 cm). Musée du Louvre, Paris.

The Paleolithic peoples who created cave paintings were nomadic hunters and gatherers. Neolithic culture (New Stone Age), which first appeared in the Near East c. 8000 B.C.E., is characterized by settled villages, domesticated plants and animals, and the crafts of pottery and weaving. The highly abstracted, stylized animal forms, representative of the "Animal Style," and patterns decorating this Neolithic beaker from Iran are commonly found in works from the ancient Near East. An ibex (wild goat), with enlarged, circular horns and a body consisting of two curved triangles, decorates the center of this vessel. The top band contains skinny, long-necked birds, and, directly below, a band of elongated dogs encircles the beaker.

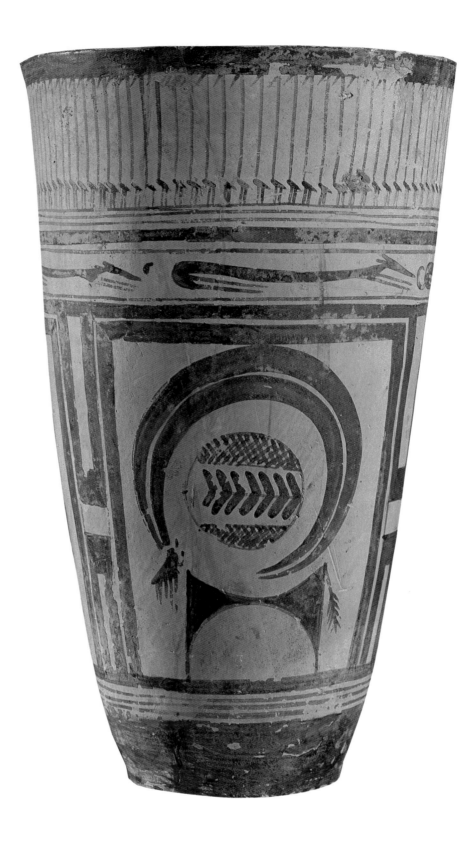

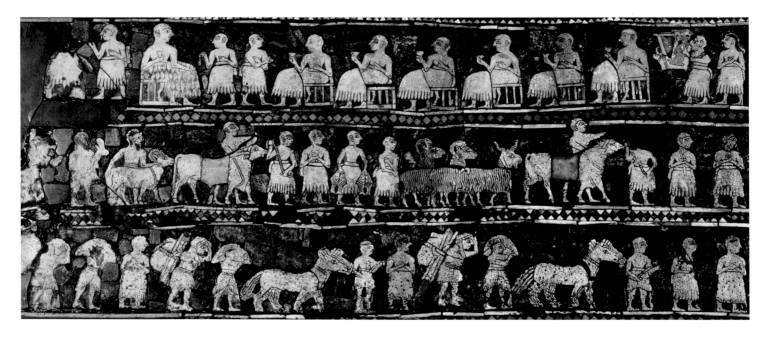

Triumph of a King, the Standard of Ur. c. 2700 B.C.E. Mesopotamia. Wooden panel inlaid with shell, lapis lazuli, and red limestone. Approx. 8 x 19 in. (20.3 x 48.2 cm). British Museum, London.

Neolithic village communities in the ancient Near East gradually developed into complex city-states, which were often politically unstable societies almost constantly at war with each other and against invading peoples. War and victory are frequent subjects of ancient Near Eastern art. This image, an inlaid panel from the side of a box, may show an actual historic event, depicting the aftermath of war, with a victorious banquet scene in the top register. Historical narrative and a clear, formal composition distinguish this image from prehistoric cave paintings.

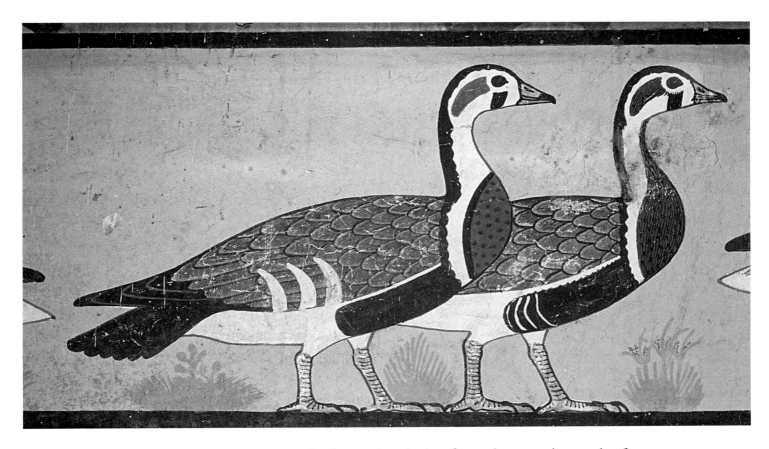

Geese. Dynasty 4, c. 2680–2500 B.C.E. Detail of a tomb painting from the mastaba tomb of Nefermaat at Medum. Height: 10 1/2 in. (27 cm). Egyptian Museum, Cairo.

The Egyptians spent much of their life on earth preparing for death and the afterlife. Elaborate tombs were constructed, stocked with provisions, and decorated with statues, reliefs, and wall paintings. Of course, such luxurious burials were the privilege of pharaohs (kings), their families, and their officials only. This painting of geese comes from a mastaba, an Old Kindgom tomb form consisting of a rectangular structure of mud brick or stone surmounting an underground burial chamber. It is from the contents of tombs that we have acquired most of our knowledge of Egyptian civilization.

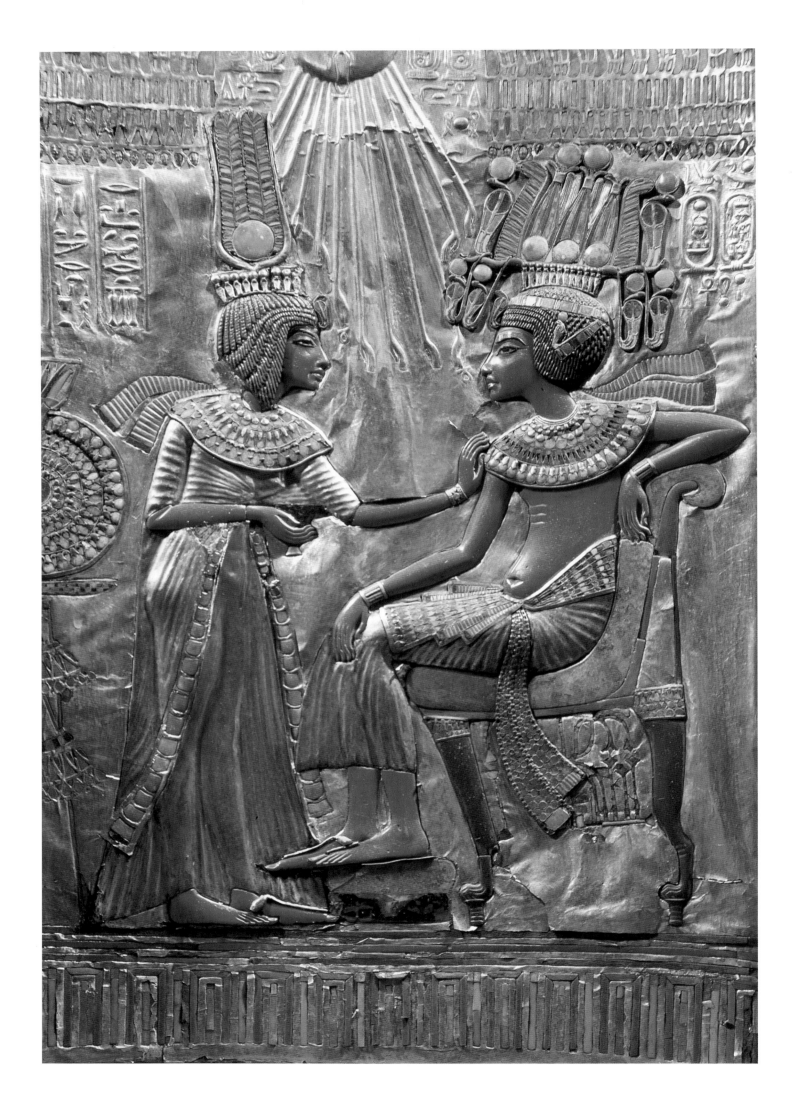

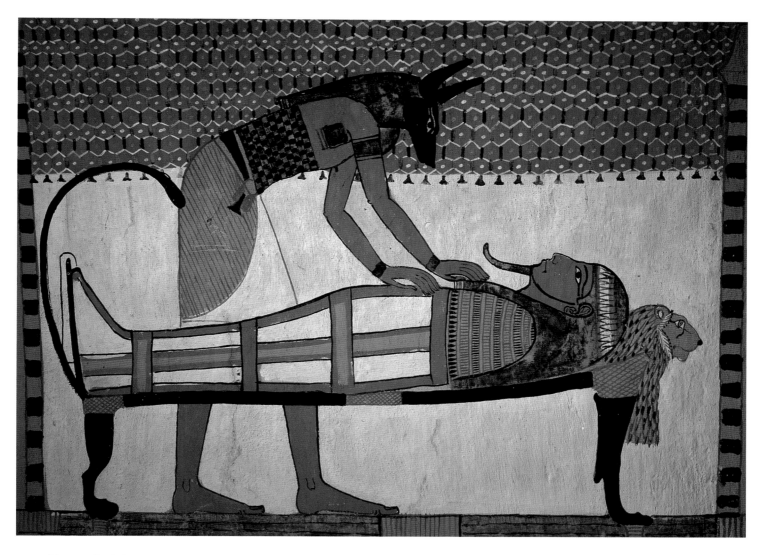

Anubis, God of the Dead, Leaning over Sennutem's Mummy. Dynasty 18.
Tomb of Sennutem in the cemetery of Deir el-Medina, Luxor-Thebes, Egypt.

Many images in tombs deal with death and the afterlife. In this image, Anubis, the jackal-headed god of the dead, attends to Sennutem's mummy. The Egyptians mummified their dead in the hope of preserving the body for eternity so that the *ka,* or spirit of a person which lived on after death, was provided with a body to inhabit. Mummification involved the removal of the internal organs, placement of the body and organs in a salt-based preservative for a month or so, and, finally, wrapping the body and organs in layer after layer of linen.

opposite:

Tutankhamen with His Queen Ankhesenamen. Dynasty 18, c. 1355–1342 B.C.E.
Detail of the back of the throne of King Tutankhamen, from the tomb of Tutankhamen, Valley of the Kings.
Carved wood covered with gold and inlaid with faience, glass paste, semiprecious stones, and silver.
Height of throne: 41 in. (104 cm). Egyptian Museum, Cairo.

Among the many luxurious items found in the tomb of King Tutankhamen is a magnificient throne, the back of which is shown here. The relaxed informality of this tender moment between King Tut and Queen Ankhesenamen is somewhat unusual in Egyptian art, but typical of this particular period in Dynasty 18. Under Tut's predecessor, King Akhenaten, a less rigid depiction of royalty, characterized by fluid, playful lines, and elegant, feminine figures, resulted in images of royal figures which were not as static, formal, and idealized as were typical depictions of royalty in Egyptian art.

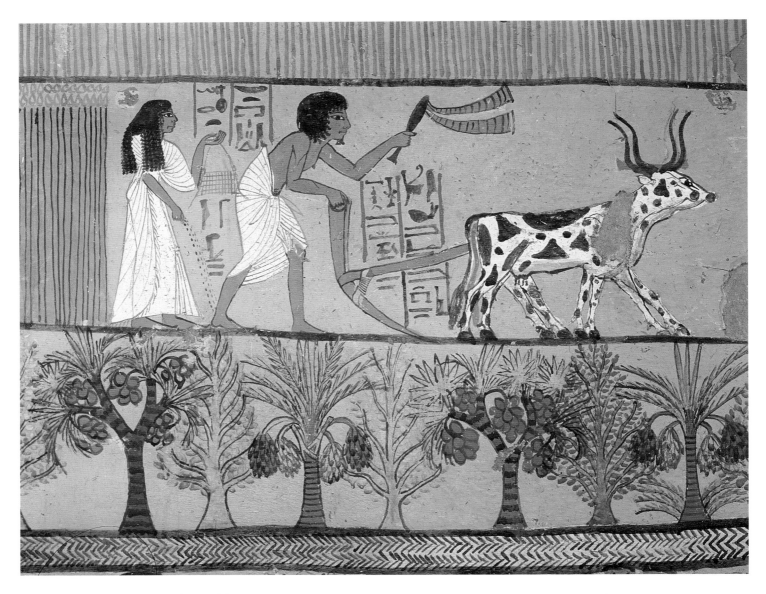

Sowing and Plowing in the Fields. Dynasty 19, 13th century B.C.E. Tomb of Sennedjem, Thebes.

Many tomb wall paintings show hunting and farming scenes meant to reflect the cycle of the seasons that will repeat for eternity. In this image, sowing and plowing are depicted. Egyptian painters seem to have had little interest in rendering three-dimensional human forms existing in space. Painted figures are not modeled, made up instead of flat areas of color contained by line. Background settings are often excluded, and the frequent presence of hieroglyphic texts calls attention to the flatness of the space. The desire for clarity seems more important to the Egyptian painter than the illusionistic rendering of space and form.

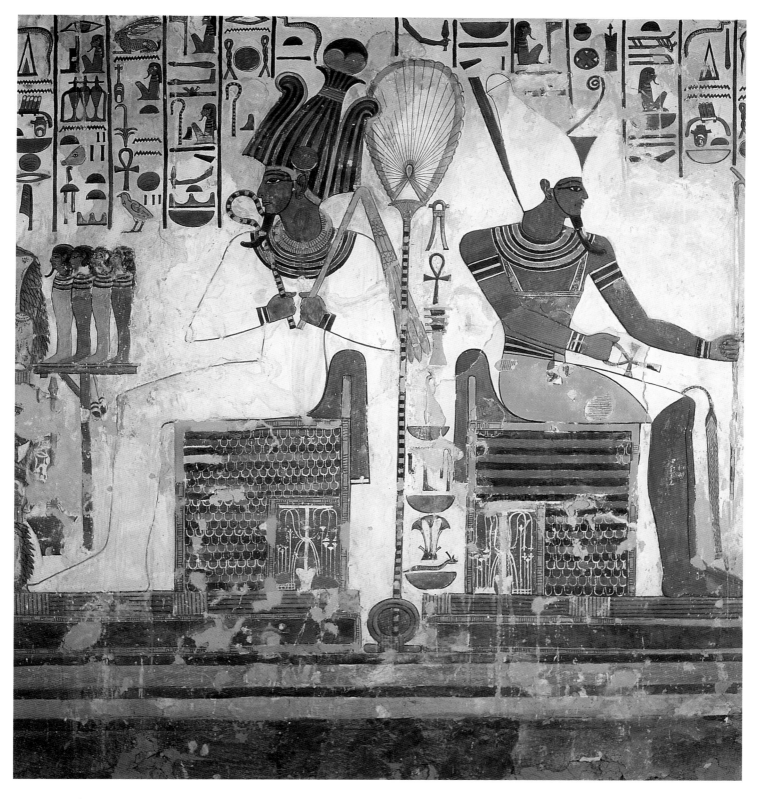

Atum and Osiris. Dynasty 19, c. 1279–1212 B.C.E. Wall painting from the tomb of Nefertari (wife of Ramesses II). Valley of the Queens, near Deir el-Bahri, Egypt.

The tomb of Nefertari, wife of pharaoh Ramesses II, was discovered in 1904. It was found plundered, and with much of the painted surface of the walls flaked off. These paintings, however, have been quite successfully restored. Atum (right), creator of the world, is depicted holding the ankh, the symbol of everlasting life, in his right hand. Osiris (left), ruler of the dead, holds the symbols of kingship, the crook and flail. According to Egyptian religious belief, Osiris was violently murdered by his brother, thus accounting for his mummy-like appearance.

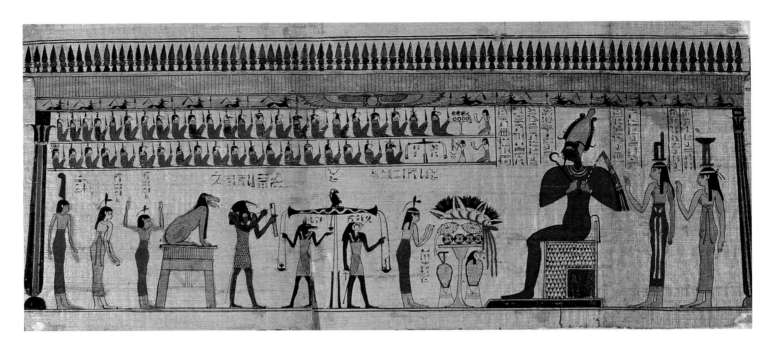

Judgment in the Other World, from the Book of the Dead. 350 B.C.E. Papyrus.
Staatliche Museen, Egyptisches Museum, Berlin, Germany.

Egyptian Books of the Dead were actually included in the wrappings of the mummified body. These books, which were meant to aid the trials of judgment in the afterlife, were actually scrolls of papyrus. The judgment scene illustrated here is typically found in Books of the Dead. The heart of the deceased is weighed against a feather representing truth to determine the deceased's fate. Ammit, the lion-like monster on the pedestal at the left, awaits the decision; if it is negative, he will devour the heart. The god Thoth, to the left of the scales, records the event. The deceased herself is depicted presenting her offerings before the god Osiris (god of the dead). Behind Osiris stand the goddesses Isis (wife of Osiris) and Nephtys (sister of Isis and Osiris).

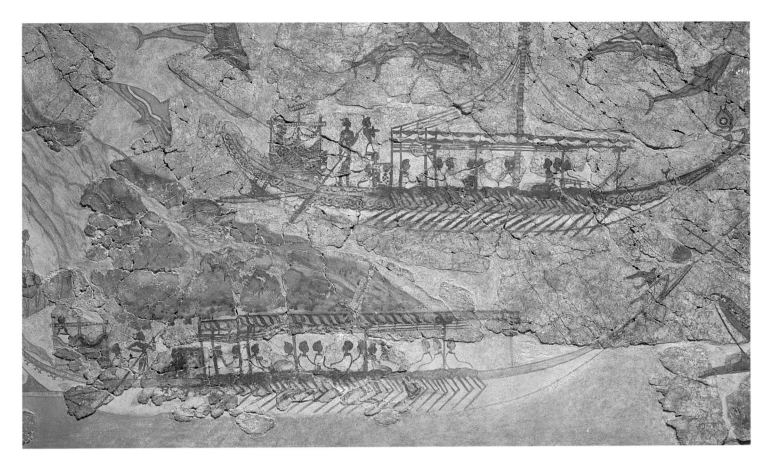

Boats. c. 1650 B.C.E. Detail of Minoan fresco, Thera (Santorini). National Archaeological Museum, Athens.

The Minoan peoples traded with the Greek mainland, Egypt, and the Near East. They were certainly skilled seafarers. The boats shown here are part of a larger frieze. The attention paid to the details of boat design and the awareness of the different tasks carried out by the crew members in this mural reveal that the designers of these murals were certainly very knowledgeable when it came to boats. Dolphins, along with other aquatic creatures, are found frequently in Minoan art.

following spread:

Bull Jumping ("Toreador Fresco"). Wall painting from the palace complex, Knossos, Crete. c. 1450 B.C.E. Height: approx. 24 1/2 in. (62.3 cm). Archaeological Museum, Heraklion, Crete.

Minoan religious practices remain somewhat obscure. This enigmatic scene may be a religious ritual in which male and female participants (females are fair-skinned, as in Egyptian art, indicating their sheltered lives out of the sun) take turns vaulting over a charging bull. The grace, elegance, and rhythmic playfulness of both the bull and the bull-jumpers, achieved with curvy, elastic lines, is characteristic of Minoan style.

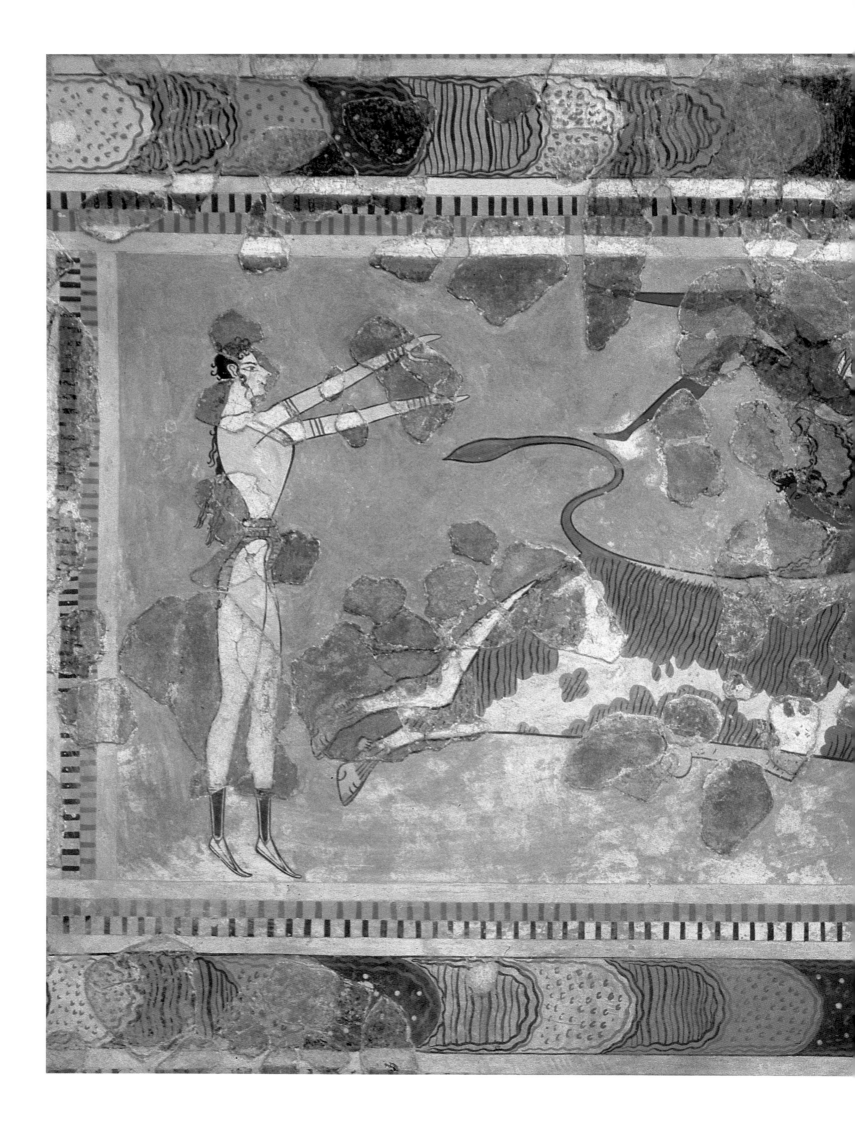

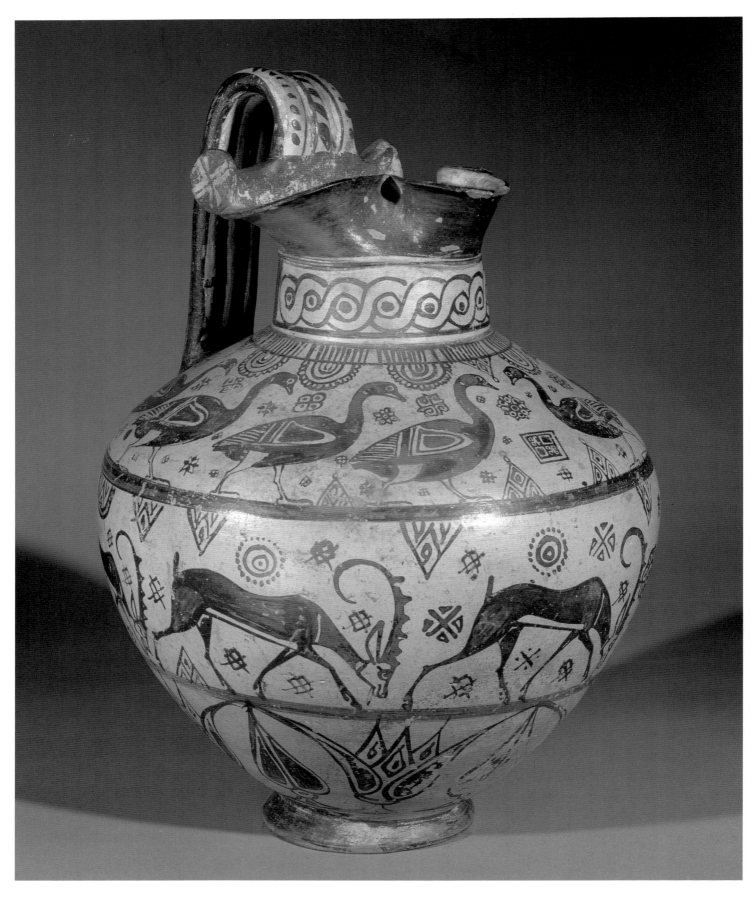

Rhodian Oenochos (wine jar). Second half of the 7th century B.C.E.
Height: 13 in. (32.5 cm). Musée du Louvre, Paris.

"Orientalizing" vases such as the one illustrated here, so called because of the influence of works from the Near East and Egypt on the decoration, were produced in Greek pottery centers, such as Rhodes, in the seventh century B.C.E. The elegantly stylized deer and geese on this wine jar resemble animal forms found in the art of the ancient Near East. The decorative plant forms at the base are very similar to the lotus buds found depicted in ancient Egyptian art.

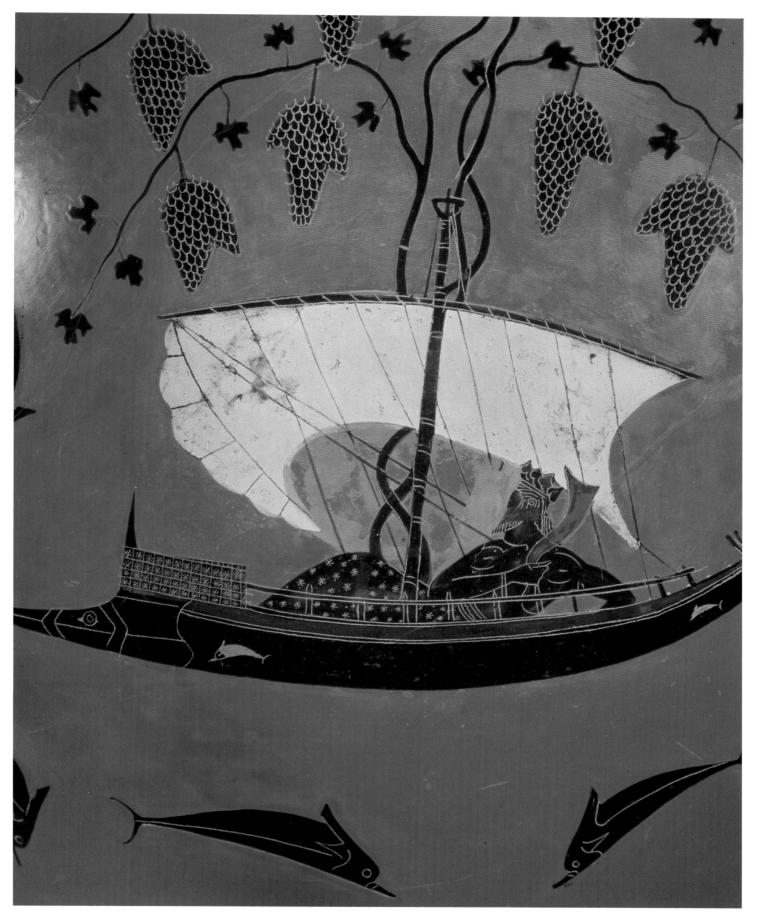

EXEKIAS. *Dionysus in His Boat*. C. 540 B.C.E. Interior of an Attic black-figured kylix. Diameter: 12 in. (30.5 cm). Staatliche Antikensammlungen, Munich.

Dionysus relaxes in his boat after having frightened off a band of pirates by causing grape vines to spring up. The pirates, after jumping overboard in fear, are turned into dolphins. Suitably, this story about the god of wine decorates a kylix, or drinking cup.

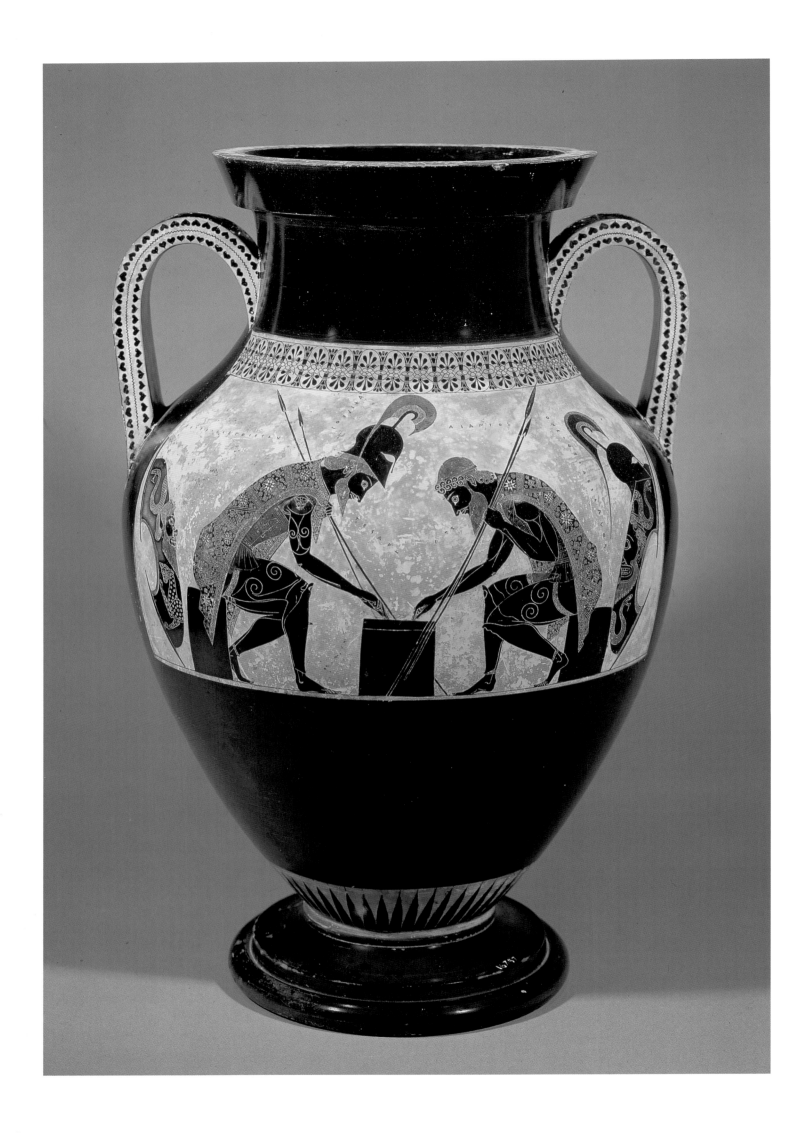

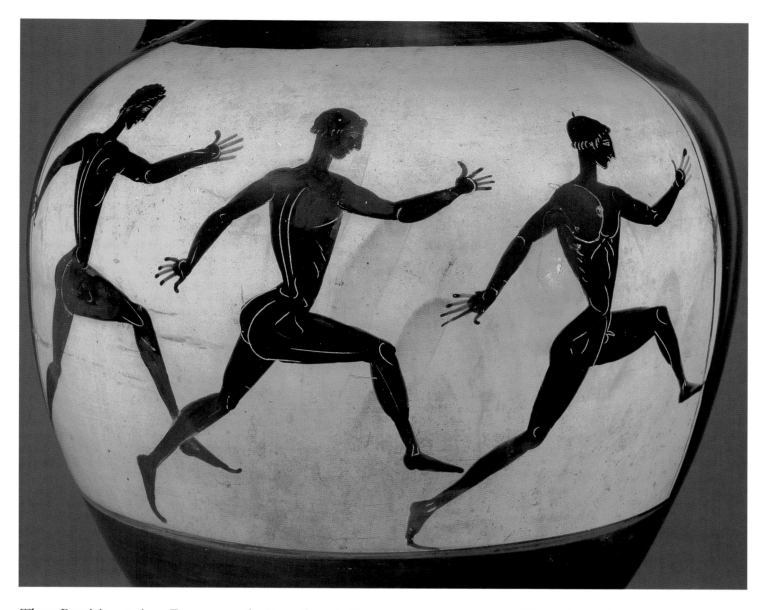

Three Participants in a Footrace at the Panathenaic Games. 6th century B.C.E. Black-figured amphora. Musée Vivenel, Compiegne, France.

This vase was given as a prize to the winner of a footrace at the Panathenaic Games. What the Greeks considered the naturally beautiful human figure, whether mortal or immortal, had become the main subject of vase painting by this time. Athletes, because they competed nude, were a favorite subject of Greek artists perfecting the depiction of the human form. The arrangement of small figures and patterns in horizontal registers, characteristic of the "geometric" and "orientalizing" styles, is replaced in Archaic Greek vases, such as the one illustrated here, by larger, less crowded scenes.

opposite:

EXEKIAS. *Achilles and Ajax Playing Dice.* c. 540–530 B.C.E. Attic black-figure amphora from Vulci. Height: 24 in. (60.7 cm). Museo Gregoriano Etrusco, Vatican.

In the black-figure technique of Greek vase painting, figures were painted using a slip which turned black when the vase was fired. The red background is the unslipped area of the ceramic surface. A stylus was used to scratch through the slipped surface to create details in red—the complex, delicate, deftly incised patterns on the cloaks worn by Achilles and Ajax in this image testify to Exekias' genius. Although engaged in a game of dice (Achilles calls out "tesara" [four] and Ajax calls out "tri" [three]), both heroes sit poised for action, holding their spears at the ready. Many Greek vases owe their survival to the Etruscans in pre-Roman Italy. The Etruscans were avid collectors of Greek vases. This vase comes from the Etruscan site of Vulci, roughly half way between Rome and Florence.

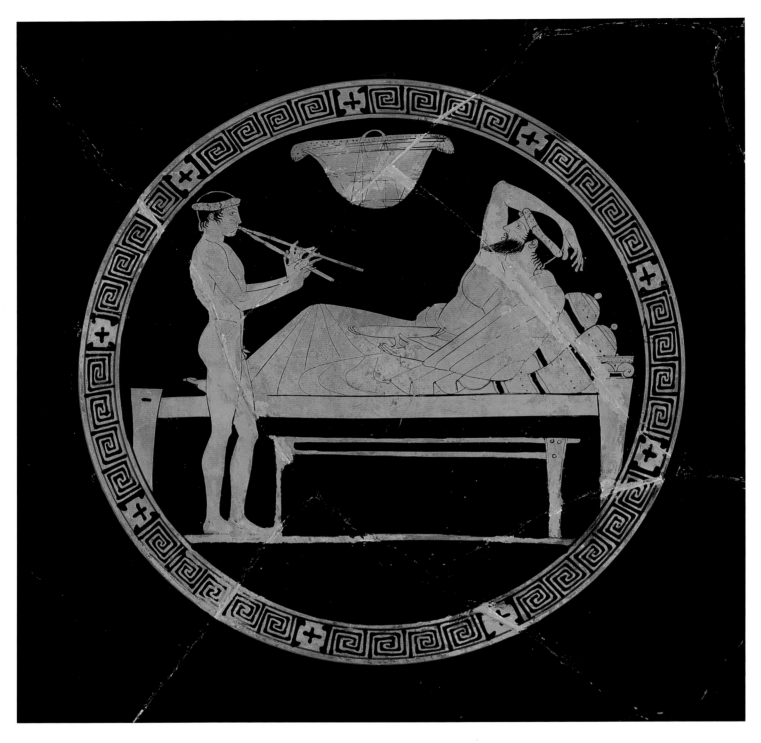

Banqueting Scene, a Guest Reclines on a Couch Listening to a Musician Play the Double-Flute. 460–450 B.C.E.
Center medallion of a red-figured cup. Musée du Louvre, Paris.

The youthful flute-player, rendered in full profile (including the eye), is successfully depicted occupying space and stands with his weight concentrated on his right leg. The Greek artist's keen interest in the rendering of the human form is clear here. Compare this figure with painted depictions of Egyptian pharaohs, with their awkward combined frontal-profile forms and rigid stances. Thin, black lines delineate musculature and drapery folds in this banqueting scene. The reclining figure holds a kylix, or drinking cup, similar to the one which this image decorates.

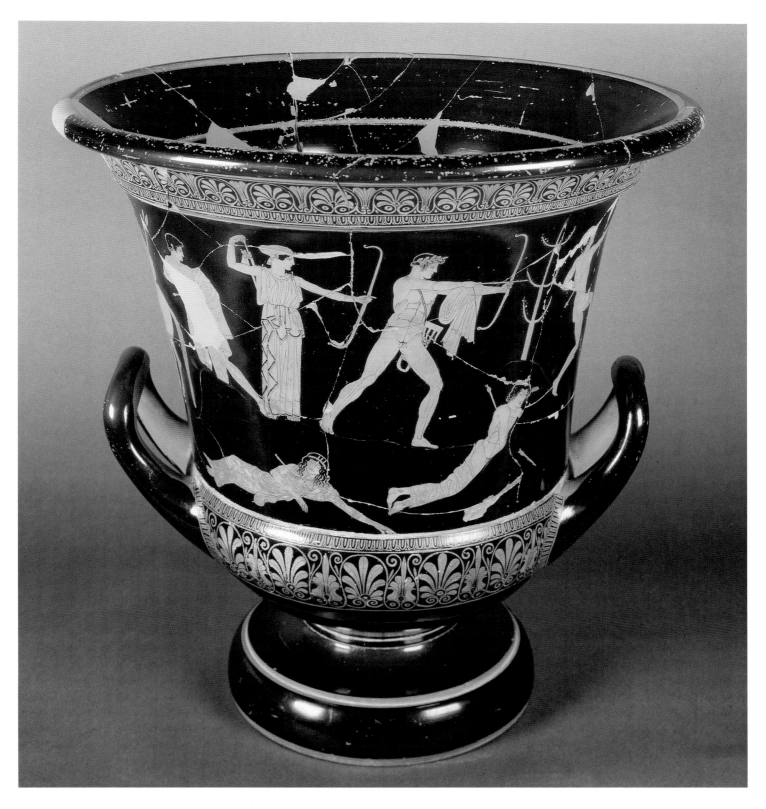

NIOBID PAINTER. *Apollo and Artemis Slaying the Children of Niobe.* Attic red-figure calyx-krater from Orvieto. c. 455–450 B.C.E. Height: approx. 21 in. (53.3 cm). Musée du Louvre, Paris.

In Greek mythology, Niobe was the granddaughter of Zeus, ruler of the gods. After boasting about the number of children she had (seven sons and seven daughters) in comparison to the goddess Leto, Niobe was punished for her hubris by Apollo and Artemis, the two offspring of Leto, who slaughtered all Niobe's offspring. The red-figure technique was more conducive to the Classical Greek artist's interest in realism, qualified by idealism, in the depiction of the human form. In portraying the nude figure of Apollo, the Niobid Painter has clearly delineated musculature. Despite the horror of the event, Apollo and Artemis have typically controlled, rational expressions on their faces—the essence of the Classical ideal.

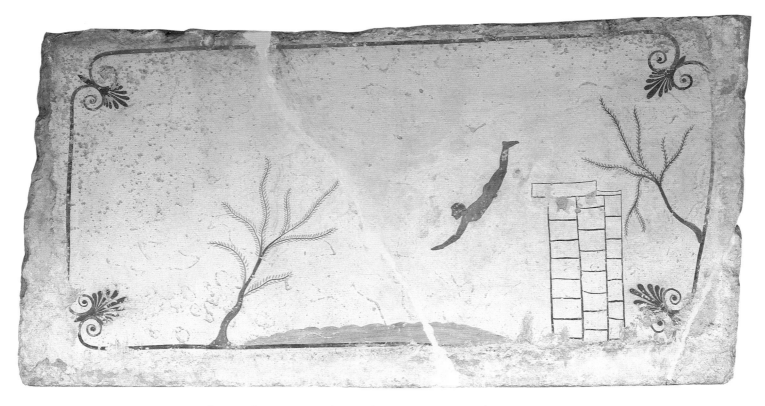

Diver. c. 480 B.C.E. Ceiling fresco from a Greek tomb at Paestum, Italy.
Height: approx. 40 in. (101.6 cm). Museo Archeològico Nazionale, Paestum.

We know that in addition to vase painting, the Greeks painted large-scale compositions on panel, which have not survived the tests of time. A few mural paintings do survive, like this one from a Greek tomb in Paestum, Italy. The dive taken by the youth perhaps symbolizes the passage from life to death.

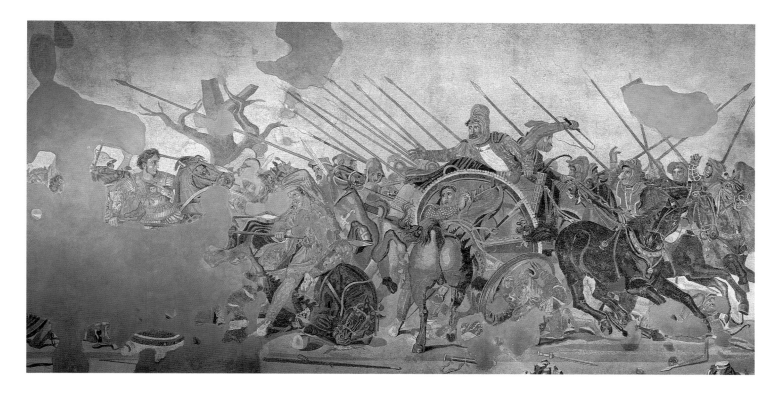

PERHAPS BY PHILOXENOS OR HELEN OF EGYPT. *Alexander the Great and Darius III at the Battle of Issos.* Roman mosaic copy after a Greek painting of c. 310 B.C.E. 106 1/4 x 200 in. (270 x 510 cm). Museo Archeològico Nazionale, Naples.

The 5th-century Peloponnesian War weakened Greece considerably. By the end of the fourth century B.C.E., the Greeks were under Macedonian rule, the most famous leader of which was Alexander the Great. This Roman floor mosaic from a house in Pompeii is a copy of a large-scale Greek painting and depicts the battle between Alexander and the Persian king Darius III. Foreshortening—note in particular the horse seen from behind in three-quarter view in front of Darius' chariot—is masterfully employed here. Light is reflected from the shiny surfaces of armor, and figures cast shadows. The dramatic emotionalism of this image is probably typical of 4th-century Greek panel painting, none of which survives.

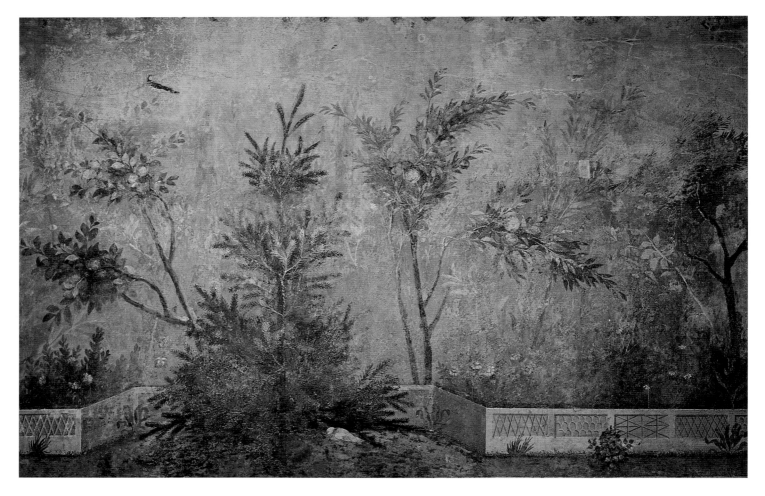

Garden Scene. c. 30–20 B.C.E. Detail of a Second Style wall painting from the Villa of Livia, Primaporta (north of Rome). Height: approx. 79 in. (200 cm). Museo Nazionale Romano, Rome.

The artist of this Second Style wall painting has masterfully created the illusion of distant space through atmospheric perspective. The trees, birds, fruit, flowers, and fence of the foreground are portrayed with sharp clarity. The woodsy background is less distinct, giving the impression that the intervening atmosphere has blurred the more distant landscape elements.

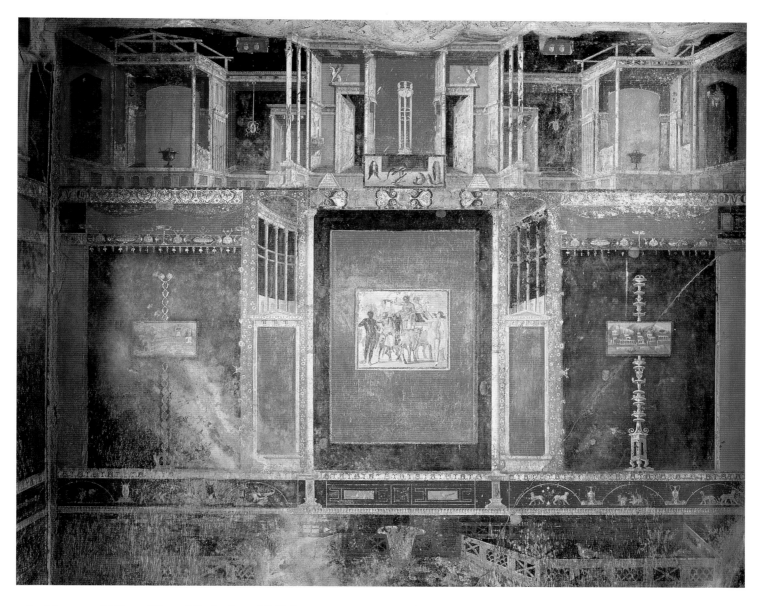

Architectural View, "Panel Paintings." Mid-1st century C.E. Third Style wall painting in the House of M. Lucretius Fronto, Pompeii.

While the illusionistic paintings of the Second Style denied the wall surface, Third Style Roman wall paintings often call attention to the flatness of the wall. Solid-color panels serve as backdrops for "hung" panel paintings and paintings illusionistically placed on stands. Here, the central panel painting is a mythological subject while the paintings in the side panels are of seaside villas. Architectural forms in Third Style painting are reduced to absurd slenderness, which results in elegant, fantastical structures.

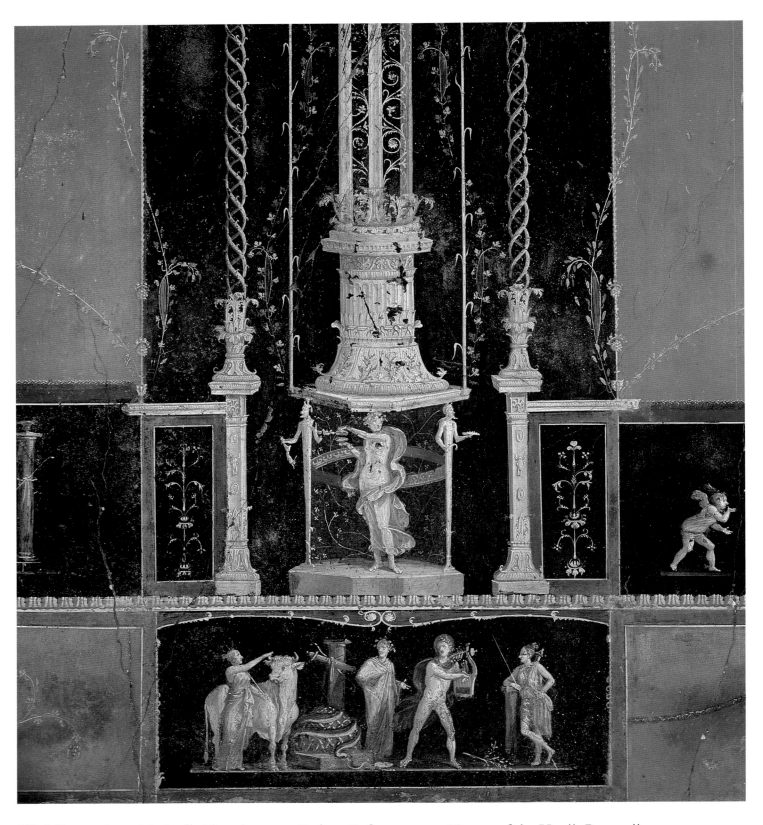

Wall Decoration with Apollo Victorious over Python. Before 79 C.E. House of the Vettii, Pompeii.

The delicate architectural forms and floral designs of the Third Style are seen here. Also typical of this style is the placement of figures, landscapes, etc., directly on the monochrome ground. The scene at the bottom of this image shows Apollo playing his lyre after having slain the Python, the serpent who had guarded the oracle at Delphi. The Python is seen to the left of center. In honor of the god Apollo, the Pythian Games (musical and literary contests) were held at Delphi every four years.

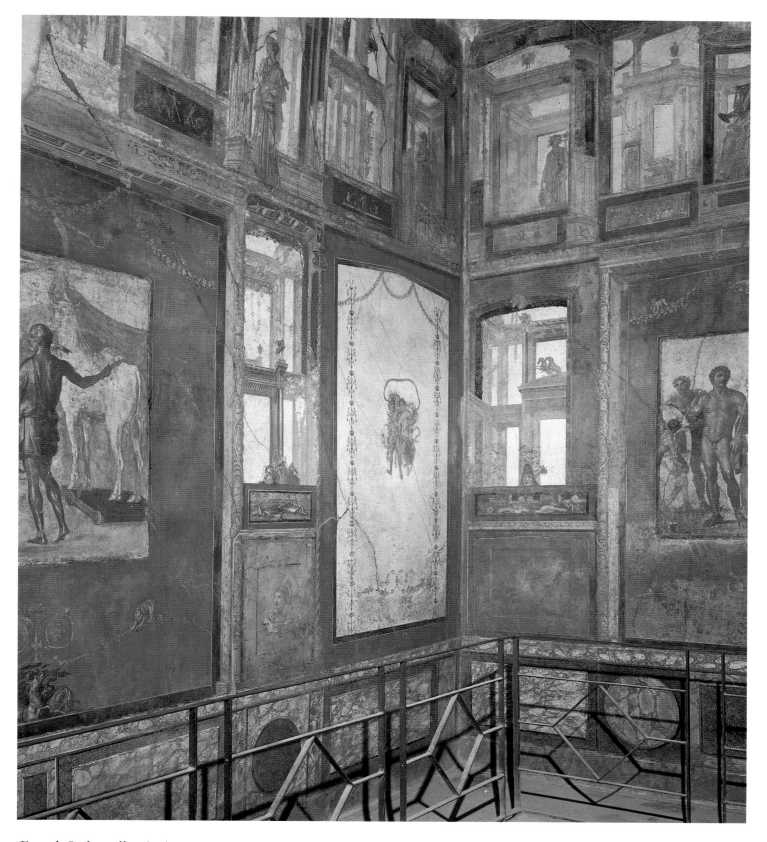

Fourth Style wall paintings. c. 70–79 c.e. Ixion Room of the House of the Vettii, Pompeii.

Fourth Style Roman wall paintings often combine the three previous styles. In this example, the lowest register contains First Style painted marble. The large white panel at the corner, with its delicate floral border decoration and the "context-less" image floating against the solid white backdrop, is a stellar example of refined Third Style painting. The "panel paintings" of mythological subjects "hanging" on red backdrops are also typical of Third Style painting. Illusionistic architectural vistas, similar to those found in the Second Style, are also present, although the architecture is far more fantastical, irrational architectural views being a main characteristic of the Fourth Style.

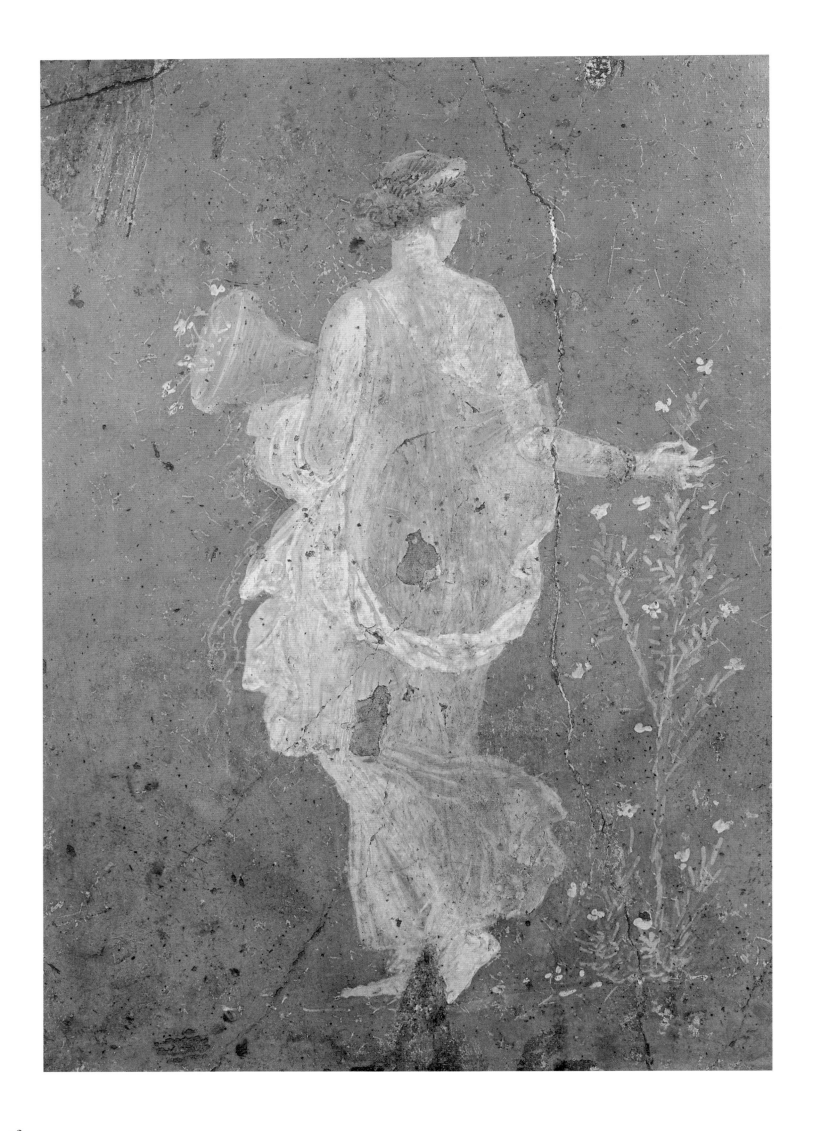

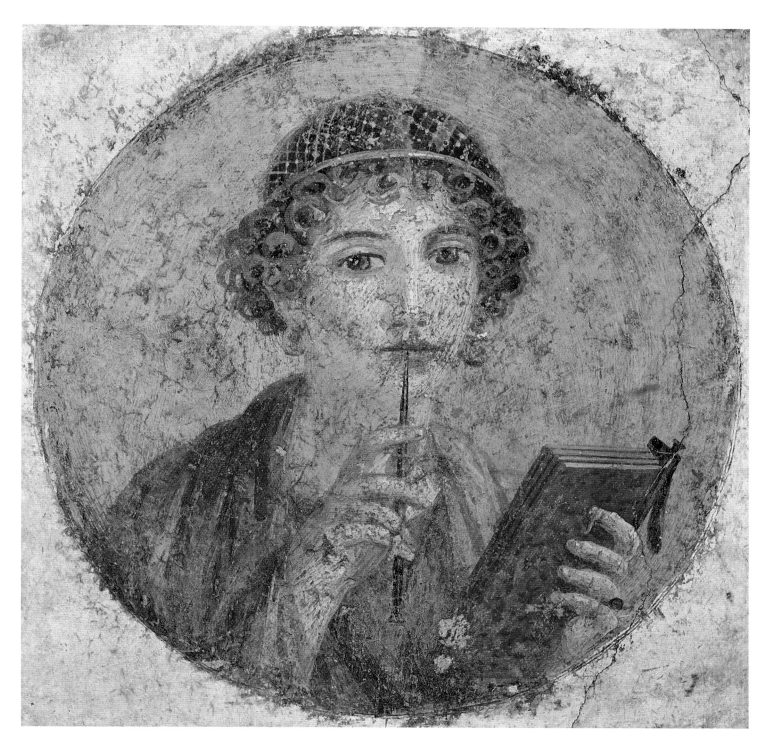

Young Woman Writing. Late 1st century C.E. Detail of a wall painting from Pompeii.
Diameter: 14 5/8 in. (37 cm). Museo Archeològico Nazionale, Naples.

This pensive young woman holds a writing stylus to her mouth and a wax tablet in her left hand. The pointed end of the stylus was used to engrave texts into wax; mistakes could easily be erased with the flat end. Once a text was completed, it could be copied onto a more permanent medium.

opposite:

Primavera, from a bedroom of a villa in Stabia. Before 79 C.E. Museo Archeològico Nazionale, Naples.

The young, gentle woman depicted here gracefully turns away from the viewer and picks flowers from the only plant indicating a natural surrounding. The flat green background, however, suggests a springtime field, and the subtle movement of the drapery around the young woman's feet suggests a soft, cool breeze.

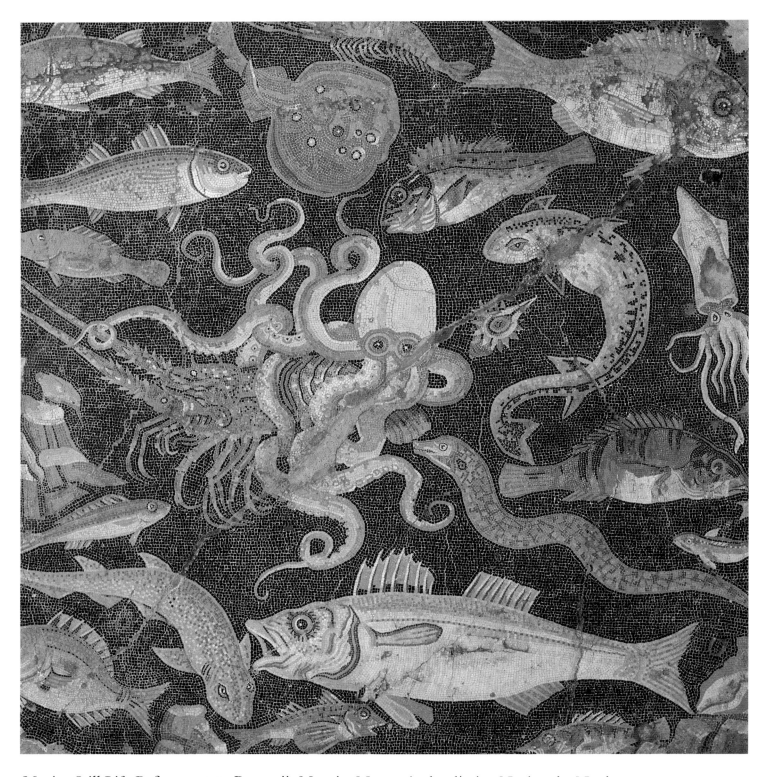

Marine Still Life. Before 79 C.E. Pompeii. Mosaic. Museo Archeològico Nazionale, Naples.

Before the eruption of Mount Vesuvius, Pompeii was located quite close to the sea and many Pompeiians were fisherman. This floor mosaic comes from a private home and shows, in almost encyclopedic detail, the many different kinds of marine life familiar to Pompeiians. Wild animal pitted against wild animal was a popular event in Roman amphitheaters. This love of animal combat may account for the struggle between an octopus and lobster in the center of this mosaic.

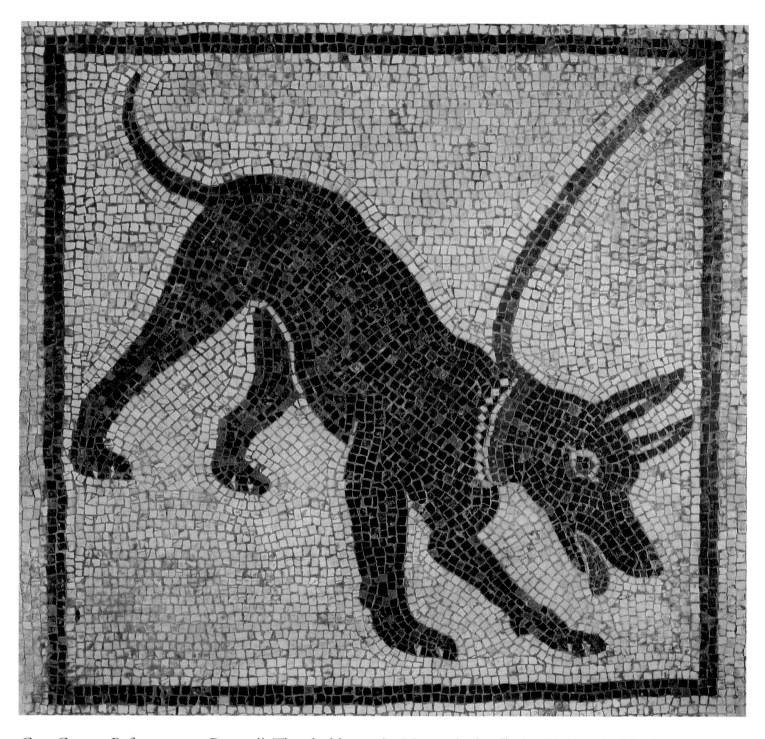

Cave Canem. Before 79 C.E. Pompeii. Threshold mosaic. Museo Archeològico Nazionale, Naples.

Like many homeowners today, Romans owned dogs to protect their homes from thieves and announced the presence of guard dogs with signs indicating "Beware of Dog" ("Cave Canem"). Mosaic warnings, such as this purely pictorial one (frequently the words "Cave Canem" were rendered in mosaic as well), were commonly found at the entrances to Roman houses.

The Middle Ages

Age of Faith

In the vast, cosmopolitan Roman Empire, people of various religious traditions mixed freely. In many parts of the Roman world, Graeco-Roman polytheism, the polytheistic traditions of the Near East, and the monotheism of Judaism and Christianity blended and influenced each other significantly. At the Roman outpost of Dura-Europos, in modern-day Salahiyeh, Syria, for example, pagan Roman temples existed side by side with a Jewish synagogue, a Christian church, and shrines dedicated to Persian gods. While certain late Roman emperors tolerated the practice of non-Roman religions, others did not. The most famous example of the latter is Diocletian who, threatened by the Christians' refusal to worship Roman emperors, clashed with the Christians and persecuted them from 303 to 305 C.E. The situation improved for Christians, however, with the late Roman emperor Constantine's personal acceptance and active support of Christianity.

EARLY CHRISTIAN PAINTING

Before the era of Constantine (ruled 306–337 C.E.), the earliest Christian paintings come from catacombs, which were underground graveyards consisting of tunnels with long rectangular niches carved into the walls to hold the bodies of the dead, and larger, chapel-like spaces for the sarcophagi of the more well-off and for funerary services and feasts. The walls and ceilings of Christian catacombs were frequently painted with Christian subjects, and, on occasion, pagan subjects that in that context became "Christianized."

The Christian images themselves are often derived from pagan and Jewish artistic traditions, revealing once more the influence various religions had on one another at this time. Christians sought

Abraham Presents His Prisoners and Booty to Melichizedek, from the *Psalter of St. Louis.*
Ms. lat. 10525, f.6. 1253–70. Paris. 5 x 3 1/2 in. (13.6 x 8.7 cm).
Bibliothèque Nationale, Paris.

legitimacy by adapting Jewish motifs, thus presenting themselves as updated Jews. The figure of the Good Shepherd, for example, comes from the Twenty-third Psalm of the Old Testament; in the Christian tradition he is further identified with Jesus, the "good shepherd" who "lays down his life for the sheep" (John 10:11). In pagan art, both Hermes, protector of shepherds and their flocks, and Orpheus, who charms the animals with his lyre, are shepherd-like figures. And, while this image of the Good Shepherd from a Christian catacomb has a Christian meaning, the pose itself—the shepherd with a ram over his shoulders—is derived from pagan statues. Many catacomb paintings also display stylistic features of Roman wall paintings.

Although he did not officially become a Christian until he was baptized on his deathbed, Constantine, influenced by his mother, Helena, was responsible for building and decorating a large number of Christian churches. Most importantly, in 324 he donated the site

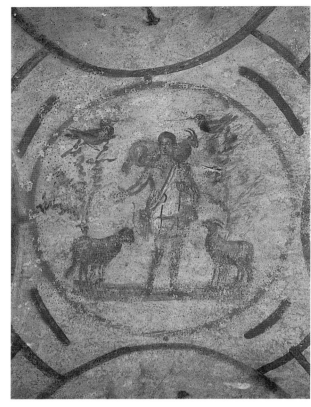

The Good Shepherd. Second half of the 3rd century. Cubiculum of the Velati. Catacomb of Priscilla, Rome.

for the building of Old Saint Peter's in Rome, where the current Saint Peter's, virtually rebuilt in the sixteenth century, stands today. Before Constantine, the absence of official recognition caused early Christians to worship primarily in private. Services were held secretly in catacombs and in the homes of the faithful. With the construction of Old Saint Peter's and other Constantinian churches, Christians worshiped in public for the first time.

Constantine, the great supporter and promoter of Christianity, was also, as Roman emperor, obligated to defend the pagan gods. To avoid conflict, he often had the Christian structures built outside city walls, away from the pagan centers. Like the catacombs, fourth-century Constantinian buildings often contained both Christian and pagan imagery. For example, Santa Costanza, the mausoleum built for Constantine's daughter, Constantia, originally displayed scenes, now lost, from the Old and New Testaments, but depicted classical pagan imagery as well, much of which still survives. Elaborate grapevines filled with birds and putti are part of the decorative program at Santa Costanza. While grape harvests and wine-making scenes are found associated with Bacchus in classical art, and thus befit the daughter of a Roman emperor, the

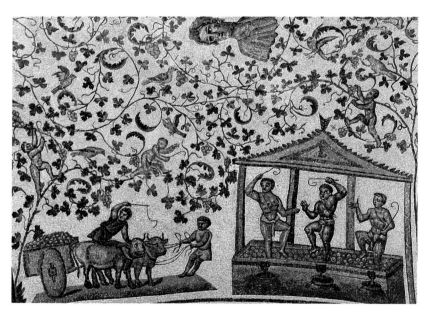

Grape Harvest. c. 350. Mosaic from the ambulatory vault of Santa Costanza, Rome.

Christian viewer would have understood the symbolism of the wine transformed by the Eucharistic celebration into the blood of Christ.

While early Christian churches were relatively plain on the outside, their interiors were richly decorated, usually with Old and New Testament scenes rendered in mosaic. As we have seen, the Greeks and Romans also used the mosaic technique, most commonly employing opaque marble tesserae to decorate floors. Christian mosaics, on the other hand, cover

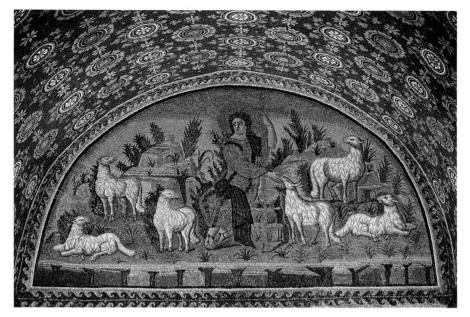

The Good Shepherd. c. 425–26. Mosaic in the Mausoleum of Galla Placidia, Ravenna.

the walls of churches with tesserae frequently made of colored glass. The shimmering, reflective quality of the glass aids in creating characteristically Christian images, which are more metaphorical and otherworldly, in keeping with the spiritual context, while Roman wall paintings and mosaics are more naturalistic. Whereas the Romans created the illusion of receding space, Christian mosaicists, frequently through the use of gold tesserae, often strove instead to create a more timeless, heavenly realm, peopled with figures that seem to transcend physical existence. Christian artists did not emphasize the beauty of the human body, as the Greeks and Romans had done; nudity in Christian art was often associated with sin—Adam and Eve were depicted naked—and the draped figure in Christian art often betrays no evidence of a living, breathing person beneath.

Many early Christian mosaics, however, were influenced by Roman advances in the illusionistic rendering of forms and spaces. For example, in the mosaic in the apse of Santa Pudenziana in Rome (c. 400, but heavily restored), Christ, who, despite his halo, strongly resembles an enthroned Roman emperor, is positioned in an urban setting (here, Jerusalem) that is similar to the architectural constructions found in Roman wall painting. Classical styles and motifs are once again appropriated and changed as needed to convey a new, Christian message, just as the classical naturalism is accompanied by Christian symbolism—the large cross, and the four symbols of the Evangelists hovering over the scene below.

A mosaic from the first quarter of the fifth century, in the Mausoleum of Galla Placidia, depicts a familiar subject, the Good Shepherd, who here is more obviously Christian, with cross and halo. The landscape setting is somewhat reminiscent of the illusionistic Roman mosaic landscapes. The Christian artist has rendered a foreground and background, and created convincingly three-dimensional figures and landscape elements by using different-colored tesserae to create the effect of light on form.

The mosaic of the Doubting of St. Thomas from the Church of Sant'Apollinare Nuovo in Ravenna dates to about seventy-five years after the Good Shepherd. Here, we can see a dramatic break with the classical tradition: landscape setting has been reduced to a strip of green at the bottom of the image and a simple building; the Doubting takes place before a gold backdrop, which prevents any recession into space and flattens the picture; and what classical illusionism remains is seen in the very narrow space

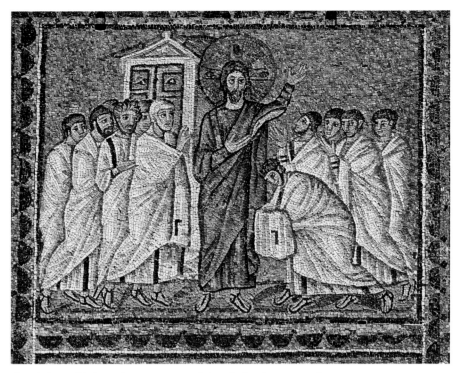

Doubting of Saint Thomas. c. 500. Mosaic in the nave of
Sant'Apollinare Nuovo, Ravenna.

the figures seem to occupy, as indicated by their cast shadows. Decoration and details are omitted, so that the viewer is forced to focus on the message, which is unambiguous: Christ is placed front and central, and he is larger than the flanking groups of Apostles, who point toward his imperial figure. Already medieval are the hand gestures that convey emotion; here, the hands are enlarged for clarity. This scene is not set in a specific time or place; the earthbound, descriptive world of Roman mosaics has given way to an ethereal, timeless, abstract Christian world, a "higher" reality.

Classical styles and motifs, however, will recur time and again in the Christian art of the medieval period, until the great revival of the classical that defines the Renaissance signals the end of the Middle Ages.

The designers of early Christian mosaic cycles most likely drew heavily on pictorial motifs they found in books. Early books were in scroll format; the reader progressed through a text by unrolling it as needed, while rolling up the parts already read. This scroll format was not conducive to heavily painted imagery, which would have suffered from being constantly rolled and unrolled. Thus, scrolls tend to be illustrated with simple line drawings. Eventually, the scroll format gave way to the codex, which closely resembles the modern book in that pages are bound together and protected by a cover. Papyrus was replaced by parchment (lambskin) or vellum (sheepskin), which was carefully cleaned, dried, and scraped to provide a relatively smooth surface that would hold the ink and pigments of text and the accompanying complex, colorful imagery. Until the printing press was invented in the fifteenth century, texts and images were painstakingly hand-copied, hence the term "manuscript," from the Latin, meaning "handwritten." Frequently this task fell to monks and nuns.

Very few early books survive, but one example is the *Rossano Gospels* from the first quarter of the sixth century, the earliest surviving codex with New Testament illustrations. A sumptuous production, this manuscript consists of pages of purple vellum with text inscribed in silver. On a page showing the parable of the Good Samaritan, setting is reduced to a cluster of buildings at the left; the story itself takes place in two scenes that are painted directly on the purple surface of the page.

BYZANTINE PAINTING

In 330, when Constantine moved the capital of the Roman Empire to Byzantium and renamed it Constantinople (modern-day Istanbul), he also shifted the artistic center of the empire from west to

east. In 395, under the emperor Theodosius I, the mighty Roman Empire split in two, becoming the Roman West and the Byzantine East. For a while, the West withered under the onslaught of invading Germanic tribes, while the Byzantine East flourished, reaching its peak under the rule of Justinian I (ruled 527–565). Justinian extended Byzantine rule into part of the Roman West, specifically Sicily, most of Italy, and part of Spain. Although the Christian Church did not officially split into the Western, or Roman Catholic, Church and the Eastern, or Orthodox, Church until 1054, the political schism of the fourth century also in effect resulted in a religious schism.

In 539, Justinian conquered the city of Ravenna in northern Italy. This city had functioned as the capital of the West for a time after the decline of Rome, and Justinian in turn made it the principal city of the Byzantine Empire in Italy. Several Christian buildings that had been under construction at the time of the Byzantine takeover were completed in Justinian's reign, notably the Church of San Vitale, dedicated to the Italian martyr Saint Vitalis, and the Church of Sant'Apollinare in Classe, dedicated to Saint Apollinaris, the first bishop of Ravenna.

Justinian and his wife, Theodora, are depicted in separate mosaics that face each other across the sanctuary apse of San Vitale. Dressed in royal purple and gold, the haloed figures of the emperor and empress respectively present their offerings: a paten for holding the Eucharistic bread and a chalice for holding the wine. Their haloes and their presence in the apse—even only as images—are significant. In the Eastern Church, unlike the Western, the emperor was not only a secular leader, but leader of the Church as well. While the mosaic portrait of Theodora draws on classical imagery—most notable in the canopy and the fountain atop a pedestal—these mosaics are far removed from their naturalistic predecessors in ancient Rome. Not only does the gold background in the Justinian and Theodora mosaics preclude any illusion of receding space, it seems to push space forward toward the viewer. The figures cast no shadows whatsoever. The drapery worn by these figures falls stiffly, and though the folds create interesting patterns, they do not really serve to suggest the bodies beneath. Although Justinian, Theodora, and their corteges were powerful people, acting in this world, the style in which they are depicted here conforms more to the incorporeality characteristic of Christian mosaics. They appear to exist outside time, yet they are present always, participating in the sacred rites.

The apse mosaic from the Church of Sant'Apollinare in Classe (c. 533–549) moves even further away from the naturalistic and more toward the transcendent. There is no illusionism at all in the depiction of a giant cross flanked by the hovering forms of Moses and Elijah in a landscape that itself is now quite stylized. The entire composition is meant

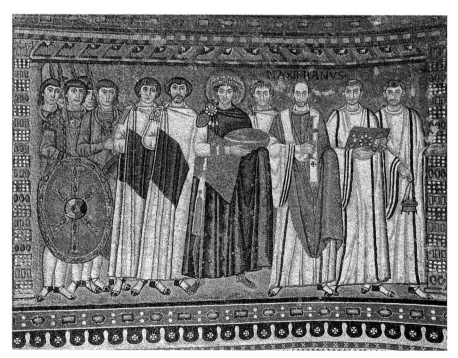

Emperor Justinian and His Attendants. c. 547. Mosaic on the north wall of the apse. 104 x 144 in. (264 x 365 cm). Church of San Vitale, Ravenna.

to be read as a symbolic representation of the Transfiguration, when Jesus appeared in radiant glory before three of his disciples, here portrayed as lambs, rather than as a reflection of sensory reality.

Christians of the Byzantine East prayed to Christ, his mother Mary, the saints, and angels while looking at icons, or images, of these holy figures, even though the veneration of icons was regarded by some as idolatry. The Second Commandment forbids the making of *graven* images (Exodus 20:4), and this may be one reason why there is little early Christian and Byzantine large-scale sculpture, and why images in general were from time to time viewed with theological suspicion. In the eighth century, this suspicion led to an outbreak of iconoclasm, or the systematic destruction of images, in the East. Thousands of icons were destroyed, and churches were redecorated with nonfigural, even abstract religious symbols.

The Iconoclastic outbreak of the eighth century marks the end of the so-called Early Byzantine period in art, which began under Justinian, while the return to images—the triumph of the iconophiles, or lovers of images—in 843 opens the Middle Byzantine period, during which the production of icons was enthusiastically taken up again. Damaged by candle smoke and incense, and repainted several times, except for the faces, which are original, the twelfth-century icon, the *Virgin of Vladimir*, like many others, has had miraculous protective powers ascribed to it. This particular icon is believed to have prevented several Russian cities from being overtaken by invaders on numerous occasions. Even today, it is one of the most revered images in Russia.

Some of the most famous works of Byzantine architecture and art from this middle period are monastic churches in Greece, with their magnificent mosaic decoration. These small churches were built on a plan whereby a Greek cross, which has arms of equal length, is contained within a square. The center, where the two arms intersect, is usually capped by a dome. This design is in contrast to the typical plan of Western churches, which closely resemble Roman public assembly halls, or basilicas. Essentially, Roman Catholic churches are rectangular in plan, with the principal entrance at one short end and the apse with the altar at the other. Their emphasis is longitudinal rather than vertical.

The central plan of the Middle Byzantine church created a vertical emphasis that, when decorated with mosaics, was conducive to a certain hierarchic placement of imagery. In other words, more important figures—Christ or the Virgin Mary, for example—were given privileged positions, usually high up within the space. A mosaic of Christ is commonly found

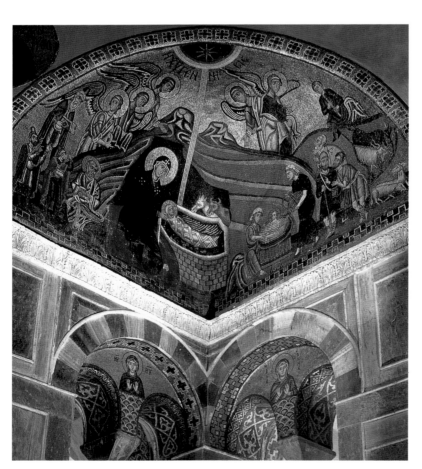

Nativity. Early 11th century. Mosaic in the Monastery Church, Hosios Loukas, Greece.

on the inside of the central dome, while Mary is accorded a place in the apse conch. Scenes from the life of Christ, such as the Nativity from Hosios Loukas, would occupy the squinches or pendentives supporting the central dome. Closest to the viewer and the earthly realm, we find saints, church fathers, and the like.

An interesting mix of Western and Eastern Christian architectural and artistic traditions can be seen in the churches of Sicily built during the

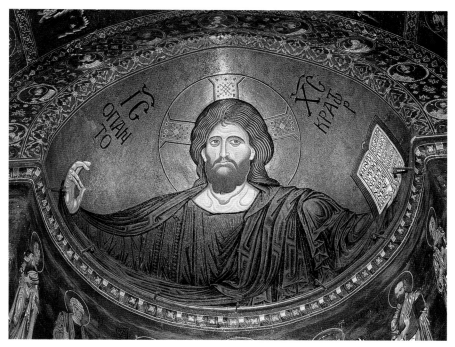

Pantocrator. c. 1183. Apse mosaic in the Cathedral of Monreale, Sicily.

Norman occupation in the twelfth century. The Norman churches of Sicily follow a typically Western, basilican plan, but are decorated with Middle Byzantine–type programs, which, as mentioned earlier, emphasize verticality. In a church in Monreale, Sicily, Christ dominates the nave from the most important focal position in a Western church, the apse. The Christ shown is of a type called the Pantocrater, or All-Ruler. The frontal view, large eyes, arched brows, and long, thin nose—the generalized, iconic appearance of Christ—goes back to the treatment of the mosaic portraits of Justinian and Theodora. The stylized drapery and hair (note the looping patterns of the beard) and the strangely "modeled" face, neck, and hand convey an almost hypnotic emphasis on otherworldliness. The artist has used the shape of the apse to make Christ appear to be embracing our reality, in yet another instance of Christian mosaics seeming to project into our space instead of receding from us, the way Roman paintings do.

In contrast to the hieratic style of the Monreale mosaic is the work of a Byzantine artist who was still influenced by Greek and Roman classicism. The mosaic of Christ from the south gallery of Hagia Sophia in Istanbul is less forbidding and severe, and far more compassionate and human, than the Christ at Monreale. Here, too, are a solid gold backdrop, an iconic stare, and very stiff, angular drapery, but the subtle modeling of Christ's face and the gentle blending of colors are very classical. One argument the iconophiles brought to the Iconoclastic controversy was that Christ could be depicted because of his human nature. Images of Christ that emphasize his humanity over his divinity appear regularly in post-Iconoclasm Byzantine art, perhaps as a celebration of the return of images.

During the Late Byzantine period, roughly the fourteenth and early fifteenth centuries, the Byzantine Empire suffered under attacks by western Crusaders, and even more under the onslaughts of Muslim invaders. In 1453 the Byzantine Empire fell to the Ottoman Turks. Icon painting continued to flourish, however, in the outlying Orthodox regions, such as Russia. One of the best-known painters of icons is the Russian Andrei Rublev (c. 1370–1430). It is interesting to consider one of his most famous icons, the *Old Testament Trinity* (c. 1410), in relation to what was happening in the West at this time, the beginning of the Renaissance.

EARLY MEDIEVAL PAINTING

Having now completed our discussion of Byzantine art, that is, the art of the Eastern Church up to 1453, we now must return to western Europe. When we last considered this region, it was roughly the fifth century and the western half of the Roman Empire had collapsed, overrun by Germanic tribes. The Middle Ages, the thousand years between this time and the Renaissance, was once pejoratively considered by historians of earlier generations to be a period of decline between two classical eras, Greek and Roman antiquity on the one hand, and the Renaissance, when classical Greek and Roman values were reborn, on the other. The name stuck, although now most historians view the Middle Ages in a more positive light, as an age of Faith. Medieval art is commonly divided into three periods: Early Medieval, from the fifth to the tenth century; Romanesque, from the tenth to the twelfth century; and Gothic, from the twelfth to the fifteenth century.

During the Early Medieval period, many Roman contributions in the areas of law, administration, education, economics, art, and so on had disappeared with the decline of the empire in the West. Barbarians, as the Romans called them, from the North and the East pursued their aggressive, sometimes forced, migrations into western and southern Europe, their progress no longer checked by the Romans. Early medieval western Europe was a battlefield; Germanic tribes fought each other, and intermarried with or conquered the Indo-European peoples of western Europe. Disease was rampant, famine and warfare were commonplace. In addition, exhausted and wary of further change, people believed that everything was as God had planned, thus bringing to a halt any sort of progress. This tumultuous period, lasting roughly from the death of Justinian in the mid-sixth century to the reign of Charlemagne in the late eighth century, is sometimes called the Dark Ages.

Interestingly, while the culture of western Europe was either destroyed or subsided into dormancy, Ireland, which had not been subjected to either Roman control or Germanic invasion, flourished. Some of the most beautiful illuminated manuscripts of the Early Medieval period come from Irish monasteries in England and Ireland. Far from Rome, Christians in this part of Europe deviated from the practices of the Roman Church, and the Hiberno-Saxon art of the Irish-English islands was, at first, more influenced by Celtic and Germanic styles (as the name suggests) than by the more classical styles emanating from Rome. These include the "Animal Style," which incorporates ornamental animal forms into works of art. The Animal Style originated in prehistoric times, later appearing in the ancient world in the East, among both nomadic peoples and the civilizations of Mesopotamia, and in Egypt, passing westward to the Germanic tribes, where it appears in a more abstracted form. The Animal Style appealed to the pagan past of the newly Christianized Germanic peoples, just as, in the Early Medieval period, pagan nature cults, occult practices, the magical use of amulets, potions, and spells to control the natural world, and a strong belief in fantastic creatures such as trolls, demons, and dragons, mixed with Christian theology and practices.

The application of the Animal Style by the Germanic tribes primarily to small, portable metal objects explains both its wide propagation and the fact that, frequently, artworks in other media employing the Animal Style resemble metalwork. A page from the *Book of Durrow*, a manuscript possibly from a monastery on an island off the coast of Scotland, shows the lion that symbolizes the evangelist Mark. The stylized, patterned appearance of the animal—completely unnaturalistic and with no trace of the classical—and the intricate, typically Germanic interlace of the border closely resemble metalwork from this region.

The combination of the Germanic Animal Style and the Celtic tradition of abstract, geometric, highly intricate, and disciplined designs is found in Hiberno-Saxon images, where zoomorphic forms are so completely abstracted and geometrized that they are virtually unrecognizable. On a page of an early eighth-century Christian manuscript from a monastery on the island of Lindisfarne, off the northeast coast of England, Celtic abstract geometric interlace and Germanic interlace of fantastical animals harmonize with Christian symbolism, though the Christian cross that dominates the page visually contains, structures, and symbolically subdues paganism. Zoomorphic forms and elaborate knot designs are paired and repeated with subtle symmetry, resulting in the electric maze-like quality of this image. Repetition, symmetry, and knot forms all represent the worldviews of the pre-Christian peoples of the British Isles.

Another page from the *Lindisfarne Gospels* shows the evangelist Mark writing at his desk, his symbol, the lion, above him. Roughly contemporary with this image is a page from the *Codex Amiatinus* showing the scribe Ezra. Note the differences. The artist who painted the Ezra image has attempted foreshortening and tried to create a three-dimensional space for his author. The naturalism of Ezra's drapery, achieved through a careful blending of colors, contrasts with the treatment of Mark's, where the folds are transformed into an abstract, almost frenzied pattern, resembling the energetic linearity of the other page from the *Lindisfarne Gospels*. The bulging eyes and emphasis on line in Mark's face are worlds apart from the subtle shading of Ezra's face. Mark's desk is a solid, upright disk, not a foreshortened object illusionistically receding into space; the absence of setting is reinforced by the flat, reddish background and by the writing on the page. The *Lindisfarne* page as a whole is a pleasing design made up of wonderfully balanced colors and shapes contained by line.

Lion, Symbol of the Evangelist Mark, from the *Book of Durrow.* Ms. 57-A.4.5, f.191v. c. 660–80. Ink and tempera on parchment. 9 5/8 x 5 11/16 in. (24.5 x 14.5 cm). Trinity College, Dublin.

Carpet Page with Cross, from the *Lindisfarne Gospels.* Ms. Cotton Nero D. 4, f.2v. c. 700. 13 1/2 x 9 3/4 in. (34.3 x 24.8 cm). British Library, London.

How do we account for the differences in these contemporary images? The author of the *Lindisfarne* image, who lived outside the humanistic Mediterranean tradition and was thus unfamiliar with techniques for representing the human form illusionistically, created instead a more abstract image, made up of lines and flat areas of color. In contrast, the illustrator of the Ezra page clearly was familiar with the humanism and illusionism of Late Antiquity. The eventual collapse of the independence of Irish Christianity, in part due to the expansion of influential Benedictine monasteries closely tied to the papacy and the Roman Church, resulted in the demise of the Hiberno-Saxon style, and its replacement by Mediterranean traditions.

Out of the chaos of the various migration and settlement patterns of the Germanic tribes during the Dark Ages emerged the Frankish empire. Charles the Great, better known as Charlemagne, the most famous ruler of this Carolingian state—"Carolingian" comes from *Carolus*, the Latin for "Charles"—controlled much of western Europe, and, wanting to create a unified Christian empire, was crowned emperor by Pope Leo III in the year 800.

A great admirer of the arts, literature, and sciences, Charlemagne gathered talented Byzantine and Western artisans and authors at his palace in Aachen, and supported the revival of Greek and Roman learning. Mural painting, very little of which survives in good condition, certainly was a part of this artistic production, but Carolingian art is predominantly book centered. The court of Charlemagne is famous for producing a new, more legible script, for building up a remarkable library, and for sponsoring the copying of many Christian and classical Latin works of literature. Many of these classical works, in fact, would be unknown to us were it not for Charlemagne's commitment to preserving them. A number of the artists employed to illuminate Carolingian manuscripts were coming from the Hiberno-Saxon and Germanic antinaturalistic tradition. Imported northern European, Italian, and Byzantine manuscripts in the royal library exposed these artists to the realism of Late Antiquity and the classicizing tendencies of some Byzantine art. It is interesting to note that the Iconoclastic controversy was taking place at this time in the Eastern Empire, and that many of the Byzantine artists fleeing Iconoclasm were moving to the West. Charlemagne, while adamantly against the worship of images, considered them very valuable teaching tools, particularly given the high rate of illiteracy.

Carolingian art often combines Germanic and Mediterranean traditions. While Carolingian initials frequently comprise Hiberno-Saxon abstract, interlace forms, Germanic abstraction was not always appropriate for books meant to educate; a more realistic style was better for conveying information. A renewed interest in both the human form and in the effect of modeling, seen in the depiction of Saint Matthew from a Carolingian manuscript, certainly takes its cue from ancient Greek and Roman painting. Even the

Emperor Otto Receiving the Homage of the Nations. Late 10th century. Folio from an Ottonian manuscript. Musée Condé, Chantilly, France.

landscape is somewhat reminiscent of classical settings. However, the swirling drapery, the energetic, spontaneous brushstroke, and the dynamic quality of the whole recall the vibrant intricacy visible in many Hiberno-Saxon images.

By the mid-ninth century, the Carolingian empire was already in decline. In the mid-tenth century, the eastern part, roughly modern Germany and Austria, came under the control of a dynasty of German emperors known as the Ottonians, after the three best-known rulers of this empire, all named Otto. The Ottonians revitalized the Carolingian cultural ideals, and like their Carolingian predecessors, sought to revive the Roman imperial past, making themselves the emperors of a united Christian Europe. The reference to imperial Rome is explicit in the title "Augustus," which appears in the inscription on a portrait of one of the Ottos (Otto II?) enthroned and flanked by four female allegorical figures labeled *Germania*, *Francia*, *Italia*, and *Alemania*, the lands over which Otto wished he had control, although, in fact, he ruled only Germany.

MAIUS. *The Lamb of Mt. Sion and the Chaste, Apoc. 14:1–5*, from *Commentary on the Apocalypse*, by Beatus of Liébana. M.644, f.174v. Mid-10th century. Probably San Salvador de Tábara, province of León, Spain. 385 x 200 mm. The Pierpont Morgan Library, New York.

In 786 a Spanish monk, Beatus of Liébana, wrote his famous *Commentary on the Apocalypse*, copied and illuminated over the succeeding centuries. The large number of copies, however, that date to the tenth century perhaps reflects the belief by many that the Apocalypse was to occur in the year 1000. A folio showing *The Lamb of Mt. Sion and the Chaste* comes from a Beatus *Commentary* manuscript dating to the mid-tenth century and was copied and illuminated in a monastery in northern Spain. Spain was largely under Muslim rule at this time, and thus cut off from the rest of Europe and from Western culture. As a result, this Beatus manuscript, like others produced at this time in the area around Léon in northern Spain, demonstrates a singular style, characterized by wild, visionary images, very bright colors, the division of the page into flat bands of color, the total lack of concern for indicating space, flattened and simplified human and animal forms, and bulging eyes. To modern eyes, the naive depictions of humans and animals that are seen in these manuscripts resemble more contemporary folk art, or children's drawings.

ROMANESQUE PAINTING

The term "Romanesque," coined in the nineteenth century to describe the style of European art from c. 1050 to 1200, is usually applied to architecture. This architecture tends to be "Roman-esque" in that it is characterized by rounded arches and solid, heavy walls, like the architecture of the ancient Romans. By the Romanesque period, the turmoil of the past five hundred years had virtually come to an end. As

pilgrimages and crusades began, trade routes that had been closed were reopened, and contact with classical Greek ideas was restored through Byzantine and Muslim sources. Cities and towns began to appear, thanks to reinvigorated economies.

Feudalism, a hierarchical system whereby vassals, bound to landowning lords, promised allegiance and military service, receiving both protection and property in return, was the dominant societal and political structure in western Europe from the late ninth century on. Revived trade, commerce, and manufacturing in the Romanesque period, however, created a new urban middle class of merchants, traders, and artisans, an economic development that began to erode feudalism, a system predicated on land ownership.

Unlike those of the Carolingian and Ottonian eras, many Romanesque wall paintings survive, some in fairly good condition. While mosaics can be found in Romanesque churches, wall paintings were far more common. Cheaper and easier than mosaic, wall painting was the medium of choice during the Romanesque period, as the number of churches increased, all of them requiring decorative programs. An excellent, though somewhat faded example of a complete cycle of Romanesque mural paintings is that in the Church of Sant'Angelo in Formis, near Capua, Italy.

Romanesque painting, especially manuscript illumination, draws on Carolingian and Ottonian styles, as well as on Hiberno-Saxon illumination, as seen in an initial from the Cistercian monastery of Cîteaux in Burgundy, France. Cîteaux and its sister abbey, Clairvaux, produced many beautifully illuminated manuscripts in the twelfth century. Monasteries were extremely important patrons of the arts at this time, and as the primary centers of learning in pre-Gothic medieval Europe, they were also centers of book production. The large letter *R* that begins the word *Reverentissimo* on this page that dedicates the manuscript to a bishop, is partly made up of a knight elegantly poised on his squire's back and brandishing a sword. The rest of the *R* is formed by fantastical Animal Style dragons. Interestingly, not long after this initial was completed, Saint Bernard, the famous Cistercian abbot, condemned figurative art as impious, perhaps seeing images such as this one as (too) derivative of pagan forms.

The abstract linearity of this image is characteristic of much Romanesque art. Line is emphasized, and it is often a nervous, energetic, even jagged, line. Outlines in particular are heavy, dark, firmly drawn contours. Shading has a decorative quality, evident in the way drapery falls in tubular, unnaturalistic, ornamental pleats; note, for example, the dynamic, decorative drapery of the squire. Bodies are often elongated, and heads are small. The human figure in Romanesque art often seems a bit dehumanized—vulnerable, almost puppet-like—flattened out, angular, and stylized. The animated pose of the squire is similar to the writhing, contorted postures found in

Initial "R" with Saint George and the Dragon (?). Illumination from the *Moralia in Job,* by Saint Gregory the Great. Ms. 168, f.4v. Early 12th century. Abbey of Cîteaux, France. 13 3/4 x 9 1/4 in. (35 x 23.5 cm). Bibliothèque Municipale, Dijon.

Romanesque sculptural decoration. The geometric and floral border and the violation of the border by the figures—note the squire's back foot—are also typically Romanesque.

Knights were extremely significant during the Romanesque period. By the mid-eleventh century, Christianity had triumphed throughout Europe. Lords often left their land to take up arms in the service of the Church, which was launching Crusades to take the Holy Land back from the Muslims. Those who went on Crusade desired not only to regain Christian lands and to spread Christianity, but thereby to atone for their sins and win salvation for themselves. Pilgrims, too, sought to expiate their sins and to obtain salvation, as well as to be healed of earthly ailments. The number of pilgrims traveling long distances, often putting themselves at great risk, to visit shrines housing the relics of saints increased dramatically during this time. Monasteries constructed along pilgrimage routes provided shelter and food to weary travelers. Eastward pilgrimages and Crusades brought Romanesque Europe into close contact with Byzantine and Islamic art, influences that can be seen in much Romanesque painting and sculpture.

One of the most famous and fascinating Romanesque works of art is the *Bayeaux Tapestry*, not only because it is secular in subject, but because it illustrates a contemporary historical event. This magnificent embroidery—"tapestry" is a misnomer—was originally over 230 feet long and 20 inches high. Designed to hang in the nave of the Cathedral of Bayeaux in Normandy, in northwest France, it is composed in such a way that viewers moving clockwise from pier to pier could follow its detailed narrative of the Norman Conquest, that is, William the Conqueror's successful invasion of England in 1066. This event, which resulted in the rule of England by the dukes of Normandy, took place only a few years before the tapestry was made. Although probably executed by women, historians doubt that women designed the *Bayeaux Tapestry*, given the advanced knowledge of military maneuvers and weapons displayed in it. The placing of fantastical animals and vignettes in the margins above and below the main scene may, however, have been the idea of the women who embroidered it.

In the late twelfth century, a classicizing style reappears, discernible in an enamel plaque from an altar in the Abbey at Klosterneuburg, near Vienna, completed in 1181 by Nicholas of Verdun. The stylized depiction of the water in which Christ stands goes back to early Christian representations of baptism scenes and recalls wavy patterns encountered in other—earlier—Romanesque works. However, in con-

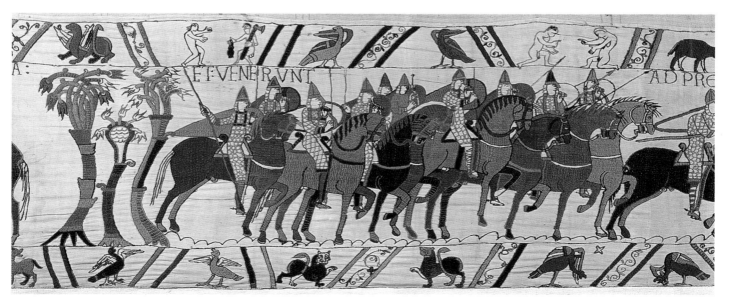

Soldiers Going to Battle King Harold. c. 1070–80. Episode 48 from the *Bayeaux Tapestry*.
Wool embroidery on linen. Height: 20 in. (50.8 cm). Musée de la Tapisserie, Bayeaux, France.

trast to this antinaturalism are Christ's swaying, *contrapposto* stance, which points toward the Gothic; the realistic depiction of facial expressions and hair, and the shadows and highlights of the drapery, which give the figures their three-dimensional quality.

A leaf from an English Bible dating to between 1160 and 1180 showing scenes from the life of David displays typically Romanesque traits: indifference to consistent scale, solid-color backdrops, flat space, the crowding of figures into compartments, the movement of figures outside their frames, dramatic gestures, and schematized architectural and landscape settings that are really just framing elements. However, the artist has deftly shaded and highlighted the drapery of the figures so that it appears to fall naturalistically over the human forms beneath, anticipating a treatment seen in much Gothic painting.

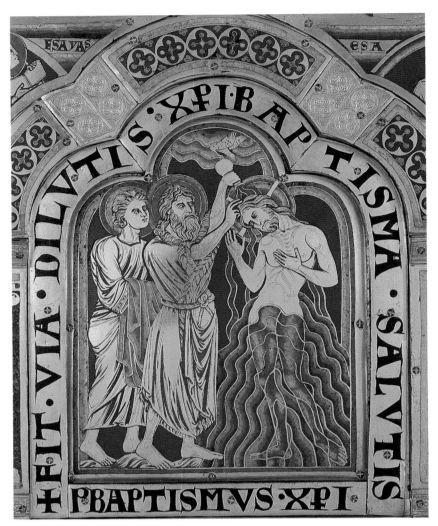

NICOLAS OF VERDUN. *Baptism of Christ.* Completed 1181. Verdun Altar. Enamel plaque in champlevé technique on gilded copper. Height: 5 1/2 in. (14 cm). Sammlungen des Stiftes, Klosterneuberg, Austria.

GOTHIC PAINTING

Like the term "Romanesque," "Gothic," the word used by Renaissance Italians to describe the cathedrals built from about 1200 up to their own time, also refers primarily to architecture. The Italians of the Renaissance found these cathedrals so barbaric, compared with ancient Roman architecture, that they attributed the style to the invading Goths of the fifth century, destroyers of the classical. The name stuck, and not until the eighteenth century were the beauty and logic of the Gothic cathedral truly appreciated.

Romanesque art had been important in southwest France, Normandy, and England. As we have seen, monasteries were the main patrons of art, by building pilgrimage churches, providing these churches with sculptural programs, and copying and illuminating manuscripts. In the twelfth century, the Capetian kings, who had ruled over Paris and its vicinity, became increasingly powerful, expanding into outlying regions and creating a centralized administration that was virtually unique in Europe at this time. The Gothic style first appeared in the Île-de-France, the region around Paris, around 1140, and eventually spread to the rest of Europe, though remaining primarily a French phenomenon. As cities grew and developed, universities began to appear, eventually replacing the rural monasteries as centers of learning. Secular and religious studies began to mix at these universities, and in the thirteenth century Christian dogma, mysticism, and Aristotelian rationalism were brought together by Thomas Aquinas

(1225–1274), the founder of Scholasticism. Thomas, born in the Italian town of Aquino, taught at the renowned university in Paris, then as now the intellectual and political heart of France.

Gothic cathedrals were quite unlike their Romanesque predecessors. The ribbed groin vaults and flying buttresses of Gothic churches supported the incredible weight of stone vaults in such a way that the massive walls typical of Romanesque construction were no longer necessary. As a result, the walls could be opened up for many more and much larger windows than ever before in church architecture. These windows were filled with stained glass that washed the interiors with an ethereal light. It is, in fact, the harmony and luminosity of Gothic cathedrals, and not necessarily the architectural forms themselves, that characterize Gothic architecture. Harmony—the perfect geometric relationship between the parts of a cathedral—and what the medieval mind considered the mystical, wholly divine light entering through soaring Gothic windows, combined to create a space suggestive of the Heavenly Jerusalem.

Stained glass consists of small pieces of tinted glass, carefully cut, attached by strips of lead, and assembled to compose predetermined shapes. Details could be painted on. With little wall space remaining in Gothic churches, stained-glass windows became the principal medium for depicting biblical events, episodes from the lives of the saints, or other inspirational images, in place of the mosaics or wall paintings found in earlier medieval periods. Not much stained glass has survived from the Gothic period; Chartres Cathedral, in northern France, is unique in that it has preserved much of its original stained-glass work.

The late twelfth and thirteenth centuries saw the rise of the cult of the Virgin Mary. Images of Mary were ubiquitous, and many cathedrals were dedicated to her. In the center of the rose window from the Cathedral of Notre-Dame ("Our Lady") in Paris, Mary is shown in her role as the Mother of Christ, holding the Christ Child on her lap. The roundels radiating outward depict Old Testament prophets, kings, high priests, and patriarchs. Like early Christian and Byzantine mosaics, Gothic stained-glass windows dematerialize and thereby spiritualize church interiors; however, while mosaics reflect light, stained-glass windows transmit it.

During the Gothic period, the demand for books increased. Whereas, previously, religious texts had been copied primarily for the Church, now, for the first time, religious and secular books alike were copied and illuminated in great numbers for private owners. Students at the universities needed books, as did their professors, and those who could afford them ordered richly illuminated manuscripts for their own private pleasure or as status symbols. While the books of students and scholars tended to be rather simple, perhaps adorned with a few images, manuscripts made for the rich—usually members of the royal court—might be sumptuously decorated. Monasteries functioned less and less as the centers of manuscript illumination. The rising call for both religious and secular texts and the emergence of universities in cities resulted in the opening of workshops in urban centers, where often lay scribes copied and illuminated manuscripts.

Moralized Bibles are Bibles in which pairs of roundels containing biblical and moralizing scenes are accompanied by biblical texts and commentaries which interpret the imagery. The roundels are arranged to resemble the layout of stained-glass windows. One well-known example of a Moralized Bible was probably commissioned by Blanche of Castile, the woman depicted in the top left of a page from this Bible, for her son, King Louis IX of France, seen on the top right of the same page. Below Blanche and Louis IX, a monk, left, dictates to a scribe, right, who is shown in the act of writing the text of this very manuscript. The roundels on the page on which the scribe is working have not yet been painted in with

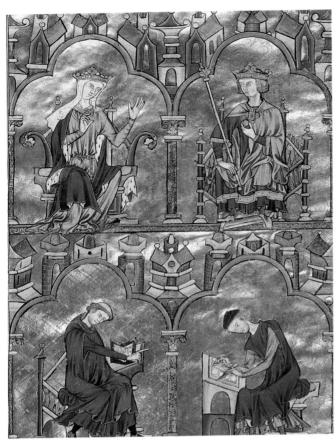

Blanche of Castile and King Louis IX of France, Author Dictating to a Scribe, from a Moralized Bible. M.240, f.8. c. 1230. Probably Paris. 375 x 262 mm. The Pierpont Morgan Library, New York.

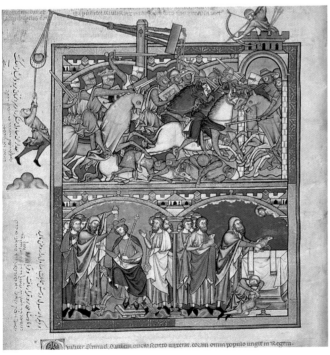

Saul Destroying Nahash and the Ammonites, Saul Annointed by Samuel, Offering Scene. M.638, f.23v. 1240s. Paris. Old Testament Miniatures. 390 x 300 mm. The Pierpont Morgan Library, New York.

their images. Typically, manuscripts were illuminated after the text was copied.

Louis IX (1214–1270) was probably quite young when this manuscript was made for him; he ascended the throne at age eleven, with his mother serving as regent. France prospered under the rule of this beloved king, considered to be the ideal Christian monarch, combining deep piety, honesty, and generosity with leadership skills and a remarkable talent for peacekeeping. He was canonized in 1297.

Louis IX had several manuscripts made for him, all luxurious, as befitted his position. A page from the *Psalter of Saint Louis,* from around 1260, is a good example of typical Gothic illumination coming out of Paris, a main center of manuscript illumination in the thirteenth century. Most noteworthy is the purely Gothic architectural setting of this image. The gables, pointed arches, delicate tracery, and rose windows are typical Gothic architectural elements. The architecture frames the figures in this illumination in a way similar to that in which small Gothic canopies surmount and frame figural sculpture on cathedral facades. Blue and red predominate here, as they do in stained glass from this period. Space is treated rather two-dimensionally, in part due to the extensive use of gold leaf, and the compact grouping of figures is characteristic of this period, yet the figures are modeled, and drapery falls naturally. The outlines of forms, however, are dark, recalling the lead strips of stained-glass windows. The elegant, refined features and graceful movement, and the slender, swaying forms with tiny, delicate hands and feet, are appropriate to the figures in a courtly manuscript, as the severity of the Romanesque gives way to a gentler Gothic style. Finally, note the border, with its magnificent animal interlace reminiscent of Hiberno-Saxon manuscript illumination.

Private prayer books, called Books of Hours, as they contained prayers to be said at the eight

canonical hours of the day, became popular in the late thirteenth century, and when made for the nobility were often richly illuminated. A page from a Psalter, or collection of Psalms, and Book of Hours made for Yolande of Soissons around 1290, shows Yolande herself at prayer before a decorative blue background framed by Gothic architectural elements similar to those on the page from the *Psalter of Saint Louis*. The architectural backdrop and the predominance of red, blue, and gold reveal the influence of the court style of Paris on this manuscript from the vicinity of Amiens in northern France. The borders of the frame are populated by wonderful little animals, precursors of the marginalia prominent in manuscripts of the fourteenth century.

Gothic painting of the thirteenth century, particularly that produced in France during the reign of Louis IX, belongs to what is considered by many to be the golden age of Gothic art. The following century, however, was stricken with war, plague, problems in the papacy, and other disasters, contributing to the view, popular until recently, that the late Gothic period in Europe, particularly in France, was a period of decline. It is true that in the early and mid-fourteenth century, the French lost key battles in the Hundred Years War with England (1337–1453), such as the Battle of Crécy, a crucial engagement in which England defeated France.

In 1364, however, Charles V, known as "the Wise," rose to the throne of France; like Louis IX, he was a great leader and a devout Christian. In the art of the late fourteenth century and early fifteenth century, the manner called the International Style flourished in the great courts of Europe, mostly in northern Europe, and mostly at the courts of France. The style was "international" because many artists traveled from court to court, and many owners of art intermarried, so that similar styles appeared in different courts. French court life at this time was characterized by aristocratic pastimes such as falconry, hunting, and the ritual of courtly love. Kings, queens, and nobles collected luxury objects made of gold and jewels, as well as highly valued, richly illuminated manuscripts, particularly Books of Hours, though these manuscripts were at times more status symbols than devotional aids. The courtly International Style features lithe, seemingly weightless, and graceful figures, often abnormally elongated and slim; they are softly modeled, yet linear, and clad in lavish, fashionable costumes with long, elegant, mannered drapery folds. The figures are often placed in sumptuous settings. Verging on preciosity, the aristocratic traits of the International Style nevertheless drew on daily reality so that many details are actually true to life.

Many of the artists working in the International Style in the French courts at this time were not French. The *Angers Apocalypse Tapestries*, executed for a brother of Charles V, although woven by a Frenchman, were designed by Jean Bondol, an artist from Bruges working at the French king's court.

One of the most important influences on the International Style was Italian painting. Though Gothic art and architecture never really took root in Italy as they had in France, they reached their

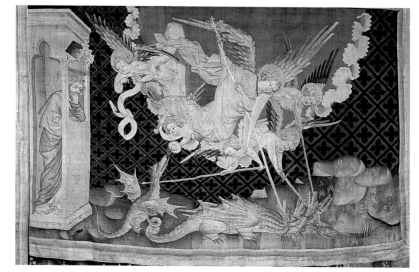

JEAN BONDOL AND NICOLAS BATAILLE. *St. Michael Defeating the Dragon*, from the *Angers Apocalypse Tapestries*. c. 1375–79. Tapestry. Musée des Tapisseries, Angers.

BOUCICAUT MASTER. *Pentecost,* from the *Boucicaut Hours.* Ms. 2. 1408–10. 11 7/8 x 7 1/2 in. (29.6 x 19 cm). Musée Jacquemart-André, Paris.

climax there from roughly 1300 to 1350, with the art of Giotto, Duccio, and Simone Martini, although these artists are usually considered in the context of the early Italian Renaissance. The realistic settings found in Sienese art in particular, especially in Duccio's paintings of the early fourteenth century, had a profound effect on the artists working in northern Europe at this time. Northern artists certainly made trips to Italy, and Italian artists also traveled north. Followers of Simone Martini—and Simone Martini himself from the 1330s to 1344—followed the papal court to Avignon during the so-called Babylonian captivity of 1305 to 1378, when Philip IV moved the papacy from Rome to France in order to establish a line of French popes. The depth and realism of the *Fishing Scene* from the papal palace in Avignon are characteristic of much fourteenth-century Italian painting, and had a radical effect on the art of the North, particularly in the depiction of space.

In the Pentecost scene from the *Boucicaut Hours,* a late International Style manuscript illuminated in Paris in the early fifteenth century by a Netherlandish artist, the artist attempted to create a realistic architectural and landscape setting; the inexact perspective is similar to the inexact illusionistic settings of early Italian Renaissance paintings. The figures are drawn with delicate, graceful lines, although they do possess a certain monumentality, achieved through the manipulation of effects of light and shade on the drapery. Also typical of the International Style is the artist's attention to the naturalistic rendering of details and the interest in patterned fabrics.

Some of the best examples of the International Style are from the French courts outside of Paris. Two of the most famous works in the International Style are the *Très Riches Heures,* a Book of Hours illuminated by the Limbourg Brothers for the court of John, Duke of Berry in Bourges, and the panels painted by Melchior Broederlam for an altar for Philip the Bold, Duke of Burgundy, in Dijon. These works will be discussed in the following chapter within the context of the Renaissance.

While the Gothic style was extremely short lived in Italy, it continued for some time in parts of northern Europe. With the Renaissance would come the revival of large-scale wall painting and panel painting. This, along with the revolutionary invention of the printing press in the mid-fifteenth century, led to a decline in the number of manuscripts being commissioned and illuminated. Nevertheless, some of the most beautifully illuminated manuscripts date to well after the beginning of the Renaissance in Europe, and many retain medieval elements, while others display Renaissance traits, reminding us that art historical categories are only markers applied to the complex and elusive continuum of artistic endeavor.

Pharaoh's Daughter Finding Moses. c. 250. Detail of mural painting in the synagogue at Dura-Europos, Syria.

The finding of the baby Moses is one of many Old Testament scenes arranged in three registers on the west wall of the 3rd-century synagogue in Dura-Europos, Syria. In the center, Pharaoh's daughter rescues the infant Moses from the Nile River. Moses had been placed in a basket and cast afloat by his mother who feared for her son's life after Pharaoh's injunction that all male Jewish infants be killed. The stiff, frontal poses, large eyes, and lack of three-dimensionality foreshadow later Byzantine style.

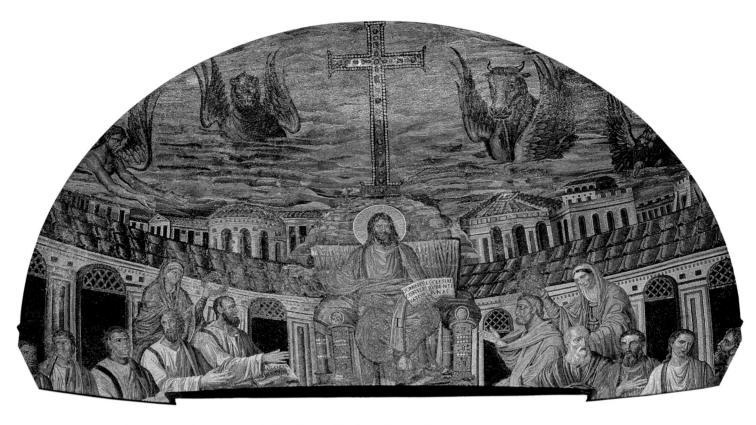

Christ Enthroned. c. 400. Apse mosaic in Santa Pudenziana, Rome.

The church of Santa Pudenziana was originally a Roman building that was converted to Christian use c. 400. Christ, enthroned at the center of this composition, closely resembles a Roman emperor, and the backdrop of buildings representing Jerusalem is reminiscent of architecture depicted in Roman wall paintings. The large cross dominating the background is a depiction of the jewelled cross erected during the reign of Constantine on the site of Christ's Crucifixion in Jerusalem.

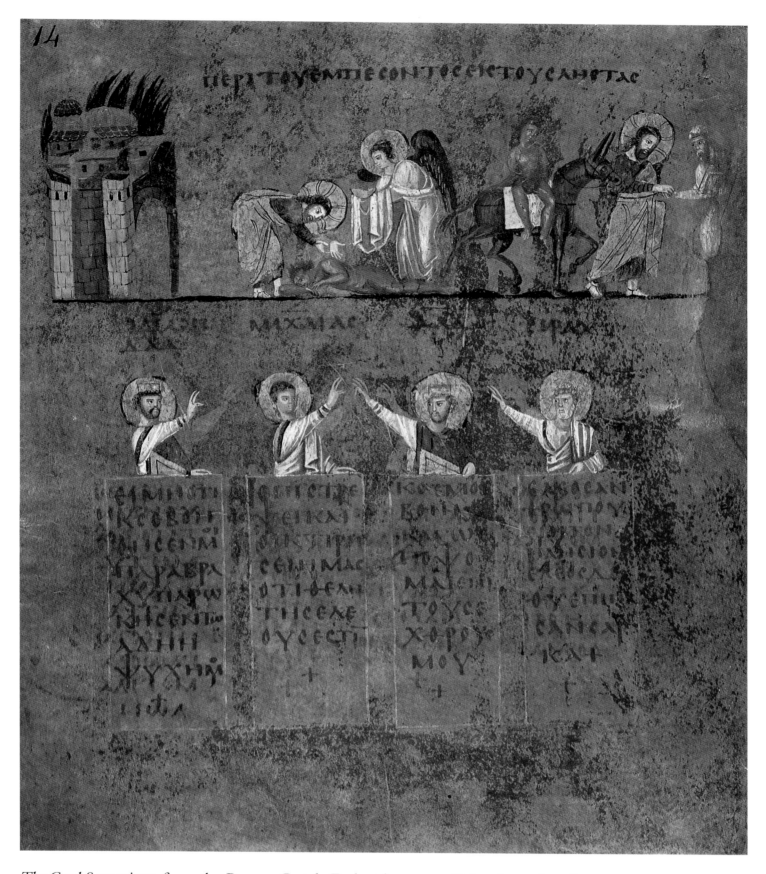

The Good Samaritan, from the *Rossano Gospels*. Early 6th century. Painted purple vellum.
Approx. 11 x 10 1/4 in. (28 x 26 cm). Biblioteca Arcivescovile, Rossano, Italy.

The *Rossano Gospels* is the earliest surviving example of a manuscript in codex (book) form with New Testament imagery. The artist who illuminated this page has created a continuous narrative whereby two scenes from the story of the Good Samaritan (Luke 10:30–37) are depicted consecutively. To the right of the buildings, the Samaritan (Christ) tends to the poor traveler who has been attacked by thieves on route to Jericho. Following this scene, to the right, the Samaritan takes the traveler to an inn and offers the innkeeper money to provide for the poor man.

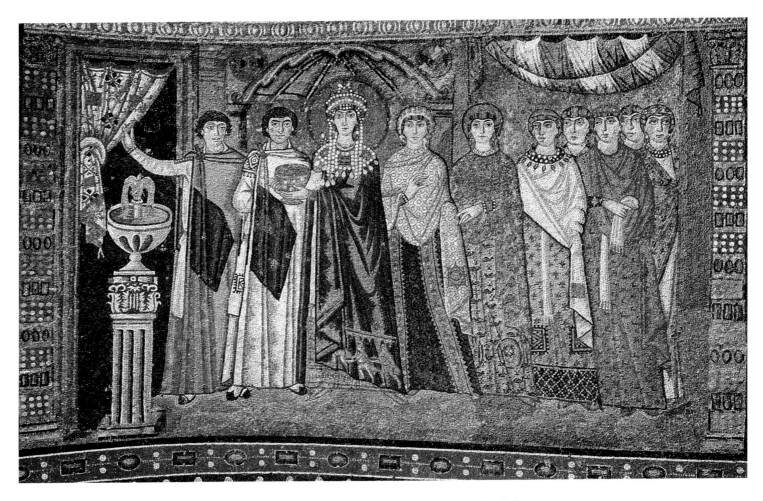

Empress Theodora and Her Attendants. c. 547. Mosaic on the south wall of the apse.
104 x 144 in. (264 x 365 cm). Church of San Vitale, Ravenna.

Justinian, Byzantine emperor from 527 to 565, was said to be deeply devoted to his wife, Theodora, depicted here among her attendants, and was inconsolable after her death not long after the completion of this mosaic. Theodora presents her offering of a golden chalice (for containing the wine of the Eucharistic celebration), emulating the offerings brought by the three figures—the Magi—pictured at the bottom of her robe, who presented gold, frankincense, and myrrh to the newborn Jesus.

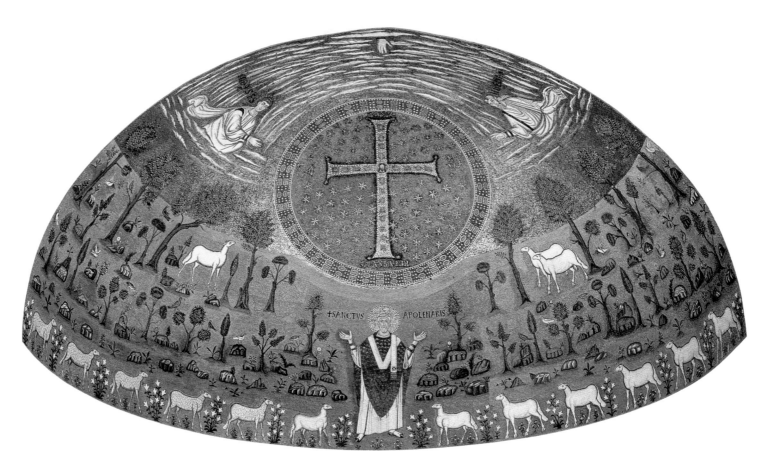

Apse Mosaic. c. 533–49. Sant'Apollinare in Classe, Ravenna.

This mosaic is a symbolic representation of the Transfiguration, when Christ revealed his divinity to his disciples, Peter, James, and John. The transfigured Christ is depicted as a radiant cross and his three disciples as sheep. The Old Testament figures of Moses and Elijah flank the cross. Saint Apollinaris, to whom the church is dedicated and whose remains were originally kept in the crypt beneath the altar, stands, arms uplifted in prayer.

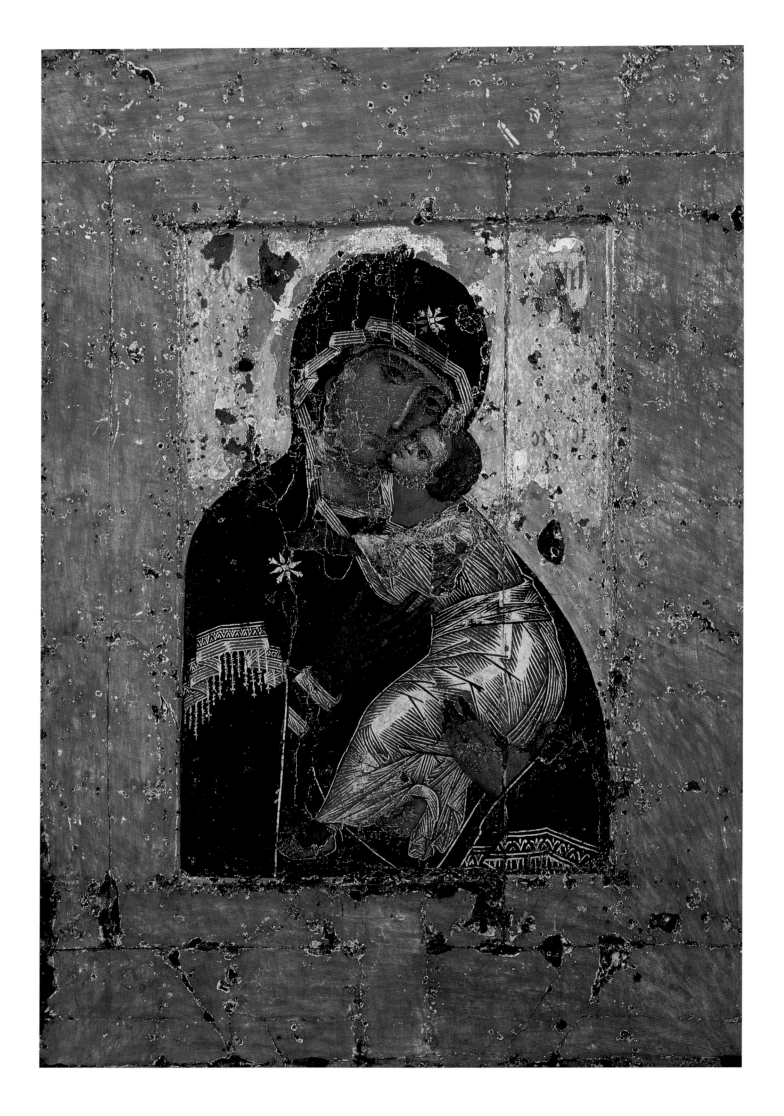

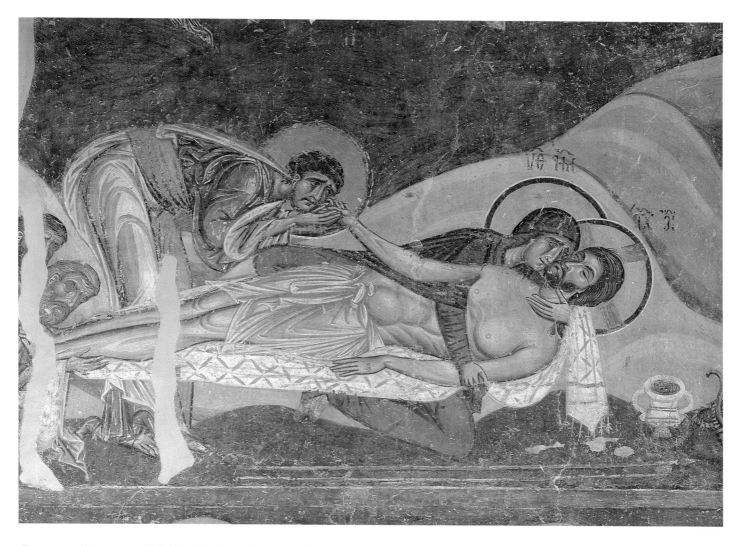

Lamentation. 1164. Wall painting. St. Pantaleimon, Nerezi, Macedonia (formerly Yugoslavia).

Middle and late Byzantine churches and monasteries in Serbia and Macedonia were decorated in the less expensive medium of fresco painting. Trained artists form Constantinople and other major centers worked on these frescoes, often alongside the frequently less-talented local artists. The intense grief seen in the faces of Mary and John as they mourn the body of Christ is quite unlike the hieratic, stern appearance of the roughly contemporary Pantocrator mosaic from Monreale.

opposite:

Virgin of Vladimir. 12th century (faces only). Probably from Constantinople.
Tempera on panel. Height: approx. 31 in. (78 cm). Tretyakov Gallery, Moscow.

Icons are two-dimensional images of Christ, Mary, or another saint before which prayers are said in the Orthodox Church. Iconoclasts, or destroyers of images, conflated the veneration of icons with pagan idolatry. Those who supported the veneration of icons claimed that an icon was simply a material aid in the contemplation of the prototype. In this icon, a tender, affectionate relationship between mother and child is exhibited. This type of image, in which Mary and Jesus are depicted with their cheeks touching, is known as the Virgin of Compassion.

Christ. Late 13th century. Mosaic in the south gallery, Hagia Sophia, Istanbul.

This iconic image of Christ is actually a detail of a larger composition. Not depicted here are the figures of the Virgin and John the Baptist flanking Christ to form a commonly found subject in Byzantine art known as the Deësis. In a Deësis image, the Virgin and John the Baptist turn and gesture toward Christ serving as intercessors who intercede on behalf of the faithful when Christ appears to judge at the end of time.

ANDREI RUBLEV. *Old Testament Trinity (Three Angels Visiting Abraham)*. c. 1410–20.
Tempera on panel. 55 1/2 x 44 1/2 in. (141 x 113 cm). Tretyakov Gallery, Moscow.

Icons were both privately owned and used publicly in church services. Try to imagine this brightly colored icon hanging on an iconostasis—a screen adorned with icons that separates the sanctuary from the rest the church— amidst shining jewelled candlesticks and crosses, silver and gold liturgical vessels, sumptuously illuminated books encased in gold, ivory, and enamelled covers, clergy in richly embroidered robes, and incense hanging in the air.

Saint Mark, from the *Lindisfarne Gospels.* Ms. Cotton Nero D. 4. c. 700.
13 1/2 x 9 3/4 in. (34.3 x 24. 8 cm). British Library, London.

War, famine, disease, and a complete lack of progress characterize the period known as the Dark Ages, which lasted from roughly the mid-6th to the late 8th century. In the Irish-English islands, however, Irish-established monasteries flourished and produced magnificently illustrated books, such as this one from a monastery on the island of Lindisfarne, off the northeast coast of England. Saint Mark is depicted here in the act of writing his gospel accompanied by his symbol, the lion.

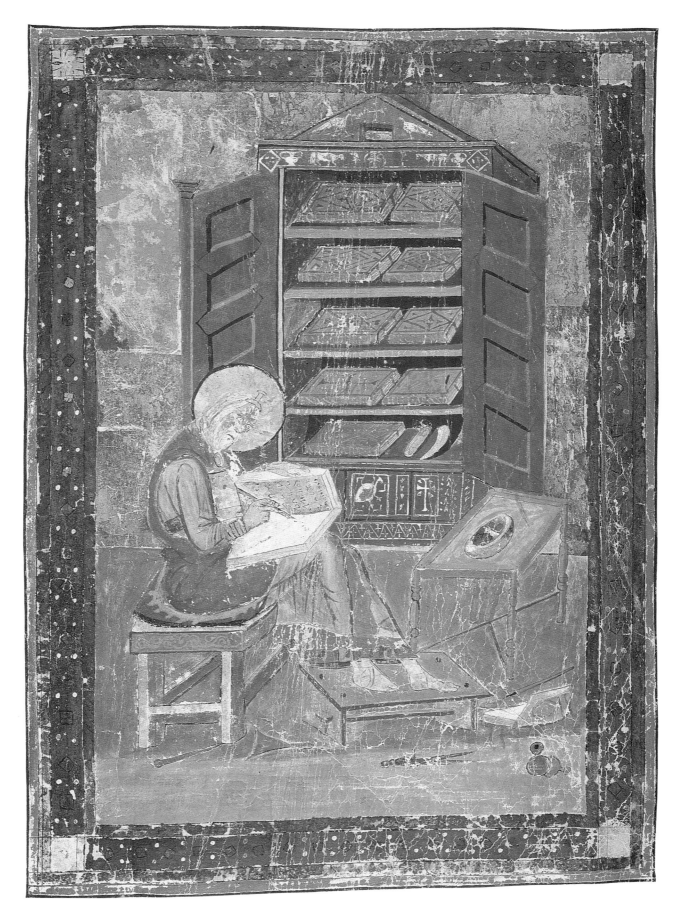

The Scribe Ezra, from the *Codex Amiatinus.* Ms. I, f.5. Early 8th century.
20 x 13 1/2 in. (50.8 x 34.3 cm). Biblioteca Medicea-Laurenziana, Florence.

This image was painted by an artist trained in the Mediterranean tradition influenced by the illusionism and humanism of Late Antiquity. In contrast, the emphasis on line, the flat areas of color, and the overall pattern-like quality of the depiction of the Saint Mark on the previous page are typical of Hiberno-Saxon art coming out of England and Ireland during the so-called Dark Ages.

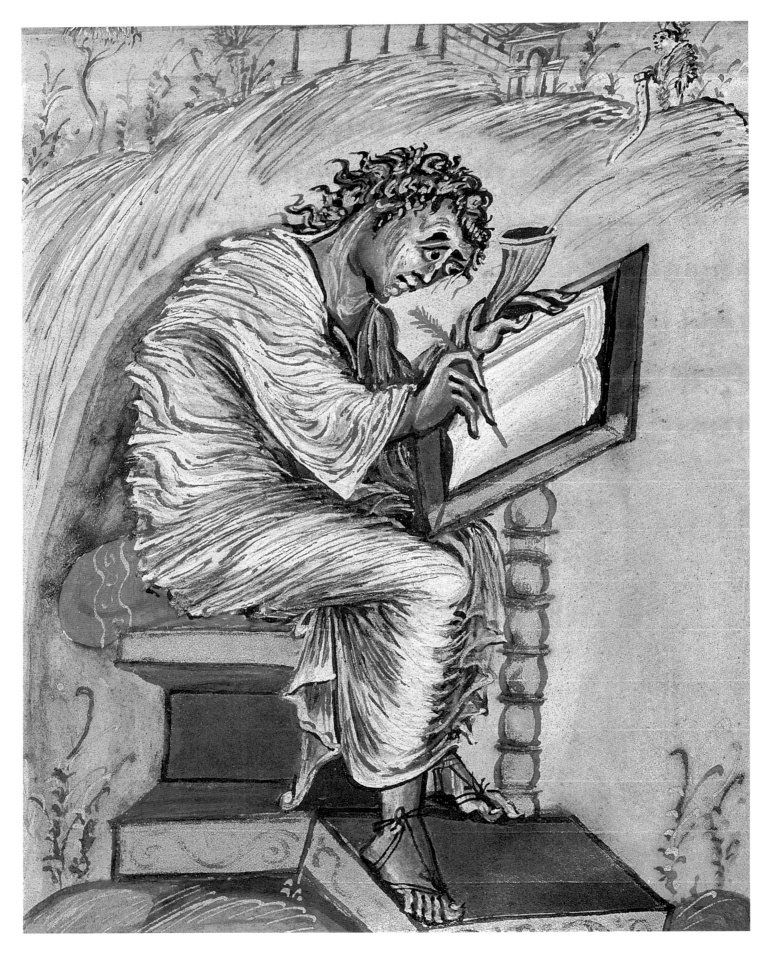

Saint Matthew, from the *Ebbo Gospels (Gospel Book of Archbishop Ebbo of Reims).* Ms. I, c. 816–35. Carolingian manuscript. 10 1/4 x 8 3/4 in. (26 x 22.2 cm). Bibliothèque Municipale, Epernay.

The *Ebbo Gospels* was produced in the town of Reims in northeastern France, one of the many centers of manuscript illumination under Charlemagne. The sketchy, quick brushstroke and general frenzied appearance of this image are typical of the style of the Reims School, and beautifully convey the spiritual excitement of the inspired evangelist.

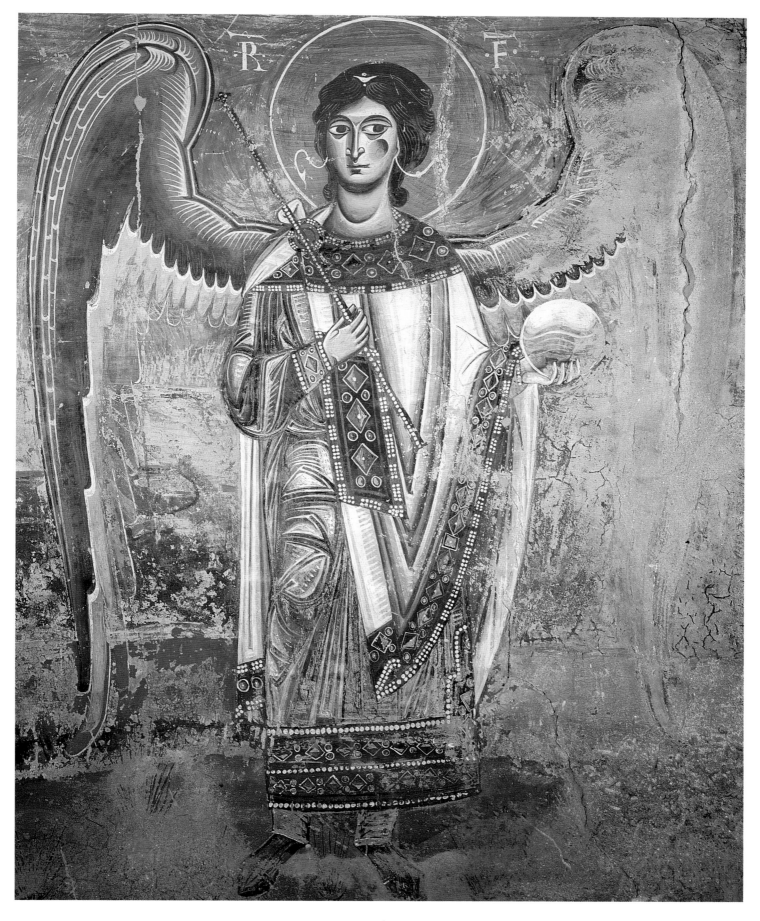

Archangel Raphael. c. 1085. Apse fresco from Sant'Angelo in Formis, near Capua, Italy.

This beautiful image of the archangel Raphael appears in the central apse of the church of Sant'Angelo in Formis, built by the Benedictine abbot Desiderius (later Pope Victor III). The frescos in this church, depicting scenes from the Old and New Testaments, constitute one of the most well-preserved medieval fresco cycles in Italy.

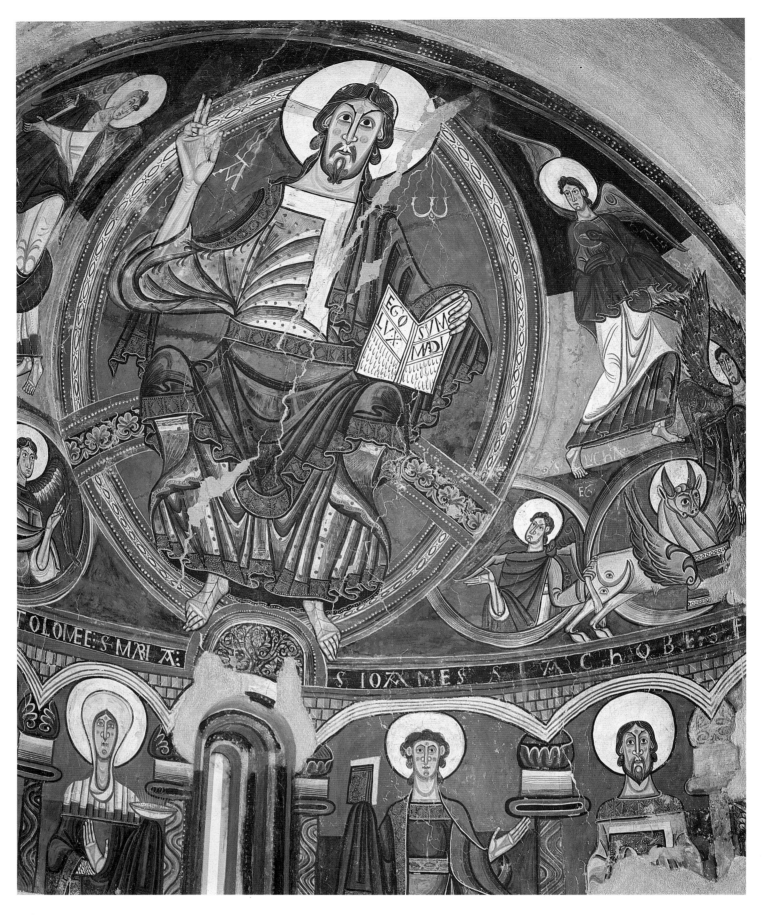

Christ in Majesty. c. 1123. Wall painting from the apse in the Church of San Clemente, Tahull, Lérida, Spain. Museu Nacional d'Art de Catalunya, Barcelona.

Some of the most well-preserved examples of Romanesque wall painting come from the region of Catalonia in northeast Spain. This figure of Christ in Majesty recalls the Pantocrator mosaic at Monreale; the strict frontality, formality, and iconic look of the Catalonian Christ are very Byzantine. The elongated, somewhat emaciated arms and legs, and the dynamic, nervous, decorative linearity of the drapery, however, are typically Romanesque.

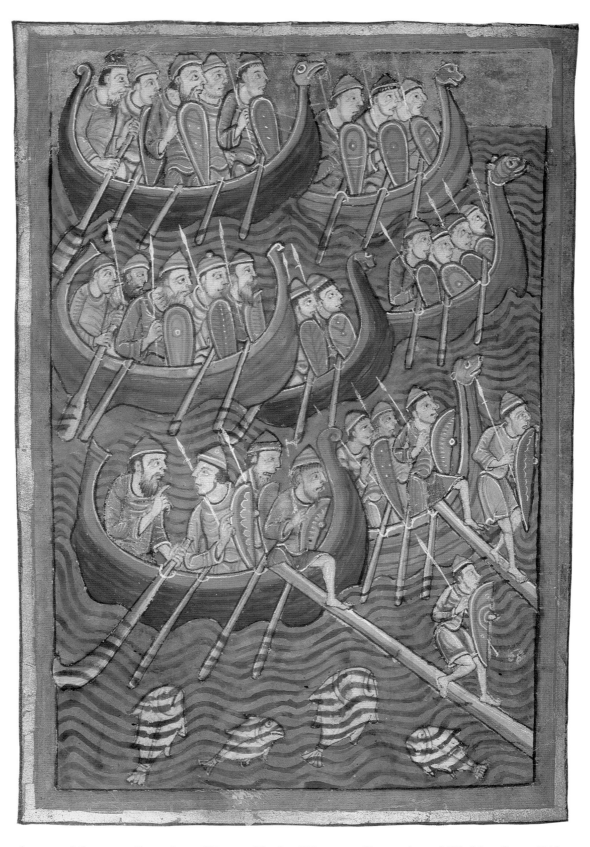

ALEXIS MASTER. *Invasion of Danes Under Hinguar (Ingvar) and Hubba*, from *Life, Passion, and Miracles of St. Edmund*. M.736, f.9v. c. 1130. Abbey of Bury St. Edmunds, England. 274 x 187 mm. The Pierpont Morgan Library, New York.

This manuscript, made for the Benedictine Abbey of Bury St. Edmunds in the 12th century, contains illustrations from the life of the abbey's patron saint, St. Edmund, king of East Anglia in the second half of the 9th century. The miniature illustrated here shows the invasion of East Anglia in 869–70 by the Vikings under the leadership of Hinguar. Refusing to renounce his Christian faith and serve under Hinguar, Edmund was martyred.

MASTER OF THE MORGAN LEAF. *Scenes from the Life of David.* M.619, verso. c. 1160–80.
Single leaf from a Bible. Cathedral Priory of St. Swithin, Winchester, England. 580 x 390 mm.
The Pierpont Morgan Library, New York.

This single leaf—probably from one of the greatest Romanesque English bibles, the Winchester
Bible—was intended as the frontispiece to I Samuel, and depicts scenes from the life of David.

Vision, from Saint Hildegard of Bingen's *De Operatione Dei (On the Works of God).* Codex Latinum 1942, f.98r c. 1200. Biblioteca Statale, Lucca, Italy.

Hildegard of Bingen (1098–1179) became a Benedictine nun at age fifteen and an abbess at age thirty-eight. She was quite well known for her visions, which she wrote down, and corresponded with secular and religious leaders alike (including Emperor Frederick Barbarossa and Pope Eugenius III). She also authored poems, books on natural history and medicine, and religious commentaries. In the illumination illustrated here, Hildegard herself is depicted at lower left recording her mystical revelation.

JEAN DE CHELLES. *North Transept Rose Window, the Virgin Surrounded by Prophets, Old Testament Kings, Priests, and Patriarchs.* 1240–50. Stained glass. Diameter: 43 ft. (13.1 m). Cathedral of Notre-Dame, Paris.

The light entering the Gothic cathedral was a radiant, divine light, a revelation of God. This passion for light in the Gothic period is exemplified by the rose window illustrated here, rose referring to the round shape. Virtually the entire wall is opened up, dissolving the architecture and allowing beautiful, colored, holy light to enter and spiritualize the cathedral space.

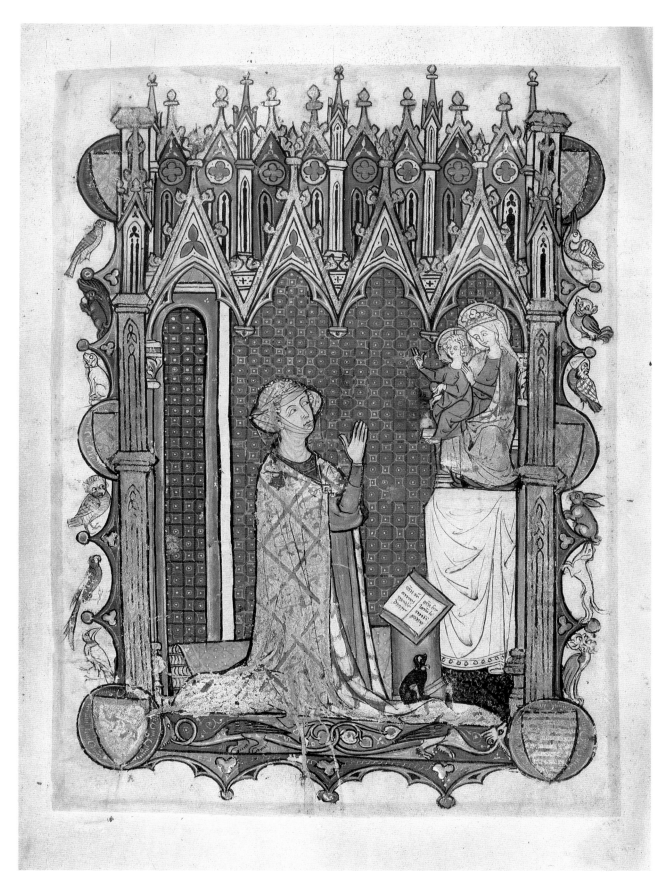

Yolande de Soissons Kneeling Before a Statue of the Virgin and Child, from the Psalter and Book of Hours for Yolande de Soissons. Amiens (northern France). M.729, f.232v. c. 1290. The Pierpont Morgan Library, New York.

The woman for whom this book was made, Yolande de Soissons, is depicted here kneeling in prayer before the Virgin and Child. The patterned blue backdrop, Gothic architectural setting, complete with trefoil arches, pointed gables, and lancet and rose windows, and the predominance of red, gold, and blue, are typical characteristics of 13th-century French manuscript illumination. The coats of arms of Yolande's family are seen in the four corners and in the middle of the long sides of this image.

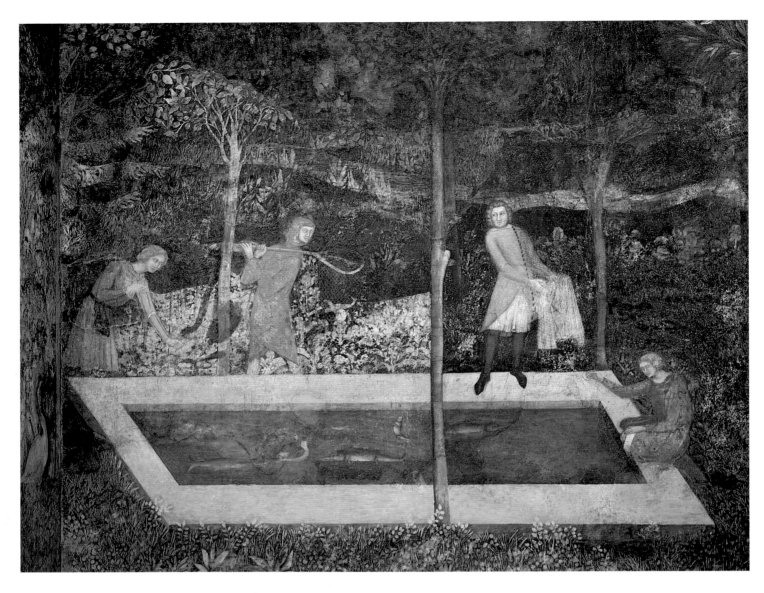

ITALIAN OR FRENCH SCHOOL. *Fishing Scene.* Mid-14th century.
Fresco in the Tour de la Garderrobe, Papal Palace, Avignon.

One characteristic of the courtly International Style of the late 14th to early 15th century is an interest in the realistic depiction of space in a two-dimensional image, something the Italian artists such as Duccio and Simone Martini were already doing. Northern artists would have had access to Italian paintings in a number of ways. One way was through the presence of Italian artists on French soil, such as during the "Babylonian Captivity" in Avignon (1305–78) when Philip IV moved the papacy from Rome to France in order to establish a line of French popes. Italian artists worked alongside French artists at the papal palace producing frescoes and panel paintings.

Master of Vyssi Brod (Hohenfurth) Altarpiece. *Agony in the Garden.* c. 1350.
37 1/2 x 33 1/2 in. (85 x 95 cm). National Gallery, Prague.

Charles IV (1316–78) was the King of Bohemia. Educated in France and, later, married to Blanche of Valois, Charles IV was determined to make Prague an international and cultural capital comparable to Paris. This image, by an artist known for the altarpiece he executed for the Cistercian monastery in Vyssi Brod in southern Bohemia, shows Christ in prayer on the Mount of Olives after the Last Supper and before his arrest. An angel appears to give Christ strength to bear his imminent suffering on the Cross, and the three disciples—Peter, James, and John—who accompanied Christ, are shown asleep at the left.

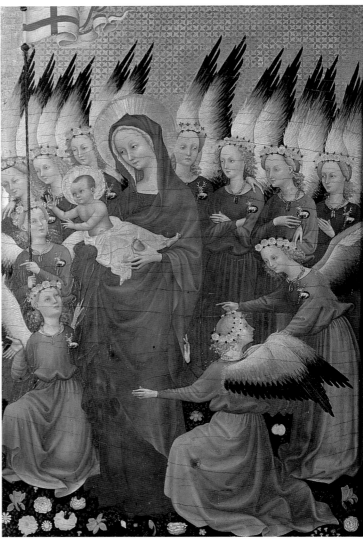

Wilton Diptych. c. 1377–1413. Each panel: 18 x 11 1/2 in. (46 x 29 cm). The National Gallery, London.

Richard II, King of England, is depicted in the left panel of this diptych kneeling before the Virgin and Child surrounded by angels in the right panel. Richard is accompanied by John the Baptist, and kings Edward the Confessor and Edmund. The naturalism of the faces and hands of the figures is combined with a courtly refinement. Italian, especially Sienese, influence is noted, and typical of the "international-ness" of the International Style, it is difficult to determine whether the painter was English or French. The textured gold background and intricate patterns of the garments worn by the figures in the left panel are also typical of the International Style.

opposite:

Huntsmen Exercising and Brushing Dogs, from *Livre de la chasse,* by Gaston Phébus. Paris. M.1044, f.44v. c. 1410. 385 x 287 mm. The Pierpont Morgan Library, New York.

The *Livre de la chasse (Book of the Chase)* is a hunting treatise written in the late 1380s by count Gaston Phébus, who was reportedly an expert on and breeder of dogs. Many illuminated copies of this work were made, this one dating to c. 1410. The text and illuminations of the *Livre de la chasse* deal with everything from dog care—in this image, the dogs are being groomed—to effective hunting with dogs.

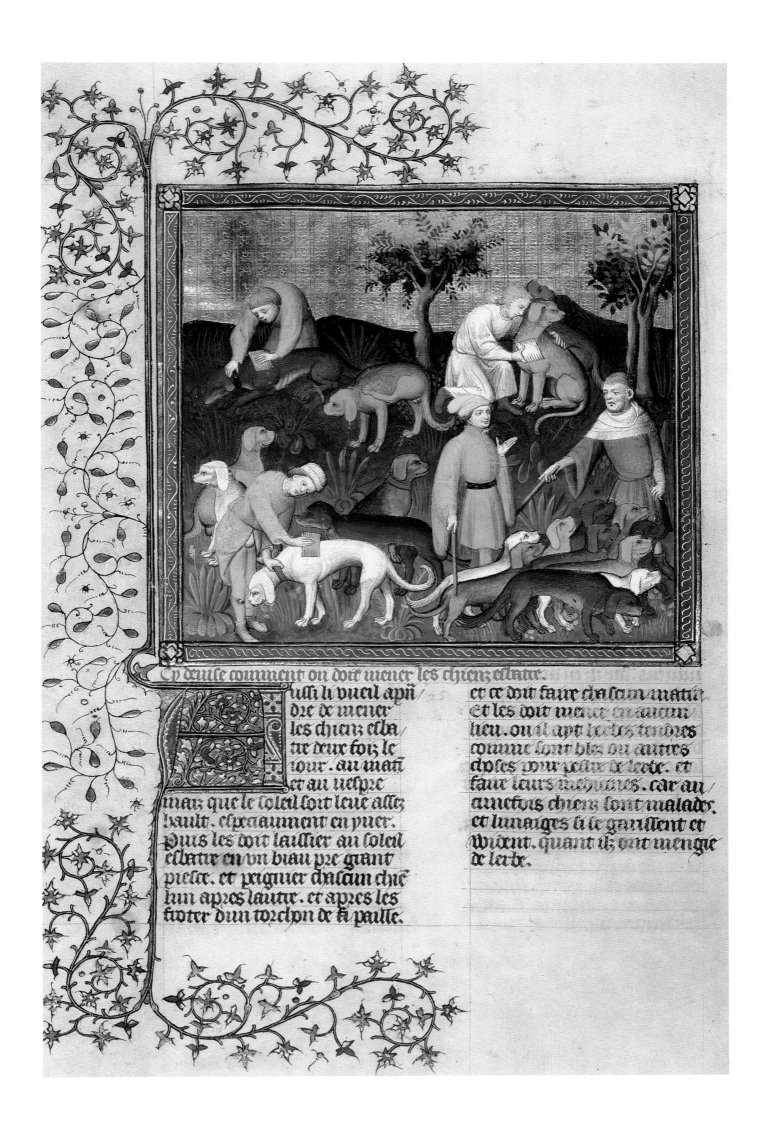

Cy deuise comment on doit mener les chienz esbatre.

ussi li vueil apn̄/
dre de mener
les chiens esba
tre deux foiz le
iour. au mati
et au uespre
maiz que le soleil soit leue alte
hault. especiaument en yuer.
Puis les doit laillier au soleil
esbatre en vn biau pre grant
piese. et peigner chascun chie
hun apres lautre. et apres les
tioter dun torchon de li paille.

et ce doit faire chascun matic.
et les doit mener en aucun
lieu. ou il ayt herbes tendres
comme sont bles ou autres
choses pour pesture de herbe. et
faire leurs medicines. car au
cunefois chiens sont malades.
et luentges si le garissent et
vuident. quant ilz ont mengie
de herbe.

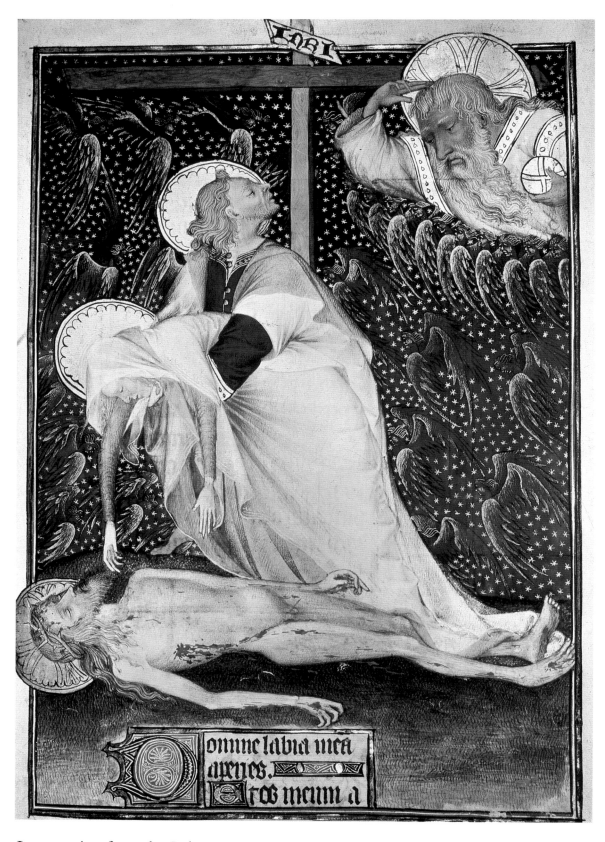

Lamentation, from the *Rohan Hours.* Ms. lat. 9471, f.135. c. 1420.
10 x 7 in. (25.4 x 17.8 cm). Bibliothèque Nationale, Paris.

The images in this Book of Hours are highly unique. Illustrated here is a macabre rendition of the Lamentation, the episode after the removal of Christ's body from the Cross. The emaciated, awkward, greenish body of Christ lies on the bare ground, while the figure of John the Evangelist supports the grief-stricken Virgin reaching toward her dead son. The backdrop, consisting of golden angels' wings, heightens the expressive energy of the drama taking place.

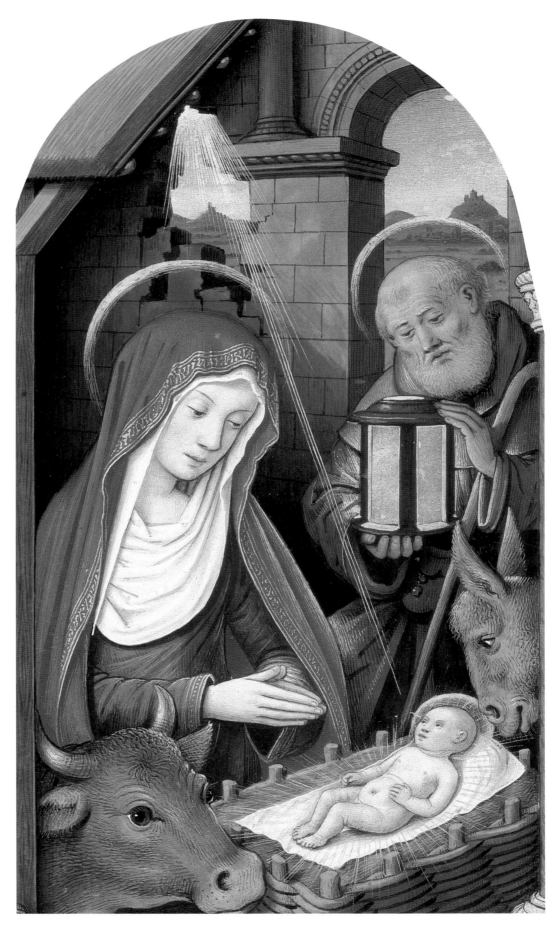

JEAN BOURDICHON. *Nativity*, from a Book of Hours. M.732, f.31v. c. 1515. Tours, France. 302 x 200 mm. The Pierpont Morgan Library, New York.

This page from a 16th-century French Book of Hours depicts the Nativity as if it were a large-scale panel painting in a Renaissance frame. Emphasis is placed on the key participants of the Nativity: Joseph, Mary, and the Christ Child. The elimination of extraneous narrative elements results in an icon-like, devotional image .

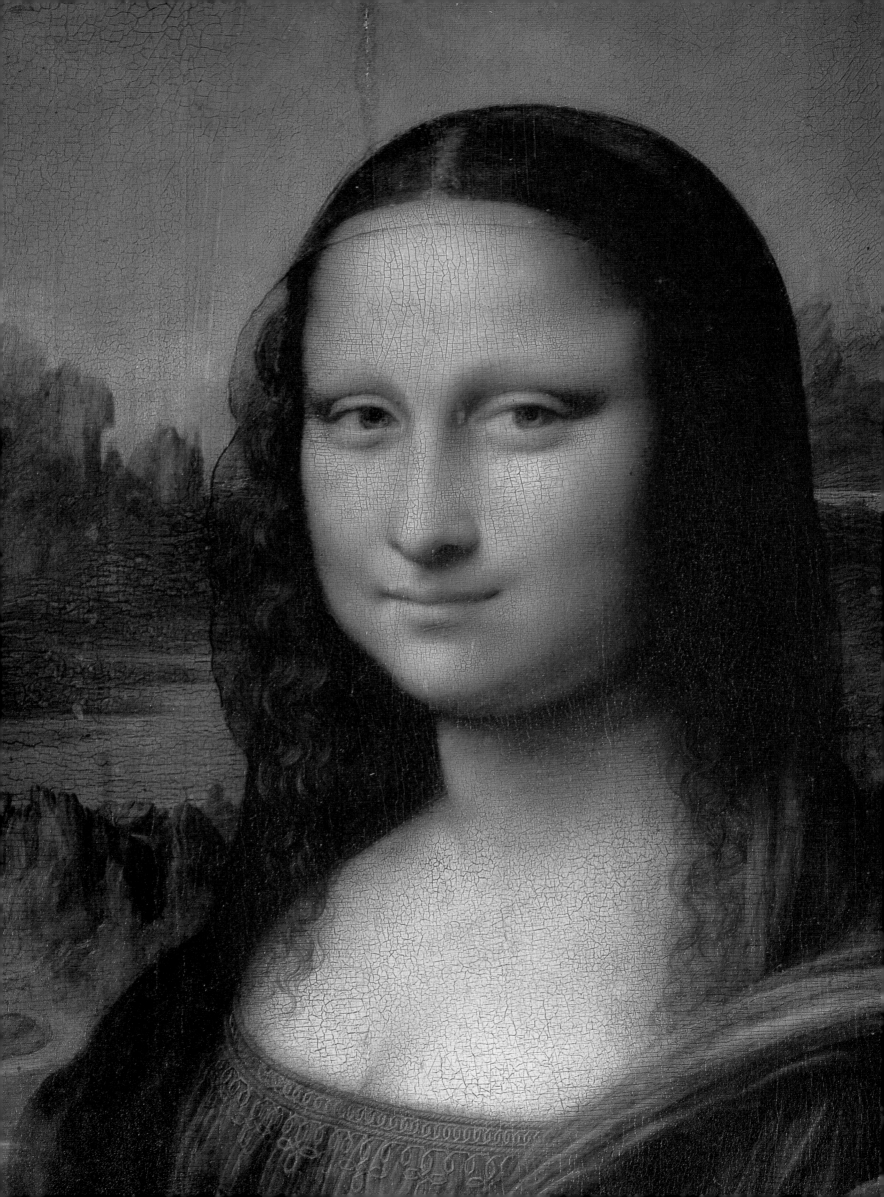

The
Renaissance
Miracles in a Measurable Universe

THE FRENCH WORD RENAISSANCE, meaning "rebirth," acquired its capital letter *R* in the early nineteenth century, when the term was first applied to a period of overlapping scientific and artistic investigations inspired by a renewed interest in classical Greek and Roman art, architecture, philosophy, and literature. The term "Renaissance," with its subcategories of "Early Renaissance" and "High Renaissance," is conventionally used to describe certain features of artistic expression that are characteristic of the fifteenth and sixteenth centuries, though, as in any human activity, there are defining currents that both precede and follow those years, and others that elude classification entirely.

Classical Greek art—principally architecture, sculpture, literature, and philosophy, but also mathematics (which included music)—developed from approximately the sixth century to the first century B.C. Plato, and through his writing, Socrates, were extremely influential in the Renaissance, and down to the present age. For example, Plato proposed that there exists an ideal form for everything in the world, and that everything tends toward its ideal. In other words, that progress is inherent in human activity. Plato also reported Socrates' belief that "poets," that is, artists, are inspired by a divine spark, that they are in some way special human beings. Both of these views are now commonplaces of Western thought, and it was during the Renaissance that they became so.

The Roman Empire embraced, even revered, these works of antiquity, which inspired Roman writers such as Pliny, whose vast, human-centered *Natural History* became a European model of observation and classification. During the Empire, painting, and particularly fresco, in which paint is applied to still-damp plaster on walls, evolved, as the wealthy commissioned artists to decorate their city and country homes.

The fall of the Roman Empire in the fifth century A.D. encompassed the physical destruction of libraries and with them, the virtual annihilation of nearly a thousand years of learning. Saved by the copier monks

LEONARDO DA VINCI. *Mona Lisa.* 1503.
Tempera on panel. 30 1/4 x 21 in. (76.8 x 53.3 cm). Musée du Louvre, Paris.

of Ireland, and by Jewish and Muslim scholars, the lore of Greece and Rome made its way back into continental Europe by way of Moorish Spain and the thirteenth-century court of Frederick II in Italy.

After the fall of Rome, Constantinople had been the capital of the Eastern Roman Empire, a cynosure of learning and the arts. Its religious art was profoundly influenced by the art of Asia, with a mystical, timeless quality that inspired contemplation of a higher reality. Before the reemergence of classicism, Italian art still reflected Byzantine conventions, sometimes reinterpreting the magnificent gilt icons to exalt the simplicity preached by Saint Francis of Assisi in the thirteenth century.

The saint preached in reaction to the increasing prosperity and power of Western Europe. Materially, and in all aspects of creative and social life, the thirteenth and fourteenth centuries were a period of enormous activity. It was a time of dramatic contrasts, of great political, social, and religious upheavals, of warring city-states, and of the elaboration of democratic government that left a legacy down to our own day. The Church was torn between Saint Francis's ideal of poverty and a tendency toward worldly pomp, reflective of its secular might, that produced some of the most beautiful, spiritually significant works of art of all times and places. It was a time of learning, exploration, and passionate discussion—and it was the era of the Inquisition and of Girolamo Savonarola's Bonfire of the Vanities.

The creations of this period have had an enviable staying power, ranking among the most potent and beloved in the Western world. Pictures such as Leonardo da Vinci's *Mona Lisa* (1503–1506) and Michelangelo's *Creation of Adam* from the Sistine ceiling are familiar to us all, thanks to their frequent appearance in a variety of media, from advertising campaigns to kitschy bric-a-brac. The names of four great Renaissance masters—Donatello, Raphael, Leonardo, and Michelangelo—have even enjoyed a second "renaissance" as crime-fighting reptiles. Though the way we look at the paintings may have changed, Renaissance works of art have survived into the twentieth century carrying much of the force today that they did five hundred years ago.

"Italy" as we know it today was not unified politically until the second half of the nineteenth century, though a common vernacular language was taking shape by the fourteenth century, spoken by merchants and other travelers. Italy was a region of city-states, each controlled by its own ruling class or by occupying foreign powers. A display of wealth was an aestheticized show of power, and good taste implied peace, prosperity, and political stability. The model of the merchant-citizen patron of the arts was probably Cosimo de' Medici (1389–1464), progenitor of the older branch of this influential lineage.

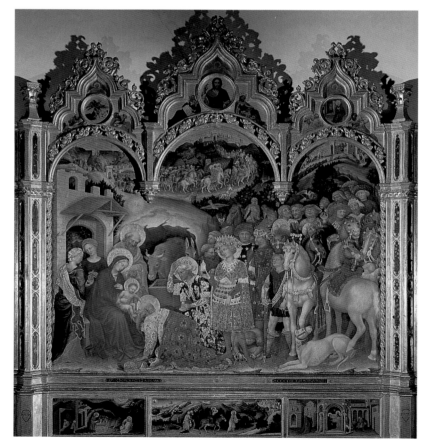

GENTILE DA FABRIANO. *Adoration of the Magi (Strozzi Altarpiece)*. 1423. Tempera and gold on panel. 118 x 111 in. (299.7 x 282 cm). Galleria degli Uffizi, Florence.

The existence of a patron class played a crucial role in the development of Renaissance painting. For the first time in the history of European art, on such a large scale, the noble class and the wealthy commissioned works of art for private devotion, enjoyment, or to decorate their urban *palazzi* or country villas. The splendor of the garments in Fabriano's *Adoration of the Magi (Strozzi Altarpiece)* is highlighted by an almost overabundant

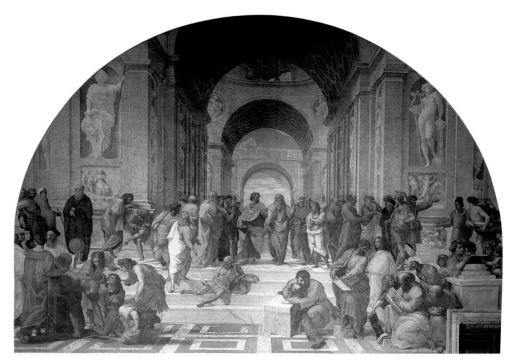

RAPHAEL. *School of Athens.* 1510–11. Fresco. Base: 303 1/8 in. (770 cm). Stanza della Segnatura, Vatican, Rome.

use of gold, testament to the wealth not only of the Magi, but also of the patron of the altarpiece, Pala Strozzi. It is important to note as well that the works commissioned were not only religious depictions, but often had mythological themes, in keeping with the resurgence of classical literature and art. One of the best-known examples of a classical theme may be Sandro Botticelli's *Birth of Venus*, commissioned by Lorenzo de' Medici, Cosimo's grandson.

The Roman Catholic Church was becoming an increasingly important political power. The popes, themselves scions of the noble families, modeled themselves on their worldly counterparts, commissioning some of the greatest works of art, such as Michelangelo's Sistine Chapel and Raphael's *School of Athens,* as part of the revitalization of the Vatican and the city of Rome that began at the turn of the sixteenth century.

GIORGIO VASARI

The artists of the Renaissance are known to us not only through their monuments but also through the work of a singular individual named Giorgio Vasari (1511–1574). Painter, sculptor, architect, and "decorator of all works" to Grand Duke Cosimo I de' Medici, of the younger branch of the family, in Florence, his artistic output is largely ignored today. He is best known, however, as a biographer: his *Lives of the Most Eminent Italian Painters, Sculptors, and Architects*, written between the 1530s and 1560s, is still essential reading for every student of the Renaissance. Its very title was a tribute to the *Parallel Lives* of the ancient Greek biographer Plutarch. But where Plutarch analyzed the character and accomplishment of mainly political and military leaders, Vasari wrote about artists, those special beings touched with genius. A remarkable book, Vasari's *Lives* begins with Cimabue (c. 1240–1302) and ends with Titian (c. 1485–1576) and Michelangelo (1475–1564). A contemporary of a number of artists himself, and friendly to the point of hero-worship with Michelangelo, Vasari devoted a great portion of his book to the idea of a linear

evolution of painting from the flat, Byzantine style of Cimabue to the ultimate, heroic achievement of Michelangelo. This notion of inevitable progress was in some ways informed by Plato's idealism.

Vasari saw the progress of painting from the close of the Middle Ages to his own day in three distinct stages, with a seminal figure in each stage. The artists of the first stage made the initial steps out of the Byzantine style that Vasari, as a convinced humanist, perceived as "unnatural," and on toward an imitation of the natural world. The principal proponent of these early naturalistic attempts was Giotto (c. 1276–1337). In the second stage, headed by Masaccio (1401–1428), new scientific inquiry, in the form of experiments in perspective and anatomy, brought artists even closer to the ideal of the absolute capture of the three-dimensional world on a two-dimensional surface. By the third stage—which was of course Vasari's own, and, pointedly, Michelangelo's as well—artists had mastered the imitation of nature to such a degree that, in Vasari's view, they had surpassed nature itself, and with it, the art of the ancients. As an artist himself, Vasari was determined to ennoble the act of artistic creation and remove it from its artisanal origins. The *Lives* also reflects the Renaissance notion that a history of high-minded accomplishment should instruct and inspire readers to noble accomplishments themselves.

Today, we still describe someone who integrates learning in a number of fields as a "Renaissance" man or woman, a term that implies the possession of taste and manual skill as well. The fact that learning was so prized meant that people usually excluded from the realms of power could gain some degree of access. Artists were one such group; originally of the artisan class, they sometimes found themselves wealthy and in—though never of—aristocratic circles. Especially in Italy, a few noblewomen, such as the poet Vittoria Colonna and the patron and political strategist Isabella d'Este, whose court was famous throughout Europe, also contributed to the intellectual investigations of the time.

Although the Renaissance, like any imposed classification, is to some extent arbitrary, there are certain stylistic hallmarks that distinguish "Renaissance" painting from the painting of the Middle Ages. The Renaissance style includes a commitment to portraying the natural world, as Vasari noted, coupled with references to the antique, in the form of heroic gesture, setting, and subject matter. Following Vasari's lead, we will explore the quintessential Renaissance period, beginning with its origins in the fourteenth century.

GIOTTO

Though he precedes the Renaissance by almost a full century, Giotto di Bondone (c. 1267–1337) is generally considered to have formulated pictorial expressions that his artistic descendants would develop.

Giotto's style is markedly less Byzantine and much more representational than that of his predecessors. This is readily apparent if we compare Giotto's *Ognissanti Madonna*, dated 1310, to the *Enthroned Madonna and Child* of 1280 by Cimabue, Giotto's teacher. With Giotto we now have a clear sense of the weight of the figures. His Madonna sits physically in her throne, rather than floating just above it. She holds the child in a convincingly naturalistic way that conveys a sense that she is supporting his weight. The folds of her gown drape naturalistically between the knees. All these elements combine to contribute to our perception of the figure on her throne as existing in space.

In contrast, Cimabue's painting is so ethereal as to appear, to our post-Renaissance eyes, as simply an elaborate decoration with no clear expression of space or weight. Cimabue's angels form a celestial dis-

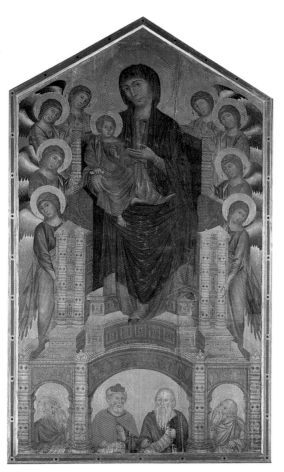

CIMABUE. *Enthroned Madonna and Child.*
c. 1280. Tempera and gold on panel. 139 x 88 in.
(353 x 223.5 cm). Galleria degli Uffizi,
Florence.

play around the margins of the throne, unlike Giotto's, who stand in ranks, another device that emphasizes the sense of depth in the painting. Cimabue's image of the Virgin and Child is thoroughly iconic—nonhuman—in its presentation, much more so than Giotto's interpretation of the same subject. Finally, the use of gold is significantly reduced in the figures in Giotto's picture. In Cimabue's figure of the Madonna, the gold is used as a decorative surface element, a two-dimensional effect that contributes to the otherworldly quality of the painting which is a metaphor for the riches of the afterlife. Giotto eschews gold leaf in favor of the observed effects of natural light—denotation instead of connotation. Where the forms are closer to the source of the light, as in the knees of the Virgin, the saturation of color dissolves into a paler hue.

Giotto's career spanned many years and took him throughout the Italian peninsula, including Padua, Rome, and Naples, as well as France. His influence was felt long after his death, thanks both to his productivity (though sadly a mere fraction of his output remains today) and his students, who perpetuated his style into the next decades. Well into the following century, Masaccio turned not to his immediate predecessors for guidance, but to the works of Giotto. In the family tree of Italian Renaissance painters, in fact, Masaccio is his direct heir.

The bubonic plague visited Tuscany several times during the fourteenth century, but was most devastating in 1348, when it may have as much as halved the population. Although many of the rich could escape the plague-ridden cities for country villas—Boccaccio's *Decameron* is set in one such villa during this time, where the refugees amuse themselves and pass the time by telling stories—the Black Death struck the upper and lower classes alike. The artistic community was as ravaged as any other. In the aftermath of the plague, painting returned to a sort of hieratic rigidity and an abandonment of natural observation, as if abandoning Giotto's naturalistic explorations for a chastened contemplation of the unknowable ways of God.

MASACCIO

It took several decades, but late in the first quarter of the fifteenth century—the *quattrocento,* or "four hundred," in the Italian style—Florentine painting rediscovered Giotto's legacy, mostly through the work of the main exponent of the early Renaissance style, Tommaso di Giovanni di Simone, known as Masaccio. Masaccio lived only twenty-seven years, but in that short time he revolutionized Italian painting, much as the architect Filippo Brunelleschi (1377–1446) and the sculptor Donatello (1386?–1466) revitalized their fields, initiating developments in spatial representation that affected the art of the rest of

the period. In Masaccio's figures we see a revival of Giotto's volumetric, weighty forms. At least as important, Masaccio was one of the first artists, and perhaps the first painter, to employ a consistent system of one-point linear perspective.

One-point perspective allowed Masaccio to open up the picture plane and delve sharply into "real" space, thereby creating an illusion of three dimensions on a two-dimensional surface. In one-point perspective, orthogonals—receding lines in space—converge at a single vanishing point on a horizon line. The technique was not new; the ancients had employed perspective systems, and Giotto and the Sienese Lorenzetti brothers had also experimented with perspective systems through direct observation of nature. But generally in these earlier attempts there are multiple vanishing points, not a single one, so that the perspective achieved is not consistent. It may also be that medieval artists were engaged in capturing a different notion of reality altogether, one better expressed by allegory—for example, with relative sizes determined by relative importance rather than as observed in the visible world—than by architectural perspective. In any case, the use of linear perspective characterizes Renaissance painting, distinguishing the quattrocento from that of the *trecento,* or fourteenth century.

Masaccio's *Trinity*, probably painted in 1428, is the best example in his oeuvre of a systematic depiction of three-dimensional space. His fresco shows Christ on the Cross, supported by God the Father and the Holy Spirit as a dove, and flanked by the Virgin and Saint John. These figures are set before a deep barrel vault, whose coffers recede convincingly into space, effectively creating the illusion of a church interior. The vanishing point here is located directly at Christ's head, making it subliminally as well as thematically the focus of the picture. With this work, the painted two-dimensional surface has become a window through which we can look from our actual space into another space that is fictive but believable.

Masaccio also elaborated new effects of light and shadow. *Chiaroscuro*—made up of the Italian words for "light" and "dark"—employs light to define form and space. In the physical world, when light falls from a single source it illuminates the objects closest to it, while plunging into shadow those farther away or blocked from it by an intervening object. Masaccio observed this effect and employed it with great success, most particularly in his work on the Brancacci Chapel (c. 1425), where a single source of light illuminates the figures and spaces of a complex pictorial program that details the lives of Saints Peter and Paul. Masaccio's use of chiaroscuro emphasizes his figures' anatomical structure and gives them a recognizable human quality unprecedented even in the art of Giotto.

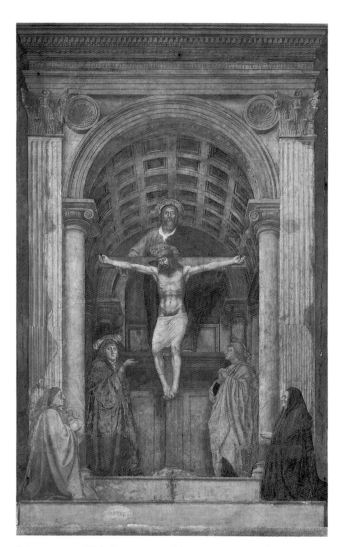

MASACCIO. *Trinity.* c. 1428. Fresco. 252 x 125 in. (640 x 317.5 cm). Sta. Maria Novella, Florence.

For the remainder of the fifteenth century, Masaccio's art would prove a starting point for the work of artists such as Masolino, Paolo Uccello, and Filippo Lippi, who continued and refined his perspectival principles, his chiaroscuro, his observation of nature, and his deeply felt humanity.

LEON BATTISTA ALBERTI

A survey of Italian Renaissance painting would not be complete without mention of Leon Battista Alberti (1404–1472). Alberti was an architect, theorist, humanist, and mathematician, the kind of multi-faceted individual for which the Renaissance, with its various commingling currents, is famous. Though not a painter himself, his most enduring written work is a treatise on the subject, *Della Pittura (On Painting)*, published in 1436. *Della Pittura* is both a painters' handbook and a theoretical essay in which Alberti prescribes the formulae painters could employ to achieve a higher distinction in their art to "make painting absolute and perfect." Alberti exhorted painters to take themes from antiquity as their subjects; to assure that it would be a singular work of art, each picture was to have a grand subject of heroic or dramatic import, what Alberti called its *istoria*, its "story," or "episode." *Della Pittura* gives specific instructions on how best to achieve this: pictures should be well ordered, filled with a variety of detail, but not cluttered; the emotions of the figures and of the dramatic situation should be readily apparent, expressed particularly through the gestures of the figures; perspective must situate the figures in a realistic setting; chiaroscuro should accurately model the human form; and color should be used judiciously and in harmonic balance.

In the decades following Masaccio, the patronage of the rich and powerful continued to nurture a seemingly inexhaustible surge of creative activity in Florence. Artists such as Paolo Uccello and Piero della

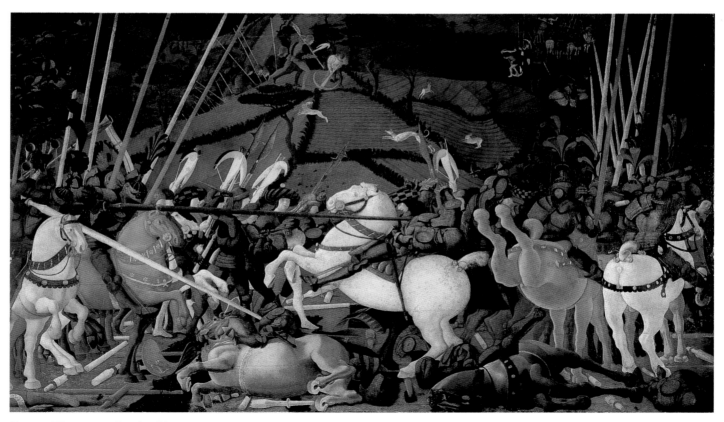

PAOLO UCCELLO. *Battle of San Romano.* c. 1445. Tempera on panel. 72 x 127 in. (182.9 x 322.6 cm). Galleria degli Uffizi, Florence.

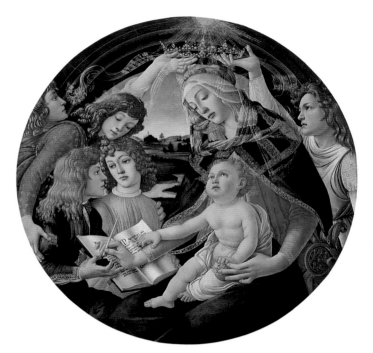

SANDRO BOTTICELLI. *Madonna del Magnificat.*
c. 1485. Tempera on panel. Diameter: 46 1/2 in. (118 cm).
Galleria degli Uffizi, Florence.

Francesca drew on the tradition of Masaccio and the instruction of Alberti to achieve greater refinements of perspective, color, light, and the exploration of the human spirit. In the work of all these painters there is an emphasis on monumental construction and unified pictorial space. In their art, as in that of many others, imagination and craft combined with scientific inquiry to investigate the mysteries of representation.

Uccello's *Battle of San Romano* of the mid-1400s shows the extent to which perspective can be taken to create complicated spaces. Here, linear perspective is used in an imaginative way with no architectural setting. The field is strewn with lances and bodies, providing a thrusting orthogonal framework for the aggressive battle depicted. Vasari relates that Uccello was so obsessed with perspective that he would stay working on drawings late into the night, ignoring the pleas of his wife to come to bed, in favor of a late night with *la dolce prospettiva*—"sweet perspective."

Piero della Francesca (c. 1410/20–1492) is perhaps the best example of a painter who expressed the Albertian ideal in the second generation of fifteenth-century painters. His decorations for the Church of San Francesco in Arezzo, depicting the story of the True Cross, are an outstanding tribute to Alberti's principles of *istoria* and proportion. His *Madonna and Child with Saints* (1472–1474; known also as the Brera Altarpiece), painted late in his career, is a showy masterpiece of perspectival arrangement, gravity, and complicated iconography. Piero appeals very much to the modern eye; the purity of his forms finds its echo in early twentieth-century modern painting, while the sometimes cryptic isolation of figures and groups can resonate with contemporary existential themes.

Following Piero, as the fifteenth century drew to a close, was Sandro Botticelli, an artist of individual style, less concerned with the tradition of monumentality of forms that so characterized the art of Giotto and Masaccio than with the expressive power of line. Beloved of and well known to twentieth-century viewers, Botticelli's linear grace and somewhat flat style may be the very antithesis of Albertian principles, even though he looked to classical models for his subjects.

In his two best-known paintings, the *Birth of Venus* and *La Primavera (Springtime),* he presents his figures against stage sets—one a brilliant blue-green backdrop of sea and sky, the other a veritable tapestry of flowers and foliage—a far cry from the plunging depths of regularized space that characterize Masaccio and Piero. The subject of the *Birth of Venus* is classical; the pose of the figure is derived directly from the antique *Venus pudica,* in which the female figure (inadequately) covers her breasts and genitals with her hands. But unlike in the classical models, the primacy of linear description takes over, so that the forms—Venus's left arm, for example—are greatly exaggerated in the interest of a sinuous, effortless grace:

The turn of the century brings us to the cusp of the High Renaissance—the century of Leonardo, Raphael, Michelangelo, and Titian—the period that has come to epitomize Renaissance style. It is diffi-

cult, in the wake of Vasari, not to see the High Renaissance as the culmination of an inevitable process. Here, artists begin to go beyond scientific constructions of the natural world. Balance and harmony for their own sake, sometimes to the exclusion of observed reality, become the rule within painted universes that often appear supranatural. A heightened, more deeply felt representation of humanness has taken hold. We have, in Leonardo da Vinci, one of the most astute investigators into the observable world.

LEONARDO DA VINCI

The motivating force in Leonardo's life (1452–1519) was the study of nature, which he documented in thousands of pages of notebook entries. His explorations in a stunning range of fields—among them painting, sculpture, botany, engineering, anatomy, geology, architecture, and music—made him the model of the "Renaissance man." One of the paradoxes of Leonardo's posthumous reputation as a painter is that there are remarkably few paintings definitely attributed to him, though one is among the most well known of all time. His passionate interest in nature is as evident in his few works as in his voluminous notebooks. The *Mona Lisa,* for example, takes a conventional portrait, which until that time had usually placed the sitter against a background of flat color, and gives the figure a mysterious mountain valley setting, not dissimilar to the landscape studies recorded in his journals. The landscape is barren, seemingly without evidence of human activity, until we notice a small bridge just over the right shoulder of the sitter. But a bridge to where? In this timeless, enigmatic landscape the extreme distance dissolves into the blue haze of accurately rendered atmospheric perspective.

This portrait is remarkable in a number of ways. The mysterious landscape in the background only reinforces the riddle of the sitter's smile, which has launched a thousand discussions. Breaking from previous portrait tradition, the sitter is shown in three-quarter profile, not from the side, and with both arms fully visible. She is both fully integrated into the landscape and set in front of it. The mist, typical of Leonardo, that seems to envelop the painting is called *sfumato,* or "smokiness." It melts form into form, softens the line, and adds volumetric nuances, a world away from the linear flatness of Botticelli. Enhancing the appeal of the portrait is the complex self-possession of the sitter, as she gazes out at the viewer in perfect serenity.

MICHELANGELO BUONARROTI

Born near Florence, Michelangelo (1475–1564) studied classical art in the Medici palaces. His main preoccupation throughout his life was sculpture, and this is evident in the frescoes of the Sistine Chapel, for which he produced some of the most enduring painted images of the Renaissance, including the *Creation of Adam.* Unlike Leonardo, with his ardent curiosity about the workings of things, Michelangelo was possessed of an impassioned, sometimes troubled, faith. And even more than Leonardo, he approached the modern stereotype of the artistic genius: tempestuous, neurotic, difficult, sensitive, a loner.

Michelangelo considered himself a sculptor rather than a painter, and indeed his painted output is rather small. The frescoes on the ceiling of the Sistine Chapel, commissioned by Pope Julius II, were

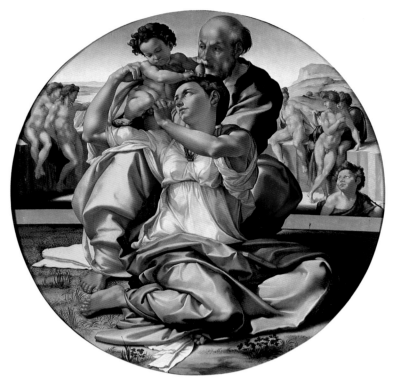

MICHELANGELO BUONARROTI. *Doni Tondo.* c. 1503.
Tempera on panel. Diameter: 47 1/4 in. (120 cm).
Galleria degli Uffizi, Florence.

undertaken with much grumbling on Michelangelo's part, but over four years he managed to complete the huge task with very little assistance. The hundreds of figures set amid fictive architectural elements compose a massively complex visual scheme that expresses an equally complex program of theological doctrine.

One tenet of Michelangelo's faith in God was that the beauty of the human form, particularly the male form, was a direct manifestation of the Divine. Thus, the male figure achieves a sublime primacy in Michelangelo's sculptured and painted work. The Adam from the *Creation of Adam* is one example; like all Michelangelo's painted figures, it is sculptural in its contours and modeling. Adam lies propped up on one elbow, languid, sleepy, not quite alive. The figure—a massive, heroic nude, in the best tradition of the antique—is strangely unempowered before the spark of full humanity is transmitted by God's hand. In the pause before the awesome life-giving moment that Michelangelo has chosen to depict, we are invited both to view Adam in his half-finished state and to imagine the power of the fully enlivened creature.

Michelangelo's influence on other artists cannot be overstated. The Sistine ceiling and the *Last Judgment* (also in the Sistine Chapel, but begun some thirty years later) are a vast compendium of figural types and attitudes that have served generations of artists in the centuries since their completion.

RAPHAEL

Known as Raphael, Raffaello Sanzio (1483–1520) was born in Urbino and apprenticed to Perugino, to whom his early style is indebted. He came to Florence in 1505 and traveled to Rome a few years later to work on the decorations for the Papal Apartments of Julius II. He died in that city, tragically young, at thirty-seven.

If Leonardo was particularly concerned with nature, and Michelangelo with faith, Raphael's signature theme was harmony. The paintings of Madonnas for which he is justly renowned are ideally balanced and ordered. Generally set in a landscape, the Madonna and Child, often with the young Saint John the Baptist, sit with placid sweetness. Compositionally, the figures are almost always structured in a pyramidal group, an innovation of Leonardo's. As the pyramid, or equilateral triangle, is an inherently stable form, it is perfectly suited to Raphael's harmonic ideals, grounding the figures gracefully in their setting.

As Raphael matured as an artist, the quiet stability of his earlier works gives way to a contained dynamism, visible, for example, in the *Sistine Madonna* of 1513. The Madonna and Child hover in a celestial space, flanked by Pope Saint Sixtus and Saint Barbara, and revealed by curtains that may be emblematic of the mystery of the Immaculate Conception. The figures, full of Raphael's beauty and grace, twist, without anguish, and lead the eye up from the left-hand corner, following Sixtus's upward gaze, to the Virgin, who is the focal point of the picture and the apex of the composition. The eye is led down again on the right through Saint Barbara, who turns on her own axis to guide us downward. The Madonna herself is in motion, walking toward us, her draperies blown perhaps by the breath of the ranks of seraphim and cherubim that fill the background. Spirals and curves predominate contained within the framework of the pyramidal scheme.

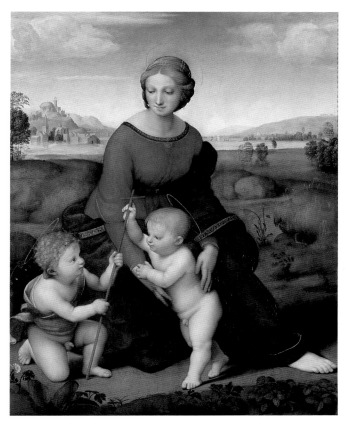

RAPHAEL. *Madonna of the Meadows.* c. 1505. Oil on poplar wood. 44 1/2 x 34 7/8 in. (113 x 88.5 cm). Kunsthistorisches Museum, Vienna.

TITIAN

In the latter half of the sixteenth century, the Most Serene Republic of Venice was still a major European power and the prime locale for High Renaissance style. The pride of Venice was Tiziano Vecellio (c. 1485–1576), known as Titian. Another long-lived artist, he produced a body of work of amazing variety that included paintings with secular, religious, and mythological themes, as well as portraits. His fame grew beyond the lagoon, and he eventually became painter for the Holy Roman Emperor Charles V and for his son, Philip II, King of Spain.

With Titian, the operative word is color. Drawing was much less important to him than to any of the other High Renaissance masters discussed, who worked out of a Florentine tradition that emphasized drawing, or *disegno*. Titian incorporated the major stylistic innovations of his Florentine and Roman contemporaries—harmony, balance, study of the human form—as well as the Renaissance homage to antiquity, into the coloristic models of his direct predecessors Giovanni Bellini and Giorgione.

A case in point is the *Assumption of the Virgin* (1516–1518) painted for the high altar of the Church of Santa Maria Gloriosa dei Frari. The painting is divided into three tiers: the earthly realm below, inhabited by the living Apostles; the celestial realm at the top of the picture, where God the Father waits to receive the Virgin into Heaven; and a middle ground in between, neither Heaven nor earth, through which the Virgin rises in her transit from terrestrial creature to celestial being.

The whole picture is in movement, almost frenetic, but is given structure by a modified pyramid,

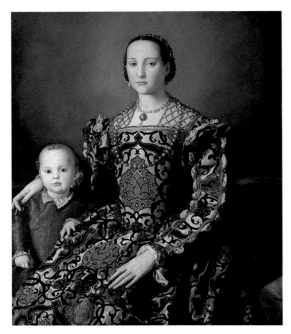

AGNOLO BRONZINO. *Portrait of Eleanora of Toledo with Her Son, Don Giovanni.* 1545–46. Oil on panel. 54 1/4 x 37 3/4 in. (137.8 x 95.9 cm). Galleria degli Uffizi, Florence.

which is established coloristically. The two Apostles in their red robes at the base of the picture are the two sides of the pyramid; one leads our eye up, the other's turned back closes the triangle. The Virgin, also in red, is the apex; her form is triangular as well, though inverted. The composition, an extension of the *Sistine Madonna*'s dynamic design, is now two steps removed from the serene stability of Raphael's early paintings of Madonnas. Behind the triangles that structure the composition, wide, intersecting arcs of angels and clouds bear the Virgin up toward a severely foreshortened God the Father. This band of angels also helps to contain the activity of the figures, which threaten to tumble out from the sides. The whole is suffused in rich, glowing Venetian tones of gold and red, very different from the cooler palettes of Michelangelo and Raphael.

In the late teens and twenties of sixteenth-century Florence, a new current developed, partly in response to stylistic innovations made by Michelangelo, and partly to the political and religious crises of the time. Known as Mannerists, a younger generation, initially Pontormo (1494–1557) and Fiorentino Rosso (1495–1540), and later Parmigianino (1503–1540) and Agnolo Bronzino (1503–1572), began to make paintings that seem to defy many of the guiding principles of the High Renaissance. Balance and harmony are gone; in their place we find instability and asymmetry. Spatial clarity gives way to crowded pictorial fields with little or no clue as to setting. The colors change from chromatic chords to a distinct visual dissonance. Figures become elongated; poses and gestures are exaggerated; proportional unity is sacrificed to sensation.

What was the reason for this profound change? Historians have pointed to a radically changing political climate. In Florence in 1512, the Medicis, who had been expelled in 1494, returned to the city and destroyed the republican independence that had prevailed since their expulsion. In Rome, the center of Christendom was literally and unthinkably undone in 1527, when the city was brutally sacked by the troops of Charles V. Religious ferment was smoldering as well, with excesses at the papal court in the years before 1527 (most notably under Leo X, a Medici) exciting calls for sumptuary, ethical, and, eventually, theological reforms, led most notably in Northern Europe by Martin Luther. Given such widespread unrest, it is tempting to read the Mannerist style as a reflection of the psychological havoc wrought by the upheavals of the times.

But whether Mannerism was the result of a deep communal angst, or simply the work of extremely individualistic artists, the Renaissance as such came to an end with this generation, which stylistically paved the way for the artists of the Baroque period.

The Renaissance in northern Europe found significantly different expression than in Italy, even though some of the fundamental concerns were the same. For example, the renewed interest in the representation of external reality took a slightly different turn outside of Italy. In the North, particularly in the Netherlands and in Flanders (today's Holland and Belgium), there is an almost obsessive atten-

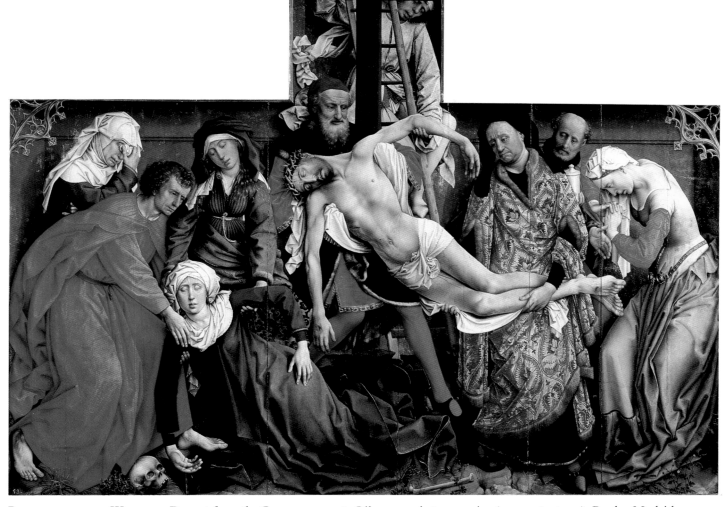

ROGIER VAN DER WEYDEN. *Descent from the Cross*. c. 1435–38. Oil on panel. 87 x 103 in. (221 x 262.6 cm). Prado, Madrid.

tion to the minutiae of everyday life. The meticulous depiction of the different textures of fabrics, for example, and of the effects of light on various surfaces absorbed Northern artists much more than their Italian counterparts. Monumentality of forms and perspective, though not totally absent, play a lesser role here. Many of the paintings themselves tend to be smaller, as they were destined for private appreciation in smaller domestic spaces. Indeed, the architectural settings of Northern Renaissance paintings tend not to be classically inspired, but either retain the Gothic influence or are depictions of aristocratic or, increasingly, middle-class domestic interiors.

Painting of the Northern Renaissance still owes much to the tradition of manuscript illumination, which may explain in part the detailed depictions and smaller size of fifteenth-century painting in that area. Contributing, too, to the distinction between Northern and Italian Renaissance styles is a difference in medium that results in a different technique. Oil paint was developed in northern Europe, reportedly in Flanders. Because colors can be laid over one another cleanly, oil paint lends itself much more easily to capturing minute details than does tempera, the previously predominant medium for panel and other paintings. Northern artists had explored the possibilities of the new medium for some decades before its secrets were known in Italy. (Fresco painting, which by its very nature precludes a large amount of detailed work, is virtually nonexistent in the North.)

At the same time there was also a good deal of Italian influence in the North. Italian bankers had established branches of their home banks in several northern cities, and there was regular trade and

travel between the regions. This inevitably led to an exchange of artistic influences. Indeed several painters from the North, like Jan van Eyck, Albrecht Dürer, and Pieter Brueghel, discussed later, either worked for Italian patrons or visited Italy.

Another aspect of fifteenth-century Northern Renaissance painting is the heavily encoded content of the pictures, a carryover from the Middle Ages. For example, a smoking candle can be a symbol of the Incarnation, or musical instruments might connote lust.

The religious climate in the North was different from that of Italy as well. In the first quarter of the fifteenth century, the Roman Catholic Church was approaching the height of its spiritual and temporal power, but by the beginning of the sixteenth century a revolution was brewing in Germany that would have broad consequences for the art of the century.

JAN VAN EYCK

The leading exponent of the early Flemish style, and a master of representation and virtuoso execution, Jan van Eyck (d. 1441) created a flawless realism in his pictures, based on acute observation of the external world. His *Arnolfini Wedding Portrait* is a typical case, where each surface and texture is rendered in exacting detail. The painting, whose actual meaning is much debated, seems to record the marriage vows of Giovanni Arnolfini, an Italian silk merchant living in Bruges, and Giovanna Cenami; we and the painter are the witnesses. Van Eyck's exquisite technique accurately captures the effects of light on reflective surfaces as well as on the wood floor and on Giovanni Arnolfini's fur cloak. In a display of technical bravura, he has included, reflected in the convex mirror at the very back of the room, a self-portrait of himself at work on the picture, along with a rear view of the couple. The picture is a marvel of observation and detail, a perfect reflection of the world in a painting measuring only 32 x 23 inches.

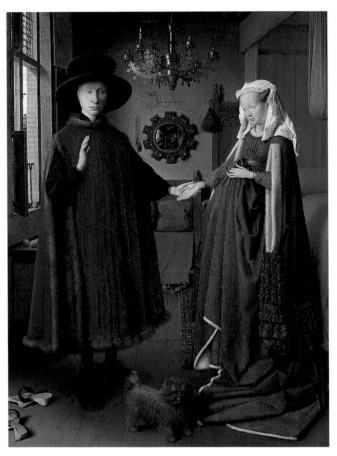

Jan van Eyck. *Arnolfini Wedding Portrait.* 1434. Oil on panel. 32 1/4 x 23 1/2 in. (81.9 x 59.7 cm). The National Gallery, London.

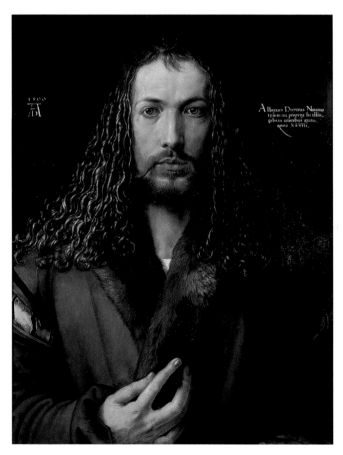

Albrecht Dürer. *Self-Portrait at Age Twenty-Eight.* 1500. Oil on panel. 25 5/8 x 18 7/8 in. (65 x 47.9 cm). Alte Pinakothek, Munich.

HIERONYMUS BOSCH

Northern Renaissance painting has its share of personalities, and Hieronymus Bosch (c. 1450–1516) is certainly among the most original. His *Garden of Earthly Delights* is among the most complex paintings within his very complex oeuvre. The painting is a triptych depicting, from left, the Garden of Eden, an orgiastic paradise, and Hell. The central panel is full of frolicking humanity, animals, and fantastical creations—living and mechanical. A great deal of coupling and other sexual activity is going on, among all sorts of creatures. This is a moralizing sequence, for in the Hell panel the fate that awaits the frolickers is represented with a ferocious, ingenious violence that harks back to the Middle Ages in its specificity. All manner of tortures are loosed upon the damned: they are eaten and excreted; strung up upon a harp to be plucked; impaled; and beset by fantastic monsters of innumerable variety that recall the fabulous beings of illuminated manuscripts. The whole triptych is a veritable Freudian field day of symbols and dreamlike imaginings. Not surprisingly, Bosch's dark vision produced few imitators, until the twentieth century, when his bizarre works found a kindred audience in the Surrealist group.

ALBRECHT DÜRER

The German visual arts in the sixteenth century experienced a golden age analogous to that of northern Europe, Florence, and Rome in the fifteenth, in part because it drew on those traditions. The leading painter of the High Renaissance in Germany was Albrecht Dürer (1471–1528), to some extent a Renaissance man in the Italian mold. Born in Nuremberg to a family of goldsmiths, Dürer was an innovative printmaker as well as a painter. He made two trips to northern Italy, where he absorbed the Italian High Renaissance principles of proportion and heroic description, combining them with a keen observation of the natural world. His painting style often reflects his printmaker's approach to contour, while, conversely, in his prints, he exhibits a painterly approach to modeling, giving his figures a fullness of form based on Italian types.

The Four Apostles of 1526 shows clearly how well he has assimilated the lessons of his Italian sojourns. The four Apostles—John, Peter, Paul, and Mark the Evangelist—are arranged on two panels (originally the wings for a central panel that was never completed) in a tight, shallow space lit sharply from the right. The foreground figures of John and Paul are fully illuminated and fully described. The background figures are given only enough room for their faces and attributes—Peter's keys, Mark's scroll—but despite this we have a clear sense of their mass. The two panels are balanced and counterbalanced by the disposition of the figures and the framing elements of the draperies on either side, two broad swaths of color at left and right. The harmonious proportions, size, and psychological characterizations of the figures recall Italian models.

Germany in the sixteenth century was increasingly a battleground between the more radical factions of Lutheranism, conservative Lutherans, and Catholics loyal to traditional dogma and to Rome. Dürer embraced a non-radical Lutheranism at the end of his life, and this picture illustrates his new devotion. The painting was originally inscribed below with verses from Luther's German translation of the New Testament, warning against those who sought to undermine the true word of God. The stern countenance of Paul, who meets the viewer's gaze with a sidelong glance, seems to underline the admonition implicit in the inscriptions, which may have been addressed to the Lutheran extremists as well as to the

Catholics. It is worth noting, too, that the figure of Peter, symbol of the papacy, is not only relegated to the background, but is the least prominent figure of the four. Paul, whom Luther considered the "Apostle of the Reformation," is given the most prominent position in the painting, and is the only figure who faces the viewer.

PIETER BRUEGHEL THE ELDER

The most important painter of sixteenth-century Flanders was Pieter Brueghel the Elder (c. 1525–1569). Though he made the obligatory trip to Italy, he was little influenced by Italian models, while some of his paintings resemble Bosch's in their busy compositions and the almost spherical volumes of the bodies. He was also an enthusiastic documenter of peasant life, and these pictures show none of the frightening vision of Bosch, though they serve up a wry commentary on a rustic landscape.

The *Wedding Feast* of 1566 shows a nuptial banquet in a small town. The table is set at a sharp angle, plunging deep into the space. The complacent crowned bride sits in the middle of the table, highlighted by a green cloth behind her that is decorated with a parody of a crown. Despite her special status, no one is paying attention to her. Typical of Brueghel, the figures are hulking, ponderous types, moving slowly in cloddy sabots. Broad swaths of color, rather than painstaking details of texture and optical effects, predominate. Brueghel has carefully observed all the social dynamics of a group meal, perhaps seeing in the peasants the raw or baser elements of human nature, but maybe also celebrating a refreshing freedom from the constraints of refined behavior. The whole scene is described with a slightly patronizing good humor, almost a mocking air, that suggests that Brueghel, like some of his southern European confreres, was concerned with his social class. Indeed, the gentleman seated at the right of the table in distinctly upper-class dress, has often been identified as Brueghel himself, making the artist at once spectator, participant, and amused outsider.

Throughout Renaissance Europe, artists were drawing on local traditions, blending them in different degrees with the themes, styles, and techniques that characterize the Renaissance. Rediscovered ancient ideas found modern media, and the result was an explosion of creativity. The techniques of modeling and perspective, for example, were inspired by a classical view of the place of human beings in the universe, derived from direct observation, and facilitated by the new medium of oil paint. The Renaissance artists who explored classical ideals of proportion and beauty were moved by a scientific dedication to capturing reality, not only external reality, but, increasingly, the specific interior reality of individuals—their personalities. This emergence of the importance of the individual would prove to have incalculable consequences on the history of art and of the world.

opposite:
GIOTTO DI BONDONE. *Ognissanti Madonna.* 1310. Tempera and gold on panel.
128 x 80 1/4 in. (325.1 x 203.8 cm). Galleria degli Uffizi, Florence.

In this painting, surface decoration and an otherworldly incorporeality give way to grounded solidity and keenly observed spatial relationships. The Virgin sits solidly in her throne, the forms of her legs clearly visible under the draperies. The throne itself is architecturally believable, with cut-aways that allow for a clear sense of space around the structure.

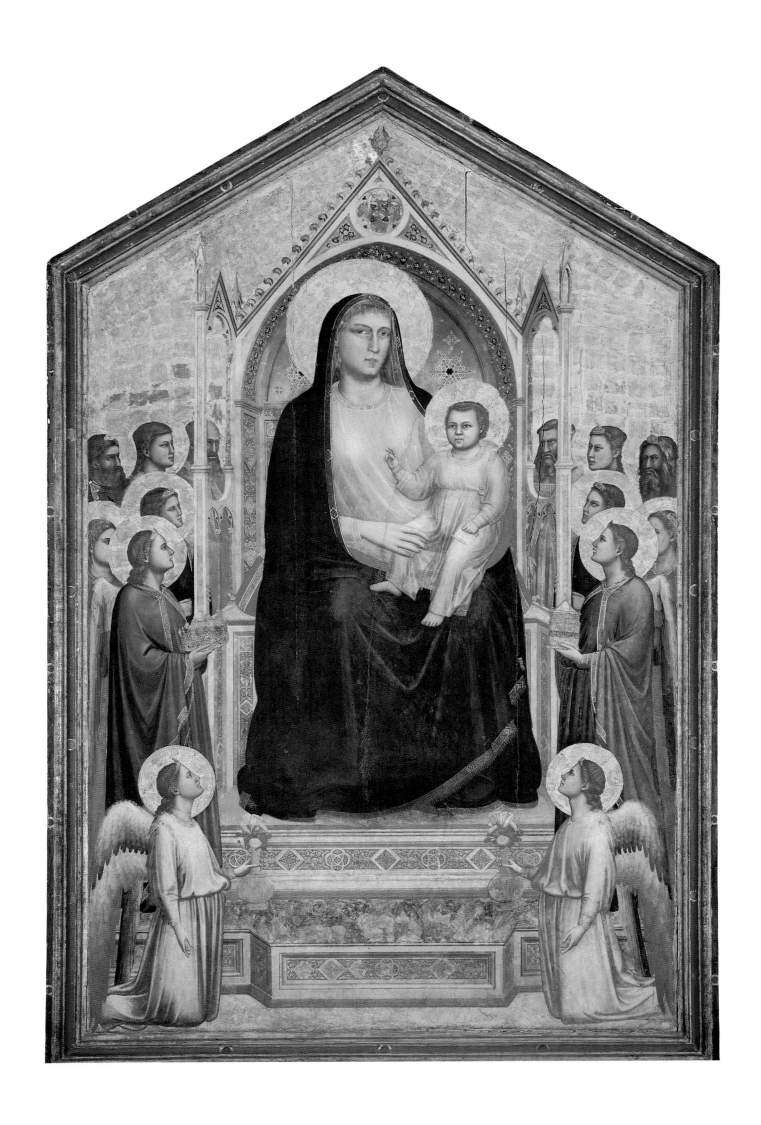

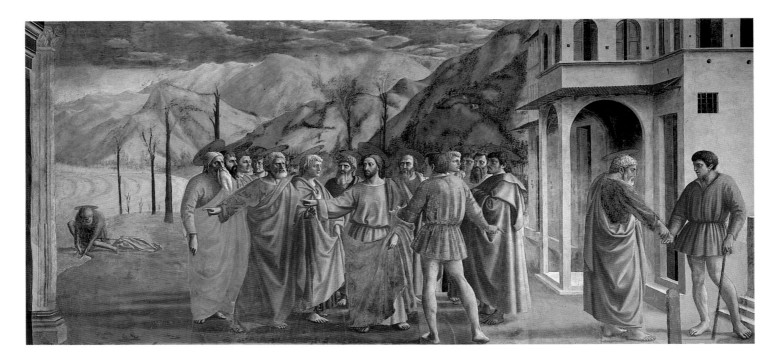

MASACCIO. *The Tribute Money.* 1425. Fresco.
Brancacci Chapel, Sta. Maria del Carmine, Florence.

This fresco employs the device of a continuous narrative to tell its story. The episode, rarely depicted, comes from the Book of Matthew. At the center of the painting, in response to the demand for tribute from a tax collector (shown with his back to us in a short tunic) at the gates of Capernaum, Christ tells Peter to catch a fish. At the left we see Peter get the fish, and at the right we see Peter again pay the tax collector with money miraculously found in the mouth of the fish, as Christ had predicted.

opposite:

FRA FILIPPO LIPPI. *Madonna and Child.* c. 1455. Tempera on panel.
35 1/2 x 24 in. (90.1 x 61 cm). Galleria degli Uffizi, Florence.

Set in front of a window, which also has a double-function as a frame for the figures, Lippi's Madonna is a beautiful 15th-century woman. She is dressed at the height of contemporary fashion, including a headdress bedecked with pearls which come to a point midway down her forehead. In contrast to celestial Madonnas of the previous century, this very real woman has a halo that is no longer a gold disk, but rather a transparent plate, barely described by a thin gold line around its circumference.

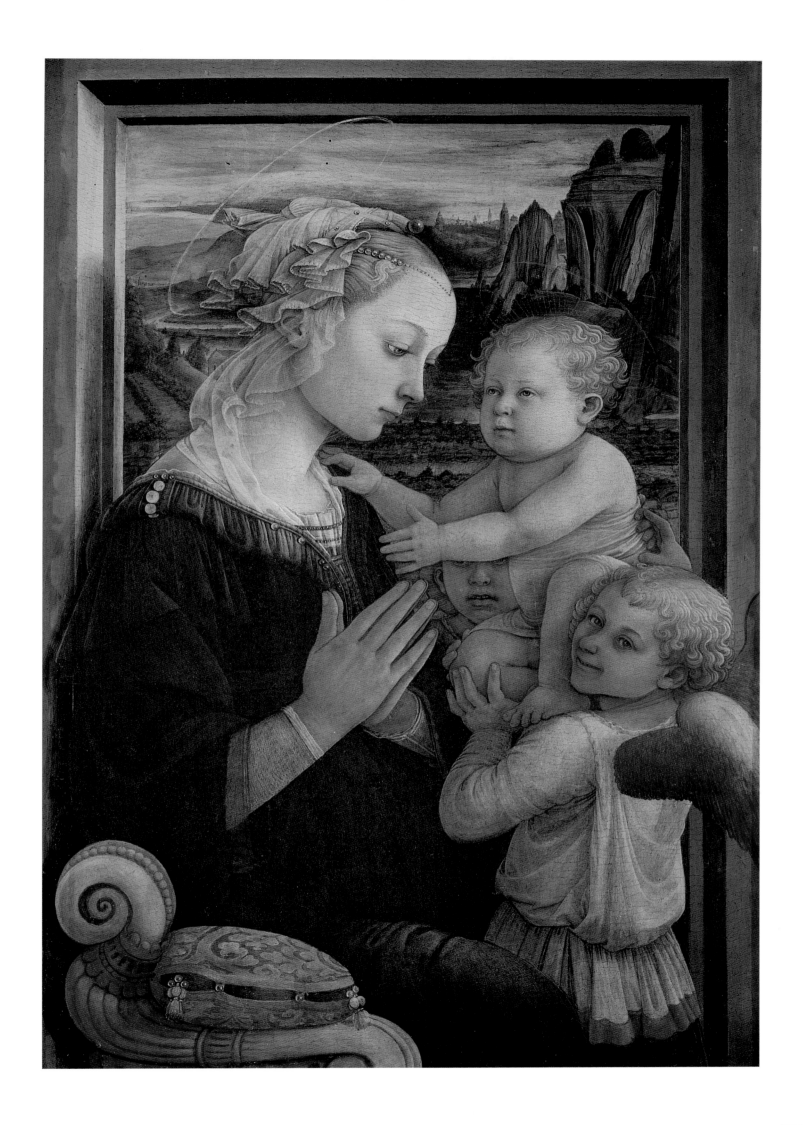

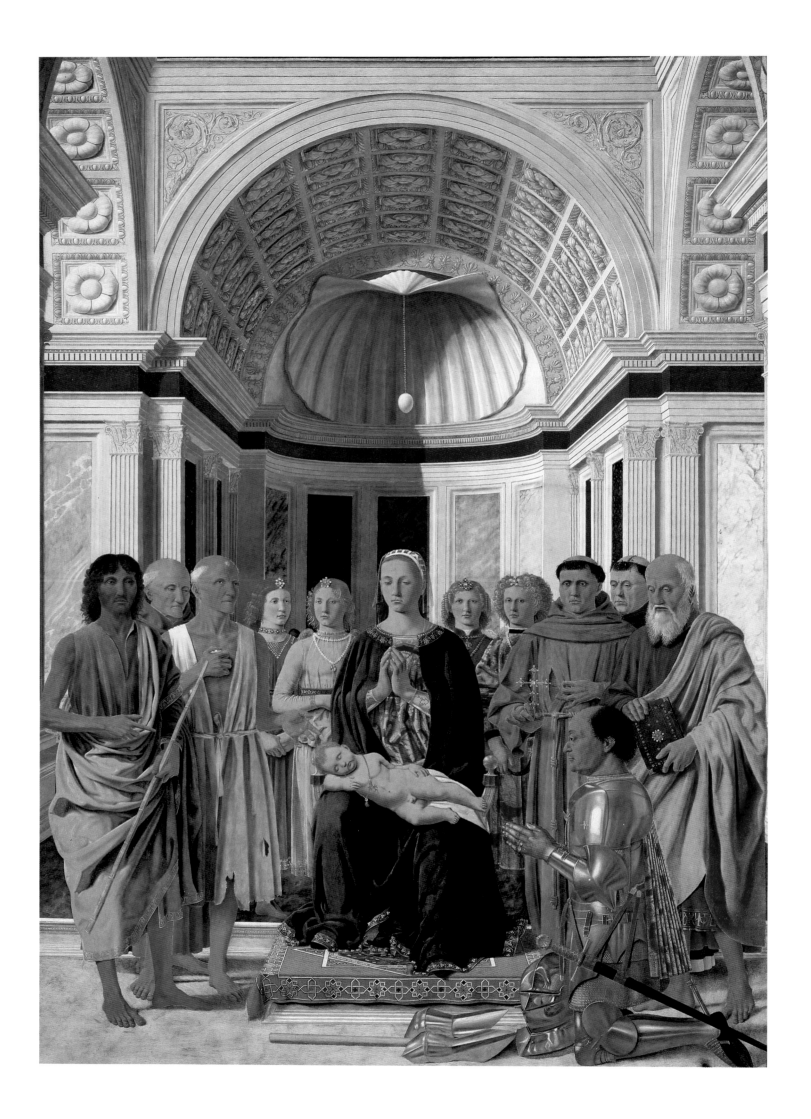

ANDREA MANTEGNA. *Ludovico Gonzaga, His Family, and Court.* 1465–74.
Fresco. Camera degli Sposi, Palazzo Ducale, Mantua.

Ludovico Gonzaga, Marquis of Mantua, commissioned Mantegna to decorate a room in his palace called the
Camera degli Sposi with scenes of his family. In this portion, Ludovico, his wife, and his children sit on a patio,
while a variety of courtiers and hangers-on mill about. There is a studied spontaneity to the scene, which is at once
a family portrait and a "snapshot" of courtly life.

opposite:

PIERO DELLA FRANCESCA. *Madonna and Child with Saints (Brera Altarpiece).* 1472–74.
Tempera on panel. 98 x 79 in. (249 x 200.7 cm). Brera Gallery, Milan.

Piero has set the figures here in an impeccably painted—and three-dimensionally convincing—church interior.
An ostrich egg is suspended from a shell-shaped niche at the back, a reference to the Virgin. Mary sits with
the sleeping Christ Child on her lap, his sleeping pose a foreshadowing of his eventual death. Kneeling at the
right in front of the Virgin is Federico da Montefeltro, Duke of Urbino, the patron of the work. Notably
absent is his beloved wife Battista, who had died just a few months earlier, and who would have occupied the
now vacant space opposite her husband.

SANDRO BOTTICELLI. *Primavera*. c. 1477–78. Panel.
80 1/4 x 124 in. (203 x 314 cm). Galleria degli Uffizi, Florence.

Botticelli was asked to paint several monumental mythological subjects by Lorenzo de' Medici. The *Primavera* is among the most mysterious of these, since it conforms to no known story. A carpet of flowers heralds the coming spring, as does Mercury at the left, who dispels lingering winter clouds with his cadeusis. Venus presides over the scene, while above her blind cupid takes aim at the Three Graces. The whole is conceived as a tapestry rich with the renewal of life.

Sandro Botticelli. *Birth of Venus*. After 1482. Tempera on canvas.
69 x 110 in. (175.3 x 279.4 cm). Galleria degli Uffizi, Florence.

Here, Venus, conceived from the union of the sea and the severed genitals of Uranus, rises from the water on a scallop shell, and is borne by the breath of two winds toward the shore, where a waiting figure prepares to cover her with a cloak. Venus is rendered in a beautiful sinuous line, full of a grace typical of Botticelli. Her pose is derived from classical statues of Venus, the *venus pudica,* who modestly covers herself with her hands.

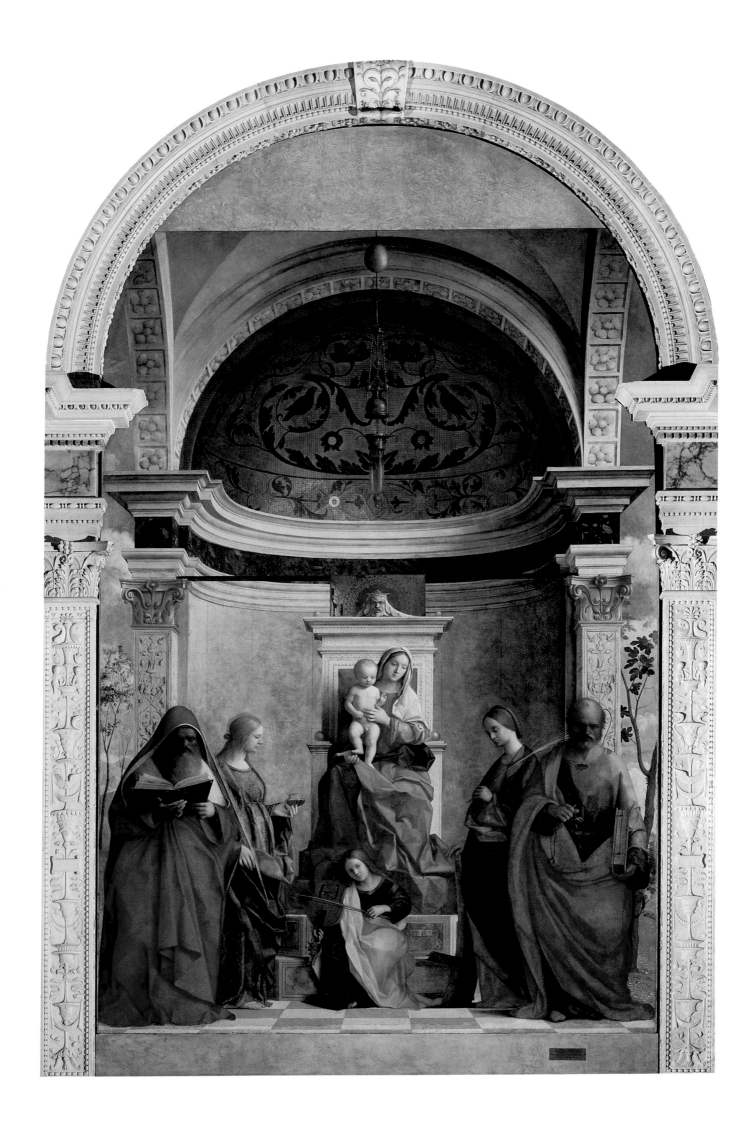

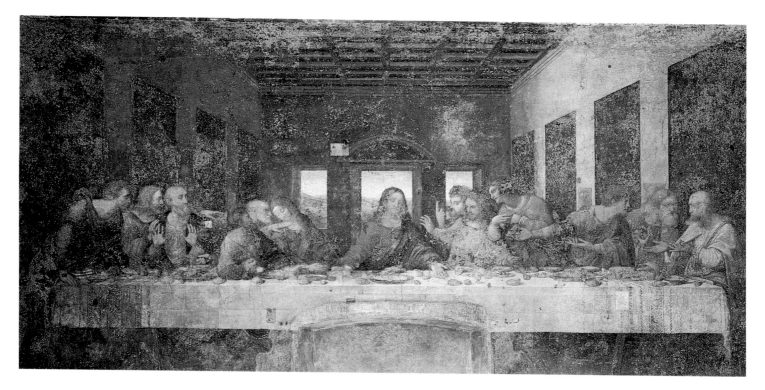

LEONARDO DA VINCI. *Last Supper*. 1495–98. Fresco. 184 5/8 x 346 1/2 in. (469 x 880 cm).
Refectory, Sta. Maria delle Grazie, Milan.

This fresco has suffered, ironically, from Leonardo's genius. The painting was not done in true fresco technique, in which a water-based paint is applied to the wet plaster to become part of the wall, but rather with an oil-based paint of Leonardo's own invention, done directly on the dry plaster. Because of this, the paint has been flaking off for centuries. Despite its ruinous condition, the stability and monumentality of the composition, and the handling of the figures, assured its timeless appeal from its inception; it is surely one of the most beloved works in all of Western art.

opposite:

GIOVANNI BELLINI. *Enthroned Madonna with Saints (S. Zaccaraia Altarpiece)*. 1505.
Canvas transferred from panel. 197 1/2 x 93 in. (476.2 x 236.2 cm). S. Zaccaria, Venice.

Set in a chapel in the open air, soft light drifts in from the landscape and plays luminously over the figures. The composition is delicately balanced, both in the poses of the figures, who subtly echo each other—the two male Saints stand frontally, while the two female Saints turn slightly—and the color harmonies of which Bellini was a master. The whole painting has a quiet, contemplative mood, which seems to exclude the viewer, except for the direct gaze of the music-making angel at the foot of the throne.

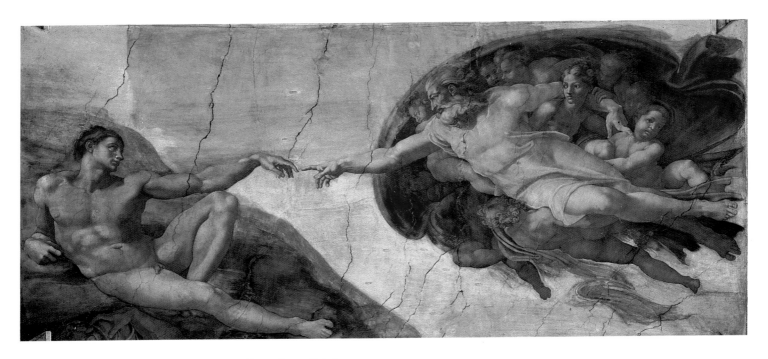

MICHELANGELO BUONARROTI. *Creation of Adam.* c. 1511–12.
Fresco. Sistine Chapel, Vatican, Rome.

This picture, along with Leonardo's *Mona Lisa* and *Last Supper,* is one of the best-known images in the world. The simplicity and monumentality of the composition have contributed to its lasting power. Adam, languid and barely alive, awaits the spark of life that will come from God's outstretched hand. Within the small space that separates the two fingers lies a potent anticipation, frozen in time. The nude figure of Adam is a direct heir of ancient statuary.

opposite:

MICHELANGELO BUONARROTI. *Last Judgment (detail of the Damned).* 1536–41.
Fresco. Sistine Chapel, Vatican, Rome.

The huge composition on the altar wall of the Sistine Chapel is composed of hundreds of nude figures in a variety of poses, and it quickly became a valuable resource for artists. The nudity of the figures in this sacred setting prompted officials to commission another artist to paint in discreet draperies over the offending anatomy. The terror on the face of a soul being dragged down to Hell by gleeful demons, shown in this image, is but one example of the many powerful portrayals in this fresco.

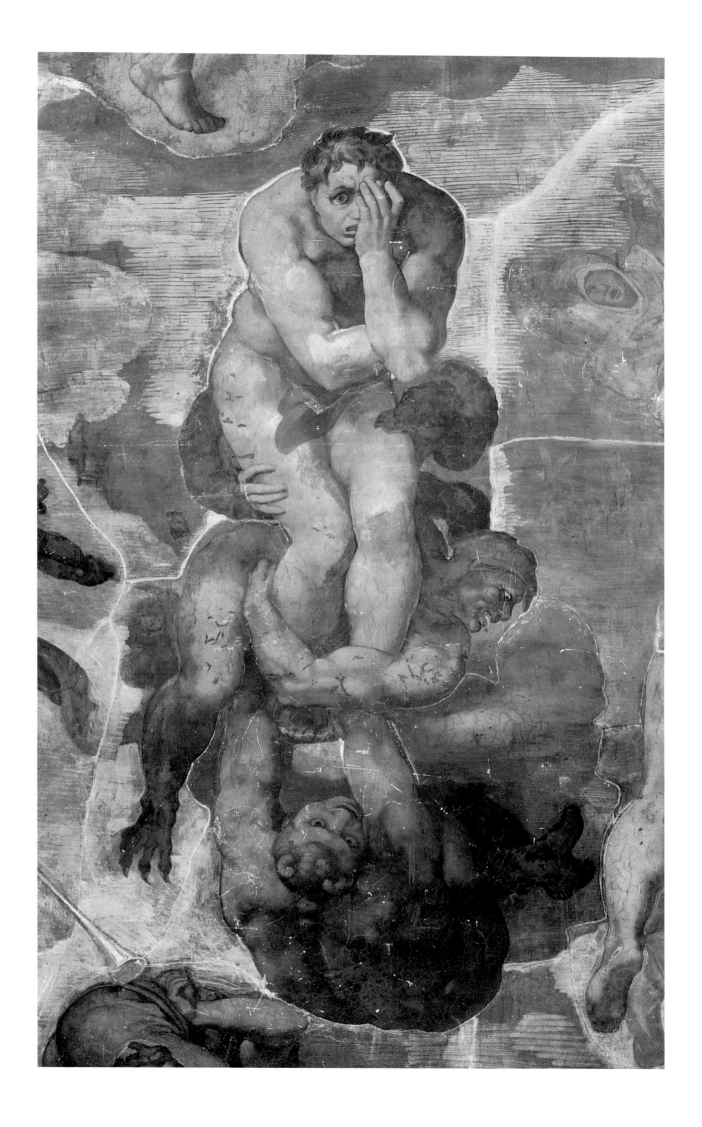

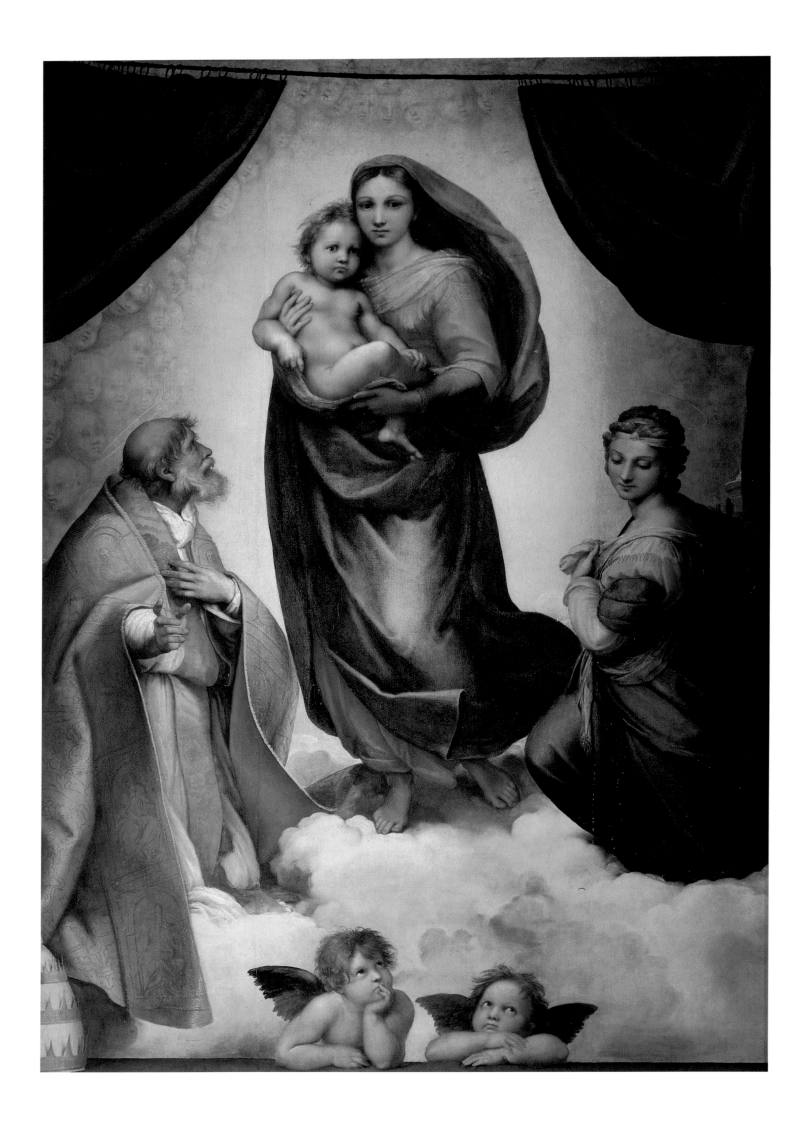

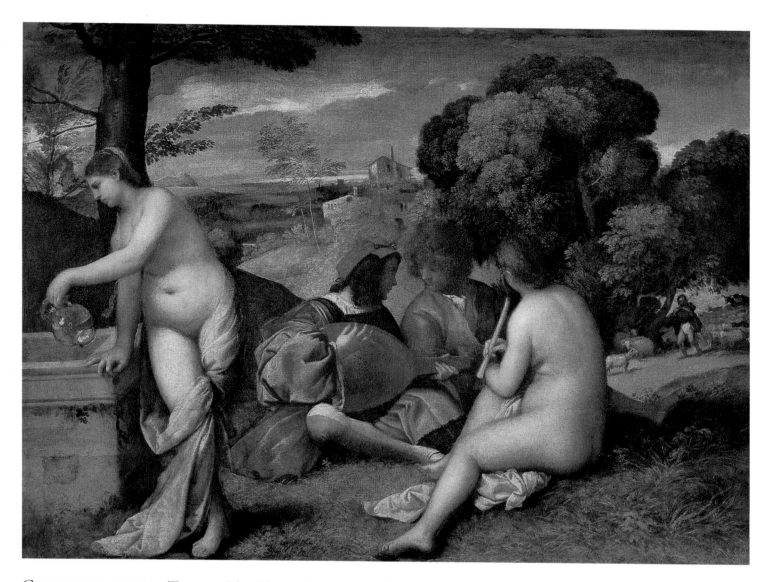

GIORGIONE AND/OR TITIAN. *Fête Champêtre.* c. 1510. Canvas. 43 1/4 x 54 1/4 in. (109.9 x 137.8 cm). Musée du Louvre, Paris.

The authorship of this painting has gone back and forth between Titian and Giorgione for decades. Similarly, the exact meaning of the picture is highly debated. In a landscape setting, two clothed men and two nude women make music together, although the men take no notice of the women. Typically Venetian, line is nowhere evident. Instead, forms are modeled in color and chiaroscuro (contrasts of light and dark), so much so that the faces of the men are almost completely obscured.

opposite:

RAPHAEL. *Sistine Madonna.* 1513. Canvas. 104 x 77 in. (264.1 x 195.6 cm). Gemaldegalerie, Dresden.

This Madonna, done later in Raphael's career than the *Madonna of the Meadows,* continues to employ the pyramidal figural composition, but with an added element. The calm stability of the earlier painting is refreshed by a moving dynamism accomplished through gesture, gaze, and billowing draperies. Now, too, the setting has changed. Instead of an idealized natural landscape, the Virgin and Child appear as a celestial vision, revealed through parted curtains.

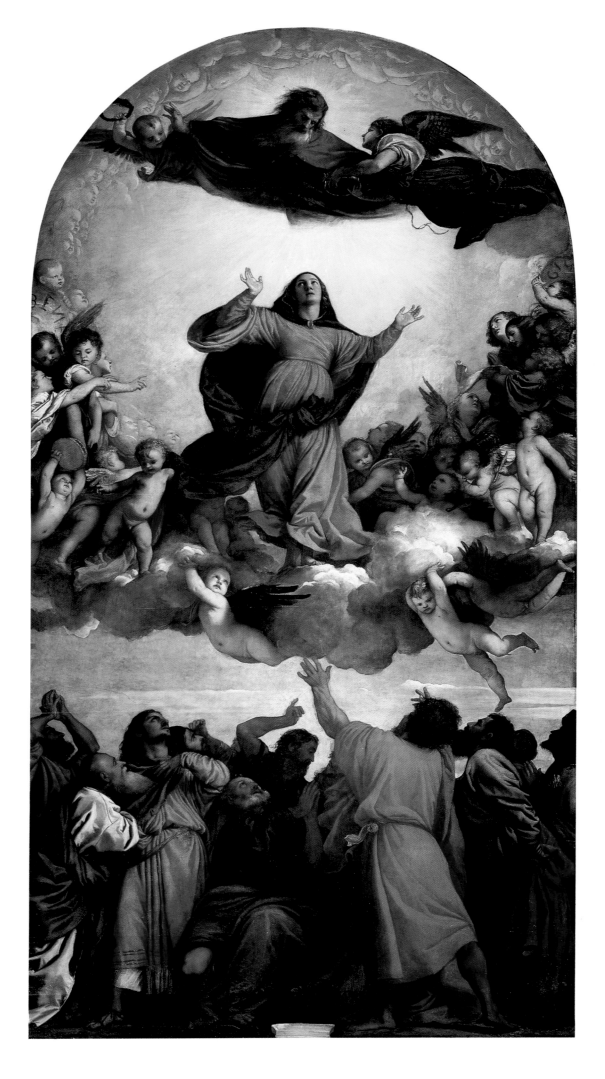

TITIAN. *Assumption of the Virgin.* 1516–18. Panel. 270 x 142 in. (685.8 x 360.7 cm). Sta. Maria Gloriosa dei Frari, Venice.

This altarpiece is divided into three registers. The lowest tier is the earthly realm, where the Apostles stand and gesture as the Virgin is lifted. The middle tier is occupied by the Virgin, borne heavenward on a swath of clouds propelled by an angelic host. The uppermost register is the heavenly realm in which God the Father waits in a golden light to receive Mary. The whole composition moves with intersecting arcs and triangles, and in that sense is an heir to Raphael's *Sistine Madonna.*

opposite:

PONTORMO. *Entombment.* 1525–28. Panel. 123 x 76 in. (312.4 x 193 cm). Capponi Chapel, Sta. Felicita, Florence.

In this Mannerist painting, we see a change from the stability and naturalism of the Renaissance. Set in an ambiguous space, figures dressed in bright, unnatural colors are piled up without clear spatial relationships. They seem to float without weight, and it is unclear, for example, what supports the topmost figures. What does become clear is that naturalistic matters are of little consequence; it is instead the emotional impact of the subject that takes on a primary importance.

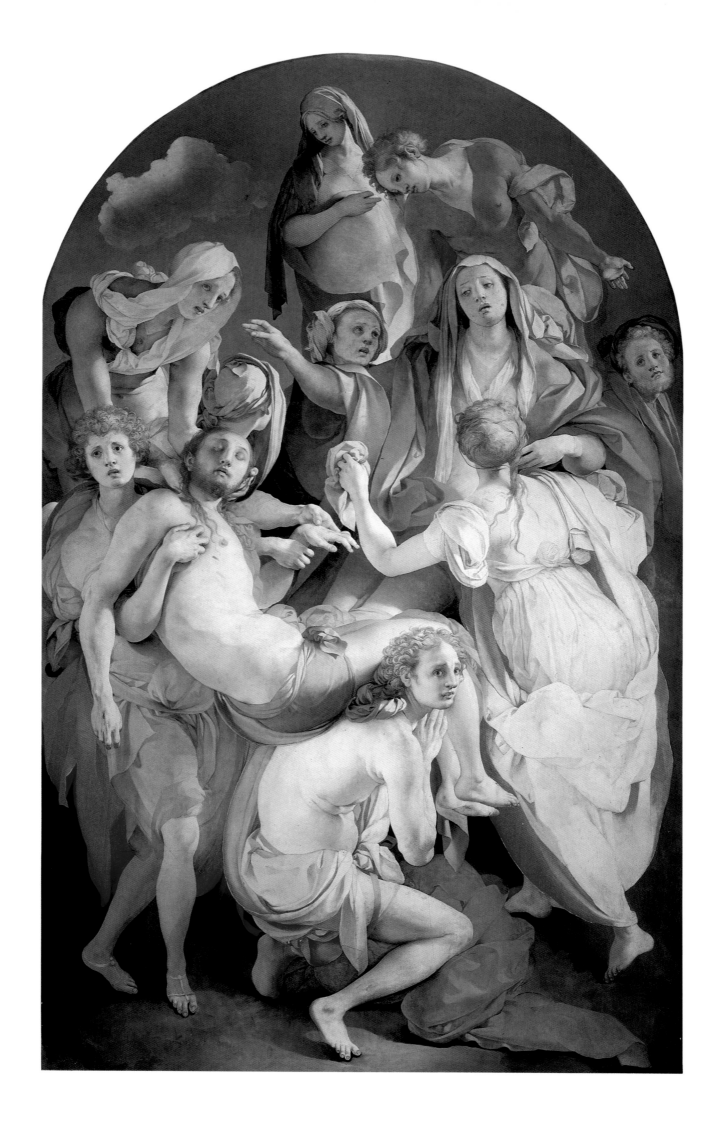

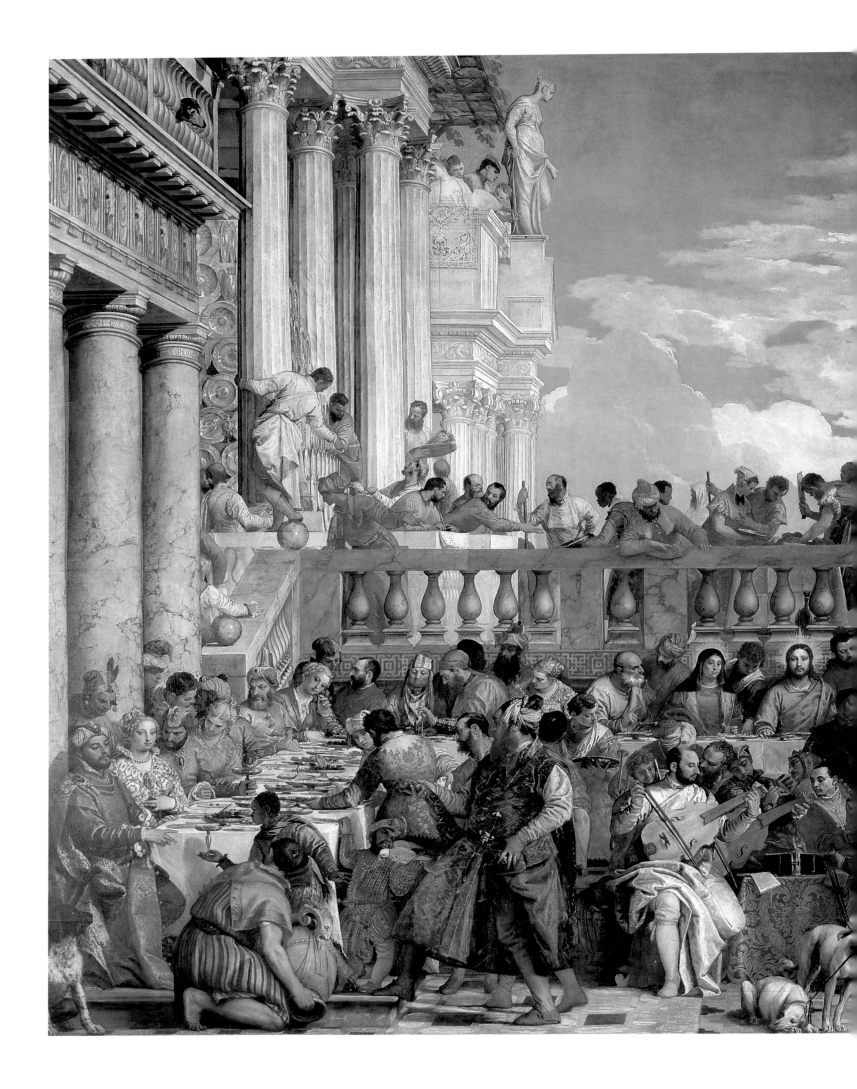

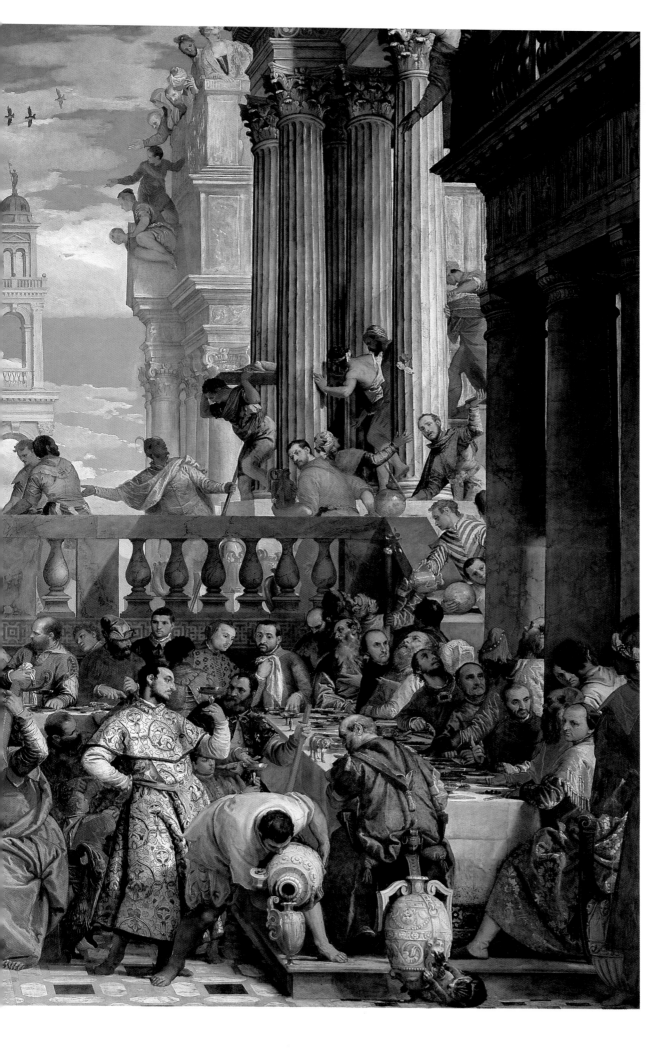

PAOLO VERONESE.
Marriage at Cana.
1563. Canvas.
262 x 390 in.
(665.5 x 990.6 cm).
Musée du Louvre,
Paris.

This enormous paint-
ing is a feast for the
eyes. The picture is
loaded with details of
a sumptuous meal
set in a grand setting.
All manner of rich
costume and accou-
trements are on
display in brilliant
color, so much so that
it is difficult to take
it all in. Within this
visual cacophony, we
have to look hard to
find Christ, who sits
with dignified calm
at the picture's center.

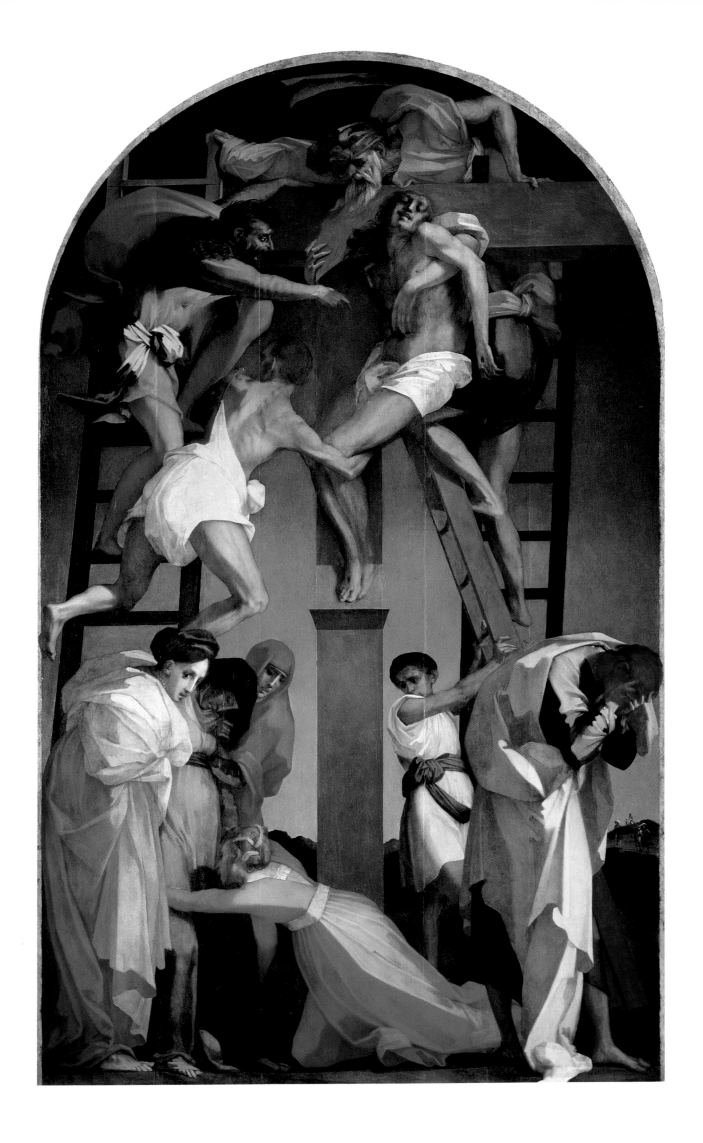

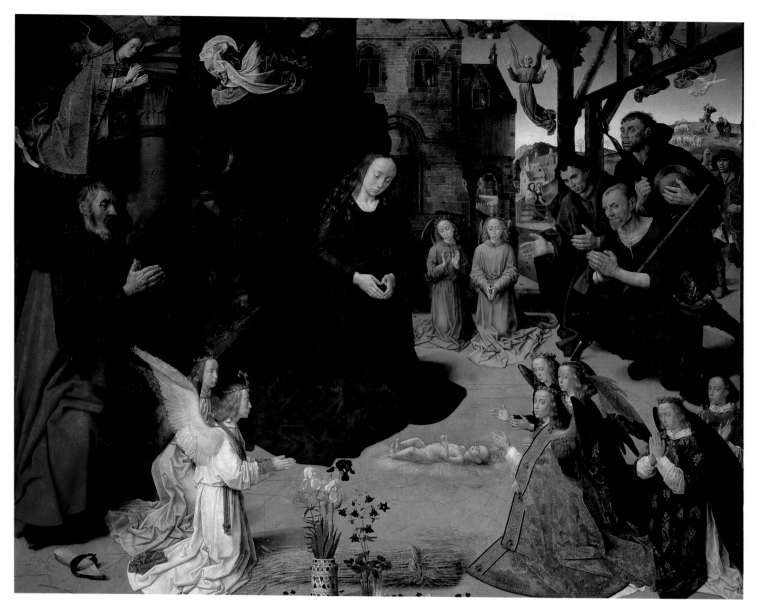

HUGO VAN DER GOES. *Portinari Altarpiece.* (central panel) 1475–76. Panel.
99 5/8 x 118 in. (253 x 299.7 cm). Galleria degli Uffizi, Florence.

The exact detailing of nature and use of disguised symbolism is typical of Northern painting. The reflective, almost
somber mood is typical of Hugo. The three shepherds show three levels of understanding of the miracle, based
on their physical proximity to the scene: the oldest shepherd understands most deeply; the shepherd in the middle
gestures in wonder, but not full belief; and the shepherd at the back looks on only half comprehending, but doffs
his cap in respect.

opposite:

ROSSO FIORENTINO. *Descent from the Cross.* 1521. Panel. 132 x 78 in. (335.3 x 198.1 cm). Pinacoteca, Volterra.

This Mannerist composition, like Pontormo's work, rejects High Renaissance ideals of naturalistic or even idealized
forms. Here, the figures are hard and planar, as if sculpted in wood, and the light reflects off their faceted surfaces.
The high emotional tone of the picture is summed up beautifully in the figure of Saint John, overcome with grief at
the right of the painting.

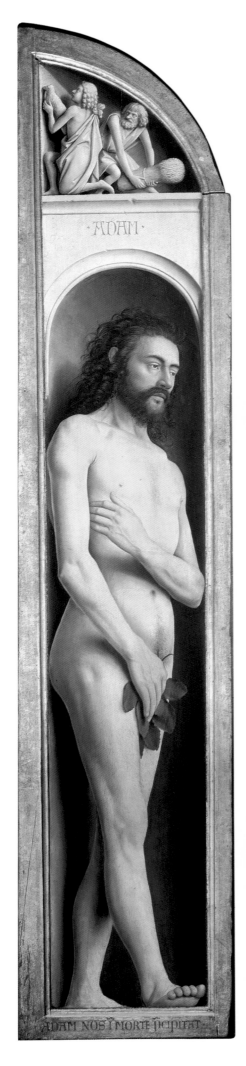
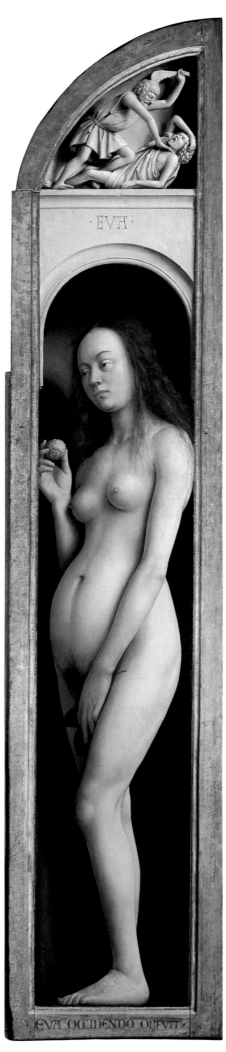

JAN VAN EYCK (WITH HUBERT VAN EYCK). *Adam and Eve,* from the *Ghent Altarpiece.* 1432. Panel. 137 3/4 x 181 1/2 in. (349.9 x 461 cm). Cathedral of St. Bavo, Ghent.

Jan's style is precise and tight, with no visible brushstrokes. The nude figures of Adam and Eve are rendered with great naturalism, shown after the Fall and covering themselves with new-found shame. They stand in niches above which are fictive relief panels representing the Sacrifice of Cain and Abel and Cain Killing Abel, and the harsh light casts strong shadows plunging the interior of the niches into total darkness.

opposite:

PARMIGIANINO. *Madonna with the Long Neck.* 1534–40. Oil on panel. 85 x 52 in. (216 x 132.1 cm). Galleria degli Uffizi, Florence.

The impossibly attenuated forms of the figures in this painting are consistent with the antinaturalistic style of the Mannerists. The Christ Child is impossibly huge, too large for the lap of the Virgin, from which he seems to risk tumbling. The Madonna herself seems posed between sitting and standing but floats effortlessly in this awkward position. The setting and spatial relationships are eccentric, producing a lopsided composition heavy on the left side, and plunging into depth on the right.

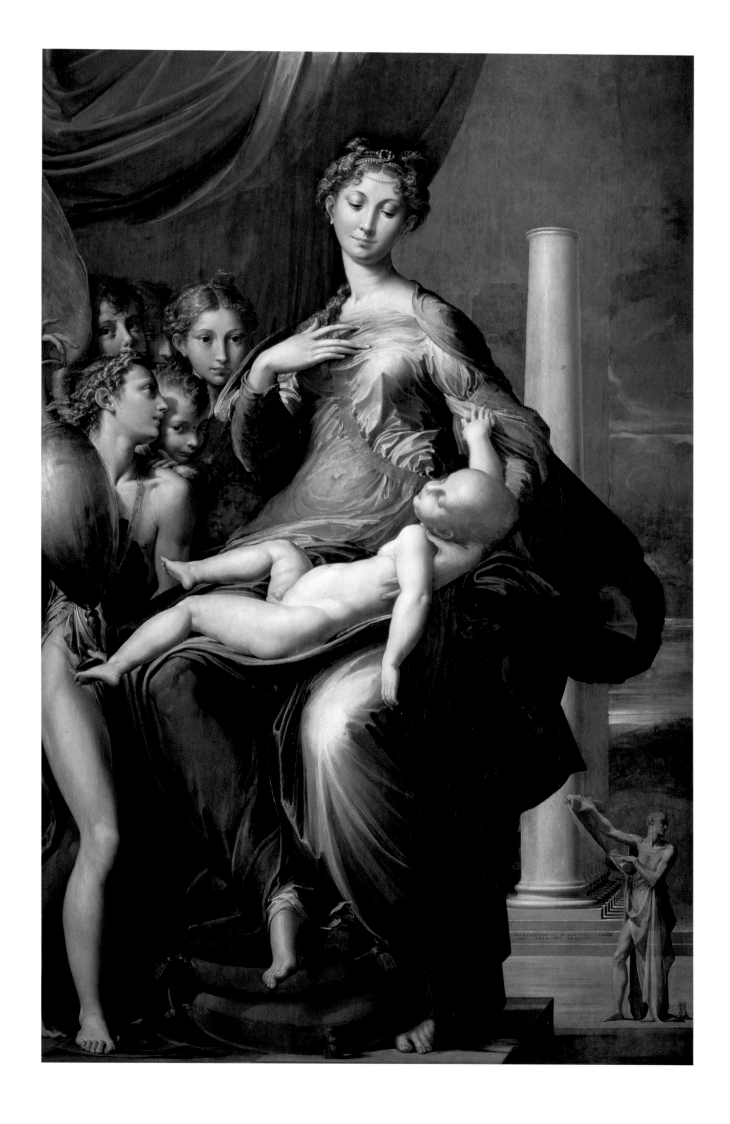

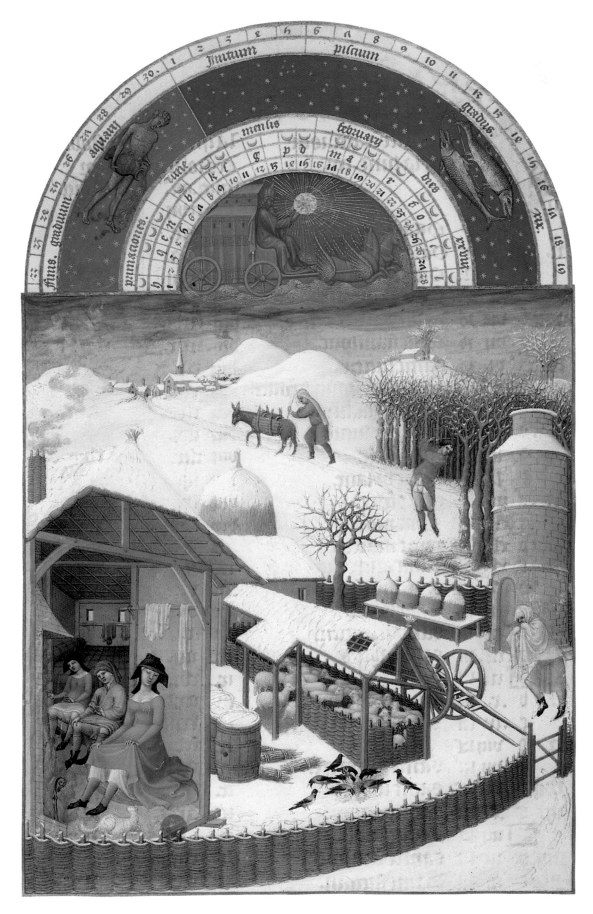

LIMBOURG BROTHERS. *February,* from the *Très Riches Heures du Duc de Berry.*
Before 1416. Manuscript. Musée Condé, Chantilly, France.

The tradition of manuscript illumination, much stronger in the north of Europe than in
Italy, is at its most magnificent in the illustrations for this Book of Hours. The calendar
section features an illustration for each month. Here, peasants warm themselves by the
fire, while outside three others still labor in the snow-covered farm. One of the first
accurate depictions of winter, the scene is observed with charming detail.

JEAN FOUQUET. *Martyrdom of Saint Apollonia,* from the *Hours of Etienne Chevalier.*
After 1445. Manuscript. Musée Condé, Chantilly, France.

Fouquet painted this Book of Hours for Etienne Chevalier, the treasurer of Charles VII. This miniature
is set as if for a play. A wooden enclosure marks the stage, and the four wild people in front hold plaques
announcing the start of the drama. There is seating for spectators—here, the inhabitants of Heaven and
Hell—behind the "performers." The vacant seat at the center was occupied by God the Father, a bearded
figure in blue, who has entered the stage and stands next to Apollonia at the moment of her martyrdom.

HIERONYMUS BOSCH. *Garden of Earthly Delights.* (center panel) c. 1510–15. Panel.
86 5/8 x 76 3/4 in. (220 x 195 cm). Prado, Madrid.

Bosch holds a unique place in the history of art as an artist of incomprehensible imagination. The keys to the
real meaning of much of his work are still a challenge to scholars. This central panel from the triptych shows
a great swarm of human beings and fantastic creatures who cavort and disport themselves in innumerable
positions within a verdant landscape, dominated at the back by a lake surrounded by strange constructions.
Erotic play and frivolity are the main order of the day.

HIERONYMUS BOSCH. *Garden of Earthly Delights.* (right panel) c. 1510–15. Panel. 86 5/8 x 38 1/4 in. (220 x 97.1 cm). Prado, Madrid.

Here we see that the consequences of the "delights" is Hell, and this is a Hell scene of shocking and disturbing potency. The torments that await the wanton behavior of man are given hallucinogenic reign under Bosch's brush. In a dark place, illuminated at the back by everlasting fires, the damned suffer tortures wreaked upon them by bizarre creatures and animals. Disturbingly, the face of the large creature—part eggshell, part tree—in the center of the painting has been identified as a self-portrait of the artist.

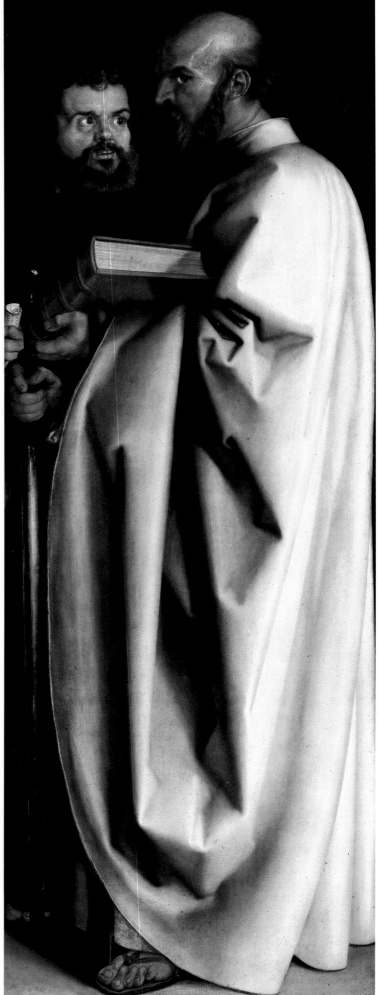

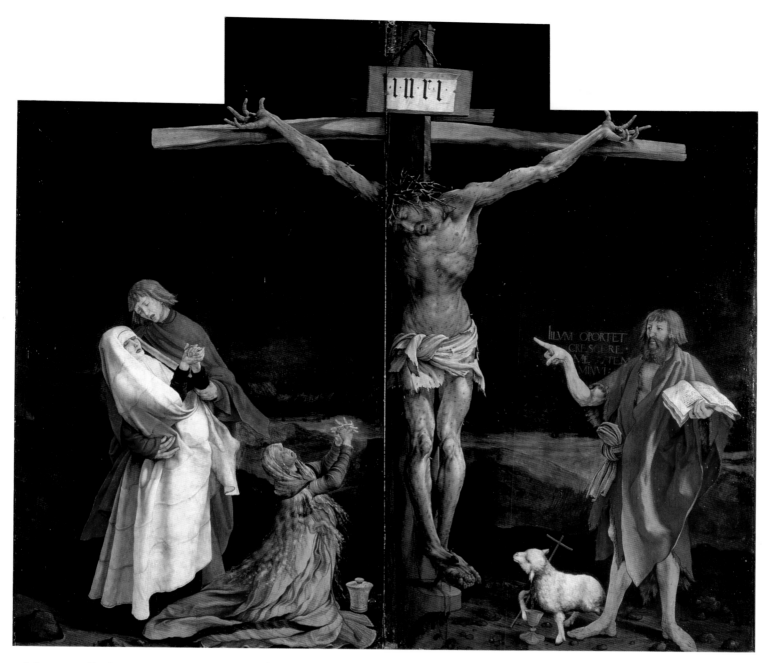

MATHIS GRÜNEWALD. *Crucifixion,* from the *Isenheim Altarpiece.* (detail) 1515. Oil on panel.
117 1/2 x 129 in. (298.4 x 327.7 cm). Musée d'Unterlinden, Colmar.

This large polyptych, of which this is the closed view, was painted for the Hospital of Saint Anthony. The crucified Christ is depicted with gruesome realism, the kind that delighted Northern artists. But this is not gratuitous; here the agony of Christ, who, in addition to the wounds from the nails, also suffers from a skin disorder, is directly related to the hospital setting. The patients could look upon the suffering of Christ and know, pointedly, that he understood their own torments.

opposite:

ALBRECHT DÜRER. *The Four Apostles.* 1526. Oil on two panels, each 84 1/2 x 30 in. (214.6 x 76.2 cm). Alte Pinakothek, Munich.

This painting on two panels (intended as wings for an altarpiece), done late in the artist's life, shows his familiarity with Italian Renaissance painting in the monumentality of the figures and the massing of the draperies. On one level, the four figures relate to the four humors of the body: phlegmatic, sanguine, choleric, and melancholic. On another level, the picture relates to the current religious debate between Catholicism and Protestantism.

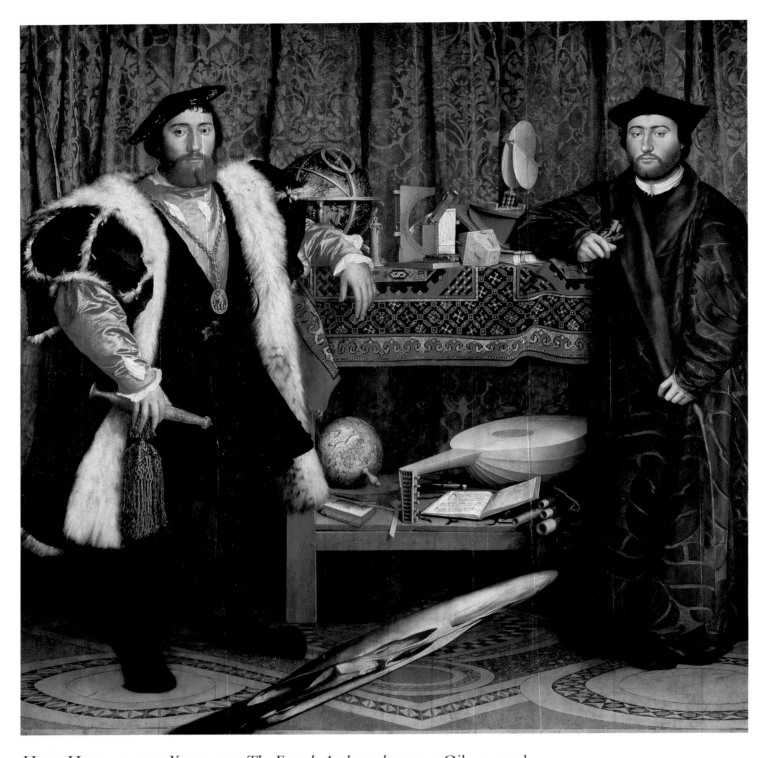

HANS HOLBEIN THE YOUNGER. *The French Ambassadors.* 1533. Oil on panel.
81 1/8 x 82 1/4 in. (206 x 208.9 cm). The National Gallery, London.

Holbein was one of the foremost portrait painters of the Renaissance, or any age. In this double portrait, the two ambassadors are shown full length in front of a table heaped with objects that represent their interests and achievements. The most unusual feature of the painting is the strange object in the middle foreground, which is a vastly distorted skull—Holbein's play on his name, which in English means "hollow bone."

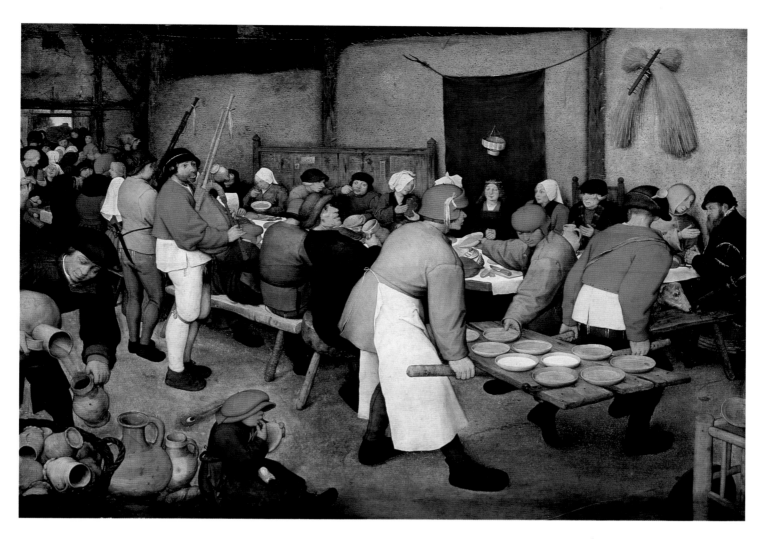

PIETER BRUEGHEL THE ELDER. *Wedding Feast.* c. 1566. Oil on panel.
44 7/8 x 64 1/8 in. (114 x 162.9 cm). Kunsthistorisches Museum, Vienna.

Brueghel, the premier painter of the Netherlands in the 16th century, had a life-long fascination with peasant life. In this picture, the bride is seated at her wedding banquet in the center of a long table. Though her presence is highlighted by the green cloth behind her, she is secondary to the hubbub of the feast in progress around her. The figure in black at the extreme right of the picture is probably a self-portrait of the artist.

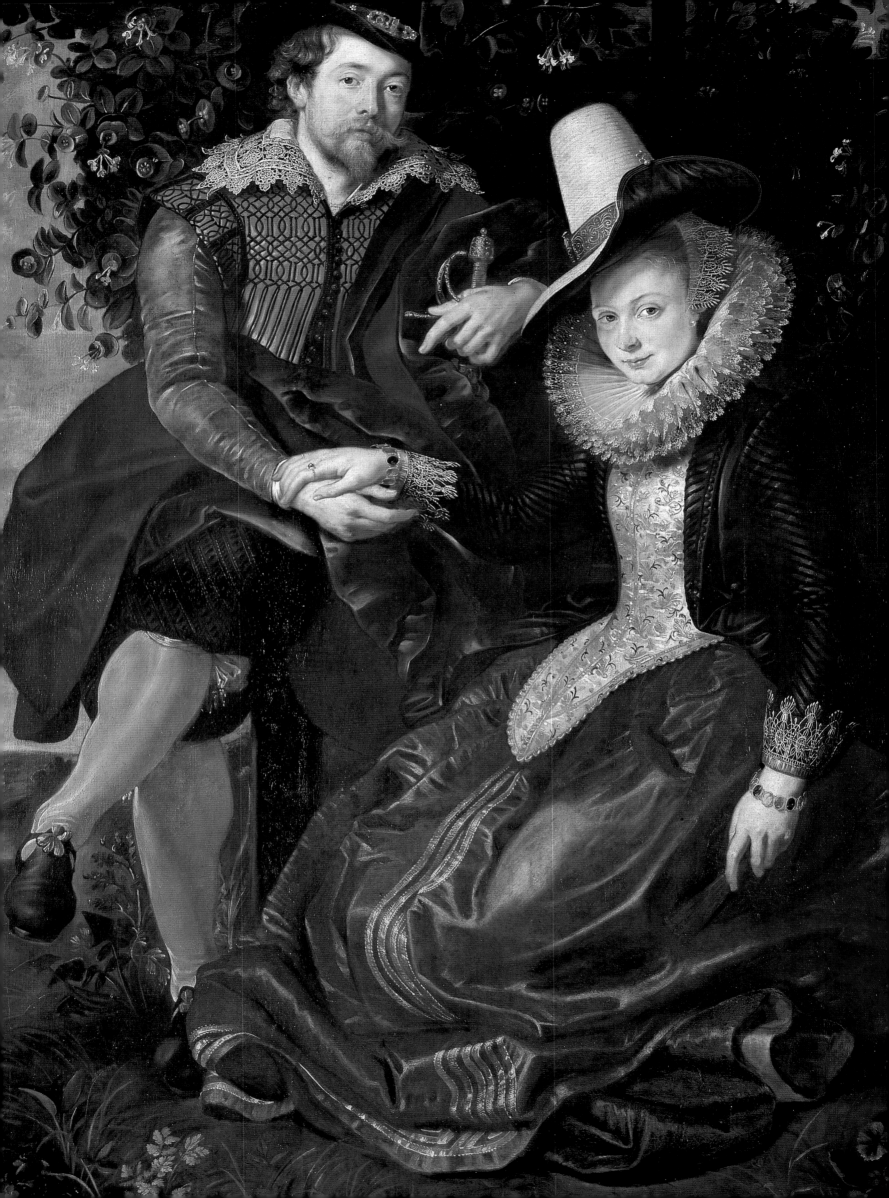

The Baroque

The Politics of Piety

THE SEVENTEENTH CENTURY and the first half of the eighteenth witnessed a period of unprecedented artistic diversity throughout the European continent. In Italy, two divergent currents became manifest in the seventeenth century, with one group of artists working in a more restrained, classical style, while others pursued a highly decorative, exuberant, and illusionistic expression. Under the leadership of Peter Paul Rubens, the second style predominated in Catholic Flanders, while artists in its Protestant counterpart, the Netherlands, adopted a self-conscious realism that reflected the daily life of its citizens. In France, Louis XIV, the Sun King, keeping to his policy of centralization, commissioned large numbers of paintings and other artworks in a rather solemn, even majestic, and occasionally pompous manner. Only much later in the century did the German-speaking countries — recovering from the devastating religious conflict of the Thirty Years' War, concluded with the Peace of Westphalia in 1648 — play a more substantial role, though for the most part they followed Italian models. To the west, in Spain, the strains of poetic realism in secular art commingled with dramatically mystical religious imagery.

Because of this great variety of styles, the term "Baroque" encompasses a period in time as much as any single set of artistic principles. The origin of the word "Baroque" is uncertain. Some believe that it derives from the Portuguese *barroco*, meaning "an irregular pearl." In any case, the word was not used as a specific art historical term by critics until the nineteenth century. As to its time limits, art historians generally agree in placing the Baroque period between the late sixteenth century and the early eighteenth century, that is, between Mannerism and Rococo. As with any category, however, the distinguishing qualities of the Baroque style are still sometimes a matter of debate. It is nevertheless safe to say that the Baroque owes more to the High Renaissance ideal of a balance of parts, each of which is perfection in itself, and less to the contrived and, at times, exaggerated formulas of Mannerism, with its contorted lines.

PETER PAUL RUBENS. *The Artist and His Wife Isabella Brant Under the Honeysuckle Bower.*
c. 1609–10. Oil on canvas. 70 x 53 3/4 in. (178 x 136.5 cm). Alte Pinakothek, Munich.

A principal feature of the Baroque is its ambitiousness. Diverse elements are subordinate to a dominant whole, individual parts blended into a harmonious grand unity. As never before, painting and sculpture serve an overarching architectural design, without losing their specific dramatic roles. Indeed, the strong emotional impact of the new art was enhanced by an embracing architecture informed by theater. In the Baroque space, the viewer becomes not just a spectator, but a participant whose emotions the artist has sought to evoke.

The humanist artists of the Renaissance had set out to express specific physical qualities of reality, including the external manifestation of individual inner experience. Baroque practitioners took these concerns further. In southern Europe, often in the service of Catholic doctrine, artists worked to elicit emotion, not just depict it. In the Protestant North, artists also pursued illusionism, in virtuoso, deeply felt representations of secular objects, landscapes, and scenes of everyday life. Artists became more and more concerned with the textures and colors of things. The physical urgency and presence of the Baroque are often achieved through calculated contrasts of light and dark, mass and void, and the use of strong diagonals and curves. These formal elements would become increasingly stylized and ornamental, evolving into the fanciful conceits of Rococo. The Baroque preoccupation with mood and color was manifested in the fashion for the multicolored decoration of chapels and atmospheric rendering of landscapes and cityscapes, and lasted well into the eighteenth century.

By the end of the sixteenth century, the Reformation had resulted in the establishment of Protestantism throughout most of northern Europe. Since the 1550s, the Roman Catholic Church had reacted with the Counter-Reformation, which explicitly expressed dogma in art in order to educate the faithful and to deter further heresies. For this purpose, art had to be not only doctrinally correct but also visually imposing if it was to impress upon the largest possible audience the spiritual power of the Church. The grandeur and subliminal harmony of the Baroque style served the goals of the Counter-Reformation very effectively.

The Catholic Church had increasingly become the principal patron of the arts, so it is not surprising that Italy led the new artistic movement, or, more precisely, that the papal court saw the opportunity to employ young painters to promulgate and assert the dogmas of the Counter-Reformation Catholic Church. The visual arts as well as the hagiographic literature emphasized heroic biblical paragons, like David and Goliath or Judith and Holofernes; models of repentance, like Saint Peter and the Prodigal Son; and above all, the glory of martyrdom and the visions and ecstasies of the saints. The practitioners of the new style worked to move the viewers, to engage them emotionally in scenes of faith and redemption. The artist's goal was no longer to provoke the spectator's admiration for either the dignified, well-proportioned beauty of the Late Renaissance ideal or the Mannerist artifice of a scene, but to find and portray the affective power of the subject, be it biblical or taken from the accounts of the lives of new saints like Charles Borromeo or Ignatius of Loyola, the founder of the Jesuit order. During the brief pontificate of Gregory V, the simultaneous canonization of Ignatius, Teresa of Avila, Philip Neri, and Francis Xavier on May 22, 1622—four great reformers who were also founders or co-founders of religious orders—served to consolidate the new spirit of the Church. The new orders required new constructions to accommodate the congregations associated with them, and a hectic flurry of building set in, starting with the church of Il Gesù in Rome, begun in 1568 and consecrated in 1584. Not since the Sack of Rome in 1527, which interrupted virtually all artistic activities for several decades, had the city seen such a flourishing of the arts. Pope Urban VIII (reigned 1623–1644) put his lasting mark on the

city with architectural and other urbanistic projects, but also patronized all other artistic expressions to an unprecedented degree. In general, the largest proportion of the artistic production in Italy during the seventeenth century, as during previous centuries, was of a religious nature, yet new subjects such as still lifes and independent landscape painting were emerging as full-fledged genres, in response to northern European developments.

ITALY

Although not wholly an Italian, much less a Roman, invention, the Baroque style developed its early stage most clearly in the Eternal City. It was here that the great tradition of monumental fresco painting from Giotto to Masaccio to Raphael was revived; throughout the seventeenth and eighteenth centuries, it was considered the most challenging art form for any painter. Annibale Carracci's (1560–1609) famous fresco decoration in the Gallery of the Palazzo Farnese in Rome follows examples of antiquity and the Renaissance, especially Michelangelo. One of the artistic highlights of the seventeenth century, Carracci's masterpiece was the first overall decorative program to embellish a unified architectural element—here, the ceiling of the gallery—with a single theme.

The decoration of the Farnese Gallery took about ten years. Begun in 1597, it may not have been completely finished until 1608. The hall, about 60 by 20 feet, has a coved vault that Annibale was commissioned to fresco with mythological scenes from the Roman poet Ovid's *Metamorphoses*. The theme is the all-conquering power of love, to which even the gods succumb. Carracci's scenes present the mythological events with vigor and directness and offer the viewer an entertaining narrative sequence. The various scenes are painted as if they were framed easel pictures transferred to the ceiling, where they are incorporated within an architectural framework. The central scene, *The Triumph of Bacchus*, balances its effect of dynamic energy and imaginative freedom with a firm classical structure. Annibale, suffering

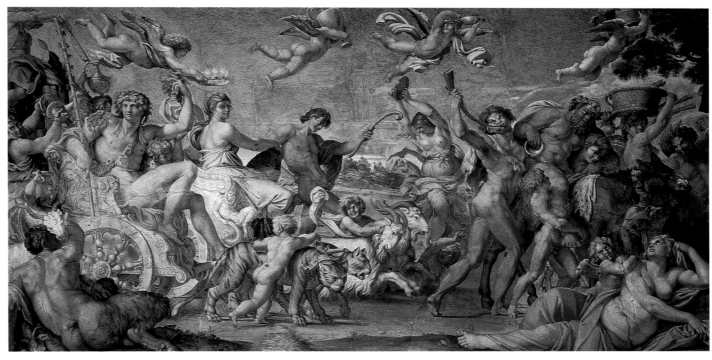

ANNIBALE CARRACCI. *The Triumph of Bacchus.* 1597–1601. Fresco in the Palazzo Farnese, Rome.

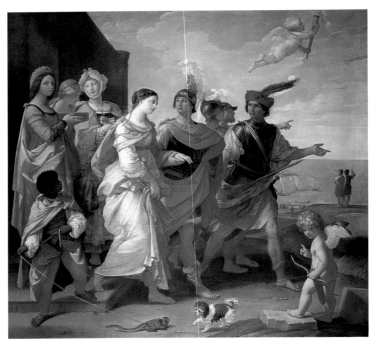

GUIDO RENI. *The Abduction of Helen*. 1631. Oil on canvas. 99 1/2 x 104 1/4 in. (253 x 265 cm). Musée du Louvre, Paris.

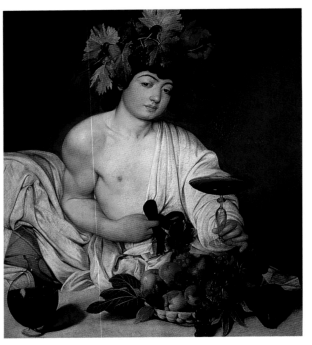

MICHELANGELO MERISI DA CARAVAGGIO. *Bacchus*. 1593–94. Oil on canvas. 37 1/2 x 33 1/2 in. (95 x 85 cm). Galleria degli Uffizi, Florence.

from deep melancholy, retired after this project; he hardly touched a brush again. Later artists would take his decorative principles to a completely illusionistic unification of space.

Among the followers of the Carracci school were two Bolognese artists, Domenichino (1581–1641) and Guido Reni (1575–1642). The latter's ceiling fresco *Aurora* at the Casino of the Palazzo Rospigliosi in Rome is even more severely classical than Carracci's decoration of the Farnese Gallery. The frieze-like composition seems to have been derived from an antique relief reinterpreted in a lyrical fashion, softened by glowing colors and transparent light effects. Graceful movements and harmonic gestures are characteristic of Reni's artistic language, though in his later paintings, such as *The Abduction of Helen*, he adopted a cooler color scheme.

After Reni returned to Bologna in 1614, Domenichino became the leading artist in Rome. His adherence to the classical current in art is evident in *The Last Communion of St. Jerome*, as well as in landscape paintings that prefigured the works of Nicolas Poussin (1594–1665) and Claude Lorrain (1600–1682).

Michelangelo Merisi (1571–1610), called Caravaggio, arrived in Rome about 1590 as a young man of fifteen or sixteen years old. His highly personal realism found few contemporary followers, and his early career was marred by the refusal of some of his works. Caravaggio's early paintings indicate a subjective mood, as in his *Bacchus*, in which an androgynous boy has replaced the traditional image of a fleshily exuberant god of wine. Unlike Annibale Carracci, who made thousands of preparatory drawings and studies for the Farnese ceiling, Caravaggio appears to have painted from the model directly onto the canvas. No drawings by him are known.

His first patron was Cardinal Francesco del Monte, who, in 1597, commissioned a monumental work, the paintings in the Contarelli Chapel in San Luigi dei Francesi, the church of the French community in Rome. These paintings can still be seen in their original setting. In the *Calling of Saint Matthew*, darkness looms menacingly over the table behind which Saint Matthew sits with a heap of coins in front of him, pointing his finger toward himself in response to Christ's invitation to follow him. Several devices lure the viewer into the drama of Caravaggio's paintings. For example, his *Conversion of Saint*

Paul in Santa Maria del Popolo in Rome is a masterpiece of bold foreshortening of the saint's figure, while the dramatic light attracts the viewer's attention first to the horse and only at a second glance to the saint himself, who lies stretched out in the foreground with his arms raised toward the heavenly vision that only he can see.

Caravaggio was an unruly character, whose violent and anarchic personality brought him more than once into conflict with the police. After killing a man in a gambler's brawl in Rome he fled to Naples, then to Malta, Syracuse, and Messina. On his way back to Rome he died of malaria on the beach near Porto Ercole in July 1610, not yet thirty-nine years old. His work, however, had a deep and lasting influence not only on a strain of Italian art, but internationally, on artists such as Georges de La Tour in France and Rembrandt in the Netherlands, as well as on various Dutch genre painters like Gerrit van Honthorst, who emulated with different degrees of success Caravaggio's rendering of light in candle-light scenes with strong chiaroscuro effects. But while the Italian master used light and shadows as a means of interpreting the emotional subject matter of his canvases, his followers were more interested in the technical application of such effects.

Caravaggio's style was too complex and idiosyncratic to be translated into easy formulas, but elements of his manner were taken up by painters of very different backgrounds and training. In Rome, Orazio Gentileschi (1563–1639) and his daughter, Artemisia (1593–1653), followed Caravaggio's naturalistic approach and adopted his mystic light effects, but their emphasis on linear definition of forms differs from Caravaggio's seemingly spontaneous handling of paint. Artemisia Gentileschi excelled in psychological realism in biblical scenes and a bloodthirsty series showing the Jewish heroine Judith with the head of the Assyrian general Holofernes, painted with rich colors and cool anatomical precision.

Artists of the next two generations were responsible for some of the largest fresco cycles in Rome. The most impressive ceiling decoration from this period is Pietro da Cortona's (1596–1669) *Triumph of the Barberini*. Painted between 1633 and 1639 for the Barberini family, the family of the reigning pope, Urban VIII, the fresco spans the entire vault of the large audience hall of the family palace. The ceiling immediately became a model for highly illusionistic paintings throughout Italy and Europe. Cortona created a painted architectural frame in order to "open" the space above the viewer; the frame itself is partially concealed by an abundance of masks, shells, garlands, and figures. The sky is the device that unifies the five separate areas of an elaborate and monumental allegory of the virtues of the pope's ancestors. Divine Providence, seated just below the center of the vault, above Time and Space, points toward three giant bees surrounded by a laurel wreath, both Barberini emblems. Immortality directs with a commanding gesture that a crown of stars be added to the Barberini bees, while other figures present various symbols of the papacy.

Urban VIII was also the patron of Gianlorenzo Bernini (1598–1680), the preeminent artist in Rome during the seventeenth century, best known for his architectural and sculptural contributions to Saint Peter's, and considered by some the preeminent Baroque artist. Giovanni Battista Gaulli, called Baciccia (1639–1709), who was born in Genoa, came under Bernini's influence and protection. Although mainly a sculptor and architect, Bernini advised Baciccia in matters of painting and helped him to obtain the commission for the decoration of the ceiling of the Jesuit church in Rome, Il Gesù. Baciccia combined painting, sculpture, and architecture into a unified scheme that transformed the austere interior into a dramatic space. The central scene, *The Adoration of the Name of Jesus*, illusionistically opens the church ceiling to the heavens, from which angels and clouds descend into the nave. To enhance the effect,

Baciccia used emphatic foreshortening, projecting the figures as they would appear from below. Off-center is a golden aureole with the letters *IHS*, a Greek abbreviation for the name Jesus. The subject is the Last Judgment; the jubilant Elect rise toward the name of God, while the Damned plunge toward the floor of the nave. This theatrical inclusion of the actual space of the church into the overall composition effectively involves the viewer's emotions, while the sweeping movement and nearly total unity of visual effect have never been surpassed.

FRANCE

In the seventeenth century, France experienced a tumultuous political period, rife with foreign and civil wars, that may have contributed to the centralization of power in the monarchy, first under Louis XIII (ruled 1610–1643), through the agency of the unscrupulous Cardinal Richelieu, and later under Louis XIV (ruled 1643–1715), the Sun King. Not only did Louis XIV contrive to concentrate the political power at his court away from the nobility, but he also expanded royal patronage in the arts, making the French court the envy of Europe, with projects such as Versailles. As part of the royal sumptuary policy and in order to bring the arts as well under the king's control, Cardinal Richelieu founded the first national academy in 1648, the Royal Academy of Painting and Sculpture. The powerful, at times dictatorial, position of the Academy was to last well into the nineteenth century. Almost every artist aspired to membership in the Academy, which assured royal and civic commissions. However, many talented artists managed to enjoy success outside the regimentation of the royal institution.

French Baroque painting was very much influenced by Italian art, both by the classicism of the Carracci school as well as by Caravaggio's evocative effects of light. Many French artists spent at least some time in Italy during their training; others, like Claude Gellée (known as Claude Lorrain) and

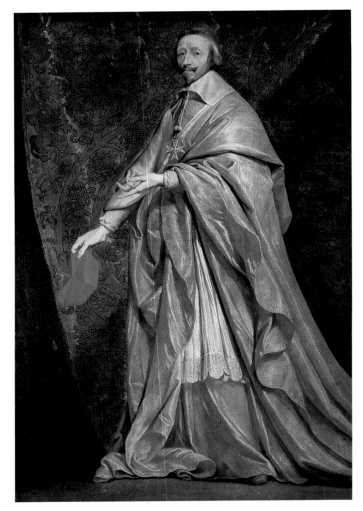

PHILIPPE DE CHAMPAIGNE. *Cardinal Richelieu.* c. 1635–40. Oil on canvas. 100 1/2 x 87 1/2 in. (225 x 222.5 cm). Musée du Louvre, Paris.

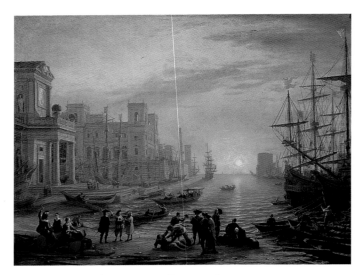

CLAUDE GELLÉE, CALLED CLAUDE LORRAIN. *Seaport at Sunset.* 1639. Oil on canvas. 40 1/2 x 54 in. (103 x 137 cm). Musée du Louvre, Paris.

Nicolas Poussin, spent most of their artistic careers in Italy, in particular in Rome. Claude became a painter of poetic landscapes, his specialty being harbor scenes such as *Seaport at Sunset*. He was mainly interested in rendering the effects of light, and frequently painted scenes with sunsets or sunrises. Small figures animate his canvases, providing a narrative that often evokes the pastoral serenity of a time long gone. Nicolas Poussin also painted landscapes with small figures, as well as historical subjects. His preoccupation with order and balance places him in the classical current of the French Baroque.

Georges de La Tour (1593–1652), one of Caravaggio's most important followers, became court painter to Louis XIII in 1639. In *Joseph the Carpenter*, La Tour fills the foreground with monumental figures, but the intense light source within the picture is the real subject of the painting. The artist probably studied Caravaggio's handling of light from Netherlandish artists in Utrecht, home to a flourishing school of Caravaggists.

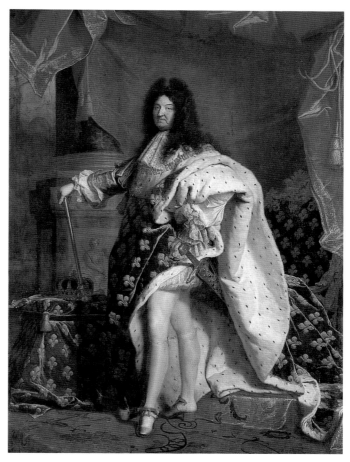

HYACINTHE RIGAUD. *Louis XIV.* 1701. Oil on canvas. 109 7/8 x 94 1/2 in.(279 x 240 cm). Musée du Louvre, Paris.

A poetic stillness and timelessness pervade the works of the Le Nain brothers, Antoine (c. 1588–1648), Louis (c. 1593–1648), and Mathieu (c. 1607–1677). Not much is known about their lives; perhaps because they painted out of a common Paris workshop for a time, their individual traits have come to light only recently. They specialized in images of modest farm families, often placed in enigmatic settings, as seen in Louis Le Nain's *Peasant Family in Interior.*

Two of the leading artists in the second half of the century were Charles Lebrun (1619–1690) and Hyacinthe Rigaud (1659–1743), whose portrait of Louis XIV is a magnificent depiction of the king in his official robe of state, an icon of his absolute monarchy. Lebrun, who became court painter to Louis XIV, was responsible for decorating the Small Gallery in the Louvre and much of Versailles. Although faithful to the classicism of Poussin, with whom he studied in Rome, Lebrun's works are rather flamboyant and grandiosely ornamental.

FLANDERS

Born in Westphalia (in modern-day Germany), Peter Paul Rubens (1577–1640) rapidly became the most prominent artist of Flanders, after several years spent studying the masters in every major Italian city. Like Albrecht Dürer one hundred years before, Rubens combined the artistic achievements of northern and southern Europe, and his influence helped to make the Baroque style truly international.

In Mantua, he was offered a post at the Gonzaga court that provided him with a regular income

while granting him the freedom to accept other commissions, as long as they did not interfere with the duke's demands. Rubens served the court in various capacities; not only did he copy many master paintings in various Italian cities for the ducal gallery, but he was also employed as an emissary to Madrid. Rubens spent two longer periods in Rome, where he studied the works of Roman antiquity and the Italian Renaissance, as well as the works of his contemporaries. In 1609, after eight years in Mantua, Rubens settled in Antwerp, where he accepted commissions from the Habsburg governors of Flanders.

Rubens combined the drama and intense emotion that he had learned from Caravaggio's paintings with the virtuoso technique of Annibale Carracci's frescoes, creating an almost monumental expressive style. Heroic figures, light effects, sweeping movements, and rich colors became the hallmarks of his work. Both the Catholic Church and secular rulers were among his clientele, while his intelligence and courtly manners qualified him to be a diplomat to the courts of Spain and England.

In 1621, Marie de Médicis, regent for her son Louis XIII, commissioned a series of twenty-one paintings dedicated to the history of her life and political career. *The Debarkation of Marie de Médicis at Marseilles* is an example of Rubens's opulent and sensitive style, which was sought after throughout Europe. While the subject of the landing in Marseilles is hardly exciting in itself, Rubens turned the scene into a grand and significant spectacle by adding the figure of Fate and other allegorical personages.

The large number of Rubens's works could only have been produced with the considerable help of studio assistants, some of whom, such as Anthony van Dyck (1599–1641), became outstanding artists in their own right. A child prodigy, Van Dyck became Rubens's principal assistant before he was twenty. Less inventive than his master, Van Dyck earned his fame mainly by creating splendid likenesses such as the *Portrait of Charles I Hunting*, in which the English monarch stands at his ease beside his horse, attended by a groom. Van Dyck's aristocratic manner continued to be fashionable well into the eighteenth century, particularly in England, where he lived from 1632 until his death in 1641.

Another artist who worked for Rubens, albeit in a more specialized field, was Jan Brueghel (1568–1625), son of Pieter Brueghel the Elder. Jan was highly respected as a flower and landscape painter and collaborated on a number of paintings in Rubens's studio. In a series on the five senses, we see interiors filled with an encyclopedic display of beautiful items, including works of art. The paintings in *Sight,* for example, are renderings of actual pictures, many of which have been identified.

THE NETHERLANDS

While Rubens and Van Dyck dominated artistic production in Flanders, its neighbor to the north was supporting a multitude of masters and styles. Local art schools flourished in many Dutch cities, including Amsterdam, Leiden, Delft, and Utrecht. The triumph of the Reformation in the Netherlands influenced both the subject matter of art and the economic situation of the artists. The Protestant injunction against "idols" in churches—a latter-day and more sober iconoclasm—meant that artists, supported in this by a new art-buying class, looked to the world around them for subjects and themes. By the same token, the banishment of the Catholic Church meant the loss of a substantial and consistent patron of the arts; in those countries where the Church's influence was negligible or non-existent, artists now depended upon private commissions. Art thus became a commodity subject to the laws of supply and demand, with demand, in turn, following economic trends in a small number of industries. In order

to hedge against the uncertainties of "the market," many artists also worked in other professions, as innkeepers, brewers, and tradesmen.

The most important Netherlandish painter—and one of the greatest artists of all times—was Rembrandt Harmensz. van Rijn (1606–1669). Born in Leiden to a miller and his wife, he began to study painting with a local artist at age fourteen. Influenced by Dutch Caravaggists and by the works of Caravaggio he saw in reproductions, Rembrandt adopted the same sharply lit and intensely realistic style, although he never traveled to Italy. After further studies in Amsterdam, Rembrandt's reputation as a painter of religious pictures, especially scenes from the Old Testament, quickly secured him a successful career. Rembrandt also painted mythological subjects and landscapes, and was proficient in drawing and printmaking as well, but his main source of income was portraiture. Highly prolific and popular, he ran a large workshop with many pupils who imitated their master's style; even today the attribution of numerous works remains a matter of debate among scholars. His *Anatomy Lesson of Dr. Tulp*, painted in Amsterdam in 1632, is an unusual subject for a group portrait that combines psychological insight and vitality. Throughout his life Rembrandt produced numerous self-portraits; in *The Artist and His Wife Saskia*, he celebrated his personal and professional success with a grand gesture of pride and self-assurance.

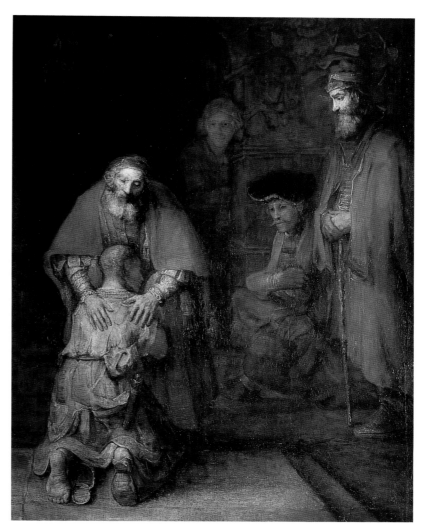

REMBRANDT. HARMENSZ. VAN RIJN. *Return of the Prodigal Son*. 1668–69. Oil on canvas. 103 x 80 3/4 in. (262 x 205 cm). Hermitage, St. Petersburg.

JAN DAVIDSZ. DE HEEM. *Dessert. Still-Life*. 1640. Oil on canvas. Musée du Louvre, Paris.

During the 1640s, Rembrandt's growing interest in portraying the inner life and character of his sitters would distinguish his mature period; Rembrandt himself once wrote that he aimed at depicting "the greatest inner emotions."

After his wife, Saskia van Uylenburgh, died in 1642, Rembrandt lived with his mistress, Hendrickje Stoffels, and their two children. Increasingly isolated, Rembrandt painted more and more for himself. His clientele was unimpressed by the shift in his style, and his popularity began to fade. In 1656 Rembrandt declared bankruptcy, and his house and effects were sold at auction in the following years. Hendrickje's death in 1663 and that of his son, Titus, in 1668 were the tragedies of Rembrandt's last years that may have inspired the intuitive understanding Rembrandt demonstrated in his *Return of the Prodigal Son* and his last self-portraits.

The new Dutch middle class, the bourgeoisie, demanded to see the comfortable reality of their achievements reflected in paintings. Today, these works are invaluable records about these people and how they lived. Two such images of contemporary life reflecting the Calvinist virtues of modesty and restraint are the *Dutch Family*, by Pieter de Hooch (1629–1684), and *A Family Dinner,* by Jan Steen (1626–1679). The enigmatic figure of Jan Vermeer (1632–1675) in Delft has attracted attention since his "rediscovery" at the end of the nineteenth century. Very little is known about him, though he was probably an innkeeper in his hometown, which he apparently never left. His renderings of the interiors and courtyards of the homes of his fellow citizens convey a sense of intimacy and great charm.

The new patrons of art were prosperous and devout merchants, bankers, and entrepreneurs. They wanted art with moral content, such as the biblical scenes that made Rembrandt's fortune, or the still lifes rich in allegorical content—usually variants on the vanity of life—in which the northern European painters excelled. These artists produced innumerable works in which flowers, fruit, and the homely objects of everyday use seem to glow with meaning from within.

SPAIN

Caravaggio's most accomplished follower was Jusepe de Ribera (1591–1652), who lived most of his life in Spanish-ruled Naples, sending many of his paintings to patrons in Spain. In his *Boy with a Clubfoot*, Ribera's naturalism is similar to Caravaggio's, but with a lighter palette. Psychologically distant from Caravaggio's moody, complex characterizations, the handicapped beggar boy emanates a strong sense of self-confidence and vitality, reinforced by the inscription on the paper in his hand: "Give me alms, for the love of God."

The greatest Spanish painter of the Caravaggesque school, however, was Diego Velázquez (1599–1660). Born in Seville, he moved

JUSEPE DE RIBERA. *Boy with a Clubfoot.* 1642–52 (?). Oil on canvas. 64 1/2 x 36 1/4 in. (164 x 92 cm). Musée du Louvre, Paris.

FRANCISCO DE ZURBARÁN. *Still-life with Cup and Vases.* c. 1633. Oil on canvas.
18 x 33 in. (46 x 84 cm). Prado, Madrid.

in 1623 to Madrid, where he became court painter under the young king Philip IV, producing numerous portraits of the members of the royal household. His most celebrated work, *Las Meninas (The Maids of Honor)*, painted toward the end of his career, includes the viewer in the pictorial space as do Caravaggio's works. Standing where the king and queen should be, given their reflections in the mirror in the back, the viewer faces the five-year-old Infanta Margarita, who is accompanied by her attendants and a dog. At the left, the artist depicted himself in the act of painting the scene—a self-portrait in which he placed himself within the royal circle.

Francisco de Zurbarán's (1598–1664) career is closely linked to the monastic orders that commissioned many of his paintings. His subjects are often of an extreme austerity, taken almost to abstraction, as in his *Saint Isabel of Portugal*. Besides his paintings with religious imagery, Zurbarán also created still lifes of timeless silence.

ROCOCO

With the death of the Sun King, Louis XIV, in France in 1715, a reaction against the excessive—and tyrannical—splendors and pomp of Versailles set in. A new style, known as Rococo, began to emerge. The word probably comes from the French *rocaille*, "rock work," or "grotto work," referring to the shells and scrolls that often decorate works in this manner. The word was first used as artists' studio argot to designate the taste under Louis XV, mainly in connection with interior design and decoration, but art historians apply the term to other areas of the fine arts as well. It covers roughly the period between 1710 and 1740 or 1750, after which Rococo began to be superseded by Neoclassicism, a new reinterpretation of the antique. The Rococo style developed most fully in France, Germany, and Austria, while artists in other countries continued to work more within the Baroque tradition.

FRANÇOIS BOUCHER. *Madame de Pompadour.* 1758.
Oil on canvas. 20 1/2 x 22 3/4 in. (52.4 x 57.8 cm). Victoria and Albert Museum, London.

Rococo's characteristic prettiness, gaiety, and lightness come to life in Jean-Antoine Watteau's (1684–1721) festive and lyrical *Pilgrimage to Cythera*, which celebrates amorous pleasures with reference to a Greek island dedicated by the ancients to Aphrodite, the goddess of Love. The paintings of François Boucher (1703–1770), whose portrait of Madame de Pompadour—mistress of Louis XV and tastemaker of his epoch—epitomizes the elegance and refinement of the French court, are often highly decorative, but in some instances also convey an emergent sense of privacy and individuality. Jean-Baptiste-Honoré Fragonard (1732–1806) displayed the gallant, even rakish, and occasionally sentimental version of Rococo, in *The Bolt*. The work of Jean-Siméon Chardin (1699–1779) is quite different from the courtly manner; still lifes and quiet domestic scenes, which are often painted on a small scale, dominate his oeuvre.

In England, the painter and engraver William Hogarth (1697–1764) took to Rococo more thematically than stylistically; his popular series of marriage scenes satirized contemporary social customs. In Italy the Rococo was largely ignored, with a few exceptions, such as the Venetian artist Rosalba Carriera (1675–1757), who is best known for her numerous portraits executed in pastels, worked in a delicate style and with an air of spontaneity in the French fashion.

By the eighteenth century, the Baroque intention to elicit emotion was evolving into a more modulated and intimate expression, conveyed in subject matter brought down to earth from the grand allegories of the previous century, and with subtly handled color. Two Italian artists whose works display these thematic and technical concerns are Giovanni Antonio Canal, known as Canaletto (1697–1768), who painted meticulous topographical renderings of Venice, and Francesco Guardi (1712–1793), whose atmospheric views of that city are executed with freely handled paint. Most of their works entered the collections of well-to-do tourists as souvenirs, thereby influencing fellow artists throughout Europe.

opposite:

MICHELANGELO MERISI DA CARAVAGGIO. *Conversion of Saint Paul.* c. 1601. Oil on canvas. 90 1/2 x 68 7/8 in. (230 x 175 cm). Santa Maria del Popolo, Rome.

After a first version of the subject had been rejected by the commissioning family, Caravaggio painted an entirely different composition. On his way to Damascus, Saint Paul experienced a heavenly vision, invisible to his companions, which threw him off his horse. In an unprecedented step, Caravaggio placed the horse's behind at the center while the saint is lying in the foreground with his arms raised. A dramatic light illuminates the scene.

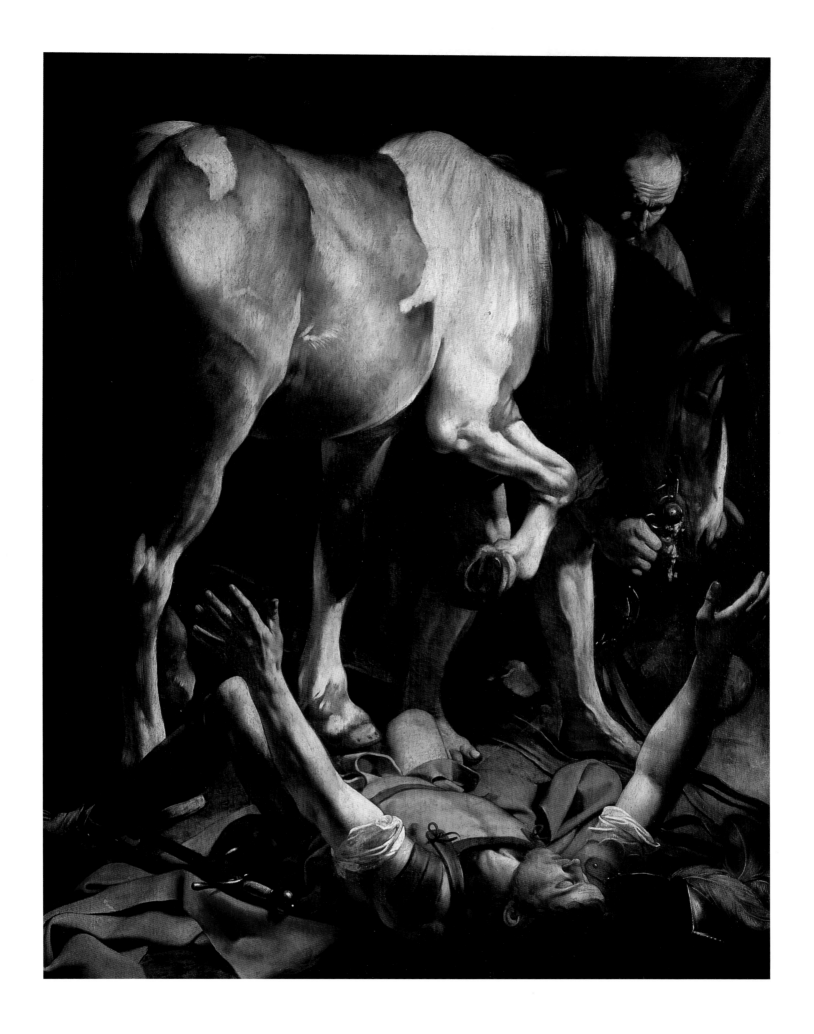

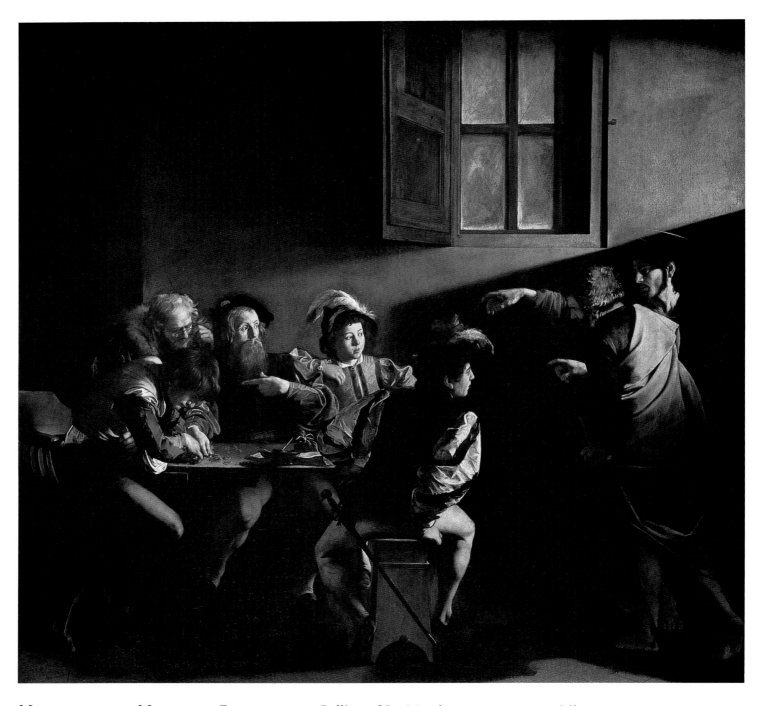

Michelangelo Merisi da Caravaggio. *Calling of St. Matthew.* c. 1597–1601. Oil on canvas. 133 x 136 in. (340 x 350 cm). Contarelli Chapel, San Luigi dei Francesi, Rome.

This scene depicts the story of Jesus calling the Roman tax collector Matthew to join him and his Apostles. Seated at the table and surrounded by well-dressed young men in plumed hats and satin shirts, Matthew is counting gold coins. Almost hidden behind another figure at the right, the haggard-faced Jesus points with a dramatic gesture at Matthew who responds surprised by pointing at himself. A light source which must be imagined coming from the upper right divides the scene sharply into brightly lit areas and dark shadows.

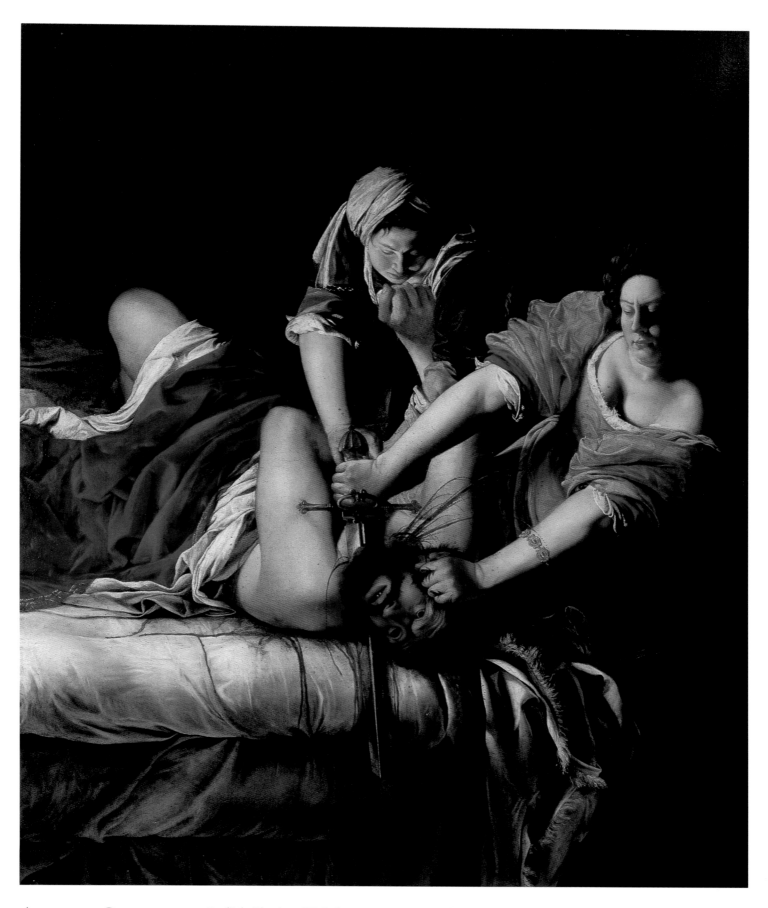

ARTEMISIA GENTILESCHI. *Judith Slaying Holofernes*. c. 1620. Oil on canvas.
78 3/8 x 64 in. (199 x 163 cm). Galleria degli Uffizi, Florence.

One of the few successful women artists of her time, Artemisia Gentileschi studied and worked first under her father Orazio, a follower of Caravaggio in Rome. After having been raped in her youth by one of her father's assistants, Artemisia returned repeatedly to the biblical subject of Judith and her enemy, Holofernes. The harsh realism of the present scene is underscored by the bold light effects.

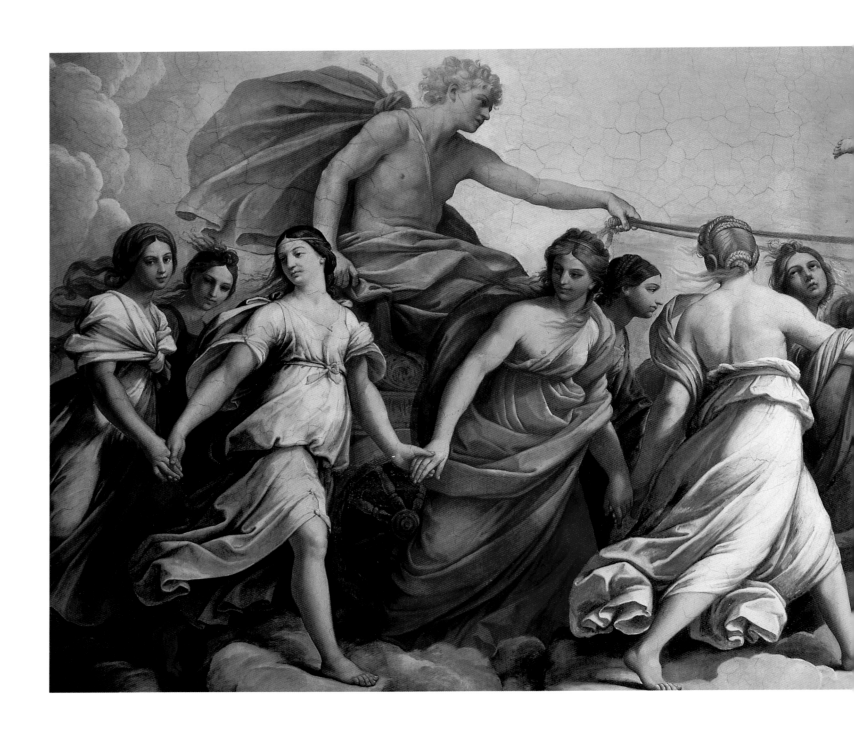

GUIDO RENI. *Aurora*. 1613. Ceiling fresco in the Casino Rospigliosi, Rome.

Apollo is seen on his sun chariot accompanied by Cupid and the Seasons, while Aurora, the goddess of dawn, is leading the way. In this ceiling decoration of a garden house at a palace in Rome, Reni achieved a balanced harmony with this frieze-like procession of figures which seem to have been derived from an antique relief. The intense, warm colors and the lyrical tenderness of the scene are, however, Reni's own.

PIETRO BERRETTINI,
CALLED PIETRO DA
CORTONA. *Triumph of the
Barberini*. 1633–39.
Ceiling fresco in the Salone,
Palazzo Barberini, Rome.

The largest and most impressive of all Italian Baroque ceilings, the fresco was commissioned by the Barberini family of Pope Urban VIII to decorate the audience hall of their palace in Rome. An elaborate allegory celebrates the virtues of the papal family. Below the center of the vault, Divine Providence is pointing toward three giant bees surrounded by a laurel wreath, which are Barberini emblems. Other allegorical figures, including Faith, Hope, and Charity, crowd this highly illusionistic ceiling, which is framed by painted architecture.

opposite:

DOMENICO ZAMPIERI, CALLED DOMENICHINO. *The Last Communion of St. Jerome*. 1614.
Oil on canvas. 165 x 101 in. (419 x 256.5 cm). Pinacoteca, Vatican.

Saint Jerome, one of the four Church fathers, receives his last communion. His emaciated body is a reference to his ascetic life in the desert. The lion next to him is one of his traditional attributes. A pupil of Annibale Carracci, Domenichino carefully arranged his composition in a boldly accentuated fashion. The open arch leads the viewer's eyes into the distance.

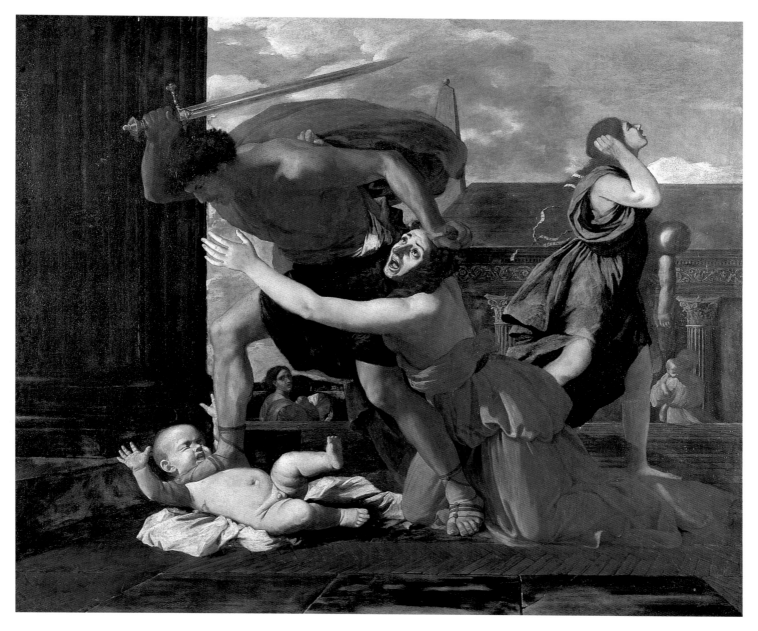

NICOLAS POUSSIN. *Massacre of the Innocents*. c. 1628–29. Oil on canvas.
57 7/8 x 67 1/4 in. (147 x 171 cm). Musée Condé, Chantilly, France.

The biblical subject of the Massacre of the Innocents is depicted in what is perhaps Poussin's most dramatic composition, in which the artist filled the foreground of the canvas with large figures engaged in grand gestures and dramatic expressions.

opposite:

GIOVANNI BATTISTA GAULLI, CALLED BACICCIA. *Triumph of the Name of Jesus*. 1676–79.
Ceiling fresco in Il Gesù, Rome.

In an unprecedented scheme that unifies architecture, sculpture, and painting, Baciccia created the illusion of an opening in the church's vault with clouds and angels floating down into the actual nave. Projected as if seen from below, the figures are engaged in the adoration of the letters IHS, a Greek abbreviation for "Jesus." The subject is the Last Judgment, with the Elect rising toward the name of God, while the Damned are plummeting through the ceiling toward the nave floor, thus appealing to the viewer's emotions.

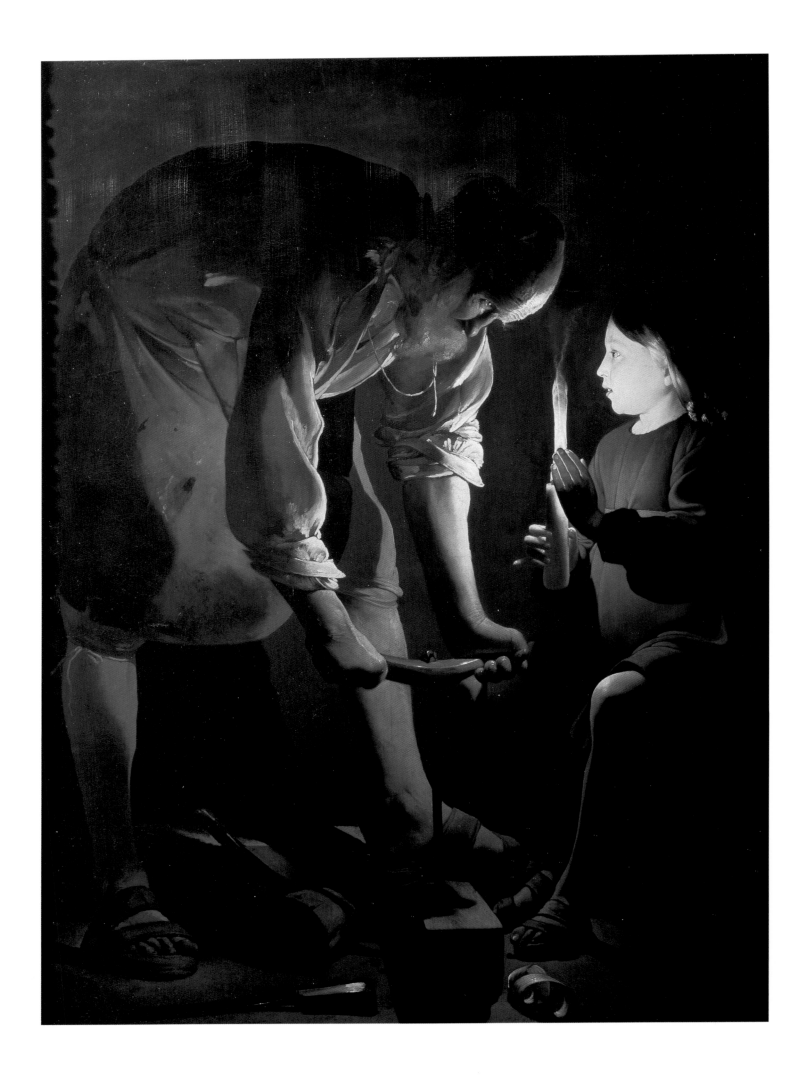

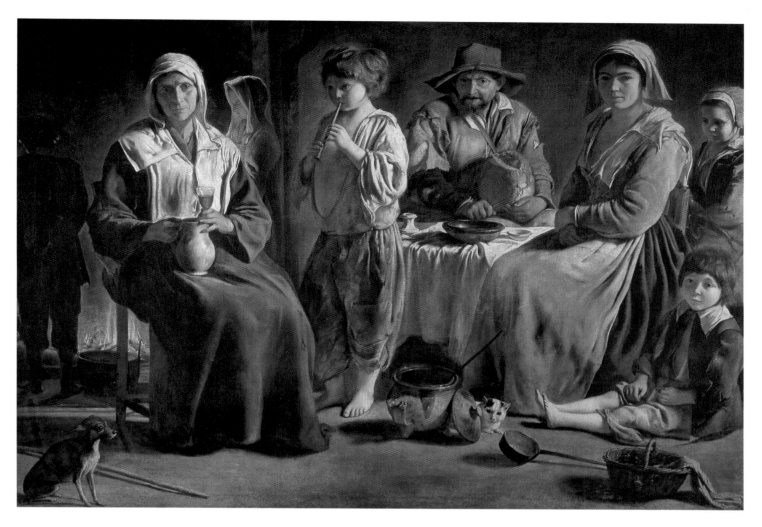

LOUIS LE NAIN. *Peasant Family in Interior*. c. 1640. Oil on canvas.
44 1/2 x 62 1/2 in. (113 x 159 cm). Musée du Louvre, Paris.

Louis Le Nain, one of three brothers known for their genre scenes of mainly poor peasants, here presents us such a family with an ennobling sense of grace and respect. However, the simple, undefined setting turns the painting into a study in neutral colors and rough textures, with contrasting faces of old and young people who appear to be absorbed in a self-contained environment.

opposite:

GEORGES DE LA TOUR. *Joseph the Carpenter*. c. 1645. Oil on canvas.
38 1/2 x 25 1/2 in. (97.8 x 64.8 cm). Musée du Louvre, Paris.

Influenced by Caravaggio's use of light and shadow, Georges de La Tour frequently exploited the effects of candlelight or torches in his night scenes. Here, the Christ Child holds a candle protecting the flame with his hand, which appears to be almost diaphanous. His father Joseph, bending over a piece of wood, fills almost the entire canvas, creating a sense of immediacy. The allusion to Christ as the Light of the World would have been immediately understood by the artist's contemporaries.

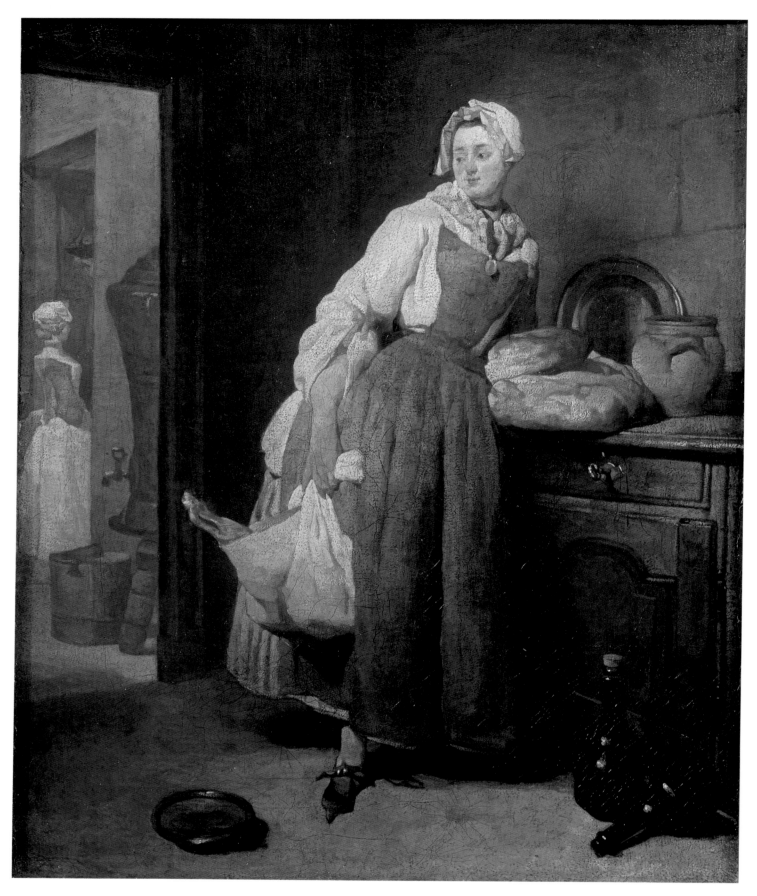

Jean-Baptiste-Siméon Chardin. *Back from the Market.* 1739. Oil on canvas.
18 1/2 x 14 3/4 in. (47 x 37.5 cm). Musée du Louvre, Paris.

Not only in his still lifes, but also in his genre paintings the artist proved to have an uncomplicated directness of vision without sentimentality or affectation. A woman has returned from the market with her purchases—two large rounds of bread and a chicken whose legs are sticking out of her shopping purse. Her body is curved in a slight swing, while her attention is caught by the conversation of a young girl, possibly her daughter, and a man whose head is barely peeking in through the door in the background.

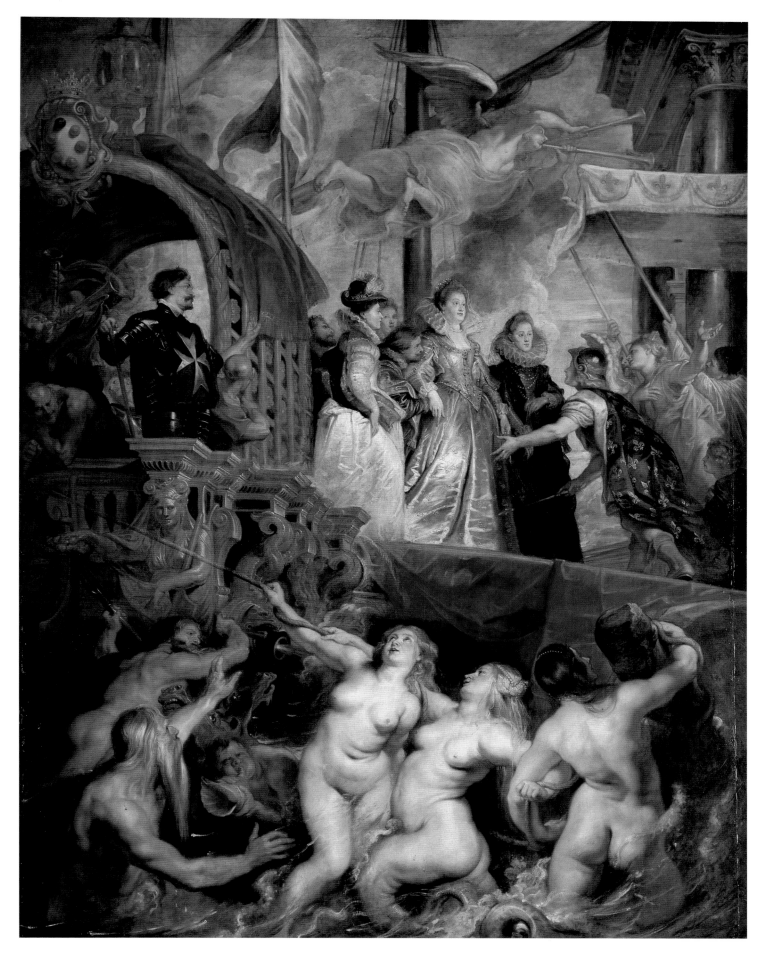

Peter Paul Rubens. *The Debarkation of Marie de Médici at Marseilles.* c. 1621–25. Oil on canvas. 155 x 116 in. (394 x 295 cm). Musée du Louvre, Paris.

Upon her arrival in Marseilles, Marie de Médici, future wife to Henri IV, is welcomed by a personification of France and announced by the figure of Fame hovering above her and blowing the trumpets.

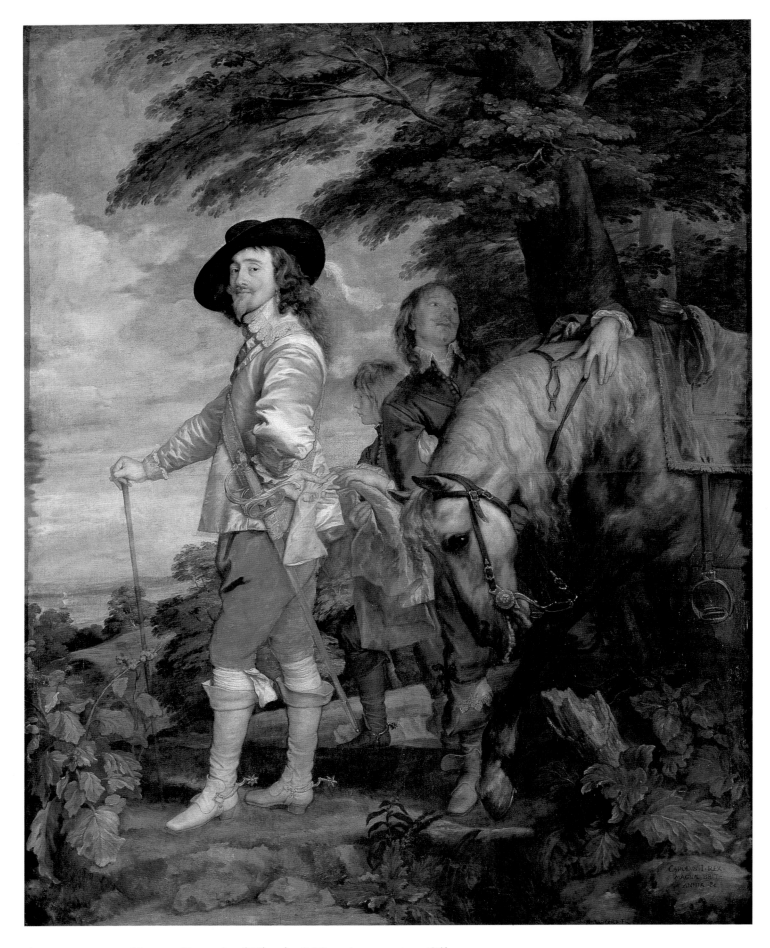

ANTHONY VAN DYCK. *Portrait of Charles I Hunting.* c. 1635. Oil on canvas.
107 x 83 1/2 in. (271.8 x 212 cm). Musée du Louvre, Paris.

Van Dyck was most successful as a portrait painter, in particular in England, where he settled from 1632 until the
end of his life. Here, King Charles I is seen standing at ease next to his horse while two grooms are attending
the animal. The self-conscious elegance of the monarch's pose is contrasted by the fluid movement of the settings.

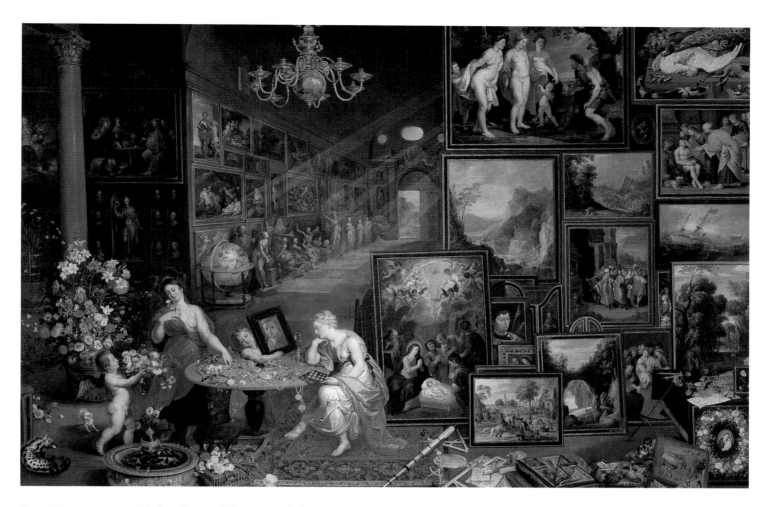

Jan Brueghel. *Sight,* from *Allegories of the Five Senses.* c. 1617–18. Oil on panel.
69 1/4 x 103 15/16 in. (176 x 264 cm). Prado, Madrid.

Part of a series of five paintings illustrating the senses, Jan Brueghel, also known as "Velvet" Brueghel, presents here a dazzling view into a collector's cabinet full of paintings and other works of art. Flower still lifes like the one to the left were his specialty. The figures might have been painted by Rubens, with whom he collaborated occasionally. The precision of execution and the overwhelming wealth of the numerous objects make this work a feast for the eye and a delectable pastime.

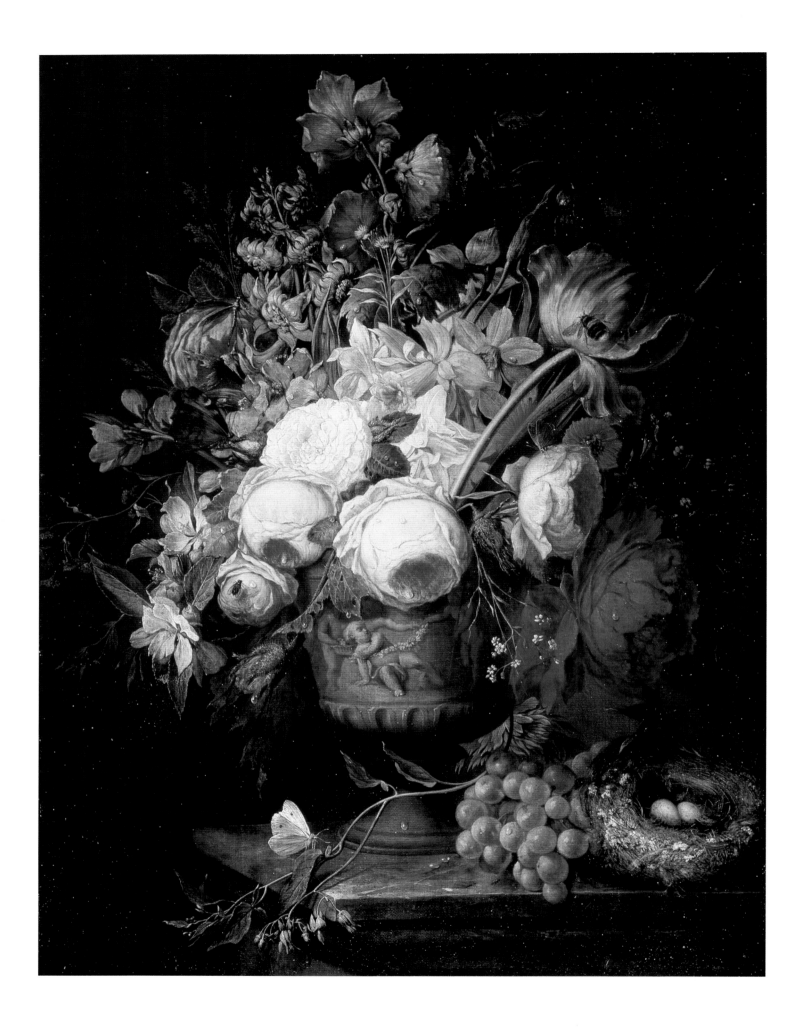

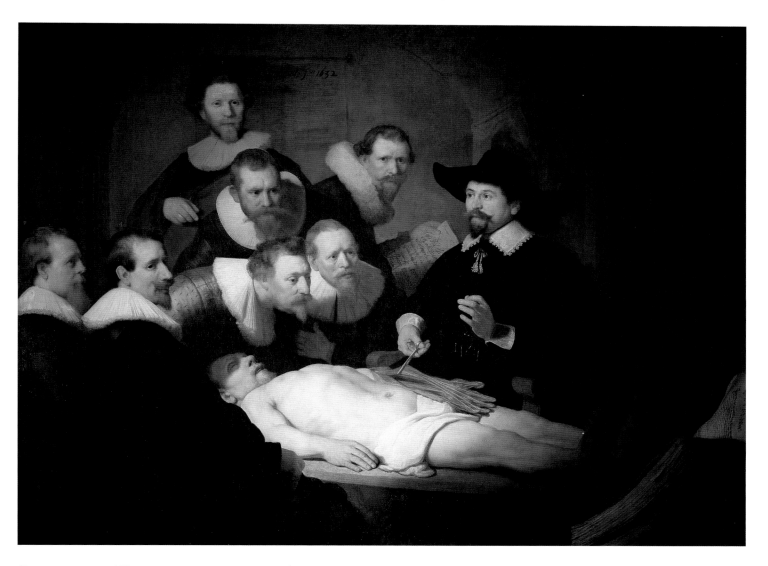

REMBRANDT. HARMENSZ. VAN RIJN. *The Anatomy Lesson of Dr. Tulp.* 1632. Oil on canvas.
67 x 85 1/2 in. (170 x 217 cm). Mauritshuis, The Hague.

The first professor to hold the chair of anatomy at the university at Amsterdam was Dr. Nicolaes Tulp, who in this painting is demonstrating to surgeons the physiology of the arm and the muscles that move the fingers. The name of his assistants have been recorded in the sketchbook held by the man just behind Dr. Tulp. Although the artist was quite precise in his rendering of the body, it is unlikely that Rembrandt attended any actual anatomic sessions.

opposite:

JAN VAN HUYSUM. *Still-life with Flowers and Birds Nest.* 1722. Oil on canvas.
31 x 23 1/2 in. (79 x 60 cm). Hermitage, St. Petersburg.

Considered by his contemporaries "the phoenix of all flower painters," Van Huysum enjoys an even wider popularity today. His flower still lifes are characterized by elegance and a calligraphic sweep. Saturated blues and vivid greens predominate in his canvases, which often have a highly finished, enamel-smooth surface. Van Huysum insisted upon working out the details of his paintings from nature.

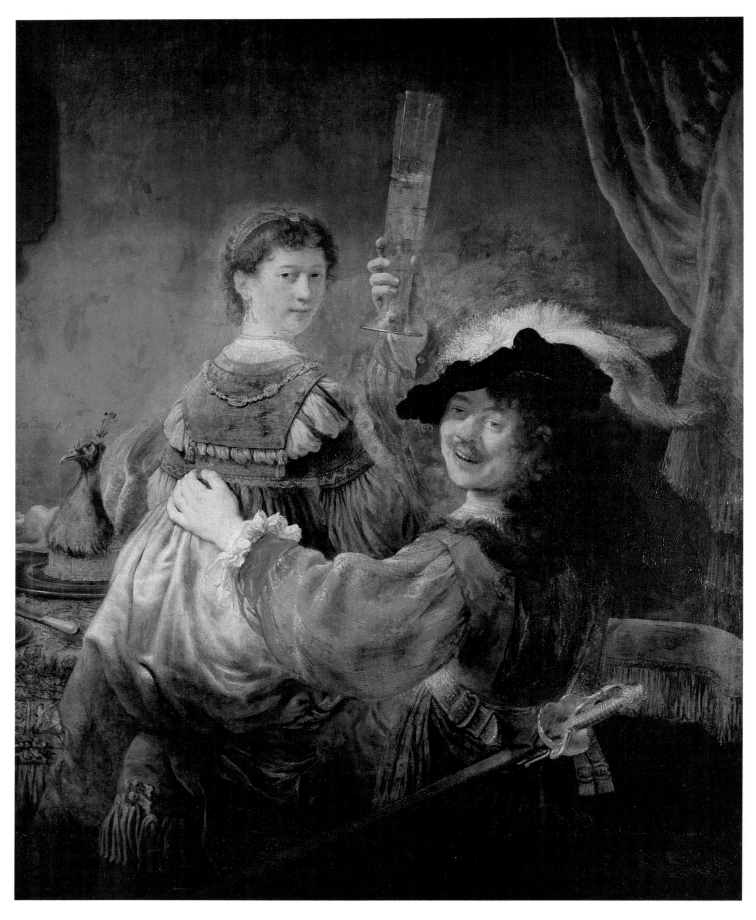

REMBRANDT. HARMENSZ. VAN RIJN. *The Artist and His Wife Saskia*. 1635–36. Oil on canvas.
63 3/8 x 51 1/2 in. (161 x 131 cm). Staatliche Kunstsammlungen, Alte Meister, Dresden.

At times also identified as "The Prodigal Son in a Tavern," the subject of this exuberant painting represents a happy moment in the artist's life. Husband and wife are turned toward the spectator with an animated expression of gaiety. While the setting is luxurious and elegant, the colors are delicate and restrained. Saskia remained Rembrandt's favorite model until her death in 1642.

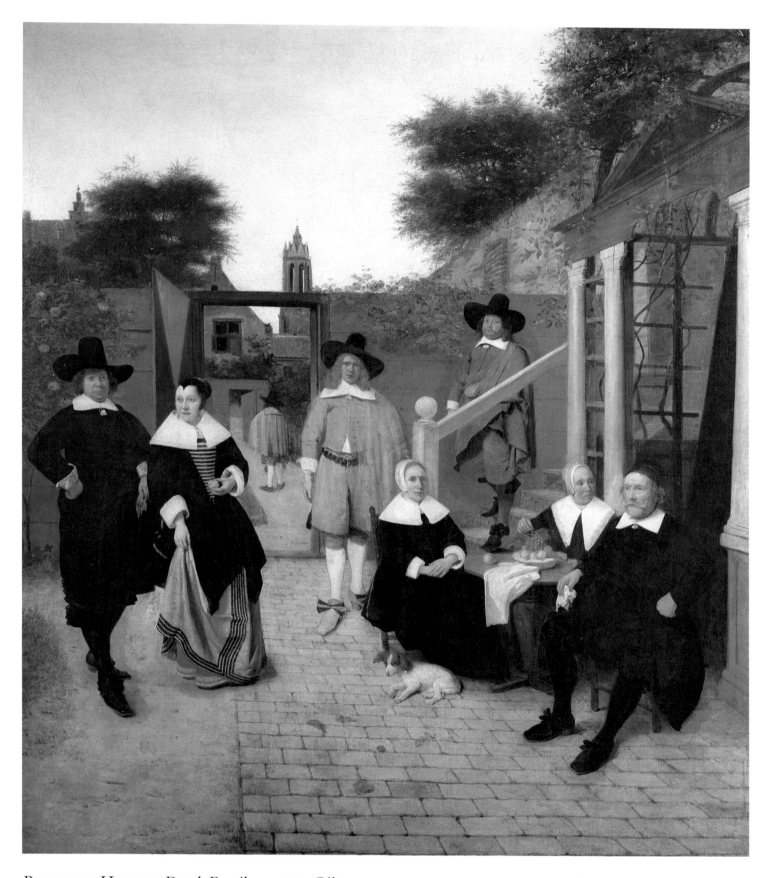

PIETER DE HOOCH. *Dutch Family.* c. 1662. Oil on canvas.
45 x 38 in. (114 x 97 cm). Akademie der Bildenden Kuenste, Vienna.

De Hooch specialized in indoor and garden scenes and views of courtyards, evoking the peace and quiet of Dutch domestic scenes of the 17th century. Seven adult members of a family have gathered in this neatly kept courtyard, where they seem to be solemnly posing for the painter. De Hooch's device of opening the vista through open gates into the distant street provides depth and thus links the family with their city.

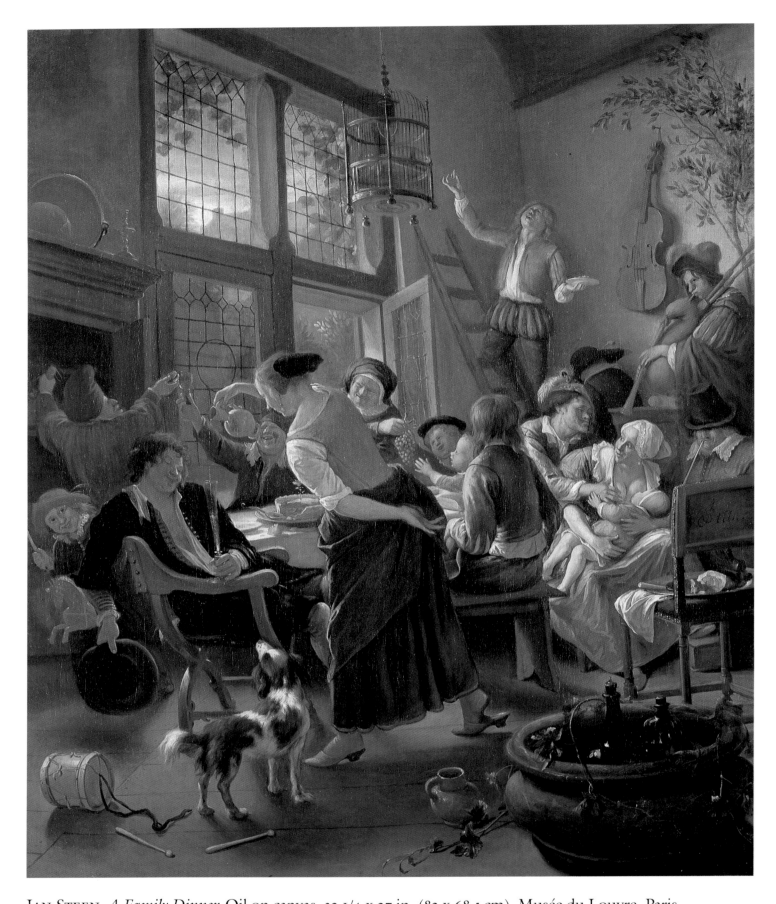

JAN STEEN. *A Family Dinner.* Oil on canvas. 32 1/4 x 27 in. (82 x 68.5 cm). Musée du Louvre, Paris.

In the Netherlands, a "Jan Steen household" has become an epithet for an untidy house. This scene of a crowded family dinner contains a variety of activities, from eating and drinking to a mother breastfeeding her child, and even a bagpiper. Everybody seems to be frolicking and enjoying themselves. Avoiding regularity in his composition, Steen indulged in diagonals, zigzags, and oblique accents to suggest movement and animation.

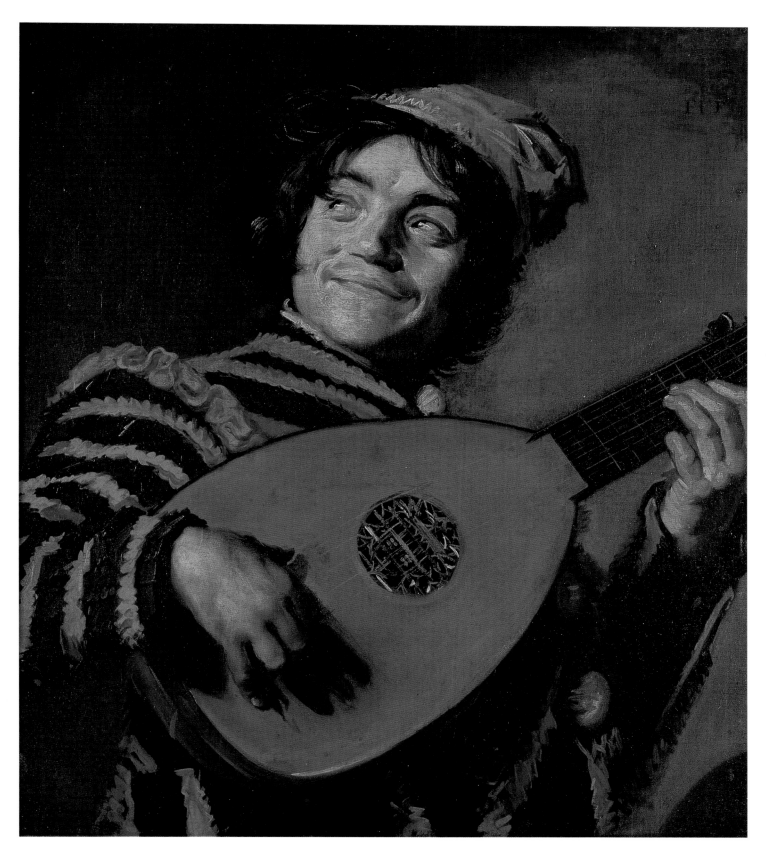

FRANS HALS. *The Clown with the Lute.* 1625. Oil on wood.
28 x 24 1/2 in. (71 x 62 cm). Musée du Louvre, Paris.

Frans Hals is best known as a portraitist who imbued his paintings with a new immediacy and liveliness. In
the face of this clown, who seems to invite us to join him in his merry music-making, the free, bold brushwork
expresses an extraordinary vitality and gaiety.

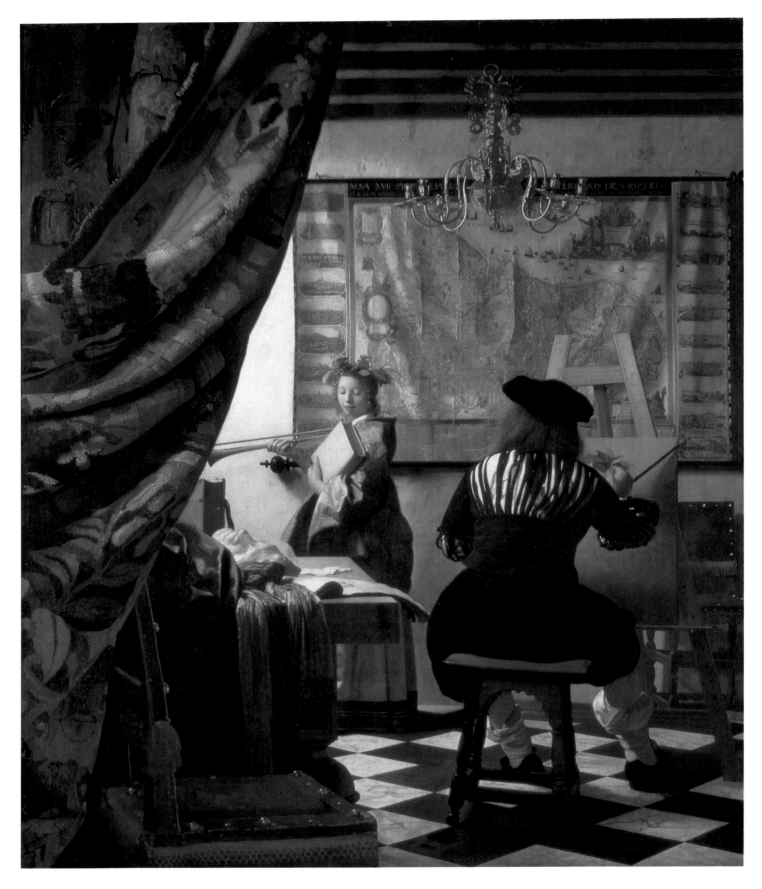

JAN VERMEER. *The Painter and His Model as Klio (The Art of Painting)*. c. 1666–67. Oil on canvas. 47 1/4 x 39 3/8 in. (120 x 100 cm). Kunsthistorisches Museum, Vienna.

One of Vermeer's greatest achievements, this canvas shows a rear view of the artist (perhaps Vermeer himself?) in front of his easel while painting Klio, the muse of history. On the wall of this luminous studio hangs a geographic map, a regular motif in Vermeer's paintings that attests to his wide range of interest. The curtain on the left has been pulled aside, thus allowing the viewer a glimpse into the world of an artist at work.

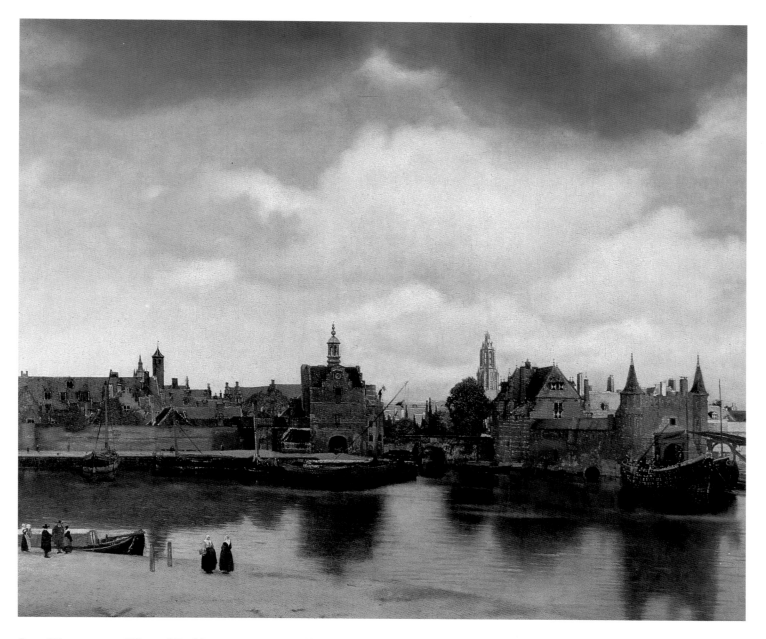

JAN VERMEER. *View of Delft*. c. 1660–61. Oil on canvas.
38 x 45 9/16 in. (96.5 x 115.7 cm). Mauritshuis, The Hague.

Jan Vermeer appears to have spent his entire life in his hometown of Delft, which he depicted in this extraordinary view seen from across a harbor. Dark clouds overshadow the sky and the foreground, leading the viewer's eyes into the sunlit interior of the city. The expressive manner of Vermeer's execution varies throughout the painting; he treats sand, brick, the rough stone of a bridge, or the rippling of the roof tiles each with different brushwork, thus achieving a mood that conveys something of the history and character of the city.

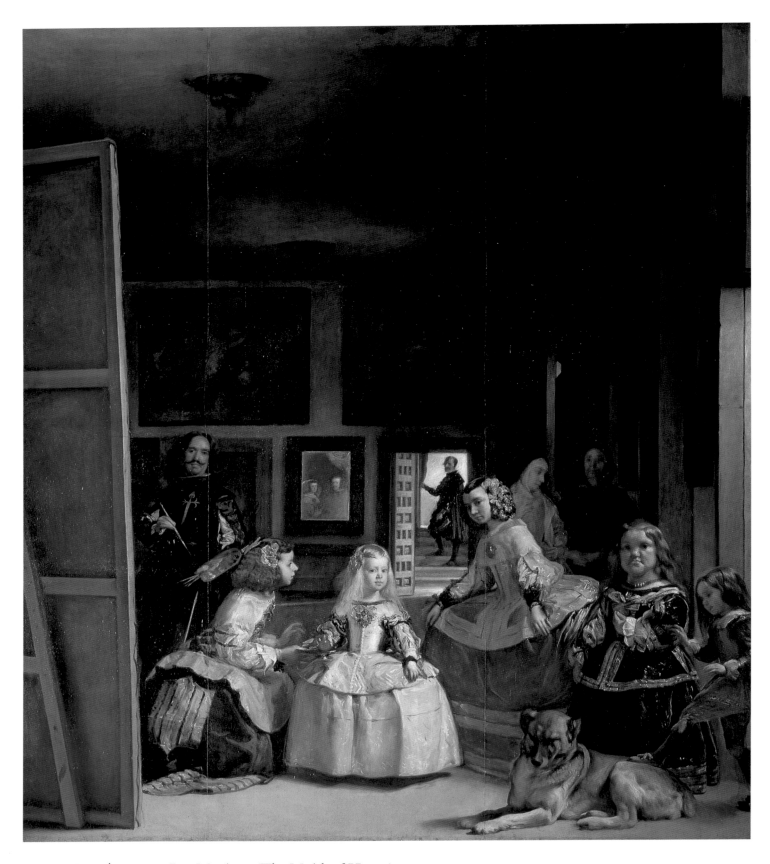

Diego Velázquez. *Las Meninas (The Maids of Honor)*. 1656.
Oil on canvas. 127 x 108 1/2 in. (323 x 276 cm). Prado, Madrid.

In this famous portrait of the five-year-old Infanta (Princess) Margarita and her attendants, the viewer is drawn directly into the scene as he stands in the space occupied by King Philip and his queen, whose heads are reflected in the mirror in the background. The artist himself is shown holding his palette in front of the easel as if he were painting the royal couple. However, one might also interpret the scene as a visit of the royal couple to the artist's studio just as he is taking a break from painting the Infanta.

FRANCISCO DE ZURBARÁN. *Saint Isabel of Portugal.* 1640. Oil on canvas. 72 1/2 x 35 1/2 in. (184 x 90 cm). Prado, Madrid.

Zurbarán was a master of a serene yet profound realism which he express-ed in monumen-tal forms of sculp-turesque quality. His most characteristic works are of single figures of monks and saints in meditation or prayer. Here, Zurbarán focused his attention on the rich dress of the saint who is holding a garland of flowers as her attribute. Set against a dark, neutral background, the woman's cool gaze faces the viewer without any emotional expression.

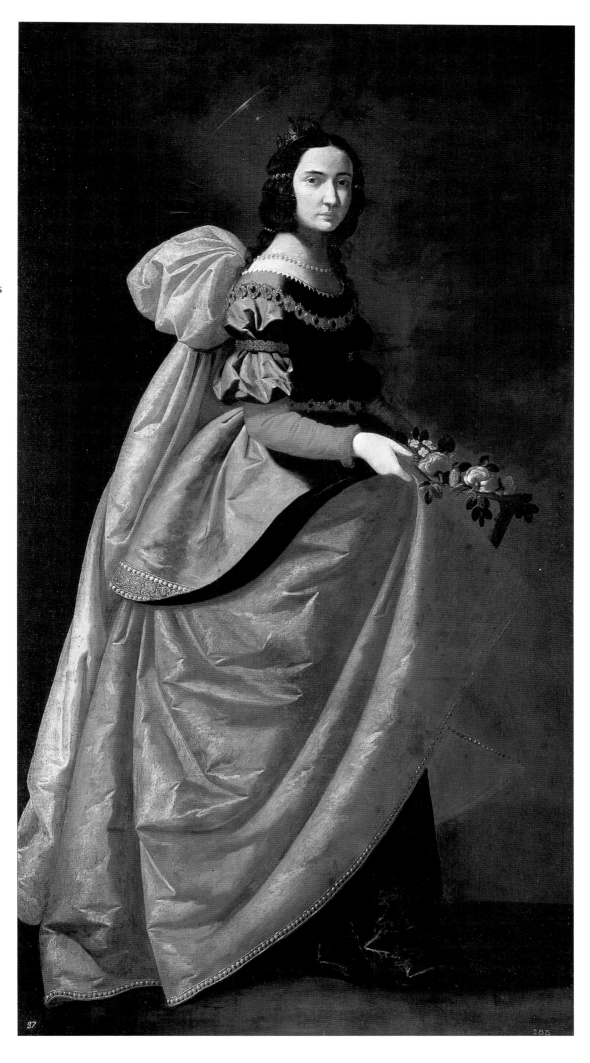

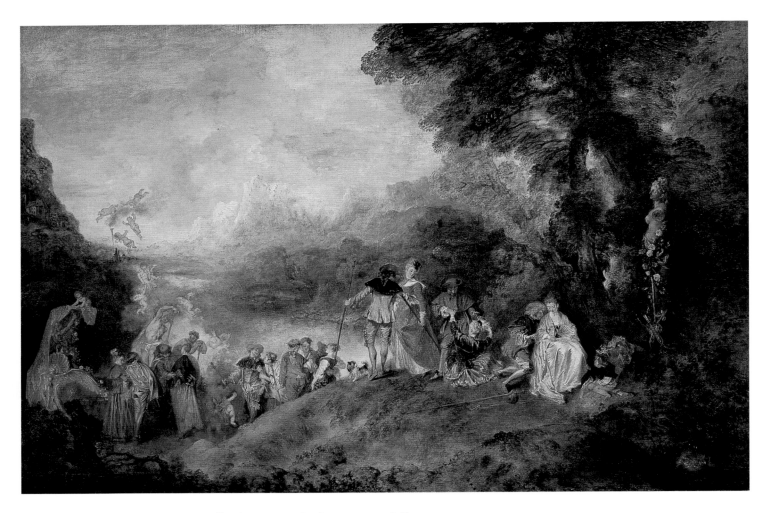

JEAN-ANTOINE WATTEAU. *Pilgrimage to Cythera*. 1717. Oil on canvas.
51 x 74 7/8 in. (130 x 190 cm). Musée du Louvre, Paris.

This scene depicts the moment in which three young couples engaged in amorous conversations under the statue of a Venus without arms are preparing for their departure either from or to the mythical island of Cythera, which is reigned by the God of Love. At the left, a boat under the guidance of putti is awaiting them. Painted as his entry piece to the French Academy, the new style and subject matter of this work provided Watteau with the title of a painter of the "fêtes galantes."

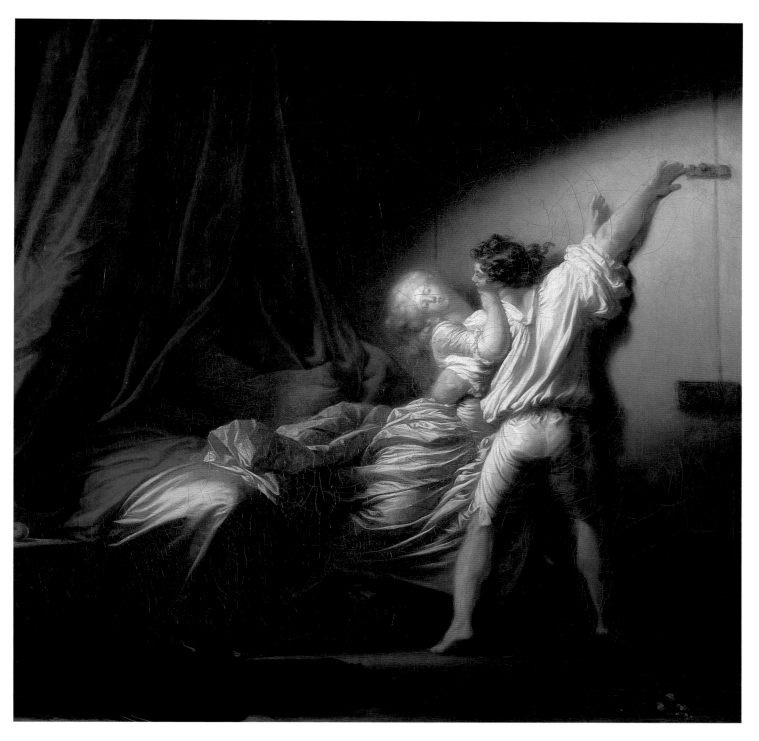

JEAN-HONORÉ FRAGONARD. *The Bolt*. c. 1778. Oil on canvas.
28 1/2 x 36 1/2 in. (73 x 93 cm). Musée du Louvre, Paris.

The title to this work comes from a small detail—the bolt with which the young man is about to lock the door of the woman's bedroom. Dressed in short pants and a white shirt, the lover intends to seduce the woman, who tries in vain to stop him. With fearful, supplicating eyes and a gesture of despair, she attempts to push away the invader, but it is clear that her battle is already lost.

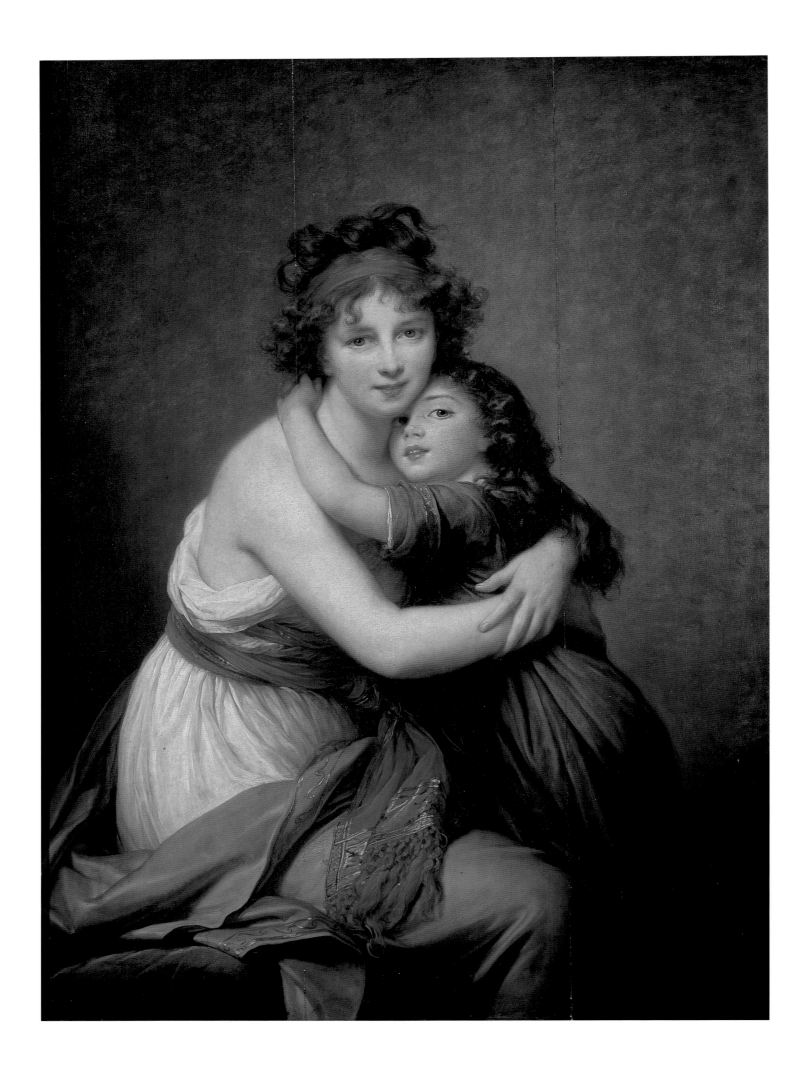

WILLIAM HOGARTH. *Mariage à la Mode: After the Wedding*. 1742–44. Oil on canvas.
27 x 35 in. (68.5 x 89 cm). The National Gallery, London.

Hogarth's comments on the social and moral content of contemporary society were often disguised as biting satire. His series of six paintings illustrating the "Mariage à la mode" were also issued as highly popular prints. Here, the artist envisions the effects of boredom and litigation in the immediate aftermath of the couple's wedding. The bridegroom appears to be already disillusioned about his new situation, while the woman is obviously ready for another strike.

opposite:

MARIE LOUISE ELIZABETH VIGÉE-LEBRUN. *The Artist and Her Daughter*. c. 1785. Oil on canvas.
51 1/6 x 37 1/12 in. (130 x 95 cm). Musée du Louvre, Paris.

A highly successful woman artist, Vigée-Lebrun is widely known for her portraits of Queen Marie-Antoinette, whom she is said to have painted twenty-five times, as well as for her self-portraits. At the outbreak of the French Revolution she left France to travel throughout Europe, where she painted numerous members of the aristocracy, before returning to Paris in 1805. Her most widely known painting is this charming self-portrait with her daughter, which was also distributed as a steel engraving.

GIOVANNI ANTONIO CANAL, CALLED CANALETTO. *The Pier, Seen from the Basin of San Marco.*
c. 1730–35. Oil on canvas. 21 x 28 in. (53.5 x 71 cm). Pinacoteca di Brera, Milan.

Canaletto specialized in topographically precise renderings of his native Venice. Painted with a smooth brush and often high keys, his works were particularly sought after by English travelers who, not unlike modern tourists, enjoyed bringing a memory of this famous city back to their families. The pier with the façade of the Palazzo Ducale in front of San Marco was certainly one of the most popular motifs and appears several times among Canaletto's works.

GIOVANNI BATTISTA TIEPOLO. *America*. 1753. Detail of the ceiling fresco
in the staircase of the Episcopal Residence, Wuerzburg.

Giovanni Battista Tiepolo was the most brilliant and sought-after Italian painter of his time; his skills as an Italian
decorative fresco painter are unsurpassed. At the peak of his career, he was called to Wuerzburg by the Prince
Archbishop to decorate the residence there. On the ceiling above the grand staircase of the palace, Tiepolo painted
an allegory of the four continents, combining architecture and painting into one vast and airy composition.

The
Nineteenth Century

Realism and Revolution

THE NINETEENTH CENTURY was a period of changes in painting as swift and deep as those in the social and political spheres throughout the world. Revolutions, in the United States and France especially, marked the beginning of the modern age as the end of the eighteenth century coincided with the end of traditional social orders that had lasted for centuries. In their place, we find economic, social, and political concerns that continue to define our own age—the meaning of equality, individual and collective responsibility, and the legitimacy of despotic or disproportional regimes.

Mechanical and other technical explorations, with roots in the Renaissance and Enlightenment, launched new modes of transportation, printing, agricultural management, and military operations, which transacted with political, social, and economic transformations. The nineteenth century, as befits an era of such profound changes, was a violent time. France in particular experienced two bloody revolutions after that of 1789, but radical upheavals were sweeping the New World as well as the Old.

All this change had a great impact on the artists of the time. Aside from stylistic development from one generation to the next within the century, some artists, whose longevity allowed them to experience several eras within their own lifetimes, adapted their manners, as well as their political views, to the new circumstances in which they found themselves. Many artists, now able to travel with greater ease, looked increasingly to exotic locales—North Africa and the Middle East particularly—for inspiration.

NEOCLASSICISM

In the last quarter of the eighteenth century, the eternal questions of the relationship of the individual to society exploded into revolution on both sides of the Atlantic. These cataclysmic events, inspired by Enlightenment ideals of rational discourse, secular government, and the importance of the citizen-

JEAN-AUGUSTE-DOMINIQUE INGRES. *The Valpinçon Bather*. 1808. Oil on canvas. 56 1/2 x 38 1/4 in. (143.5 x 97.1 cm). Musée du Louvre, Paris.

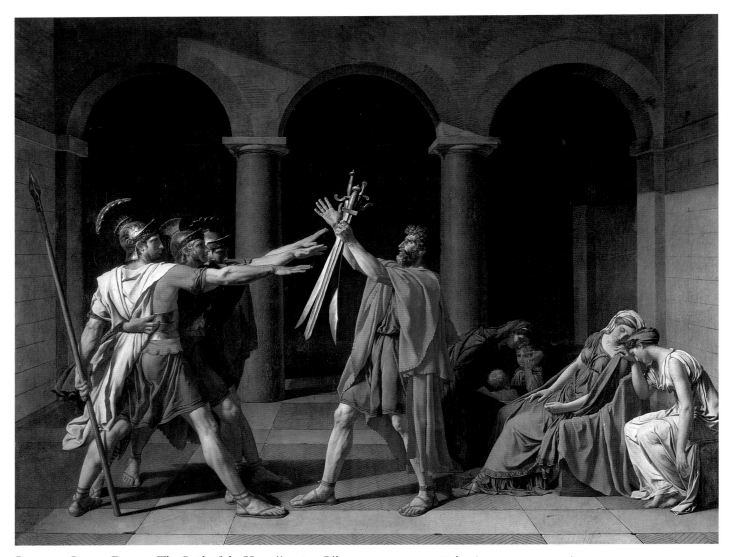

JACQUES-LOUIS DAVID. *The Oath of the Horatii.* 1784. Oil on canvas. 130 x 168 in. (330.2 x 426.7 cm). Musée du Louvre, Paris.

individual, all derived from classical writings. One explicit model for the state was Republican Rome, so much so that, for example, Napoleon Bonaparte's initial tenure was called the "First Consulate."

This Neoclassicism was equally manifest throughout the arts, from painting and architecture—think of the Capitol in Washington, D.C.—to furniture and clothing. Whether it expressed as well a reaction to the aristocratic frivolities of the Rococo, or to the bloodshed and chaos of the turn of the century, it was a movement characterized by an almost earnest sobriety, and, stylistically, by monumental and classically proportioned figures, orderly compositions, and subject matter taken from antiquity.

The representative Neoclassical artist of the period may have been Jacques-Louis David (1748–1825), who became, in effect, the official propagandist of the French Revolution. David's training was steeped in the Rococo until he went to Rome in 1775, where contact with ancient models opened a new world for him. *The Oath of the Horatii* was his first major painting in the new style, and marked a revolution of its own. The subject is based on ancient sources, by way of a seventeenth-century tragedy by Pierre Corneille (1606–1684): The Horatius brothers must defend Rome against the Curiatius brothers. The calamity of war is heightened by the intermarriage between the two families: the wife of one Horatius is a Curiatius, and one of the Horatius sisters is betrothed to a Curiatius. David's picture depicts the three Horatii pledging their allegiance to Rome and vowing to defend the city or die. In a seething political climate, such fervor must have resonated deep as a prelude to revolution.

The composition is laid out in a shallow, stage-like space, in front of a classical arcade. There are three distinct figural groups: the brothers, their father, and the women. The brothers' postures emphatically articulate the ardor with which they will undertake their honorable mission; they are thematically related to the figure of their father by similar attitudes as well as form. These two groups are in essence one unit, for in a moment the father will hand over the swords and his sons will go into battle. This unity is further emphasized by the proximity of the male figures to one another, and their distance from the grieving women on the right, who are as distinct in their emotional experience as they are physically separated. Where the men are angular, rigid, and active, the women are soft, rounded, emotional, and helpless. By preserving traditional gender roles, David manages to express, through the women's affect, the tragedy of war. Conventionally, this accentuates the nobility of the men, but we may wonder if, consciously or not, the artist has projected the men's unnamed feelings onto those at liberty to manifest them. David's painting supports his theme in its severity and luminous clarity. Here, rational order prevails, extending to the lighting and color, as well as to the composition, leaving only the essentials to convey the heroic narrative.

David, who would later paint Napoleon many times in heroic grandeur, was an associate of Robespierre and the Terrorist faction, which he served by ennobling the martyrs of the Revolution. The *Death of Marat*, painted shortly after Marat's death, is a monument to the murdered revolutionary, rendered majestic by the pose of the figure—not unlike a dead Christ—the dramatic lighting, and the somber tone. Again, the absolutely lucid composition seems to bespeak the artist's uncompromising adherence to both means and end. David was a major influence on his contemporaries, especially Jean-Auguste-Dominique Ingres (1780–1867). Ingres, a pupil of David, thoroughly absorbed his teacher's Neoclassicism, as well as Renaissance painting, thanks to a sojourn in Rome. His cool palette and tight, almost indiscernible brushwork are a far cry from the extravagant painterly excesses of the earlier Baroque manner.

His *Apotheosis of Homer* gratefully acknowledges his debt to Raphael, in what is a frank homage to the Renaissance artist's *School of Athens*. The poet of the *Iliad* and the *Odyssey* sits enthroned at the top of a stair in front of an ancient temple, flanked by humanist luminaries from the classical age, along with their creative heirs. The Roman poet Virgil (70–19 B.C.) is there with his fellow-poet Dante (1265–1321), whom he guided through the latter's *Divine Comedy*. Ingres presents, from the Golden Age of Greece, another poet, Pindar; the sculptor Phidias; and the painter, Apelles; and from the Golden Age of the Sun King, Louis XIV, the painter Nicolas

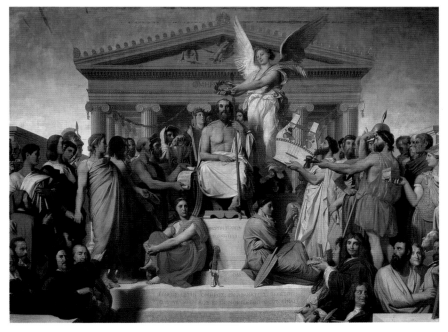

JEAN-AUGUSTE-DOMINIQUE INGRES. *Apotheosis of Homer*. 1827. 152 x 201 1/2 in. (386 x 511.8 cm). Musée du Louvre, Paris.

Poussin, revered by the Neoclassical artists, and the playwright Jean Racine. Featured, of course, is Raphael himself. The monumental figures, their postures, and the rather fancifully antique costumes are visibly filtered through the Renaissance manner and David's style.

Different from David's work, however, is the balance of the composition which is compromised by the artist's handling of the crowd; the figures are orderly, but rigidly disposed in somewhat awkward, uneasy groupings, with a dispassionate remove. The figural groups seem not to be connected emotionally at all, and despite the rather theatrical trappings of classicism, such as costume and setting, the whole lacks the majestic, overarching quality that is the hallmark of the great Neoclassic works. Indeed, one reading of the picture describes it as a struggle between the ideals of classicism and the upheavals of the modern world, a disquiet expressed analogously, for example, in Mary Shelley's *Frankenstein*, published less than a decade before this picture was painted.

ROMANTICISM

Side by side with Neoclassicism, and in some ways complementary to it, another strain of Enlightenment humanism emerged. Where Neoclassicism portrayed the architecture of a rational society, that is, the relationship between the individual and the collective, Romanticism focused on the individual's interior landscape. This school of thought, articulated in the mid-eighteenth century by the French writer and philosopher Jean-Jacques Rousseau (1712–1778), exalted the "natural man," uncorrupted by a corrupt society. Analogous to this was an appreciation for nature in general, expressed in landscape painting, at a time when the industrial age was already irrevocably looming.

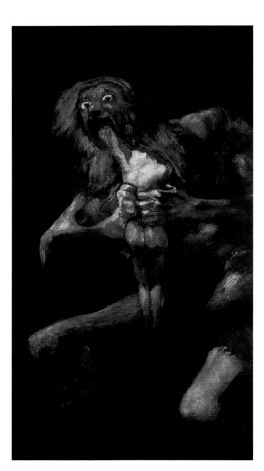

FRANCISCO DE GOYA. *Saturn Devouring His Children.* 1820–23. Mural transferred to canvas. 57 1/8 x 32 5/8 in. (145 x 82.9 cm). Prado, Madrid.

A logical evolution of the Renaissance curiosity about personality, and perhaps a reaction to the overblown, yet formalized emotionalism of the Baroque and Rococo, Romanticism, like Neoclassicism, informed a range of creative endeavors, from the visual arts to music, literature, philosophy, and the study of history. One of the characteristics of Romanticism is the "pathetic fallacy," which ascribes human emotions to inanimate events or objects, such as violent weather, or a storm-tossed sea. A curious spin on Romanticism is that, while Neoclassicism tended toward the secular as an extension of the rational, Romanticism, in its later expressions, turned to the preclassical, the pagan, the sensual exotic.

The concept of the sublime—beauty coupled with awe, nature at its most primal—became a compelling preoccupation. The rational and reasoned gave way to the untamed and irrational. In a Freudian sense, where Neoclassicism reflected the superego, Romanticism manifested the id. One need only look at the late paintings of Francisco de Goya (1746–1828)—

Saturn Devouring His Children (1820–1823), for example—to see mythology come shockingly alive with forbidden psychological truth, or at the works of Caspar David Friedrich (1774–1840) to see a meditation on nature and time.

In France, Théodore Géricault (1791–1824) painted *The Raft of the Medusa,* a quintessentially Romantic painting. The subject itself is the more horrific for being an actual event. The *Medusa* was wrecked on its way to Senegal in 1816, perhaps due to the incompetence of its captain. One hundred forty-nine soldiers and sailors assembled on a makeshift raft that was to be towed to safety by the officers' lifeboats. However, when the officers realized how the weight of the raft slowed their progress, they set the raft adrift in the open sea. Within a short time, the panicked victims began to fight each other. A number were killed or mortally wounded. More horribly, the living fed off the dead, with the stronger summarily executing the weak and dying. Within a week only fifteen survived. These were miraculously rescued by a passing ship.

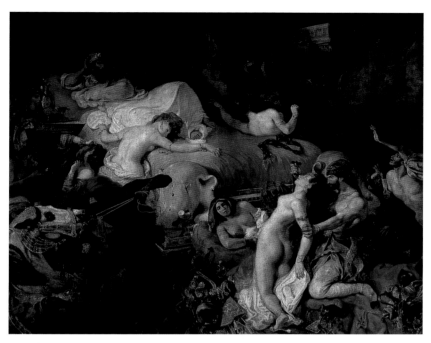

EUGÈNE DELACROIX. *Death of Sardanapalus.* 1827. Oil on canvas. 155 1/2 x 195 in. (395 x 495.3 cm). Musée du Louvre, Paris.

In a monumental composition on a huge canvas, Géricault has depicted the moment in which the rescuing ship is first spotted. With a shrewd and skilled combination of dramatic but sanitized subject matter, theatrical lighting, expressive composition, and masterful handling of the male nude, Géricault delivers the plight of the castaways on a storm-tossed sea to a heroic conclusion at a high emotional pitch. Seeing the raft, in essence, from behind, we share the survivors' point of view, their hope of salvation barely visible on the horizon. Will the ship indeed come to their rescue? The emotional swell of hope translates, in the composition, into a surging, slightly off-center pyramid, as those able to summon the strength make their presence known to the boat in the distance; those in the foreground, either languishing or introspective, do not yet realize what has occurred. The surviving figures look surprisingly healthy after close to two weeks adrift under the tropical sun, with no food save their fellows; Géricault knew well enough that he could not depict realistically the horrors of the actual events and still exhibit the painting. Nevertheless, he made many studies of severed limbs and other gruesome details in preparation for the finished picture.

Eugène Delacroix (1798–1863) succeeded Géricault, who died young, as the next great French Romantic painter. Himself a very emotional, even passionate man—a romantic, one might say—Delacroix's paintings are often characterized by themes of violence or other extreme situations. He used color and brushstroke to great effect to raise the emotional key of his compositions. In 1832, a trip to North Africa made a profound impression on him, providing his fertile imagination with subject matter for the rest of his life.

His *Death of Sardanapalus* (painted in 1827, just before his North African sojourn) is a vivid orgy of

JOHN CONSTABLE. *View of Salisbury Cathedral.* 1823. Oil on canvas. 34 1/2 x 44 in. (87.6 x 111.8 cm). Victoria and Albert Museum, London.

mayhem in a sumptuously exotic setting. The story, which Delacroix knew from a play by the arch-Romantic George Gordon, Lord Byron, tells of the Assyrian king Sardanapalus, who, upon hearing that his enemies were at the door of his palace, commanded that all his possessions—including wives, slaves, and horses—be destroyed before his eyes, as he himself would be destroyed soon thereafter.

The composition swirls around Sardanapalus, and is anchored by him, a figure of stoic detachment at one end of the maelstrom. The great diagonal sweep of red bed and red carpet from lower right to upper left not only moves the eye to the stable figure of Sardanapalus, but lures us into collusion, as we imagine the bloodshed that Delacroix has only implied. Red, the color of blood and royalty, enhances the lushness, for, despite the chaos, the picture is ripe with sensuous luxury, from the trappings of the horse in the lower left, to the jewels and carpets littering the room. There is nary a straight line to be found; typically with Delacroix there is no stasis and very little repose. The whole is a far cry indeed from the cool formalism of David or Ingres.

In England, particularly, the earliest industrial nation, tamed nature increasingly became the main subject for painters. Two very different but celebrated practitioners were John Constable (1776–1837) and Joseph Mallord William Turner (1775–1851). Constable's vision of nature is nostalgic rather than turbulent, a portrait rather than an occasion or metaphor for human emotion. Here is order—by man and God. At the same time, it is highly personal, an effect achieved because of the artist's familiarity with the settings, which are almost all in and around his home county of East Anglia. Constable conveyed mood through effects of light and shade, and meteorological massings of clouds, all closely observed and accurately rendered.

Turner's vision of nature is also meteorological, but more in the Romantic mode. His interpretation of the sublime takes the shape of extreme effects of natural forces—wind, rain, fire—rather than the more traditional and bucolic view in Constable's ordered landscape. Turner expresses this natural power through a bold use of color and brushstroke, which give a potent sensory impression of the atmospheric conditions of his subjects. The painting *Rain, Steam, and Speed—The Great Western Railway* adds a new dimension, the equation of an inexorable mechanized age with nature. The speeding train moves menacingly through the landscape—nearly mowing down a rabbit in its path—just as the unstoppable machine of the industrial age will invade the rustic quiet of the countryside.

REALISM

This French-born movement had no more vocal proponent than Gustave Courbet (1819–1877), born in the mountainous Jura region, on the French-Swiss border. Courbet spent a great deal of time paint-

GUSTAVE COURBET. *The Stonebreakers.* 1849. Oil on canvas. 63 x 99 in. (160 x 251.5 cm).
Formerly Germaldegalerie, Dresden (destroyed in World War II).

ing pictures of village and country life, particularly that of his home village, Ornans, which provided him with abundant subject matter. Imbued with an energetic sense of social justice, he championed the working and peasant classes and served a six-month prison sentence, allegedly for destroying the column of the Place Vendôme in a political action. He felt strongly that his paintings should reflect his views as well; his *Stonebreakers*, painted during and in the aftermath of one of the century's most turbulent years, is one such picture.

The picture caused an outcry when it was exhibited. Never before had a painting of common laborers been given such monumental treatment or such an unflinching portrayal (the picture was destroyed in World War II; we know it only in reproduction). The figures are set in a shallow space as they go about their task. They are anonymous drones, toiling, it seems, without respite. The old man at right, Courbet wrote, is "an old machine grown stiff with service and age," and indeed we see this in his awkward pose and the obvious difficulty he has in wielding the mallet. The younger man, on the left, is on the road to the same fate, his back already bowed with strain. Their clothes are torn. Their meager life is captured for exactly what it is: futile, relentless, back-breaking, providing only enough to allow the stonebreakers to work another day. In their anonymity, they become universal symbols; the painting ennobles their drudgery, a reminder to the newly empowered bourgeois of the dehumanizing effects of a brutal class system.

Courbet's formal sources for this and other works were not the masterpieces of the history of art (though in the *Stonebreakers* there is a nod to the heroic figural tradition) but rather popular prints and broadsheets. Widely circulated, these prints were decidedly not the domain of the elite nor even of the bourgeoisie, and the artist's references to them may be seen as a conscious refusal to participate in the traditional academic heritage.

Even though the Romantic and Realist movements flourished, they were, in a sense, marginal. The mainstream of painting in France and England was represented by the Academy, which arose in seventeenth-century France, supported by royal patronage. David, a member of the post-Revolutionary National Convention, abolished the elitist Royal Academy, but its principles survived. Academy artists were schooled in drawing from plaster casts of ancient and Renaissance statuary, as well as from live models, in order to achieve accurate and highly finished depictions of idealized human figures with postures and attitudes based on classical prototypes. Themes were often taken from mythology and were meant to delight, not instruct or inspire. Many academic painters found a wealthy clientele ready to make them exceedingly popular and rich.

Adolphe-William Bouguereau (1825–1905) was the most successful painter in France toward the end of the century, and though his art still finds an audience today, the critical reception of his work has changed over time. Bouguereau began his career with typically Romantic scenes of extreme emotional situations of suffering and death, but as public taste evolved, his paintings came to reflect bourgeois Victorian sentimentalism. He himself said, "I soon found that the horrible, the frenzied, the heroic does not pay, and as the public of today prefers Venuses and Cupids and I paint to please the public, so it is to Venus and Cupid that I chiefly devote myself."

The Academy also persisted in spirit, in government-sponsored exhibitions—the Salons—which during the nineteenth century were sometimes juried and sometimes open to all artists. The Salons allowed the public to gain access to a vast display of sanctioned art, thereby establishing official taste, and making or breaking the careers of burgeoning artists. Many of the works discussed earlier, today taken as markers in the history of art, were execrated and ridiculed when exhibited at the Salon, while unchallenging works by a Bouguereau culled the highest accolades.

SIR JOHN EVERETT MILLAIS. *Christ in the House of His Parents.* 1850. Oil on canvas.
33 1/2 x 54 in. (85 x 137.2 cm). The Tate Gallery, London.

In England at mid-century a group of young artists formed what they called the Pre-Raphaelite Brotherhood in reaction to the slick standards of the Royal Academy. The Pre-Raphaelites asserted that painting had been in a decline from the late work of Raphael on, and so they turned to the paintings of the fourteenth and fifteenth centuries for inspiration. The founders of the group were Sir John Everett Millais (1829–1896), who had himself exhibited at the Royal Academy; William Holman Hunt (1827–1910); and Dante Gabriel Rossetti (1828–1882). They soon attracted enthusiastic adherents, including Ford Madox Brown (1821–1893), Rossetti's teacher. Stylistically, all shared a commitment to the simplicity and clear colors of fourteenth- and fifteenth-century Italian art, and to that period's fervent spirituality, which the Brotherhood combined with a sensual, earthy realism that was controversial, even scandalous. The Pre-Raphaelites sought to instill in their paintings an elevated sense of moral import, an indirect rebuke to contemporary British art.

Millais's *Christ in the House of His Parents* and Hunt's *The Awakening Conscience* are typical of the Pre-Raphaelite style. A new palette suffuses each picture with an almost painful brightness, while the figures themselves are depicted with a high degree of realism. In the case of Millais's painting, the family of Christ is represented as an unidealized working-class group; in Hunt's, the figures are the essence of Victorian bourgeoisie. In both works, the specifics of the carpenter's shop or the Victorian parlor are rigorously described.

Christ in the House of His Parents caused a scandal with the public, who thought the figures too mundane and unattractive for such an elevated subject. Charles Dickens was among the most outspoken of the critics, deriding the painting and calling the figure of Mary "hideous in her ugliness." Though the picture is fraught with symbols of Christ's Passion, these are all subsumed into the secular details of a common carpenter's shop, another target of the public's outcry. This painting caused as much uproar in England as Courbet's *Stonebreakers* did at almost the same moment in France.

Hunt's picture shows the moment at which a "kept" woman suddenly awakens to her sinfulness. She rises from the lap of her lover, much to his bewilderment, since he seems to be undergoing no analogous revelation. The sharp illumination of the picture bespeaks the clarity of the woman's recognition of her state, while revealing the accoutrements of a bourgeois interior, as if a curtain were being drawn back to expose the light and in so doing, the subject's fallen condition.

THE UNITED STATES

Artists from and in the United States participated in all stylistic movements of the nineteenth century, in part because the Grand Tour, de rigueur for young gentlemen, was even more so for young artists who brought back with them the lessons they had learned in Europe. However, if there were many stylistic exchanges between Europe and the United States, circumstances unique to the American situation, most notably Westward expansion—the notion of the frontier—provided new themes for artists trained in Europe.

For this reason, the landscape genre in particular took a unique turn in the United States in the nineteenth century. There was so much land, and so much of it was just being explored. This landscape of such varied richness—its amber waves of grain, purple mountains' majesty, vanishing indigenous peoples—inspired artists such as Asher B. Durand (1796–1886), Thomas Cole (1801–1848), Frederick Church

THOMAS MORAN. *Cliffs of the Upper Colorado River, Wyoming Territory.* 1893. Oil on canvas. 16 x 24 in. (40.6 x 61 cm). National Museum of American Art, Washington, D.C.

FREDERICK EDWIN CHURCH. *Aurora Borealis.* 1865. Oil on canvas. 56 1/8 x 83 1/2 in. (142.6 x 213 cm). National Museum of American Art, Washington, D.C.

(1826–1900), and Albert Bierstadt (1830–1902).

Cole was the first of the great North American landscapists. Born in England, he came to the United States in 1819, already an accomplished portrait painter, and began to paint the countryside, with great success. His views of nature are inscribed with a reverent wonder, of a kind often reserved for religious subjects. He wrote, "The whole of nature is a metaphor of the human mind," and with metaphors of light and shadow, geological grandeur and humble human detail, he sought to enlighten and inform. The public may have been more interested in handsome pictures than they were in moralizing landscapes, but Cole succeeded in combining them.

Cole's *Subsiding of the Waters of the Deluge* of 1829 is at first glance a straightforward landscape, but its title implies a grander subject, inviting us to look more closely. As we do so, we find ourselves sheltering from the storm inside a cave or beneath a rocky overhang. From this vantage point we look out on a postcataclysmic world, one that has survived, as we have, only by divine intervention. This is Cole's vision of the world after the Flood, its desolation testament to the awesome power of nature as a tool, or perhaps an aspect, of God. The fragility of human beings in the face of this power is symbolized by the skull at the bottom right of the picture. Within this rather bleak scene, however, is a sign of hope: in the golden glow of the new day, the ark drifts placidly on a lake, and, barely visible at the exact center of the painting, the dove set loose by Noah will soon return with evidence that the waters have indeed subsided.

ALBERT BIERSTADT. *Among the Sierra Nevada Mountains.* 1868. Oil on canvas.
72 x 120 in. (183 x 305 cm). National Museum of American Art, Washington, D.C.

The German-born Albert Bierstadt made his first trip to the West in 1859, where the Rocky Mountains made a vivid and lasting impression on him. He became one of the most popular painters of the Western landscape, returning there several times in the course of his life. *Among the Sierra Nevada Mountains* is painted appropriately large, to accommodate the grandeur of the scene. The view is into a deep, lake-filled bowl in the mountains, just after a storm. The sun breaking through the mist casts a silvery glow over all, illuminating the snow-capped peaks of the Sierra Nevadas. It is a sublime vision of unspoiled landscape, with almost religious overtones. Upon seeing the picture a critic remarked, "It is a perfect type of the American idea of what our scenery ought to be."

Just as the landscape of the West fascinated artists, so did its original inhabitants, and several artists, notably George Catlin (1796–1872), documented the culture of Native Americans, even as that culture was being destroyed by white settlers and presidential decree. Catlin, a writer as well as a painter, was keenly aware of the imminent destruction of Native American ways, and took several trips throughout the Western territories in order to capture aspects of the traditions before they disappeared. Though his efforts did not extend to lobbying for the rights of Native American peoples, Catlin succeeded in capturing many rituals, costumes, and personalities of a number of American cultures. Catlin collected many of his paintings of Native American life—he made more than five hundred—into a road show he called an "Indian Gallery," which toured the United States and Europe with great success.

His painting of *Pigeon's Egg Head (The Light) Going to and Returning from Washington* underscores the encroachment of Western society on the native tribes. Catlin had done a conventional portrait of the Assiniboine warrior in national costume as well, but here we see the subject in a before-and-after picture, first wearing his native dress, and later in incongruous Western costume. Many Native American

GEORGE CATLIN. *Pigeon's Egg Head (The Light) Going to and Returning from Washington.* 1837–39. Oil on canvas. 29 x 24 in. (73.7 x 61 cm). National Museum of American Art, Washington, D.C.

delegations went to Washington to negotiate treaties with the government to save what land they could. For some of the delegates, this was their first exposure to the full panoply of European culture, and they often took home new modes of dress and other "souvenirs" of their trip.

Not surprisingly, Manifest Destiny was a popular theme of landscape painting. Emanuel Leutze's *Westward the Course of Empire Takes Its Way* of 1861, commissioned for the Capitol in Washington, D.C., is one such picture; seen following is the oil sketch for the painting. In a long, slow, sweeping S curve, a seemingly endless wagon train proceeds from the darker reaches of the picture into the golden glow of the West. At the center of the composition, a buckskin-clad pioneer husband points out the promised land to his weary wife and children. Although Leutze (1816–1868) is not shy about showing the dangers and hardships of the journey—note the burial taking place in the background—this was, after all, a government commission, intended perhaps to keep the settlement of the West in the hearts, minds, and votes of legislators.

The border of the painting is ripe with biblical images identifying the West as the new Eden, and with figures of a specifically American hagiography: the legendary pioneer guide, Daniel Boone, and William Clark, the explorer. At the bottom is a "portrait" of San Francisco Bay—the caravan's ultimate destination.

The importance of the individual artist's point of view continued to increase as the century progressed, with the last decades producing a modern art as unimaginable fifty years earlier as automobiles or women's suffrage.

opposite:

JACQUES-LOUIS DAVID. *Death of Marat.* 1793. Oil on canvas.
63 3/4 x 50 3/8 in. (161.9 x 128 cm). Musées Royaux des Beaux-Arts, Brussels.

Marat was a leader of the Revolution who was forced to spend copious amounts of time in soothing baths as a result of a skin disease he acquired while hiding out in the Paris sewers. In July 1783 he was viciously murdered in his tub by the counter-revolutionary Charlotte Corday. David has painted a moving tribute; Marat is nobly heroic at the moment of his death, his body posed in the attitude of the dead Christ.

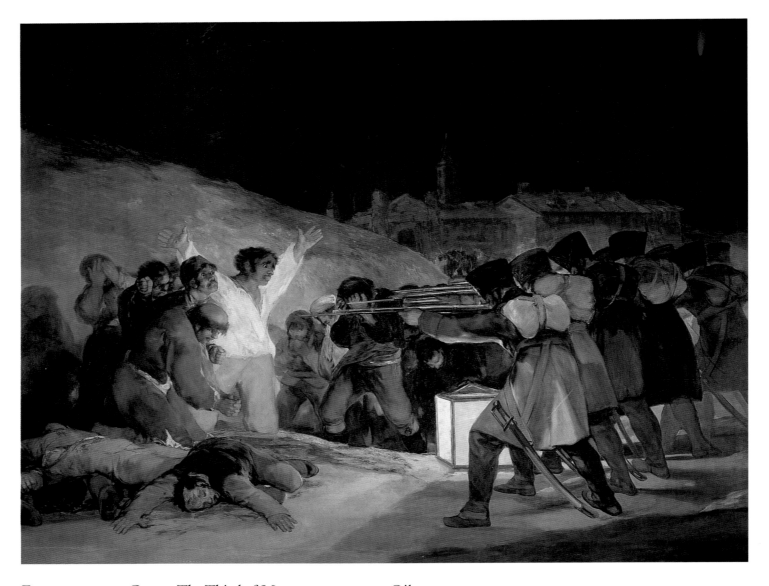

FRANCISCO DE GOYA. *The Third of May, 1808.* 1808–14. Oil on canvas.
104 3/4 x 135 7/8 in. (266 x 345.1 cm). Prado, Madrid.

This painting recounts the tragic events of May 3, 1808, when Napoleonic forces summarily executed hundreds of Spanish citizens in Madrid. Goya has captured the scene with snapshot intensity. The anonymous soldiers bend to their task with mechanized indifference to the suffering of those about to be killed. At the instant before his death, the man in the white shirt raises his arms skyward, his pose reminiscent of Christ on the Cross.

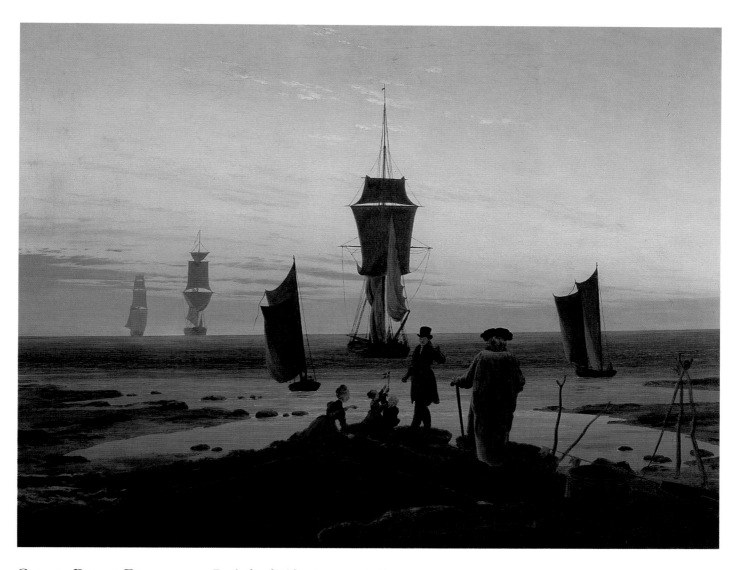

CASPAR DAVID FRIEDRICH. *Periods of Life*. 1834–35. Oil on canvas.
28 1/2 x 37 in. (72.5 x 94 cm). Museum der Bildenden Kunste, Leipzig.

Friedrich was the leading Romantic painter in Germany. Painted in Friedrich's old age, this picture probably had a symbolic meaning of a personal nature, but that meaning is elusive. The five people standing on the shore are matched by the five boats in the sea. As the title suggests, each person and each boat probably represents a different stage of life. The boats silhouetted against the sky give a mystical tone to this meditation on the passing of life.

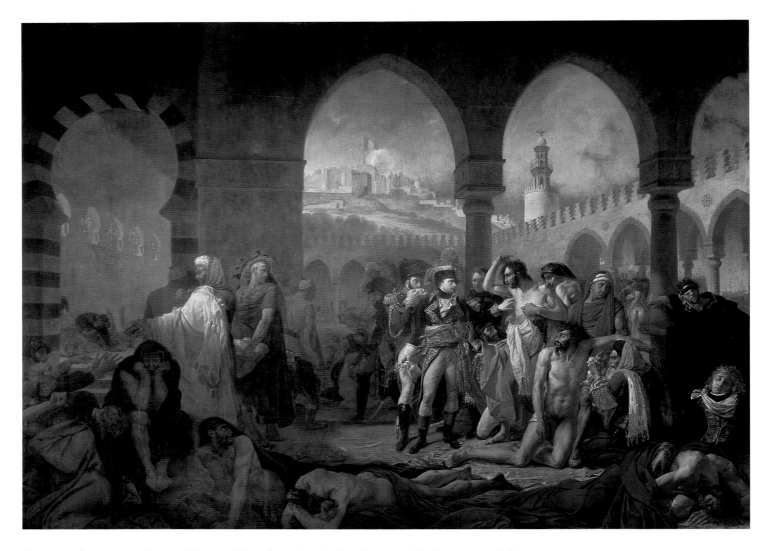

BARON ANTOINE-JEAN GROS. *Napoleon in the Pesthouse at Jaffa*. 1804. Oil on canvas.
209 1/2 x 276 in. (532.1 x 701 cm). Musée du Louvre, Paris.

Gros, like David, was an official painter for Napoleon, and his paintings often serve as propagandistic reminders of the beneficence of the emperor. Napoleon takes on a Christ-like attitude as he walks among the sick and dying, stopping even to touch the sores of one unfortunate. The noble emperor is thus heroicized, despite the fact that his military campaigns were the cause for the devastation around him.

opposite:

THÉODORE GÉRICAULT. *Officer of the Imperial Guard*. 1812. Oil on canvas.
115 x 76 1/2 in. (292.1 x 194.3 cm). Musée du Louvre, Paris.

Géricault painted this picture at the age of twenty-one, using his own resources, and presented it at the Salon of 1812. The dynamic composition and sure brushstrokes belie the very young age of the artist, who has thoroughly digested both David and Rubens. The composition spirals, the horse rears, the officer twists—all these elements vividly convey the excitement and fear of the battlefield.

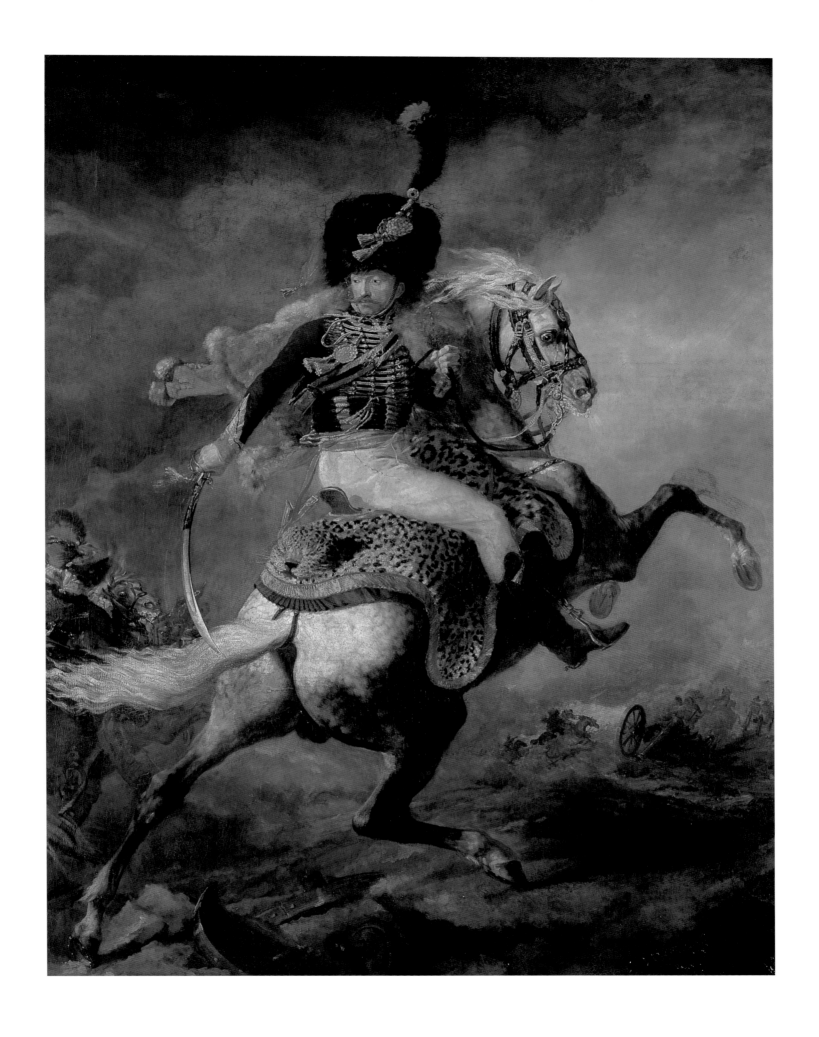

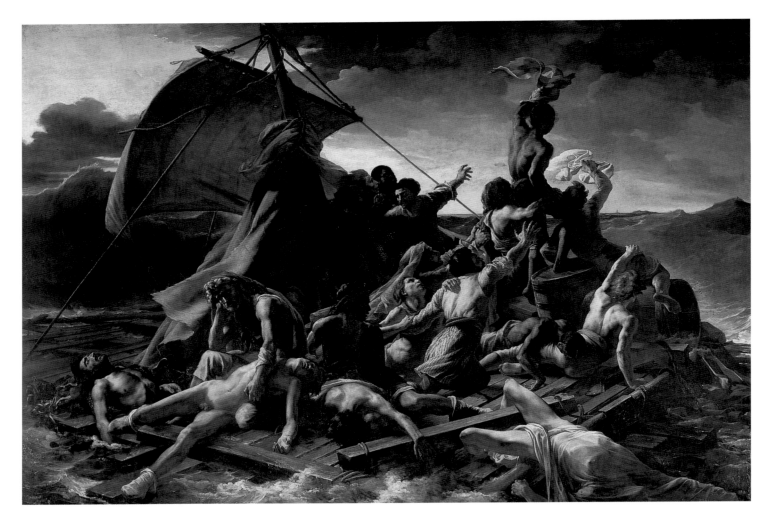

THÉODORE GÉRICAULT. *The Raft of the Medusa.* 1819. Oil on canvas.
193 x 282 in. (490.2 x 716.3 cm). Musée du Louvre, Paris.

After the shipwreck of the *Medusa*, a makeshift raft of assorted sailors was set loose on the sea. The occupants, left without food or water, eventually turned to cannibalism, though they were finally rescued by a passing ship. The inherent drama in the story is enhanced by the dynamic pyramid of figures who strive to be seen by the tiny rescue ship on the horizon.

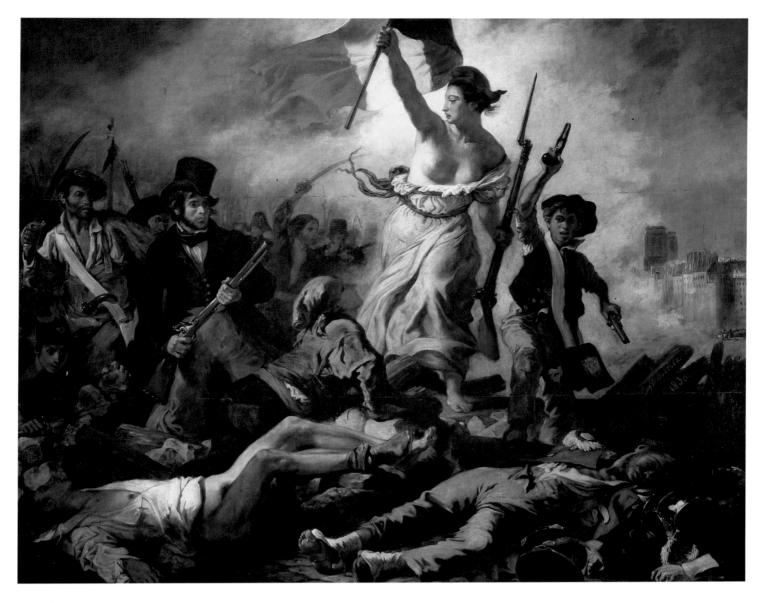

EUGÈNE DELACROIX. *Liberty Leading the People*. 1830. Oil on canvas.
102 3/8 x 128 in. (260 x 325.1 cm). Musée du Louvre, Paris.

In July 1830, repressive legislation was passed that raised taxes and severely restricted freedom of the press. This prompted a three-day revolution to which Delacroix was a witness, and which he felt compelled to commemorate. The heroic figure of Liberty, brandishing both the Tricolor and a bayonet, leads a motley crew of citizens through the smoke of battle, over the barricades, and onward toward Victory.

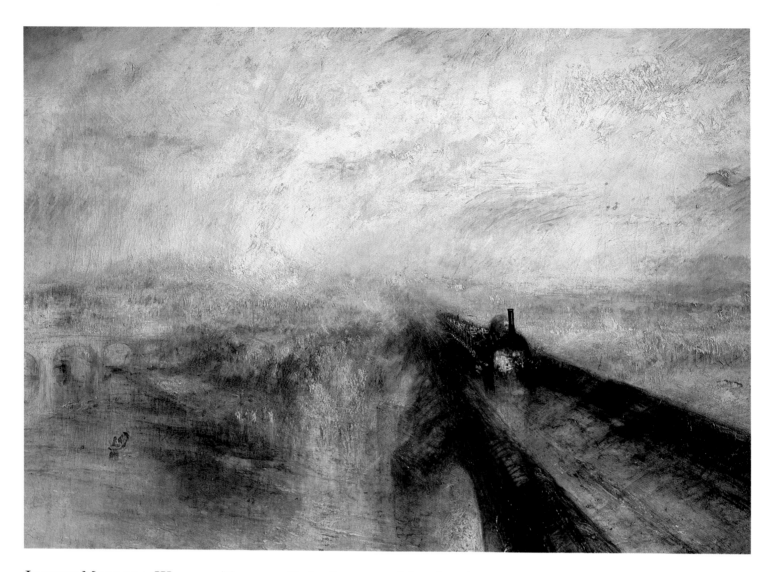

JOSEPH MALLORD WILLIAM TURNER. *Rain, Steam, and Speed—The Great Western Railway.* 1844. Oil on canvas. 35 7/8 x 48 in. (91.1 x 122 cm). The National Gallery, London.

One of the first paintings of a train, this picture is almost more a depiction of the effects of nature than of the speeding locomotive. The washes of color that enshroud the picture add to the sense of speed and tumult. The Romantic notion of idealized industrial progress through the taming of nature is the more pointed as a rabbit runs for his life in front of the speeding engine.

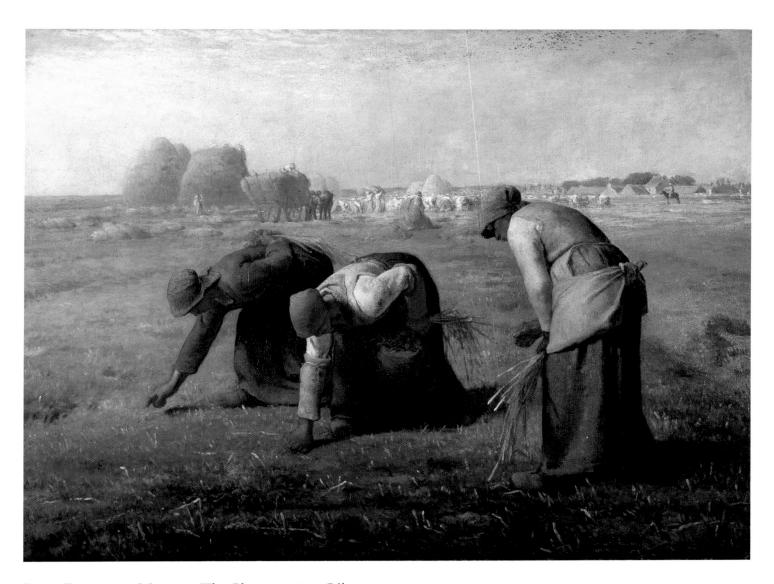

JEAN-FRANÇOIS MILLET. *The Gleaners*. 1857. Oil on canvas.
33 x 44 in. (83.8 x 111.8 cm). Musée du Louvre, Paris.

In this painting, three peasant women bend to gather the remains of recently harvested wheat, which is their only entitlement. The wheat, visible in the distance, is the province of the wealthy farmer; the women are distinctly set apart from the riches and have no access to them. Millet, however, has infused their backbreaking labor with a monumental nobility that transforms this scene of poverty into one of quiet grace.

ROSA BONHEUR. *Plowing in the Nievernais.* 1849. Oil on canvas.
69 x 104 in. (175.3 x 264.2 cm). Musée d'Orsay, Paris.

Rosa Bonheur was one of the most successful women artists of the 19th century, and partially owed her success to her father's association with liberal Socialists who advocated equality for women. She was particularly interested in documenting agrarian activities around France, with a special focus on domestic animals. This stately procession of cattle across the fields has much in common with Millet's noble peasants.

opposite:

HONORÉ DAUMIER. *The Laundress.* c. 1863. Oil on canvas.
19 1/4 x 13 1/4 in. (48.9 x 33.6 cm). Musée d'Orsay, Paris.

As Millet ennobled the agricultural laborer, Daumier gives a noble air to the urban laborer, in this case, a washer woman. Her form, silhouetted against the light background as she climbs up from the bank of the Seine, is given a monumental dignity. Though the painting documents one individual at a particular moment in time, this one laundress becomes a symbol for all women who toil in anonymous drudgery.

ALEXANDRE CABANEL. *The Birth of Venus.* 1863. Oil on canvas.
51 1/4 x 88 3/4 in. (130.2 x 225.4 cm). Musée d'Orsay, Paris.

Contemporary with Manet's *Olympia*, which shocked the public with its depiction of modern nakedness, this painting presents a voluptuous nude in a "safe" mythological setting. Cabanel's Venus lies languidly upon the waves, her sexual availability no less blatantly displayed than Olympia's, but with the sanction of art historical and cultural precedent behind her.

opposite:

ADOLPHE-WILLIAM BOUGUEREAU. *The Birth of Venus.* 1879. Oil on canvas.
118 x 85 3/4 in. (300 x 218 cm). Musée d'Orsay, Paris.

Bouguereau was a darling of the public, and rejoiced in painting just what the masses delighted in—sumptuous paintings of frolicsome nudes. In Bouguereau's version of the subject, Venus is borne on a shell, as in Botticelli's painting of 1485, surrounded by a host of putti. She stands in an exaggerated contrapposto, her femininity no longer partially hidden—à la Botticelli—but, rather, luxuriously exposed.

GUSTAVE COURBET. *The Studio of the Painter: A Real Allegory Summing Up Seven Years of My Artistic Life.* 1854–55. Oil on canvas. 142 x 236 in. (360.7 x 599 cm). Musée d'Orsay, Paris.

This huge painting is, as the title implies, autobiographical in subject. Grouped around the painter (a self-portrait) and his model are figures from Courbet's life, both real and allegorical. Almost everything in the picture has probable symbolic or double meaning, certainly deeply personal to Courbet. Here for the first time an artist's life has become the sole subject of a painting on the kind of scale previously reserved for history painting.

WILLIAM BLAKE. *Body of Abel Found by Adam and Eve.* c. 1826. Watercolor.
15 1/8 x 17 in. (38.5 x 43.3 cm). The Tate Gallery, London.

This powerful image combines grief, fear, and shame in a potent mix. As Cain is about to bury Abel, Adam and Eve make two discoveries: one son is dead and the other responsible for his murder. The shock of that discovery rolls like a wave through the picture. The sinuous form of Eve as she keens over the body eloquently bespeaks her grief. Cain, tearing at his hair, flees in terror from the scene. The red globe of the sun and the fiery background add to the emotional pitch.

JOHN WILLIAM WATERHOUSE. *The Lady of Shallot.* 1888. Oil on canvas.
60 x 80 in. (153 x 204 cm). The Tate Gallery, London.

Waterhouse felt the reach of the Pre-Raphaelites long after the Pre-Raphaelite Brotherhood had disbanded.
Details are described in sharp clarity, à la Millais, but the mood is more mysterious. The title comes from
a poem of the same name by Tennyson (a Pre-Raphaelite favorite). The doomed Lady of Shallot rides in the
boat that will become her funeral bier, the foreknowledge of her death visible on her face.

opposite:

DANTE GABRIEL ROSSETTI. *Ecce Ancilla Domini. (The Annunciation).* 1850.
Oil on canvas mounted on wood. 28 1/2 x 16 1/2 in. (72.4 x 42 cm). The Tate Gallery, London.

Rossetti, a Pre-Raphaelite, treats his version of the subject with an infusion of psycho-sexual tension. As the
mild-mannered, lily-bearing Gabriel comes near, Mary shrinks into herself as if her innocence is about to
be lost. The room into which she retreats, and her garments, are of the purist white, symbols of both the
Virgin's purity and her chastity.

RICHARD DADD. *The Fairy Feller's Masterstroke*. c. 1858–64. Oil on canvas.
21 1/4 x 15 1/4 in. (54 x 38.7 cm). The Tate Gallery, London.

Trained at the Royal Academy, in 1843 Dadd murdered his father, believing that devils
provoked him to do so. He was subsequently consigned to Bethlehem hospital ("Bedlam")
for the rest of his life, where he continued to paint. This painting depicts a fantasy woodland
world where a miniature woodchopper attempts to slice a hazelnut. The whole picture
is rendered with the sharpest clarity, where each detail is given equal weight. This painting
took Dadd six years to complete.

WILLIAM HOLMAN HUNT. *The Awakening Conscience.* 1853. Oil on canvas.
29 1/2 x 22 in. (75 x 56 cm). The Tate Gallery, London.

Here, within the trappings of a Victorian bourgeois parlor, a young kept woman leaps from the lap of
her lover with a start, as she realizes the extremity of her sinful situation, and resolves to extricate herself
from it. Upon seeing the picture and noting the cheap and tawdry furnishings of the interior, the critic
John Ruskin declared that they depicted "the moral evil of the age in which it is painted."

PIERRE PUVIS DE CHAVANNES. *Young Girls on the Edge of the Sea.* 1879. Oil on canvas.
80 3/4 x 60 3/4 in. (205 x 154.3 cm). Musée d'Orsay, Paris.

Puvis was one of the most important muralists of his day, and his work was in demand not only in France, but
in places as far-flung as Boston and Oslo. His style is flat and quiet; his palette muted and monochromatic. There
is a timeless quality to the women here, who languidly go about their business of doing nothing at all.

GUSTAVE MOREAU. *Orpheus*. 1865. Oil on canvas.
60 3/4 x 39 1/4 in. (154.3 x 99.7 cm.) Musée d'Orsay, Paris.

This vision of the Orpheus myth is told with erotic overtones in an episode outside the ancient story. Moreau has an adolescent girl find the head and lyre of Orpheus, after his brutal murder. She embraces and quietly stares down at the head, without squeamishness. The landscape background, which owes a great deal to Leonardo, is suffused with the atmosphere of hallucinatory dreamscape.

Sir Edwin Landseer. *Man Proposes, God Disposes.* 1863–64. Oil on canvas. 36 x 96 in. (91.4 x 243.8 cm). Royal Holloway College, University of London, Egham.

Landseer was inspired to paint this picture by the discovery, in 1857, of the shipwreck of the explorer John Franklin, who had set out on his Arctic voyage twelve years before. In a bleak Arctic landscape, two polar bears devour the remains of the ship, including what seem to be human bones in the mouth of the bear at right. As the title implies, Man's attempt to tame Nature is but a futile exercise.

THOMAS COLE. *The Subsiding of the Waters of the Deluge.* 1892. Oil on canvas.
35 3/4 x 47 5/8 in. (90.8 x 121 cm). National Museum of American Art, Washington, D.C.

From deep within a rocky chasm, we are invited to view the aftermath of the Flood. The quiet stillness of the
scene bears reminders of the cataclysm that preceded it; trees lie tossed about like twigs, and waters continue
to rush down the rocks at left. Most pointedly, a human skull lies prominently at the foreground. The ark lies
in the now calm sea, and at the very center of the picture flies Noah's dove, a potent symbol of the salvation
of mankind.

CHARLES BIRD KING. *Young Omaha, War Eagle, Little Missouri, and Pawnees.* 1821. Oil on canvas. 36 1/8 x 28 in. (91.8 x 71.1 cm). National Museum of American Art, Washington, D.C.

Working mostly within the confines of his Washington studio, King chose his subjects from the steady stream of tribal delegations that came to Washington to negotiate land treaties. The striking similarity of facial features among the five figures may not be simply a matter of tribal affiliation; King may have created a composite type, composed of elements (a "Roman" nose, for example) he felt would be most sympathetic to a white audience.

EMMANUEL LEUTZE. *Westward the Course of Empire Takes Its Way.* 1861. Oil on canvas.
33 1/4 x 43 3/8 in. (84.4 x 110.2 cm). National Museum of American Art, Washington, D.C.

This oil sketch is a study for a mural commissioned for the House of Representatives. Ripe with symbols and figures particular to an American mythology, the picture carries with it the sense of the United States as a land overflowing with milk and honey. The idea of the West as a sort of Eden is given full pictorial currency as the wagon train of weary pioneers comes out of the shadow of the mountains into the golden glow of the fertile plain beyond.

ALBERT PINKHAM RYDER. *Moonlight*. 1880–85. Oil on wood.
15 7/8 x 17 3/4 in. (40.3 x 45 cm). National Museum of American Art, Washington, D.C.

Ryder's childhood in the port town of New Bedford left him with a constant admiration for the ocean. The lone boat on a storm-tossed sea is painted with an almost abstract quality; broad swaths of color give rise to form without detail. The mood of the painting bespeaks the loneliness of the moonlit night. Ryder worked and reworked his canvases, and the thick impasto resulting from the accumulation of paint layers gives a unique quality to his oeuvre.

opposite:

LILY MARTIN SPENCER. *We Both Must Fade*. 1869. Oil on canvas.
72 x 53 11/16 in. (182.8 x 136.3 cm). National Museum of American Art, Washington, D.C.

The image of a beautiful young woman in luxurious silks holding a wilting flower is a *vanitas* image in the spirit of Vermeer. The fading rose, whose petals drop one by one to the floor, is a reminder of the transience of physical beauty. The richness of the gown and the jewels on the table underscore the theme, and as the woman gazes at herself in the mirror in self-assessment, her gaze seems to imply the somber knowledge of her own mortality.

EASTMAN JOHNSON. *The Girl I Left Behind Me.* c. 1870–75. Oil on canvas.
42 x 34 7/8 in. (106.7 x 88.6 cm). National Museum of American Art, Washington, D.C.

The title of the picture comes from a Civil War song, and though any direct references to the war are absent here, the painting eloquently speaks to the waiting and longing both of those gone away and those left behind. The barren landscape and raging wind contribute to the sense of loss inherent in the picture. The artist must have felt a deep personal connection to the painting, for it remained in his studio until his death.

Winslow Homer. *High Cliff, Coast of Maine.* 1894. Oil on canvas.
30 1/8 x 38 3/16 in. (76.5 x 97 cm). National Museum of American Art, Washington, D.C.

Homer painted the Maine coast over and over during his lifetime. The great power of the sea proved endlessly fascinating to the artist. Here, the picture is roughly bisected diagonally into two zones: the active, roiling surf, and the static, solid rocks. These two timeless yet very different forces collide at their frontiers in a crash of foam.

Impressionism & Post-Impressionism

Light and Modern Life

It may be more accurate to speak of the Impressionists than of Impressionism, so diverse are the expressions encompassed by the term, which was coined by a critic. These artists shared a concern with realism in painting that took several forms. On a technical level, the Impressionists were freed from a dedication to a finished illusionism by the popularization of the camera, which captured "reality" with unquestioned accuracy. This permitted the artists to engage in a virtuoso double game. On the one hand, they deconstructed the artifice of painting, with visible brushstrokes, even heavy impasto, dots of complementary color, and imperfect perspective, so as to make the viewer aware of the materiality of the medium. At the same time, the materials came together as recognizable, convincing images. Several of the Impressionists took an analogous approach to subject matter, exposing the hidden sides of society, just as the reformers and novelists of the time were doing.

This was also the age of science and invention, and objective inquiry informed these artists' endeavors. It is difficult today to convey the radicalism of the attempts to reproduce exactly the effects of light on the retina at different times of day and in different seasons, rather than to produce an ideal, timeless representation.

While some of these artists had some personal income, others did not. The nature of their investigations meant that they did less work on commission, and the innovative quality of their work often meant that what they originated was not often sold. This economic situation would give rise to the stereotype of the starving, bohemian artist, even though the Impressionists themselves were either solidly middle class or aspired to be, or were wealthy aristocrats. These men and women did not despise the worldly success that was soon theirs; their revolutionary style became generally accepted in art-buying circles in Europe and the United States in less than a generation.

The first nucleus of those who would become the Impressionists was formed in the early 1860s by four young artists who met at the studio of the prolific but rather uninspired painter Charles Gleyre

MARY CASSATT. *Young Woman in the Garden (Woman Sewing in the Garden).* c. 1883–86. Oil on canvas. 36 x 25 1/2 in. (91.5 x 64.7 cm). Musée d'Orsay, Paris.

(1808–1874), head of one of the most successful studios at the École des Beaux-Arts in Paris. The names of these four were soon to become synonymous with Impressionism itself: Claude Monet (1840–1926), Pierre-Auguste Renoir (1841–1919), Alfred Sisley (1839–1899), and Frédéric Bazille (1841–1870).

Gleyre's methods successfully prepared his students to submit works for the annual exhibitions of the official Salon, a government-sponsored event held annually in

FRÉDÉRIC BAZILLE. *The Artist's Studio, Rue de la Condamine.* 1870. Oil on canvas. 38 7/8 x 47 in. (98.7 x 119.4 cm). Musée d'Orsay, Paris.

Paris. The Salon jury consisted of academic instructors and elected officials, all of whom displayed an increasing conservatism in the selection of the thousands of works submitted by artists from all over the country. So powerful and influential was the Salon that potential buyers used the shows as consumers' guides. For those artists whose works were accepted, success was, if not guaranteed, at least likely, and positive mentions in the critical press could pave the way to fame and prosperity.

Although Gleyre offered academic training, his studio attracted numerous students interested in the realist manner. Despite his aura of officially acclaimed artist, Gleyre did not fully adhere to standard academic custom. His students paid only a nominal amount for the studio space and the models' fees, and Gleyre renounced any charges for his teachings. It was the craft of painting that was at the center of Gleyre's program. He taught his students to draw from plaster casts, reliefs, engravings, and oil paintings, as well as from real life. Although he offered full studio training, Gleyre never discouraged his students from developing their individual styles, and he encouraged them to paint landscapes *en plein air,* or out-of-doors. This was a relatively innovative approach, at a time when "serious" painters made their sketches in the open air, then finished the work in the studio.

At Eastertime of 1863, the four aspiring artists—Monet, Renoir, Sisley, and Bazille—made a trip to the Fontainebleau Forest outside Paris, where they met the painters Gustave Courbet (1819–1877) and Narcisse Diaz de La Peña (1808–1876). Both elder artists were already painting out-of-doors, something the young students were eager to practice for themselves. Walking through the forest with their portable easels, paintboxes, and knapsacks, they searched for subjects, urging one another on.

All four members of the group regularly submitted paintings to the annual Salon exhibitions—with mixed results. Works that were too unorthodox or simply not finished with the requisite academic slickness were often considered unfit to be included in the shows. Nevertheless, the young colleagues painted their works with the Salon in mind, since it was the only significant showcase for contemporary art. After leaving Gleyre's studio, the four established friendships with other artists, notably Camille Pissarro (1830–1903), Paul Cézanne (1839–1906), and Berthe Morisot (1841–1895), as well as with the critics

Théodore Duret and Georges Rivière. They met in the cafés of Montmartre, first the Café Guerbois and later the Café de la Nouvelle-Athènes, where they were joined by Édouard Manet (1832–1883), considered by some critics the forerunner of the Impressionists, even one of the first modern artists.

In October 1869, Monet and Renoir visited La Grenouillère, where they painted *en plein air* the light, life, and atmosphere of this bathing resort on the Seine outside of Paris. The paintings they executed there—Renoir's *La Grenouillère,* for example—may be considered the first true Impressionist paintings.

Located on the Seine at Châtou, La Grenouillère (literally "the frog pond") was a favorite bathing and boating site for Parisians. Here, Renoir and Monet painted side by side three pairs of landscapes of almost the same view. They capture a casual, seemingly random moment of daily life, created in an atmosphere of freedom, with vivid colors, small, intense brushstrokes, and a pervasive light. People are strolling, dining, or boating, children swim in the river, and all of this is bathed in the gleaming light reflected by the surface of the rippling water. The overall effect is that of a spontaneous execution, although both Renoir and Monet had carefully studied their compositions, painstakingly weighing every least detail.

In order to achieve the high keys of their palettes, Monet and Renoir prepared their canvases with a white or pastel tone to enhance the luminosity of the colors, rather than with a traditional warm brown or red ground. The idea of recording temporary effects rather than the permanent aspects of a subject arose from the attempt, in a scientific spirit, to reproduce on canvas the image as the artists hypothesized that the retina would actually receive it. To that end, both Monet and Renoir used "rainbow" colors and eliminated black shadows and contours. The objects depicted thus gained lightness and atmosphere, compared with objects treated conventionally. Brushstrokes vary from dry to wet and from thin to impasto, and are fragmented into hundreds of small spots, each with its own hue. Complementary colors are used to model the objects and to give them a tangible feeling in a space no longer defined by lines and perspective. It is a bold, revolutionary technique that results in an intense richness and an airy, fleeting quality.

In 1873, Monet took up the idea that he and Bazille had cherished some years earlier—that of curating a group exhibition at their own expense. The time seemed to be ripe. The introduction of liberal government ventures, such as the Salon des Refusés (the Salon of the Rejected Artists), had not mitigated the power of the despised Salon jury system. Undoubtedly influenced by his painter friends, the critic Paul

PIERRE-AUGUSTE RENOIR. *La Grenouillère.* 1869. Oil on canvas. 23 1/4 x 31 1/2 in. (59 x 80 cm). Hermitage, St. Petersburg.

Alexis wrote in an article that "like any other corporation, the artistic corporation has much to gain by organizing its own syndicate" and by presenting independent shows.

The group's intention to present their works to a larger audience finally became a reality. From April 15 until May 15, 1874, just before the opening of the official Salon, the first exhibition of the Society of Painters, Sculptors, and Engravers was held in the vacant studio of the photog-

CLAUDE MONET. *Impression-Sunrise.* 1872. Oil on canvas. 18 7/8 x 24 3/4 in. (48 x 63 cm). Musée Marmottan, Paris.

rapher Nadar on the boulevard des Capucines, in the heart of Paris. Renoir's brother Edmond wrote the catalogue essay, and twenty-nine artists took part, including Cézanne, Renoir, Pissarro, Morisot, and Monet. The most conspicuous absentee was Édouard Manet, who preferred to court the Salon and never took part in any of the Impressionists' exhibitions, though he strongly supported the group's efforts. The group exhibited a total of 165 works.

Monet later explained that he had submitted for the exhibition a painting of the harbor of his home-town of Le Havre done from his window and showing the sun appearing amid damp vapors with some ship masts in the foreground: "I was asked to give a title for the catalogue; I couldn't very well have called it a view of Le Havre. So I said, 'Put "Impression."' " Some critics have been reluctant to take this account at face value, but the fact remains that the painting appeared in the catalogue as *Impression—Sunrise.*

Some critics were very harsh in their dismissal of the exhibition; others ignored it altogether. The show was originally well attended, although most of the public, encouraged by the press, came to jeer. On April 25, an article by the journalist Louis Leroy appeared in *Charivari* under the heading "Impressionist Exhibition," which borrowed a word coined by an anonymous writer for *Le Figaro* on the basis of Monet's title. In it, Leroy ridiculed and grossly distorted the intentions of the artists and their works, making common currency of the term "Impressionist," which the artists immediately adopted for themselves.

Altogether, thirty-five hundred people went to view the exhibition, a meager showing compared to the four hundred thousand who attended the Salon. Many who went were motivated by curiosity about a phenomenon, rather than by serious interest in the works themselves. Although hardly a disaster, the exhibition failed to initiate a dialogue with a public that was apparently totally unprepared for the new work. Only a few devoted collectors bought some of the paintings on view. Between 1874 and 1886, the artists organized eight Impressionist exhibitions, which were increasingly well received. These events were not restricted to members of what was in any event a loosely constituted group, and not all members were represented in all shows; only Pissarro participated in all eight exhibitions.

Both Manet and Degas were grounded in the principles of classical art, but, by and large, the younger Impressionists opposed academic training. All of them repudiated imaginative art, including historical subjects, in favor of the objective recording of contemporary and actual experience. The emotional aspect of art, which had been so central to Romanticism, they considered secondary. The Impressionists had different priorities and painted different subjects.

CLAUDE MONET

Monet was chiefly interested in the shifting play of light over the course of a day or throughout the seasons. Rather than focus on the depiction of physical objects, he attempted to seize the fleeting moments of light as reflected on the surface of an object, the light's effect on the eye of the viewer. Such works could not be completed in the studio from oil sketches made out-of-doors, and as a result, the major criticism directed against him was that his paintings were not "finished." Monet preferred to live and paint in the country, but not too far away from Paris, where he found support among his friends, art dealers, and occasional collectors. He lived for several years in Argenteuil and Vétheuil on the Seine, until he settled in Giverny in 1883. Despite the critics' and public's initial resistance to Impressionism, by 1890 Monet was able to buy his house and create the famous water lily pond that served as the theme for his late series of paintings. Monet continued to delete dark colors from his palette, and increasingly reduced his brushwork from broader planes to smaller dots and brushstrokes.

Scenes like *Field of Poppies* seem to have been accidentally discovered, but Monet achieved such an effect by composing his subjects carefully, thereby achieving a beauty and a harmony that a photographically realistic rendering would not have provided.

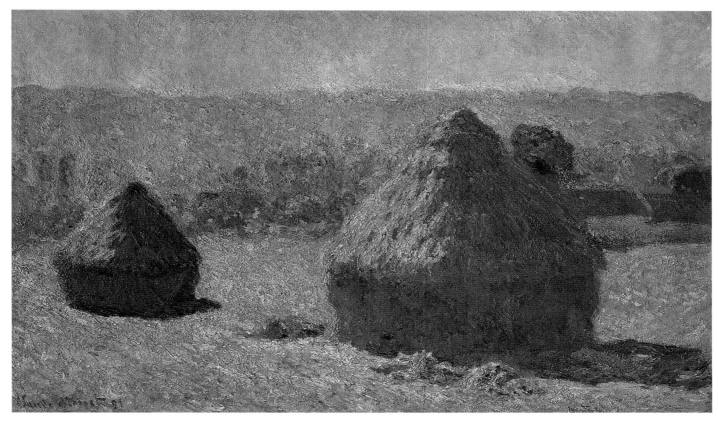

CLAUDE MONET. *Grainstacks, Late Summer, Giverny.* 1891. Oil on canvas.
23 3/4 x 39 1/2 in. (60.5 x 100.5 cm), Musée d'Orsay, Paris.

PIERRE-AUGUSTE RENOIR

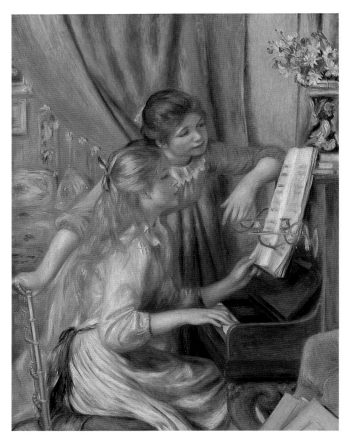

PIERRE-AUGUSTE RENOIR. *Yvonne and Christine Lerolle at the Piano.* 1897. Oil on canvas. 45 5/8 x 35 1/2 in. (116 x 90 cm). Musée de l'Orangerie, Paris.

Renoir, admired by his peers as a colorist, is known today for his portraits and scenes of recreation, especially the leisure of the upper middle class, who became his enthusiastic and well-paying supporters. After painting landscapes alongside Monet early on, Renoir became more engaged in figure painting, in which he applied Impressionist techniques to the rendering of natural light. Perhaps his most famous composition is the *Ball at the Moulin de la Galette*, which he began in 1875. Painting mostly in the garden of his studio with friends posing for him, Renoir depicted the famous dance hall in Montmartre in the flickering light of a sunny afternoon with the noisy atmosphere of a chatting and laughing crowd. He captured an essential moment of urban Parisian life in this work that most clearly epitomizes the gaiety and relaxed congeniality which pervades almost all of Renoir's paintings. In the 1880s, Renoir abandoned Impressionism to pursue a more formal expression.

MARY CASSATT

An American painter, Mary Cassatt (1845–1926) spent most of her life in Paris, where she exhibited in the Salon of 1872. Praised by Edgar Degas, she became associated with the Impressionists, exhibiting with them in four of their eight shows. She is mainly known for intimate paintings of mothers and children that charmed the critics. Like Degas, Cassatt was a skilled draftsman who often worked in pastels, and produced a number of important color prints.

ÉDOUARD MANET

In two of his most famous works, Manet took on the art establishment itself. He achieved his first *succès de scandal* at the Salon des Refusés of 1863, where his painting *Le Bain (The Bath)*, later titled *Le Déjeuner sur l'herbe (Luncheon on the Grass)*, became one of the exhibition's notorious attractions, the more so because Napoleon III himself called it "immodest." Harsh critiques of the work as vulgar and indecent rained down upon the artist. In part, Manet was exposing the exhausted conventions of Classicism, by means of figures in a landscape, just as Giorgione, Titian, Watteau, and other Old Masters

had done. To that end, he even borrowed compositional details from an engraving after Raphael, *The Judgment of Paris,* and from Titian's *Concert Champêtre* in the Louvre. *Le Déjeuner sur l'herbe* renders the female figure not classically nude but rather shamelessly—indeed professionally—naked. The woman's nudity alone would hardly have sparked off such a violent reaction as it did during the show; it was rather the fact that she did not represent anything else but herself. Here is neither Venus nor Eve, but a model of flesh and blood.

Manet's *Olympia,* shown at the Salon of 1865, met a similar fate. Stretched out on a couch like Titian's *Venus of Urbino*, Goya's *Naked Maya*, and Ingres's *Odalisques*, this woman is neither goddess, duchess, nor harem object, but unapologetically a prostitute—albeit of the costly class—whose black servant bears a bouquet of flowers from one of her admirers. The unveiled realism of the subject—her uneuphemized eroticism—which outraged Manet's contemporaries, is disturbing even to modern eyes. There is no mythological or allegorical excuse for her nudity, no conventional coyness or modesty. Nor does Olympia's body display classical standards of beauty: her torso is narrow and small, the legs a bit short. The finely modeled pale color of her flesh is set off by the exuberant range of colors of the flowers and the dark skin of the maid. The black cat at her feet is the final exclamation mark of an arch that starts with the black velvet ribbon around Olympia's neck. She gazes at the viewer with a cold, challenging, unblushing regard.

Manet's *Portrait of Émile Zola* is a tribute to the Naturalist novelist who was as shocking in literary circles as Manet was in the art world. Zola was also an ardent supporter of the new art movement, who championed Cézanne's early works in particular. Attached behind the writer's desk is a sketch of *Olympia,* an icon of the young moderns.

EDGAR DEGAS

In age as well as social background, Edgar Degas was closer to Manet than to other artists of the group. Son of a

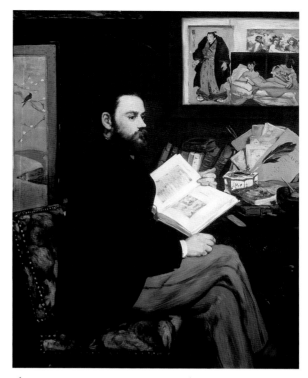

ÉDOUARD MANET. *Portrait of Émile Zola.* 1868. Oil on canvas. 57 1/2 x 45 in. (146 x 114 cm). Musée d'Orsay, Paris.

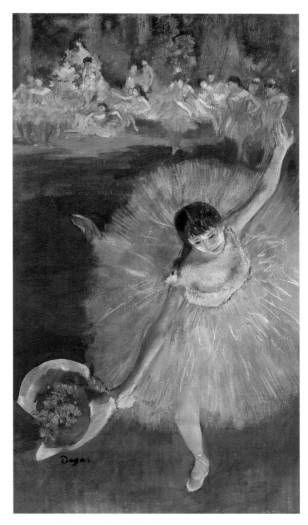

EDGAR DEGAS. *Fin d'arabesque.* c. 1877. Pastel, essence, and oil on paper. 25 1/2 x 14 in. (65 x 36 cm). Musée d'Orsay, Paris.

well-to-do banker of aristocratic extraction, he was largely a self-taught artist. During the 1870s he turned his attention to depicting the worldly life he knew, including the racetrack and the demimonde of the ballet, opera, and circus, as well as the brothels frequented by "gentlemen" of the upper classes.

Degas's best-known theme is the ballet, which was widely popular with the upper middle class. Although he occasionally painted actual performances, he was more interested in the backstage moments before a performance, perhaps because dancers, like thoroughbreds, provided a master draftsman such as Degas with opportunities to draw the attitudes of movement. *Dance Class* represents a moment of a dance rehearsal, while in *Fin d'arabesque* a star receives a bouquet of flowers after her solo performance.

From about 1875 on, Degas shifted to the opaque mediums of pastel, gouache, and distemper. These allow an artist to work more quickly and spontaneously because there is no need to wait for the oil to dry, while the mediums' opacity also permitted him to make changes to a composition.

BERTHE MORISOT

Berthe Morisot was a granddaughter of the Rococo painter Jean-Honoré Fragonard, and, like her brother-in-law, Édouard Manet, a forerunner of the Impressionists in her handling of light and brushstrokes. Morisot's work appeared in the Salon of 1864 and for a decade thereafter, until she joined the Impressionists; in 1877 she took part in the first exhibition specifically titled "Impressionist." A friend of Cassatt, Morisot is sometimes associated with the American painter as sharing an interest in domestic scenes such as the one depicted in Morisot's *The Cradle*. Regardless of class, her women are autonomous beings, living lives largely unseen by men, lives that it was Morisot's innovation as an artist to make public.

The painter Gustave Caillebotte (1848–1894) bore a special relationship to Impressionism. He was financially independent and supported his artist friends early on, purchasing a considerable number of their paintings. He left his collection to the French government, which accepted it only after a lengthy public debate; many of the Impressionist paintings at the Musée d'Orsay (formerly the Jeu de Paume) were once owned by this generous benefactor.

Although Impressionism was largely a French phenomenon, its range of techniques attracted artists the world over, with its influence being most pervasive in England and the United States, and to a lesser degree in Germany. Many of these artists studied in Paris, absorbing the group's revolutionary innovations, then disseminating the new style when they returned to their native countries.

In some ways, Impressionism was an experimental approach, rather than a school or style, and by the 1880s Impressionism was already in transition. During this decade, artists such as Georges Seurat (1859–1891), Paul Cézanne (1839–1906), Henri de Toulouse-Lautrec (1864–1901), Paul Gauguin (1848–1903), and Vincent van Gogh (1853–1890) had developed distinct styles and subjects of their own. They are loosely grouped art historically as Post-Impressionists, as their aesthetics derived principally from those of the Impressionists. In the end, however, as was the case with their predecessors, each evolved a sharply individual style. Their activity spans the decades between 1880 and 1910.

GEORGES SEURAT

Seurat's was an explicitly scientific approach to nature and color, one based on the latest discoveries in color theory and physics. It became his aim to achieve the highest degree possible of luminosity and brilliance using dots of pure color. With this pointillist method he juxtaposed tiny dots of paint, which the eye mixes additively and fuses into areas of solid color. In practice, however, his "scientific" approach to painting does not work, since his color dots are large enough to be discernable by the naked eye. Unlike Monet, Renoir, and Pissarro, Seurat employed clearly recognizable contours. He often prepared his larger paintings carefully, first making numerous drawings and oil sketches before transferring the results onto large-scale canvases in his studio. Seurat and Paul Signac (1863–1935), who worked in a similar vein and became mainly known for his views of Mediterranean harbors, both preferred the word "Divisionism" for their style.

GEORGES SEURAT. *Sitting Model, Profile.* 1887. Oil on canvas. 9 7/8 x 6 1/4 in. (25 x 16 cm). Musée d'Orsay, Paris.

PAUL GAUGUIN

A Paris stockbroker turned painter, Paul Gauguin joined the Impressionists under the influence of Pissarro. Partly of Peruvian-Indian descent, Gauguin had spent four years as a child in Peru with his family, and for some years had been a sailor. This restless background might partly explain why, at the age of thirty-seven, Gauguin suddenly abandoned his wife and five children to become a full-time artist. Thenceforth, his life was nomadic. Mistrusting, even loathing the modern world of urban civilization, Gauguin wandered unquietly from place to place in pursuit of an elusive

PAUL GAUGUIN. *Madame Ginoux in the Café de la Gare in Arles.* 1888. Oil on canvas. 23 3/8 x 36 1/4 in. (72 x 92 cm). Pushkin Museum, Moscow.

happiness, preferring remote and unspoiled parts of the country, in particular Brittany, where he painted local peasants. A short and stormy period with Vincent van Gogh in Arles in the late 1880s ended with the breakup of their friendship; *Madame Ginoux in the Café de la Gare in Arles* was painted during his short stay in that city. Gauguin traveled several times to Polynesia, settling for good in Tahiti in 1891. Today, Gauguin is best known for his paintings of Tahitian women and landscapes, which he rendered with warm, rich colors and "exotic" decorative patterns. In reality, however, his style was influenced only to a limited degree by the art of the native people. For the rest of his life, Gauguin maintained his illusions about the innocence and harmony of a people and place that existed only in his mind. He died, unhappy and poor, in the Marquesas Islands of Polynesia.

VINCENT VAN GOGH

The deeply emotional art of Dutch artist Vincent van Gogh, rivaling in its intensity and power that of his fellow countryman, Rembrandt, has earned him a special place among the Impressionists. Son of a Protestant minister, Van Gogh attempted several professions, including living as an evangelist among the coal miners of southern Belgium. As an artist, Van Gogh was largely self-taught, though in 1880 he moved to Brussels, where he embarked on a formal study of art; works from this period are characterized by dark tones in the classic Dutch tradition.

In 1886, Van Gogh moved to Paris, where his brother, Theo, who worked for an art dealer, introduced Vincent into the circles of those working in the modern idioms. The coloristic discoveries of Impressionism, especially, were an eye-opener. Van Gogh's style changed dramatically, and he adopted the bright palette that his new friends Signac, Seurat, and Gauguin had been using for some time. Life in

VINCENT VAN GOGH. *The Langlois Bridge.* 1888. Oil on canvas. 21 1/4 x 25 1/2 in. (54 x 65 cm). Rijksmuseum Kröller-Müller, Otterlo.

Paris, however, was difficult and exhausting, and after showing signs of depression and emotional instability, Van Gogh decided to leave the city for the South of France. Both Gauguin and Van Gogh preferred the simple life, and together they planned to establish a community of like-minded artists in the country. Early in the spring of 1888, Van Gogh arrived alone in Arles, where his friend was to join him later. For the remaining two years of his life, Van Gogh painted with an unprecedented speed and intensity, producing

almost a canvas a day. His works in Arles were strongly influenced by the color theories of Neo-Impressionists such as Seurat and Signac, but instead of applying his complementary colors with small dots that balance one another visually, Van Gogh painted in large juxtaposing areas of color, a treatment inspired by Japanese woodblock prints he had seen and collected in Paris.

Van Gogh was fascinated by the clear southern light and harsh, arid beauty of the countryside. Painting with bright colors and lively brushwork, Van Gogh expressed profound, passionate emotions, which he confided also to Theo in his frequent letters. His entire life was now consumed by painting and his thoughts were focused on art alone, though he did not sell any work. Gauguin finally arrived in late 1888, but to Van Gogh's disappointment, their plans went nowhere. One day their constant quarrels exploded into a violent encounter, in the course of which Van Gogh threatened Gauguin with a razor. After Gauguin fled, Van Gogh cut off his right ear and gave it to a prostitute; he subsequently spent several months in an asylum at nearby Saint-Rémy, where he continued to paint. During this time he executed some of his most beautiful works, including several self-portraits. His art began to assume a quality of almost religious ecstasy, becoming a kind of pantheistic paean to the wonders of nature. When his mental state allowed, Van Gogh returned to Paris, where his brother found him a place in Auvers-sur-Oise, a small town near the capital. There, Van Gogh was under the care of Dr. Gachet, a patron of artists and a collector. After a period of frenzied activity of little more than two months, Van Gogh, suffering from spiritual anguish and depression, committed suicide by shooting himself. His work was a precursor of Expressionism, in which intense emotion determines the treatment of the image, or dissolves it altogether.

HENRI DE TOULOUSE-LAUTREC

Another artist who developed his career over a relatively short period of time was Henri de Toulouse-Lautrec. Born into an aristocratic family in the south of France, he suffered from a hereditary disability that, after two accidents, damaged his legs and left him deformed. As a child Toulouse-Lautrec started to draw, under the guidance of his paternal uncle who was an amateur painter. When Toulouse-Lautrec moved permanently to Paris, he discovered the night life of Montmartre and the art of the Impressionists. Feeling himself to be an outcast because of his physical handicap, he lived with prostitutes and others on the fringes of society, becoming close friends with dancers like Jane Avril and La Goulue, and cabaret singers like Aristide Bruant. His work mirrored the world he knew—cafés, theaters, and cabarets, for which he produced numerous lithographs.

Toulouse-Lautrec's images of bars, dance halls, and bordellos and their inhabitants documented a moment in time that would otherwise be lost to posterity. *In the Salon at the Rue des Moulins*, for example, Toulouse-Lautrec presents a casual, sympathetic group portrait of several prostitutes waiting for their customers in the salon of their establishment. Toulouse-Lautrec's biting sense of humor, uncompromising directness, and lack of moralism can startle even today's modern viewer, in works intended to be ephemeral advertisements for transient pleasures, but enduring as images familiar the world over.

PAUL CÉZANNE

Cézanne was a radically original painter of the late nineteenth century and one of the most influential artists in the history of Western painting. Born in the south of France, at Aix-en-Provence, he spent most of his life there, painting local subjects and landscapes. His first works were violently romantic subjects, executed in dark colors, but he adopted a lighter palette after he struck up friendships with Camille Pissarro and other Impressionists in Paris, where he also studied Old Masters such as Poussin and Jean-Baptiste-Siméon-Chardin (1699–1779) at the Louvre.

PAUL CÉZANNE. *Apples and Oranges.* 1896–1900. Oil on canvas. 29 1/8 x 36 5/8 in. (74 x 93 cm). Musée d'Orsay, Paris.

Cézanne repeatedly painted the same subjects Monet did—still lifes, landscapes, and figure paintings—when the latter painted his series of Rouen Cathedral, the haystacks, or the water lilies. But while Monet was seeking to capture shades of color and other visual effects of light at different times of day, Cézanne's search was for ever deeper psychological connections. Cézanne's work does not indicate the time of day nor even the season; time is defeated by essential forms and compositions. Thus, Impressionism could encompass both the representation of fleeting moments and the monumentality inherent in intellectual construction and organization. Cézanne's idealism was to be explored further by Picasso and Braque in their development of Cubism.

The abstract beauty of Cézanne's paintings is evident in his later series of landscapes around Aix-en-Provence, especially the Mont Sainte-Victoire, which he could see from the city. No people wander on the paths, no animals enliven the scenes in his paintings; in a sense, his landscapes are like still lifes, his favorite subjects after landscapes. In his arrangements of fruit, bowls, and fabrics Cézanne was interested less in painting beautiful displays of the bounty of Nature than in analyzing the geometric and compositional qualities of the forms and shapes he so carefully disposed on the table in his studio. Frequently, he abandoned traditional perspective, so that the tables on which the objects are placed can appear dramatically, even dangerously, tilted.

His rare figure paintings also become deconstructions to pure form, for example, in *The Card Players*. In this timeless and immobile scene, the players are expressionless. As in other works, Cézanne here pursued a new monumentality. His figure paintings, too, are still lifes. Like his fellow Impressionists, he was materially expressing the paradox of illusionism on a surface, in a language of his own that was by no means universally understood during his lifetime.

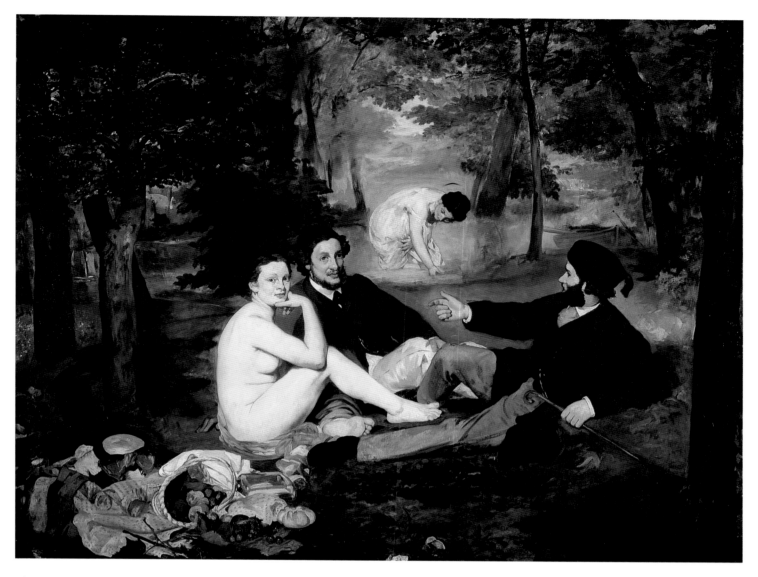

ÉDOUARD MANET. *Le Déjeuner sur l'herbe (Luncheon on the Grass)*. 1863. Oil on canvas.
82 x 104 in. (207 x 264.5 cm). Musée d'Orsay, Paris.

Rejected by the Salon of 1863, this painting was seen by more than seven thousand visitors on the first day of the
Salon des Refusés. Originally known as "The Bath," the painting offended viewers because of its modern style and
subject matter: a picnic outing of two young students with an unclad female in a classical pose. The figures were
obviously painted in the studio, the landscape added in a sketchy manner.

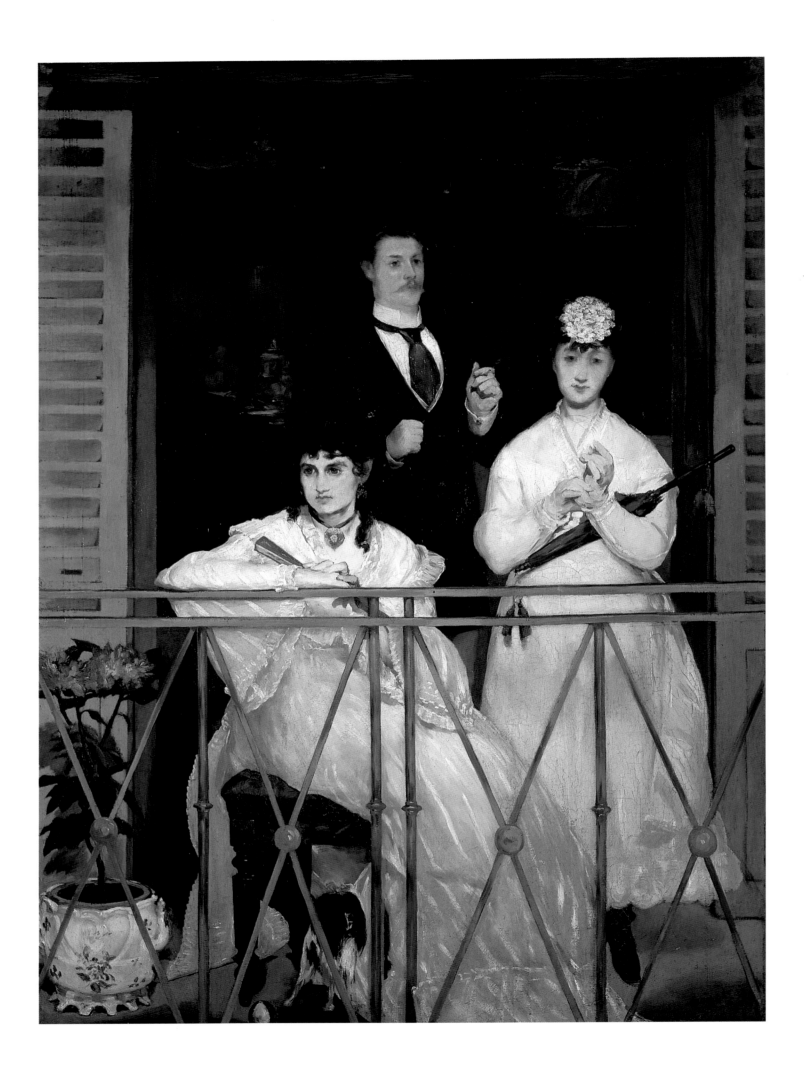

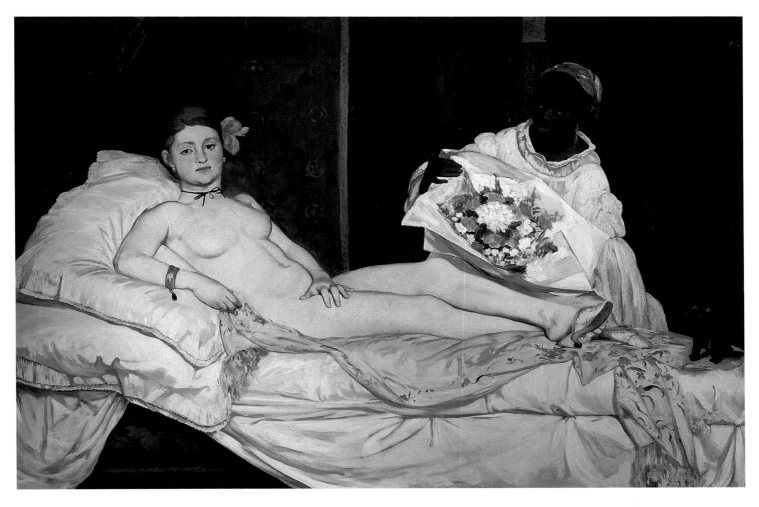

ÉDOUARD MANET. *Olympia*. 1863. Oil on canvas.
51 3/8 x 74 3/4 in. (130.5 x 190 cm). Musée d'Orsay, Paris.

The provocative, shockingly natural appearance of *Olympia* upset its first viewers during the Salon of 1865. The figure has a startling immediacy, and her face a cold directness, which led one critic to call *Olympia* a "free daughter of Bohemia, artist's model, butterfly of the brasseries . . . with her cruel, childlike face and eyes of mystery." The black velvet lace around her neck serves to stress her nakedness.

opposite :

ÉDOUARD MANET. *The Balcony*. 1868. Oil on canvas. 66 1/2 x 49 1/4 in. (169 x 125 cm).
Musée d'Orsay, Paris.

It is generally believed that Manet conceived this scene of modern life with three friends posing behind the railing of a balcony during the summer of 1868 at Boulogne-sur-Mer. The seated woman is the painter Berthe Morisot, who became a close friend to Manet. On the right is Fanny Claus, a young concert violinist, and in the background stands the painter Antoine Guillemet. The violent greens on the metal bars and shutters and the striking blue of the cravat are still arresting today.

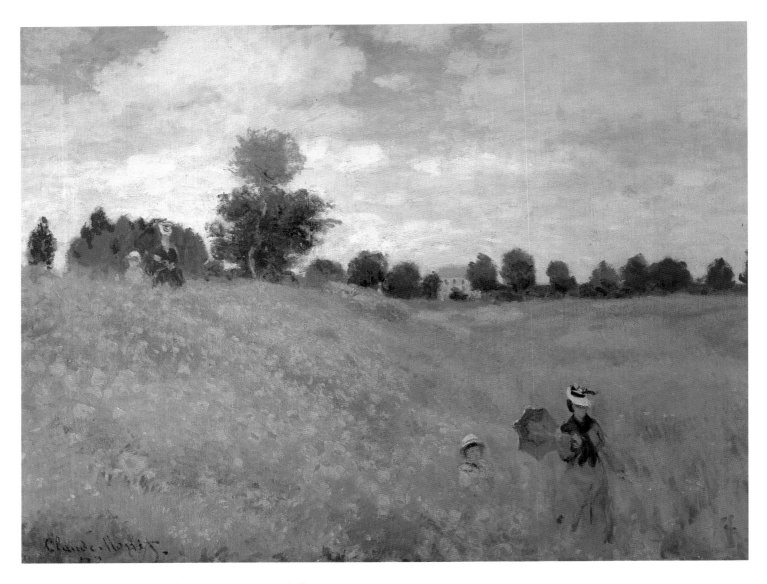

CLAUDE MONET. *Field of Poppies.* 1873. Oil on canvas.
19 3/4 x 25 1/2 in. (50 x 65 cm). Musée d'Orsay, Paris.

Exhibited at the first Impressionist show of 1874, this work has become one of Monet's most famous paintings. It shows his wife, Camille, with a blue parasol, and his son, Jean, walking through a field of high grass and red poppies at Argenteuil. A second figure group on the hilltop probably represents the same people caught at an earlier moment. In both instances, the figures are completely integrated into the landscape.

CLAUDE MONET. *The Artist's Garden at Giverny*. 1900. Oil on canvas.
31 7/8 x 36 1/4 in. (81 x 92 cm). Musée d'Orsay, Paris.

After he became successful and prosperous, Monet bought a house and some land in Giverny, where he immediately set up a garden that was a floral paradise. He himself carefully selected the colors of the flowers to plant so that they would create the specific coloristic effects he wanted to capture on his canvases.

CLAUDE MONET. *The Water Lily Pond: Green Harmony*. 1899. Oil on canvas.
35 1/4 x 39 7/8 in. (89.5 x 100 cm). Musée d'Orsay, Paris.

The small Japanese-style bridge spanning his water lilies pond at Giverny became one of the most
successful motifs in Monet's later works. He rendered it several times in almost identical versions, but each
time in different tonalities.

CLAUDE MONET. *Blue Water Lilies.* c. 1916–19. Oil on canvas.
78 3/4 x 78 3/4 in. (200 x 200 cm). Musée d'Orsay, Paris.

During the time Monet was occupied with his large decorative panels of water lilies, he also painted separate canvases of the same subject, which are unrelated to the cycle. It is hard to say whether he intended to sell them individually, although once his wartime paintings became known, they were immediately sought after by critics and collectors.

PIERRE-AUGUSTE RENOIR.
Ball at the Moulin de la Galette.
1876. Oil on canvas.
51 1/2 x 68 7/8 in. (131 x 175 cm).
Musée d'Orsay, Paris.

The open-air dance hall Moulin
de la Galette, which took its
name from a defunct windmill
on the top of the Montmartre in
Paris, was a highly popular meet-
ing place for young Parisians on
Sunday afternoons. Couples
sprinkled with sunlight are
dancing or talking in a free and
relaxed atmosphere. Several eyes
are looking out of the picture
as if to invite a casual stroller in.

PIERRE-AUGUSTE RENOIR.
Dance in the Country.
1883. Oil on canvas.
70 7/8 x 35 1/2 in.
(180 x 90 cm).
Musée d'Orsay, Paris.

The artist's wife, Aline, posed
for this painting together
with their friend, Paul Lhote.
Not afraid of showing her
sympathy for her dance
partner, Aline represents the
perfectly harmonious, loving
woman that Renoir knew.
Pride and dignity are paired
here with obvious enjoyment
of a pastime.

PIERRE-AUGUSTE RENOIR. *Woman Reading (La Liseuse)*. 1874. Oil on canvas.
17 3/4 x 14 1/2 in. (45 x 37 cm). Musée d'Orsay, Paris.

In this charming study, a young woman reading a book apparently finds pleasure in her activity judging by the smile on her face. The close-up perspective and the intimate character of this well-known work make the viewer feel like an intruder, particularly considering the small size of the canvas.

EDGAR DEGAS. *Dance Class.* Begun 1873, completed 1875–76. Oil on canvas.
33 1/2 x 29 1/2 in. (85 x 75 cm). Musée d'Orsay, Paris.

The present scene appears to represent a break during a dance class, when the students relax. The light and almost translucent handling of the paint make Degas's efforts almost unnoticeable. It was his first attempt at a large-scale dance scene commissioned by the famous baritone and art collector Jean-Baptiste Faure.

EDGAR DEGAS. *Blue Dancers.* c. 1893. Oil on canvas.
33 7/16 x 29 3/4 in. (85 x 75.5 cm). Musée d'Orsay, Paris.

The intensity of the pervasive blue and the similar rhythmic arrangement of the dancers' arms relate this work
to a pastel in the Pushkin Museum in Moscow. Here, the emphasis has been shifted toward a higher degree
of abstraction, where color, form, surface, and scale are the main concern.

MARY CASSATT. *The Caress*. 1902. Oil on canvas. 32 7/8 x 27 3/8 in. (83.4 x 69.4 cm).
National Museum of American Art, Washington, D.C. Gift of William T. Evans.

Many of Cassatt's mother-and-child groups, like this one, are modeled after Italian Renaissance paintings of the
Madonna and Christ Child. During her eight-month stay in Parma, Italy, in 1871, Cassatt had the opportunity
to study closely the works of Correggio and Parmigianino. The bold Mannerist curve of the baby's body dominates
the composition which is framed by the protecting arms of the mother. Her striking emerald blouse and lavender
skirt are proof of the painter's skills as a colorist. The blond girl about to caress the baby's face was a model
named Sara and appears frequently in Cassatt's later paintings.

BERTHE MORISOT. *The Cradle.* 1872. Oil on canvas.
21 1/4 x 18 1/8 in. (54 x 46 cm). Musée d'Orsay, Paris.

The Cradle has been a popular painting since it was exhibited at the First Impressionist show in 1874. Morisot, who was a student of Manet, as well as his brother's wife, tended to restrict her themes to the world of women. The painting was prompted by the birth of her sister Edma's baby, Blanche, in 1871. Tender pastel-like colors provide softness and a sense of intimacy.

ALFRED SISLEY. *The Bark During the Flood, Port Marly.* 1876. Oil on canvas.
20 x 24 in. (50.5 x 61 cm). Musée d'Orsay, Paris.

Like Monet, Sisley was primarily a landscape painter, living and working in rural communities on the Seine river where he could observe and record familiar surroundings from season to season. His palette always remained somewhat subdued and never achieved the intense color of the later Monet. Here, he caught a rare event, the aftermath of the flooding that devastated Port Marly by the waters of the Seine river.

CAMILLE PISSARRO. *Hoar Frost.* 1873. Oil on canvas.
25 1/2 x 36 1/2 in. (65 x 93 cm). Musée d'Orsay, Paris.

Pissarro adopted elements from other Impressionist painter friends, including Claude Monet. The traditional theme of the hardship of a peasant's life has been transformed into a study of radiant colors and atmosphere on a cold winter day. A single peasant is carrying a bundle of branches over his shoulder along a wide path across plowed fields. Having no defined foreground or background, the artist fuses near and far.

GUSTAVE CAILLEBOTTE. *Le Pont de l'Europe, Paris.* 1876. Oil on canvas.
49 1/4 x 70 7/8 in. (125 x 180 cm). Petit Palais, Geneva.

Contemporary urban street scenes became a subject of interest to several Impressionist painters. Perhaps Caillebotte's most important contribution is this view of the Pont de l'Europe, a bridge behind the St. Lazare train station. A prominent feature is the grey cast-iron structure, which leads the eye to a distant focal point. Pedestrians are wearing dresses of similar grey as if they identify themselves with the new age of steel and iron.

JOHN SINGER SARGENT. *Claude Monet Painting at the Edge of a Wood*. c. 1887. Oil on canvas.
42 1/8 x 54 1/4 in. (107 x 137.8 cm). The Tate Gallery, London.

The American-born but European-trained painter John Singer Sargent enjoyed a close friendship with Claude Monet, with whom he painted occasionally out-of-doors. Here, Sargent observed his colleague while painting a landscape at the edge of the woods. Clearly emulating Monet's loose brushwork, Sargent intended this painting to be a tribute to his friend. The woman to the right, dressed in white, is Alice Hoschedé, Monet's companion.

following page:

CHILDE HASSAM. *Isle of Shoals Garden or The Garden in Glory*. 1892. Watercolor on paper.
19 15/16 x 13 7/8 in. (50.8 x 35.2 cm). National Museum of American Art, Washington, D.C.

Attracted by a summer salon of artists and writers revolving around the noted essayist and poet Celia Thaxter (1835–94), Hassam went to Appledore off the coast of Maine during the mid-1880s. There he discovered Thaxter's informal, opulent flower garden, which became one of his—and several other artists'—favorite subjects. The Impressionistic technique of small color dots bathed in sun-drenched light evokes the fragility of this paradisal garden on the wind-swept shores of the Atlantic Ocean.

PAUL SIGNAC. *The Red Buoy, St. Tropez.* 1895. Oil on canvas.
31 7/8 x 25 1/2 in. (81 x 65 cm). Musée d'Orsay, Paris.

Signac, who owned a house near St. Tropez on the French Riviera, was attracted by the harsh Mediterranean light, which brought out the brilliant colors seen in this canvas. Among the artist's recurrent motifs were harbor scenes in which boats are reflected in the undulating surface of the water. The bold juxtaposition of bright hues are still striking for today's viewer.

GEORGES SEURAT. *Le Cirque (The Circus)*. 1890–91. Oil on canvas.
73 x 60 in. (185.5 x 152.5 cm). Musée d'Orsay, Paris.

This composition is marked by multiple points of view since Seurat was thinking in terms of decorative surface and line rather than depth of space. Somewhat puzzling is the relationship between the female performer and the white horse as well as the clown's position at the bottom. The painting was uniformly executed in Seurat's pointillist technique, which extended even to the blue painted frame. It was the artist's last work.

PAUL GAUGUIN. *Arearea ou Joyeuses.* 1892. Oil on canvas.
29 1/2 x 37 in. (75 x 94 cm). Musée d'Orsay, Paris.

Although he was not the only artist of the "fin de siècle" yearning for the simple life of nature, Gauguin was
certainly one of the most important defenders of an idealized, primitive lifestyle. He found his unspoiled paradise
in Tahiti, where he lived for several years. The almost archetypal simplicity of the two women amid a colorful
tropical world makes them appear to be primordial goddesses of nature.

PAUL GAUGUIN. *The Meal, Bananas.* 1891. Oil on paper, transferred to canvas.
23 3/8 x 36 1/4 in. (72 x 92 cm). Musée d'Orsay, Paris.

Painted not long after the artist's arrival in Tahiti, this work captures the exotic atmosphere of the island and its
inhabitants, whom Gauguin admired for their traditional lifestyle. The composition is based on several horizontals,
thus stressing the immediacy of the scene. Three children are standing behind the table, but seem to have no
relation to the objects placed before them.

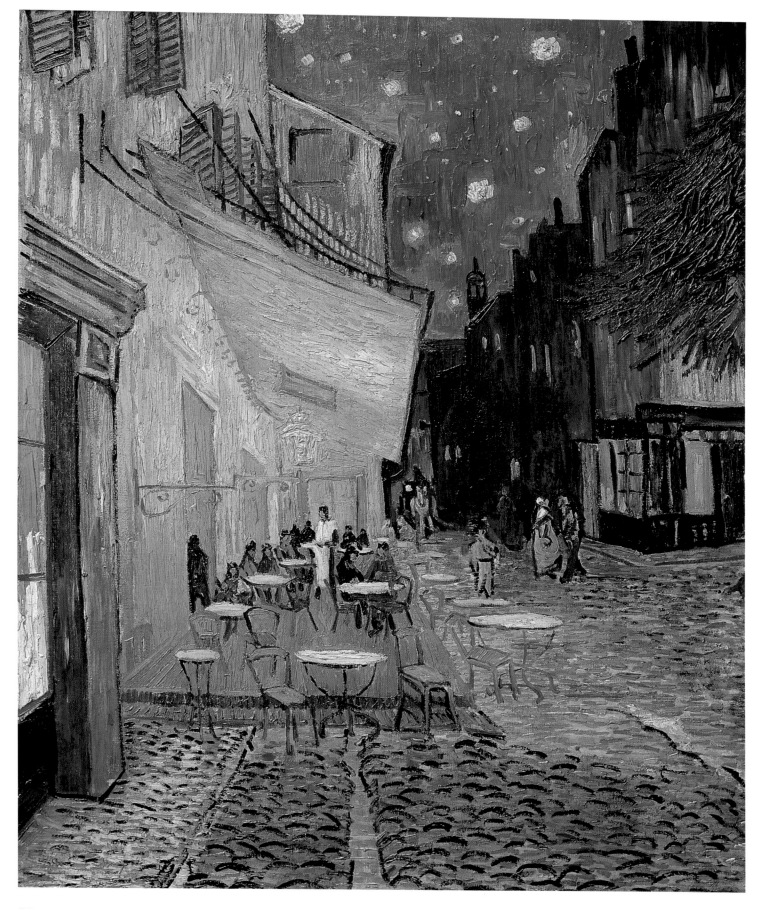

Vincent van Gogh. *Café Terrace on the Place du Forum*. 1888. Oil on canvas.
31 7/8 x 25 3/4 in. (81 x 65.5 cm). Rijksmuseum Kröller-Müller, Otterlo.

This painting was executed at night *in situ* during a fine summer evening. The illuminated terrace with its glowing yellow, and the strollers on the cobbled street walking in the calm atmosphere of their small town, make this one of the most peaceful works in Van Gogh's entire career.

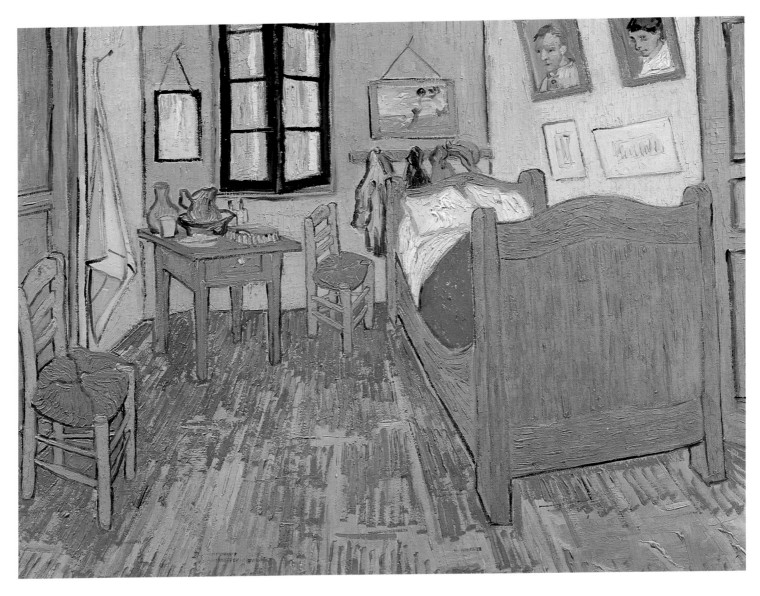

VINCENT VAN GOGH. *The Bedroom.* 1889. Oil on canvas.
22 1/4 x 29 in. (56.5 x 74 cm). Musée d'Orsay, Paris.

This neat, tidy bedroom—Van Gogh called in an "interior without anything"—is one of the artist's most successful works. On the walls of the room are displayed some of his own canvases. Intimacy and domesticity are accompanied by a harmonious balance of various color fields. The present painting is the third version of this motif, painted in the Yellow House. In a letter to his brother, Theo, Vincent recommended that the work be given a simple wooden frame.

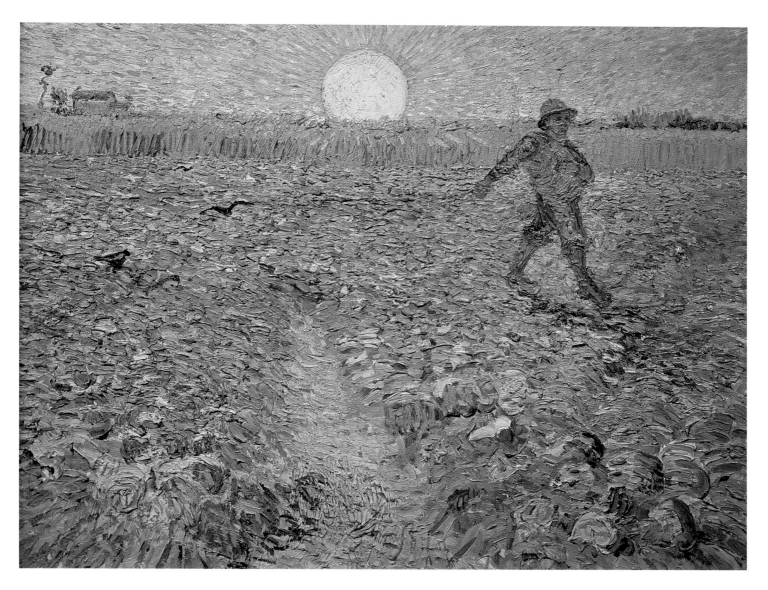

VINCENT VAN GOGH. *The Sower.* 1888. Oil on canvas.
29 1/8 x 36 5/8 in. (64 x 80.5 cm). Rijksmuseum Kröller-Müller, Otterlo.

The Sower is one of the few figure scenes Van Gogh painted of his own invention. Although he was later unsatisfied with the result, the motif of the sower haunted the artist for some time. The bold colors—especially the bright yellow of the rising sun—and their violent juxtaposition make this painting truly a novelty in its time.

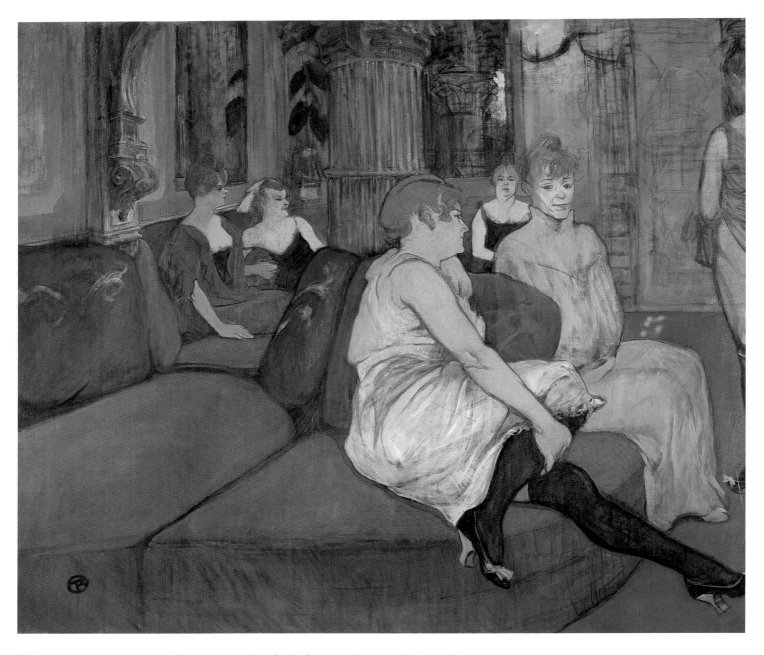

Henri de Toulouse-Lautrec. *In the Salon at the Rue des Moulins.* c. 1894.
Charcoal and oil on canvas. 43 7/8 x 52 in. (111.5 x 132.5 cm). Musée Toulouse-Lautrec, Albi.

Judging from the careful preparation and its substantial scale, this canvas was intended by Lautrec to be a major statement on the subject of the brothel. The plum-colored divans and dark coral pink of the walls provide a warm ambience, accentuated by the green of the architectural elements. The composition does not offer a precise reading of its narrative, nor can the locale be identified with certainty in spite of its traditional title; the women's faces are almost expressionless and the atmosphere seems to be silent.

opposite :

Henri de Toulouse-Lautrec. *Jane Avril Dancing.* 1892. Oil on cardboard.
33 5/8 x 17 3/4 in. (85.5 x 45 cm). Musée d'Orsay, Paris.

The white muslin dress, the plumed hat, and the swirling black petticoats are the predominant features in this rendering of the famous dancer who is kicking her left leg sideways in one of the dance figures that won her so many admirers. Lautrec's friend Paul Leclerq described the scene: "In the midst of the crowd, there was a stir, and a line of people started to form: Jane Avril was dancing, twirling, gracefully, lightly, a little madly; pale, skinny, thoroughbred, she swirled and reversed, weightless, fed on flowers; Lautrec was shouting out his admiration."

PAUL CÉZANNE. *The Cardplayers*. 1892–95. Oil on canvas.
17 3/4 x 22 1/2 in. (45 x 57 cm). Musée d'Orsay, Paris.

The result of year-long studies on the subject of cardplayers and pipe smokers, this painting has rightly been regarded as one of Cézanne's greatest achievements. Concentrating on only two figures emerging from a dark background with its harmony of purple, deep blue, black, reddish brown, and yellow-tan, the atmosphere is mysterious and dark, full of somber and serious meditation.

PAUL CÉZANNE. *Mont Sainte-Victoire above the Tholonet Road*. 1896–98. Oil on canvas.
30 3/4 x 39 in. (78 x 99 cm). Hermitage, St. Petersburg.

The narrow winding road of Le Tholonet is seen from a slightly elevated viewpoint with the Mont Sainte-Victoire in the distance. Two umbrella pines, one behind the other, cast their combined shadow on the road. Cézanne applied the paint with thin layers onto the canvas. The bright orange of the earth is complemented by the brilliant green of the vegetation. The subtly modulated mountain is more pink than blue, which has been reserved for the sky alone.

The Twentieth Century

Age of -isms

THE CHANGES THAT MARKED NINETEENTH-CENTURY art have been surpassed in swiftness and variety only by those of our own time, as dramatic as the trajectory from horse-drawn carriages to space travel. The technological advances of our time have opened every corner of the world, eradicated centuries-old diseases, and altered forever the way we communicate with and relate to one another. Paradoxically, another characteristic of our century is an uneasy sense of alienation. As art has continued its evolution, it has reflected the social, political, and existential concerns of the century. Artists have drawn on war, the processes and achievements of the machine age, psychoanalysis, democracy, sexuality, and popular culture for both subject and style.

The twentieth century is an era of "isms," and this is as true in the realm of the visual arts as in political thought. The fragmentation of artistic styles—Fauvism, Cubism, Surrealism, and Abstract Expressionism, to name a few—speaks to the rapidly shifting planes of the era, made possible in part by the increasing ease of travel and the proliferation of mass media such as lithography, photography, and, most recently, video. Perhaps because much painting of the modern era manifests a highly individual expression, or represents an instance of a philosophical investigation, it can sometimes strike viewers as arcane or forbidding. Gone are discernible objects in usual relations to one another and to space; in their place may be pure form or color. In its twentieth-century incarnation, painting has been released, sometimes with a struggle, from the bounds of illusionistic representation that was a vehicle of meaning for centuries. Sometimes this process has been motivated by an increasing individualism that has worked both ways. Not only is the artist free to paint from the inside out, but a number of painters have sought to stimulate viewers to respond with equal sincerity and spontaneity to a work of art.

Until World War II, Europe was still the center of the art world, though exchanges were frequent between the United States, Europe, and Latin America, especially Mexico. Following World War II,

MARC CHAGALL. *Memories of Paris.* 1976. Oil on canvas.
28 3/4 x 21 1/4 in. (73 x 54 cm). Private Collection.

America, specifically New York, assumed prominence, as refugees fled the devastation of the Old World. The prolific cross-fertilization of movements across decades and borders, however, permits only a sampling of the magnificent variety of the century, and of the personalities of this epic quest.

Painters, especially in the last quarter of the nineteenth century, were open to the pervasive influence of certain scientific developments. For example, Georges Seurat applied color theories and optics in his work. Cézanne, Monet, Renoir, and other Impressionists conducted investigations into the use of color. Cézanne went further, evolving a style in which color modulations structured an object's formal properties and a painting's composition; he is generally considered among the first modern artists.

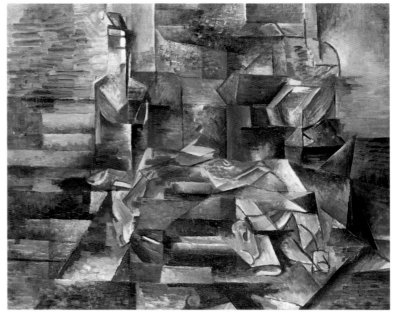

GEORGES BRAQUE. *Bottle and Fishes.* c. 1909–12. Oil on canvas. 24 1/4 x 29 1/2 in. (65.1 x 75 cm). The Tate Gallery, London.

CUBISM

In the first decade of the new century, Pablo Picasso (1881–1973) and Georges Braque (1882–1963) were creating a revolutionary new style of painting. Around 1907 both artists separately and then together began to experiment with a dissolution of the object, following the example of Cézanne, who late in life had begun translating the visible world into planes and cubes on the canvas, and rendering objects from more than one viewpoint at the same time. They called the new style "Cubism."

Picasso and Braque rethought the representation of three-dimensional space. In Picasso's *Portrait of Ambroise Vollard* (1910) the subject of the picture is barely discernible. The figure has exploded into shifting planes, determined by several different points of view. Some facial features remain—as Cubism developed, these references would become even more abstract—but all is angular, and faceted. Typical of Analytical Cubism, the palette is monochromatic. Each plane is modeled with short brushstrokes, suggesting three-dimensionality, but exaggerating the flatness of the picture plane as well. During the Renaissance, the picture frame had become a window into a separate but illusionistic space. Conventions of perspective, modeling, and color captured the three-dimensionality of objects on a two-dimensional surface. The Cubist revolution created a totally new way of representing objects in space.

Both Picasso and Braque toyed with notions of real and illusionistic space in their pictures of around 1912. They began to glue bits of newspaper, oilcloth, and other mundane materials onto the canvas. They also began to simulate in paint the same everyday objects, so that the distinction between what is "real" and what is represented becomes even further blurred. This application of physical, non-paint materials to a support is called "collage," from *colle*, or "glue."

In 1912 Picasso made his first real collage, titled *Still Life with Chair Caning*. The "painting" portrays objects on a tabletop: a pipe, a glass, a lemon, and a knife. The objects—and the title—stake the picture's claim to a place in the grand tradition of European painting, despite the homely, tattered details. The painted letters JOU are the first three letters of *journal*, French for "newspaper." The top part of the picture is done in the now familiar Cubist style of shifting planes; in the lower half,

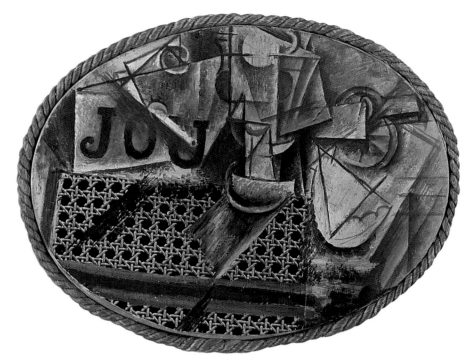

PABLO PICASSO. *Still-Life with Chair-Caning.* 1911–12. Oil and pasted paper simulating chair-caning on canvas. 10 5/8 x 13 3/4 in. (27 x 35 cm). Musée Picasso, Paris.

Picasso pasted a piece of oilcloth printed to look like chair caning, creating an illusion within an illusion. The chair caning is meant to be the top of the table, and we see this from two points of view at once—from above (the chair caning) and from straight on (the objects on top). As a further play on reality, the

shape of the picture itself is round, like a table. Finally, the whole is framed by a (real) length of rope. On several levels, *Still-Life with Chair Caning* plays with and makes jokes about our ideas of painting and of reality, and of what reality means within the limits of a two-dimensional surface.

Picasso, the most versatile and productive painter of the twentieth century, initiated or experimented with a variety of stylistic innovations over the course of his long life. He continued to turn his earliest investigations into new ways to describe objects in space from multiple viewpoints. In 1937, he brought these principles of Cubism to the height of emotive power in *Guernica*, one of his best-known paintings. The painting commemorates the brutal slaughter and destruction caused by the bombing by German planes of the Basque town of Guernica in that year. The palette has been reduced to a monochromatic range of greys, black, and white, as if to say that no brightness could illuminate such a scene. A woman at the extreme right falls terrified from a burning building.

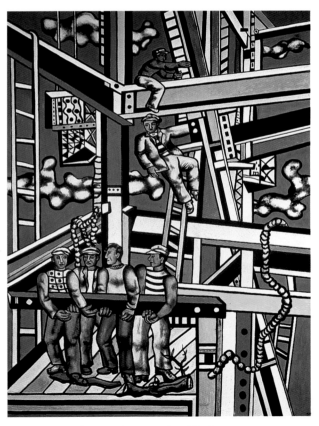

FERNAND LÉGER. *Construction Workers.* 1950. Oil on canvas. 118 x 78 3/4 in. (300 x 200 cm). Musée National Fernand Léger, Biot, France.

At the extreme left a mother wails over her dead child. In the center a triangle made up of the woman rushing in from the right, the wounded soldier on the left, and the screaming head of the horse at the apex, gives the dislocated composition a curious stability. But within the triangle, chaotic confusion and panic are conveyed through the succession of overlapping planes. The scene is lit by a bare incandescent bulb, whose jagged rays add to the overall feeling of despair. Deeply felt, and still profoundly shocking today, *Guernica* sums up the sheer horror of war.

The impact of the Cubist revolution on the art of the rest of the century cannot be overstated. The principles that Picasso and Braque developed—the multiplication of points of view and the abstraction of the painted object—were quickly absorbed by the artists that followed, who in turn transformed them into their own personal visions.

Fernand Léger (1881–1955) and Robert Delaunay (1885–1941) explored Cubist principles in different directions. Léger took Cubism to the point of total abstraction until 1914, but after four years at war returned to representation, though he infused it with his Cubist experience. His wartime experiences also left him deeply committed to people of the working class, and his subjects thereafter were often of daily life such as *The Construction Workers* of 1950. This picture is typical of Léger's later style, with its emphasis on geometry and its bright, primary colors.

Delaunay's Cubist investigations moved away from the monochromatic color scheme of Analytical Cubism and into a world of brightly colored abstractions, where the circular, rather than the rectilinear, predominates. Delaunay looked back to the color theories of the nineteenth century, and his paintings, like *Circular Forms*, of 1914, are swirling symphonies of contrasting color and graduated forms. His use of the word "symphony" is significant here, for the avant-garde poet Guillaume Apollinaire had dubbed the style of painting developed by Delaunay and his followers "Orphism," underlining the musical correspondences in their work.

FAUVISM

In the decade preceding World War I, Fauvism emerged alongside Cubism in France. The word *fauve* in French means "wild"; the *fauve* painters were so called by a critic who, seeing a work recalling that of the Renaissance sculptor Donatello amidst a profusion of brightly colored pictures at the Salon d'Automne in 1905, exclaimed, "Donatello au milieu des fauves!" ("Donatello among the wild beasts!"). With roots in the color studies of Seurat and Gauguin, the Fauve palette is vivid and sharp, rendered with discernible brushstrokes, and broad, flat planes in acid tones. Shapes are formed freely as masses of color with little attention to detail. Like their Cubist confreres (Braque was influenced by Fauvism), these artists abstracted the traditional subjects they painted—landscapes, portraits, still lifes—except that they used color to give their pictures a highly charged emotional key.

The Fauves included Henri Matisse (1869–1954), André Derain (1880–1954), and Maurice de Vlaminck (1876–1938). Derain's *Old Waterloo Bridge, London* (1906) is a good example, painted in a Neo-Impressionist patchwork of brushstrokes where rich color predominates. Here the orb of the sun, unseen but implied, showers the city with a rain of yellow and orange, while the river moves toward the horizon, a flickering mass of blues.

As a movement, Fauvism was not long lived—by 1908 it was essentially over—but its legacy has

endured throughout the century. Matisse was the innovator and leader of the group; around 1903 he began to paint with the new palette, and color, refined and complex, remained the hallmark of his work throughout his long career, regardless of his subsequent styles.

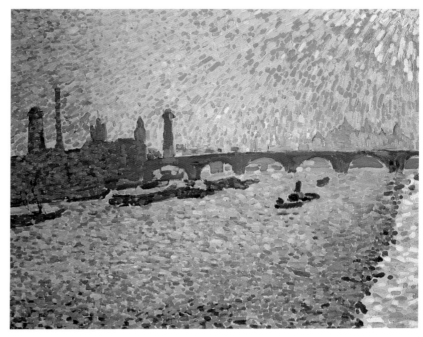

ANDRÉ DERAIN. *Old Waterloo Bridge, London.* 1906. Oil on canvas. 31 5/8 x 39 3/4 in. (80.5 x 101 cm). Fundacion Colleccion Thyssen-Bornemisza, Madrid.

Harmony in Red, painted in 1908, shows Matisse's coloristic preoccupations at the end of the Fauvist movement. The greater part of the painting is taken up with a single broad area of deep red, smack up against the picture plane, defying the limits of the room. Where does the table end and the wall begin? They are almost undifferentiated, except for the direction of the pattern that they share, and the chair and the figure placed between them. In the upper left of the painting there is a view out a window—or is it a painting within the painting? Without seeming to, traditional perspective still reigns here. The lively allover, obviously freehand, design of lines and shapes calls attention to the painting's two-dimensional identity, while the figure, with its rounded Fauve forms and extremely understated modeling, is almost a cartoon, her constituent elements reduced to a series of areas of color.

Matisse continued to paint with Fauve-like contrasts of color, further enriched following trips to Morocco and the South of France, where the bright light inspired a new realm of coloristic effects. As a final expression of his continuing love of color, at the end of his life, when he could no longer hold a brush easily, Matisse began to "paint" with pieces of painted paper cut into bold shapes and pasted on paper. In 1947 he published a limited-edition book, *Jazz,* with both text and illustrations by him. The plate of *Icarus* pares to its simplest forms

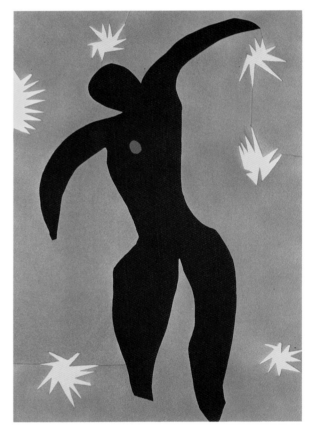

HENRI MATISSE. *Icarus,* from *Jazz.* 1947. 12 13/16 x 8 5/16 in. (21.1 x 32.6 cm). Lithograph. École des Beaux-Arts, Paris.

the story from Greek mythology of the boy who flew too close to the sun. Though the tale ends in tragedy, the accompanying text emphasizes the exhilaration of flight. The black figure, his red heart prominent in his chest, falls through a deep blue sky punctuated by yellow stars—or is he rising weightless into the firmament? The Fauves' contribution to—or subversion of—the development of Western

art consisted chiefly in a seductive yet shocking use of color. Their approaches were still painterly, and their subjects still well in the nineteenth-century mainstream.

EXPRESSIONISM

In Germany, in particular, a third current was taking shape, also in the years before World War I; after the war it would inform not only painting and printmaking but the new medium of film. Expressionism, like Fauvism, would wrench emotion from color, while, looking to Cubism, its practitioners manipulated lines, planes, and other traditional representational devices, until, eventually, Expressionism would delete the figure altogether.

At the beginning of the century, several different groups of artists in Germany exhibited together with shared concerns and aims. One of the first of these was called Die Brücke (The Bridge), founded by four architectural students in Dresden, Ernst Ludwig Kirchner (1880–1938) and Karl Schmidt-Rottluff (1844–1976) among them. The members of the group believed that artists were driven by an inner creative force, and looked to Van Gogh as their spiritual forerunner. They also studied, with great enthusiasm, ethnographic models and Gothic German art. The group's name referred to the metaphor of a bridge from the present to the future, to be constructed by means of the unstinting depiction of emotional power and social criticism.

Kirchner's *Berlin Street Scene* of 1913 is painted in a style that owes a debt to both Fauvism in its coloristic effects and Cubism in its angularity. Though at first glance the painting appears to show just what

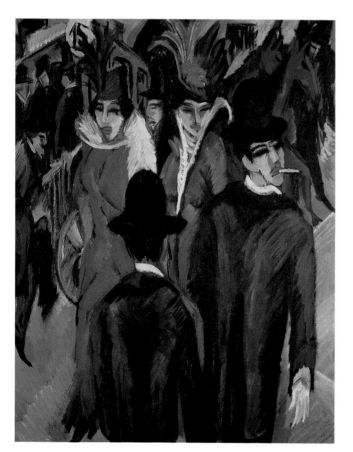

Ernst Ludwig Kirchner. *Berlin Street Scene.*
1913. Oil on canvas. 47 5/8 x 37 1/2 in. (121 x 95.3 cm).
Brücke Museum, Berlin.

its title states— people walking on the street—it is electric with tension, and specifically, sexual tension. Blatantly, the phallic hat of the foreground man pierces the V-shaped space between the two women coming toward him. Yet there is no interaction between any of the figures; if anything, there is a pointed disregard between them, a studied non-interest. The frustrations inherent in this dichotomy of sex without longing makes for the unsettling feel of the picture, underscored by the awkward poses of the figures.

The legacy of Die Brücke was taken up after the war by Max Beckmann (1884–1950), George Grosz (1893–1959), and Otto Dix (1891–1969), whose paintings offer powerful social commentary on what they saw as Germany's moral decline. Dix's *Grosstadt (The Big City,* 1927) is a deadpan commentary on the decadence of contemporary nightlife.

Der Blaue Reiter (The Blue Rider) was another prominent group, formed in Munich, and founded

by Franz Marc (1880–1916), Wassily Kandinsky (1866–1944), and Paul Klee (1879–1940). The name comprises themes particular to Marc and Kandinsky. Marc's preferred color was blue and his favorite animal was the horse, while Kandinsky had repeatedly used the figure of a horse and rider in his works, and in fact had done a painting with that title. They published a book, also called *Der Blaue Reiter*, which included writings about art and music, works by members of the group, examples of "primitive" art, and the art of children, among other things. The Blaue Reiter artists perceived the works of the "primitives" and children as examples of spontaneous expression, unadulterated by any training. The reachievement of such pure art was one of the group's aims.

Kandinsky, who had been painting since the turn of the century, became increasingly interested in the spiritual, and in the dematerialization of the object. In 1912, he published a sort of manifesto called *Concerning the Spiritual in Art,* in which he codified his belief that art should be based not on the representational but on an inner life, removed from the conventional portrayal of "things." Yet total abstraction was not the solution, as it ran the risk of degenerating into simple decoration. In *The Red Spot*, the red spot of the title glows in the upper left of the picture while around it squirm and morph a variety of shapes and colors. Specific objects have been replaced by color, line, shape, and movement, through which emotion is conveyed.

Klee believed that art arose from the personal experience of the artist, whether on a conscious or subconscious level, and this may explain why he was one of the most individual artists of the twentieth century, with a career that encompassed many styles. Like Kandinsky, with whom he was close friends, Klee made correlations between art and music. Also like Kandinsky, he was interested in the unselfconscious art of children, and many of his works have a childlike quality of playfulness and wonder at the world. His *Battle Scene from the Comic Opera "The Seafarer"* shows the seafarer on a tiny boat, set amid a post-Cubist grid, attempting to fight off fearsome sea monsters with a seemingly inadequate lance. The monsters look rather more comical than nasty—should the lance prove ineffectual the seafarer might not make out so badly—and the whole has a sprightly feel.

FUTURISM

Meanwhile in Italy, a group had formed, inspired by an iconoclastic social vision of modernism, as well as artistic principles akin to those of the Cubists. They called themselves Futurists, and based many of their ideas on the literary works of Filippo Tomasso Marinetti (1876–1944), who declared that the Italian legacy of art and literature was a burden to be destroyed, and that a new

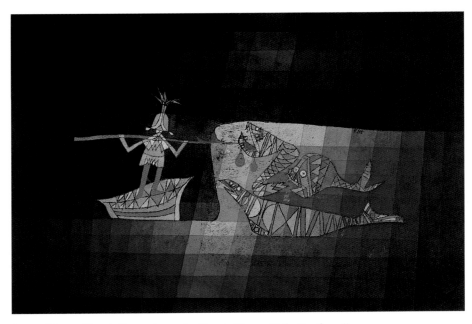

PAUL KLEE. *Battle Scene from the Comic Opera "The Seafarer."* Collection Tris Duerst-Haass, Basel.

culture should rise in its place, based on the speed of the new machine age. The Futurists, whose members included Gino Severini (1883–1966) and Umberto Boccioni (1882–1916), sought to capture the effects of the tumultuous world around them—one transformed by machines—on canvas and in sculpture. Boccioni's *Riot in the Gallery* (1910) is painted in an almost Neo-Impressionist style, which, combined with the urgent surging of the crowd, and the bright flashes of light coming from the gallery, creates an excited painting full of movement.

SUPREMATISM

Cubism developed in a very specific direction in Russia in the second decade of the century. The inventor and main practitioner of this movement, known as Suprematism, was

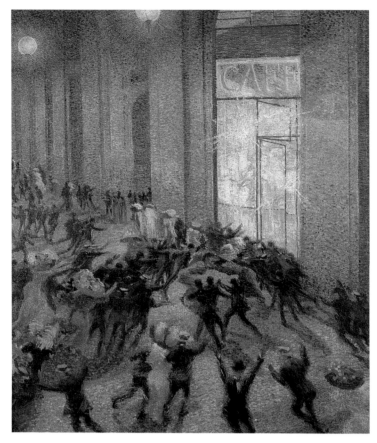

UMBERTO BOCCIONI. *Riot in the Gallery.* 1910. Oil on canvas. 30 x 25 1/4 in. (76 x 64 cm). Pinacoteca di Brera, Milan.

Kazimir Malevich (1878–1935). His is an art of pure geometry—squares, rectangles, triangles, circles, and lines—in space. For Malevich, this floating quality, like flight, stood for the spiritual values of a new society; in a world less focused on materiality, objects were unnecessary. In *Dynamic Suprematism,* of 1915, a large, lightly colored triangle hovers slightly off-center on a neutral ground. On top of the triangle is a variety of shapes in solid colors, also free floating. Their placement is a traditional illusionistic device that suggests depth, some forms clearly in front, others behind. What may seem an arbitrary pattern of shapes reveals itself to be very considered. The composition creates tensions between the groups of forms at each corner of the triangle, resulting in a delicately balanced unit; it feels as if the whole would collapse if we removed one element.

DE STIJL

Utopian social ideals informed another movement as well. At the other end of Europe, in Holland, a group of artists banded together around 1917 to found a magazine and a group called de Stijl (The Style), whose aims were to provide a comprehensive visual system for all aspects of society, thus blurring boundaries and uniting the ostensibly disparate elements of life. Formally, de Stijl artists rejected all but the most basic colors—yellow, red, blue, white, black—and reduced their art to its most basic, predominantly vertical and horizontal, forms.

Piet Mondrian (1872–1944) is the best known member of de Stijl. He had embraced Cubism, then pushed to a non-objective art that was all his own; like Malevich's, his art is one of balance through

opposition, and once he found his signature style, he explored this theme over and over again during the course of his life. *Composition in Blue, Yellow, and White,* painted in 1936, is representative. In Mondrian's vision of the world, there is an equilibrium, a poise, that underlies all natural and human expression. Every painting is an object, and Mondrian's aim in each painting was to find its particular balance of elements. This was a process that was both contemplative and painstaking, sometimes involving colored squares that the artist could move around, and often requiring painting over the grid, until he achieved the "correct" final result. Here, a grid of widely spaced black lines on a white ground is set off by sections of yellow and a section of blue at either end of the lower part. Not all the black lines reach the edges of the canvas, and the white background flows seamlessly around them, so that we are left to imagine the black lines continuing invisibly to infinity. The two rectangles of color create a tonal quiver that both balances and animates the picture, an equilibrium achieved through tension.

DADA

The carnage of World War I had a profound impact on artists all over the world. First in Zurich, in 1915, and almost simultaneously in Paris, Berlin, and New York, artists banded together in protest over the brutal destruction taking place. In a general postwar atmosphere of almost hysterical release, these artists and writers rejected traditional structures wholesale, perceiving them as hypocritical, and these included the very idea of art. In place of "fine art," which symbolized the forces that had unleashed the war, they proposed a non-art, one based on nonsense and non sequiturs. "Dada," the name they selected to stand for their enterprise, is itself a nonsense word, with no meaning except in the context of the group. Much of the art of the movement sprung from evening gatherings where the entertainment consisted of musical and spoken-word performances. Dissonance and surprising combinations of sounds, words, and thoughts were the hallmark of these evenings. Visual artists soon took up the call and began making works that attacked the very definitions of art.

Marcel Duchamp (1887–1968), a Frenchman who spent a great deal of time in New York, made the ultimate thumb-your-nose-at-great-monuments-of-Western-culture picture in his *L.H.O.O.Q.* of 1930. The picture is simply a photograph of Leonardo's *Mona Lisa,* inscribed by Duchamp with a beard and moustache. The title, read out loud in French, becomes *Elle a*

MARCEL DUCHAMP. *L.H.O.O.Q.* 1930. Photograph. 7 3/4 x 5 in. (19.7 x 12.7 cm). Private collection.

chaud au cul—"She has a hot ass." Thus are the icons of Western tradition undermined by the modern age with modern technology, in this case, photographic reproduction.

Max Ernst (1891–1976) was another Dadaist. *Celebes* (also called *The Elephant Celebes*) is an odd, enigmatic painting, but it manifests Ernst's belief in the power of psychology—he was in fact trained in that discipline—and of symbols. The use of disparate elements here follows from Ernst's experiments with collage, for which he combined arbitrary clippings from a variety of printed sources. In the picture, a strange metal creature, part animal, part machine, with a hose or trunk protruding from its center, is set in a desolate landscape. The creature has definite elephantine features—trunk and tusks—while the title of the picture recalls the nasty bits of verse passed around by the boys at Ernst's school describing various Asian elephants (to wit: "The elephant from Celebes has sticky, yellow bottom grease. The elephant from Sumatra always fucks his grandmamma. The elephant from India can't find the hole ha-ha."). On top of the creature is a collection of forms from which an eye stares out. At the bottom right a headless female figure beckons the creature; just behind where her head would be, and in place of it, rises a stack of coffeepots. The whole is a bizarre assemblage of unrelated and imagined objects, a stream of Ernst's consciousness.

SURREALISM

Coming directly out of the liberating influence of Dada, the Surrealists looked inward to the world of the mind for inspiration. The French writer André Breton (1896–1966) had launched Surrealism as a literary genre in the mid-1920s, with the aim of freeing the artistic process from the bonds of the logical and rational. Their influence, still easily visible today, has endured. Chance juxtapositions, free association, and automatic writing were methods the Surrealists used to unlock the subconscious and release it from the constraining norms of behavior that civilization imposes. Less aggressive than those of the Dadaists, the works of the Surrealists share a dreamlike quality, in which seemingly unrelated objects come together in odd spaces. Or, in the case of the Belgian René Magritte (1898–1967), where the commonplace may be set suddenly off kilter by the addition of a bizarre element.

In Magritte's work, objects and titles are often at odds. In *La Grande Guerre (The Great War)*, for example, a woman dressed all in white, with a white hat and parasol, stands at a parapet looking over the sea; her face, however, is totally obscured by a posy of violets. To what does the war of the title refer? As a Surrealist, Magritte raised questions about the relation between objects and their names; for example, he inscribed a

RENÉ MAGRITTE. *La Grande Guerre (The Great War)*. 1964. Oil on canvas. 31 1/2 x 24 in. (80 x 61 cm). Private collection.

very realistic painting of a pipe with the words "this is not a pipe." The straight-faced realism and high finish of his paintings further underscore their strangeness; at the same time, the conventionally accurate representation forces the viewer to discover the paradoxical, sometimes violent, subject of a work.

The Spanish artist Salvador Dalí (1904–1989) has become for many the quintessential Surrealist. Dalí was an individual of reckless and often offensive character, much of it reflected in his work, which encompassed sculpture, jewelry, and filmmaking, as well as painting. His brand of Surrealism is certainly brasher than Magritte's. The wildly titled *Dream Caused by the Flight of a Bumblebee Around a Pomegranate a Second before Awakening* (1944) has roaring tigers—regurgitated by a fish, who in turn springs from the title pomegranate, rawly painted—about to pounce on a sleeping nude woman, while an elephant with absurdly long, skeletal legs walks along in the background. The woman is totally exposed to the violence of the onrushing beasts (and threatened by a rifle as well), not only in her nakedness but in her sleeping vulnerability. Typical of Dalí, this picture is both overtly sexual and nightmarish in its intensity.

THE MURALISTS

Across the Atlantic Ocean, in Mexico, a government-sponsored school of monumental mural painting developed in the wake of the revolution of the second decade of this century. As in Russia, and in the United States in the 1930s, murals provided textbooks for the people who came and went through public buildings. Diego Rivera (1886–1957) is the most celebrated of the artists who worked on these projects. Though he was trained in the European tradition, including Cubism in France, in his murals he returned to representation based on the figurative tradition of ancient Mexican art, in an attempt to define a national Mexican style. One of the murals for the National Palace, *The Great City of Tenochtitlán* (1945), abounds with references to the Aztec past, in a vast panorama of a bustling pre-Columbian urban endeavor.

A different kind of revolution occurred in New York in 1913, when the International Exhibition of Modern Art was held at the New York Armory. For many Americans, the Armory Show, as it has come to be known, was their first exposure to the avant-garde European developments, including Fauvism and Cubism, and was a turning point in modern American art. The well-off and the intelligentsia in the United States were already aware of the new art. The best-known example is probably that of Gertrude Stein, who in 1903 moved to Paris, where her home became a salon for vanguard writers and artists; she bought paintings by moderns such as Picasso, and in the 1910s experimented with a writing style inspired by Cubism. Other Americans were acquiring European works as well, but, except for a few collections open to the public at the owners' pleasure, there had been no opportunities for a general audience to see modern art firsthand until the Armory Show. Both collectors and artists were profoundly affected by what they saw at the show, and from its influences sprang the germ that would become The Museum of Modern Art in New York, the first museum in the country devoted to contemporary art.

As the century progressed, many European artists fleeing wars or persecution in Europe made America their temporary or permanent homes. This new influx, combined with the ongoing exchanges between European and American artists, came to shift the center of the art world from Paris to New York by mid-century.

REALISM

Still strong in American painting at the beginning of the period, realism continued to be so, in various guises, until after the Depression. The work of Paul Cadmus (b. 1904) often combines a realistic style with biting social criticism. His *Bar Italia* of 1953–55 is a hilarious look at the convergence of visitors and natives in post–war Italy. A wide variety of types converge in and around a bar set below a semi–ruinous Renaissance arcade sprinkled with graffiti. The worst American tourist types—guidebook toting, camera wielding, phrasebook waving—are given seething treatment. They are not, however, singled out for the artist's scorn; no one in the picture is safe from Cadmus's unblinking eye and poison brush. Cadmus spent several years travelling in Italy just after liberation, and this picture sums up, quite neatly, his observations.

The realism of Edward Hopper (1882–1967) is of a rather different stripe. In Hopper's quiet paintings, the settings are often desolate spaces peopled by solitary individuals. The figures in *People in the Sun* (1960) are each self-enclosed, sharing a morning together without interacting. The only connection between the figures is formal. Their shapes overlap, creating a visual bond, but there is no communication between them. Hopper's mastery of the effects of light is also evident here; strong morning sunshine throws everything into sharp relief and casts long shadows on the ground. The block of shadows both contributes to the formal relationship between the people, and emphasizes their detachment.

EDWARD HOPPER. *People in the Sun.* 1960. Oil on canvas. 40 3/8 x 60 1/2 in. (102.6 x 153.5 cm).
National Museum of American Art, Washington, D.C.

ABSTRACT EXPRESSIONISM

After World War II, the most important development in American art was also the most important development in modern art anywhere at the time: Abstract Expressionism. The origins of Abstract Expressionism lie in the works of Kandinsky and the Surrealists, but also in the release of painting from objective models that had begun at the beginning of the century. If Picasso and Matisse and others had increasingly drawn attention to the surface of their pictures, the Abstract Expressionists carried this to its logical conclusion, with surface and ground becoming one.

The Abstract Expressionists were a varied group. The signature styles

MARK ROTHKO. *Red on Maroon*. 1959. Oil on canvas. 105 x 94 in. (266.5 x 239 cm). The Tate Gallery, London.

of Jackson Pollock (1912–1956), Willem de Kooning (b. 1904), and Mark Rothko (1903–1970), for example, are very different, but share their makers' commitment to personal expression through individual style. The impressively large scale of Abstract Expressionist paintings is also worth noting. Walk into a gallery of Abstract Expressionist paintings and you immediately have the sense that something monumental is going on. The Abstract Expressionists believed in the magnitude of their efforts and were not shy about showing it.

Pollock, a former pupil of Thomas Hart Benton, was influenced both by Surrealism and Jungian symbolism. His drip paintings—*Undulating Footpath*, for example—are familiar enough now to have become almost a cliché of modern art. The immediacy that Expressionism demanded did away with the artist's brush; instead, Pollock poured and splattered paint directly on the canvas, which he had placed on the floor, allowing him access to every side of the canvas—here was an art that raised questions about right side up. Pollock applied different colors of paint in successive layers, much as Rembrandt applied his veils of varnish, to create a deeply textured effect. The paint fills the entire field of the picture in an allover pattern; although the drips are to some extent placed by chance, within the massing of drips a certain structure emerges, the tightly woven light colors of the underlayers serving to set off the topmost swirls of black. As in the earliest expressions of abstraction, a last trace of objective painting remains, in spatial relationships developed and implied between the drips and the layers of paint. The "subject" of the picture becomes the rhythmic allover pattern of the paint itself.

In de Kooning's mature works, like *The Visit* (1966–1967), a different impetus is manifest. Unlike Pollock, a fellow Action Painter, de Kooning often inserted a figural component into his work, here a

GERHARD RICHTER. *Abstract Painting (726)*. 1990.
98 1/2 x 137 3/4 in. (250 x 350 cm). The Tate Gallery, London.

woman squatting, though the figure is integrally connected to an aggressive network of brushstrokes. Here, the spatial distinctions between the figure and the "back" ground are nonexistent. De Kooning shares with Pollock an edge-to-edge approach to the canvas, in which every inch is covered. Rothko had in common with Pollock a pursuit of "the sublime," though unlike the frenzied movement of the Action Painters, Rothko's signature style pictures (like *Red on Maroon*) invite contemplation, with fields of rich color that are subtly shaded and worked. Rothko was very concerned that the viewers interact intimately with his paintings. To achieve this, he insisted that his paintings be hung low on the wall, and that the lighting be kept low, so that the viewers could look at them long and hard. The very grand scale of the paintings—some are as high as eight feet—allows the viewer to become almost overwhelmed by the colors and the emotions they evoke.

As the 1950s and 1960s progressed, some artists such as Morris Louis and Helen Frankenthaler used the ideas developed by the older generation as a starting point for their own distinctive styles, while others turned from the gestural, abstract style to other expressions entirely.

POP ART

One of these directions was Pop art. In Pop art, typified by the work of Andy Warhol (1930–1987) and Roy Lichtenstein (b. 1923), the figure as subject returns to painting. But now the figure is often a cultural icon, such as Marilyn Monroe, and the references are not only to popular culture, but to the media that spread the image. This might be photography or film in Warhol's work, or a comic book, as in Lichtenstein's (*Whaam!* 1963). Here is "low" art, in fact, image-making only grudgingly acknowledged as art at all, the product of mass-market techniques muscling into the halls of fine art. Lichtenstein wittily bridges the gap by simulating the Benday dots of photoengraving by hand. Pop images have very little emotional content, but profound resonances, as they give the everyday iconic status. Like Dada, Pop art raises questions about art and non-art, and the part of the artist. It is cool art, a far cry from the highly keyed works of the Abstract Expressionists but is seen as a precursor of a number of currents.

Late twentieth-century art is a web of many interrelations and directions, from the stark Realism of Lucian Freud, the flat portraits of Alex Katz, and the Neo-Expressionism of Gerhard Richter to the humorous Pop of Kenny Scharf. In the twentieth century, as in the millennia of art-making preceding it, artists forged a personal expression that is at the same time a piece of the boundless human enterprise.

MAURICE DE VLAMINCK. *Restaurant de la Machine à Bougival*. c. 1905. Oil on canvas. 23 5/8 x 32 in. (60 x 81.5 cm). Musée d'Orsay, Paris.

Intense, explosive, pure color roughly applied is characteristic of the work of the self-taught Fauve painter Maurice de Vlaminck. He was not concerned with an attention to details or realism, instead imbuing traditional subjects with expressionistic color and brushstroke to record immediate sensations without ever entering the realm of abstraction.

HENRI MATISSE. *Harmony in Red*. 1908–1909. Oil on canvas.
71 1/4 x 96 7/8 in. (181 x 246 cm). Hermitage, St. Petersburg.

From the start, the Fauves were loosely affiliated, and by 1908 most of the adherents had branched off in their own directions. Henri Matisse, the leader of the group, however, remained loyal to the principles of Fauvism. What would become Matisse's life-long preoccupation with curvilinearity and color is perfectly exemplified in this painting. As in many Fauvist works, rich red, blue, yellow, and green predominate. The suggestion of perspective is flattened by the pattern dominating both table and wall.

opposite:

PABLO PICASSO. *Portrait of Ambroise Vollard*. 1910. Oil on canvas.
36 1/4 x 25 5/8 in. (92 x 65 cm). Pushkin Museum, Moscow.

Ambroise Vollard was an influential art dealer in Paris and one of Picasso's earliest supporters. This portrait was painted in the Analytic Cubist style with the typically monochromatic palette. Besides some facial features, the figure is hardly discernible under the meshwork of shifting planes and multifaceted cubes, which allow us to perceive the subject simultaneously from more than one viewpoint.

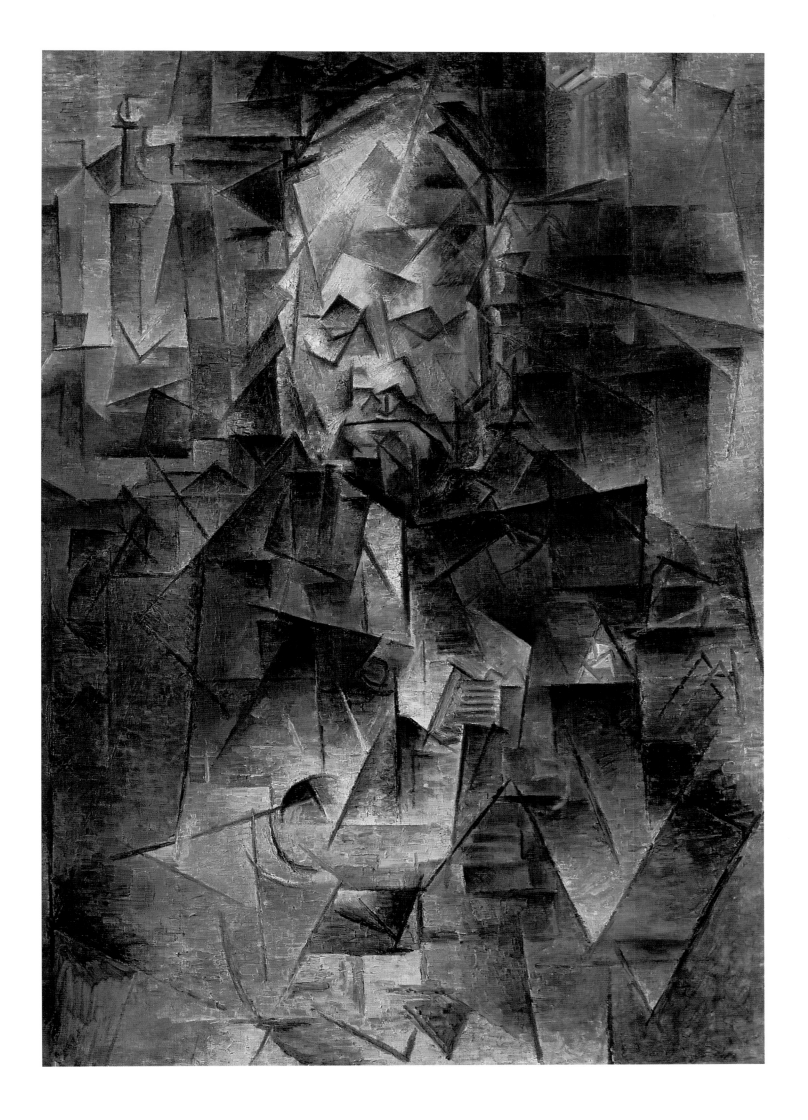

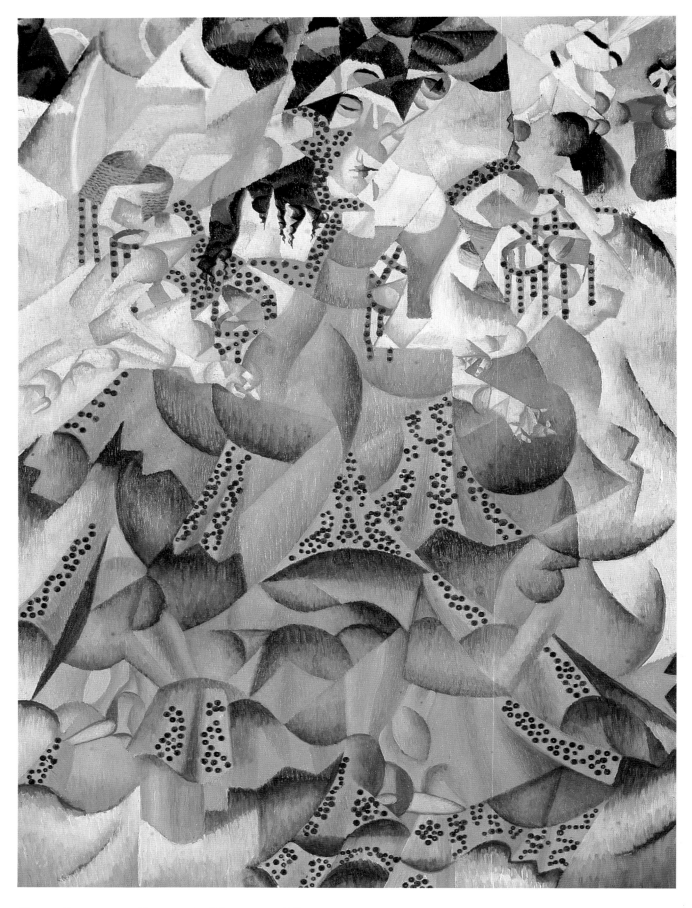

GINO SEVERINI. *Dancers in Blue*. 1912. Oil on canvas.
24 x 18 in. (61 x 46 cm). Collection Mattioli, Milan.

A leading figure of Futurism, Severini was concerned with the rendering of movement and time in a two-dimensional space. Here, he used the rhythm of dancers as an analogy for a luminous source of energy spreading through space. The viewer's impression and perception of the event are fragmented and immediate. The kaleidoscopic swirl of the blue costumes thus illustrates Futurism's simultaneity.

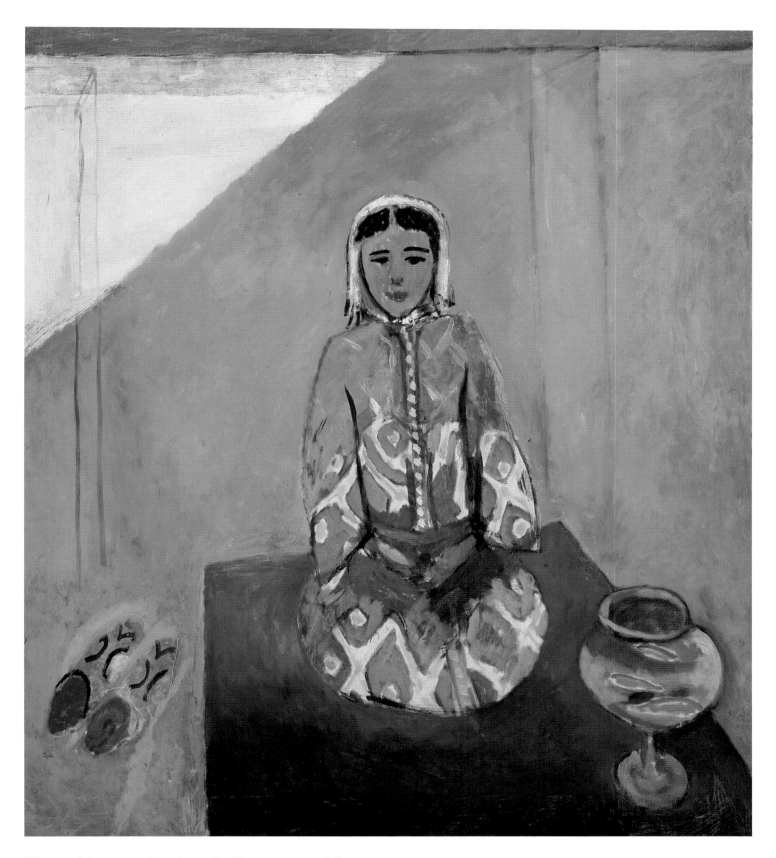

HENRI MATISSE. *Zorah on the Terrace*. 1912. Oil on canvas.
45 5/8 x 39 3/8 in. (116 x 100 cm). Pushkin Museum, Moscow.

Matisse made two trips to Morocco in 1912. He was seeking to paint in the bright north African light, as well as, perhaps, to escape the immense popularity of Cubism in France which threatened his position at the forefront of the avant-garde. In this image, Matisse has painted Zorah, a prostitute, sitting on a dark blue carpet in an aqua blue-green space, positioned between a bowl of goldfish and the hovering forms of her slippers. A bright triangle of light cuts through the space at the upper left.

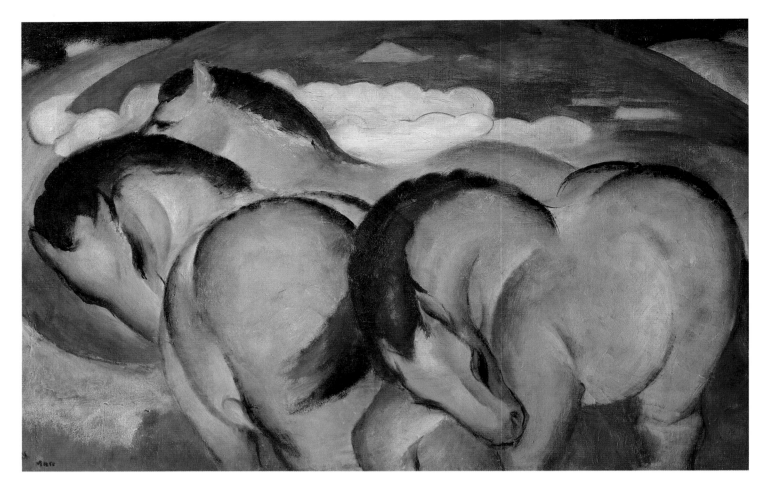

FRANZ MARC. *The Small Yellow Horses*. 1912. Oil on canvas. Staatsgalerie, Stuttgart, Germany.

Another group of artists in pre–World War I Germany (Munich) was known as Der Blaue Reiter (The Blue Rider), whose members included Franz Marc, Wassily Kandinsky, and Paul Klee. Animals were a main subject in Marc's work, horses—richly colored and composed of graceful, curving lines—in particular. Like Kirchner and other German Expressionists, Marc viewed the human race as degenerate and disgusting. Instead of criticizing in paint this loathsome society, he turned to the harmonious, simple world of animals.

opposite:

ROBERT DELAUNAY. *Circular Forms*. 1912–13. Musée National d'Art Moderne, Paris.

Around 1912, Delaunay achieved virtually abstract forms of expression for which the poet Guillaume Apollinaire coined the term "Orphism." The circular shapes are arranged as dynamic colored rhythms which the artist intended to be perceived as simultaneous contrasts. "I played with the colors the way one can express oneself in music with a fugue, colored phrases," he wrote later about his paintings.

WASSILY KANDINSKY. *The Red Spot.* 1914. Oil on canvas.
51 x 51 in. (130 x 130 cm). Musée National d'Art Moderne, Paris.

In 1912, Kandinsky published his treatise *Concerning the Spiritual in Art* in which he discussed the role of the artist's inner life in making a spontaneous, nonobjective art. Kandinsky believed in the spiritual and emotional power of color, feeling that color could directly affect the soul. In this improvisatory work, Kandinsky has entered the realm of abstraction.

KAZIMIR MALEVICH. *Dynamic Suprematism.* 1915. Oil on canvas.
31 1/2 x 31 1/4 in. (80.3 x 80 cm). The Tate Gallery, London.

In 1915, Malevich presented his first group of Suprematist paintings in Moscow. Based on the use of simple geometric forms in pure colors that seemed to float against a white background, he pursued a radical path of abstraction. Experimenting with squares, circles, rectangles, etc., Malevich studied the interactions between shapes and colors and their effect in space. He stressed the importance of feeling, denying any objective meaning.

EGON SCHIELE. *Self-Portrait with Spread Fingers*. 1911. Oil on wood.
10 7/8 x 13 3/8 in. (27.5 x 34 cm). Historisches Museum der Stadt Wein, Vienna.

During his brief life, Egon Schiele painted many self-portraits. In these intense, harsh images, Schiele frequently depicts himself nude, displaying his emaciated, tortured self. A certain jaggedness and angularity are typical of his style, seen here in his gaunt face and gnarled hand. The flat patterns of this image may recall the art of Gustav Klimt, and, in fact, the two artists were quite close. Nude women were frequently a subject of Schiele's art as well. These sexually explicit images are often startlingly haunting.

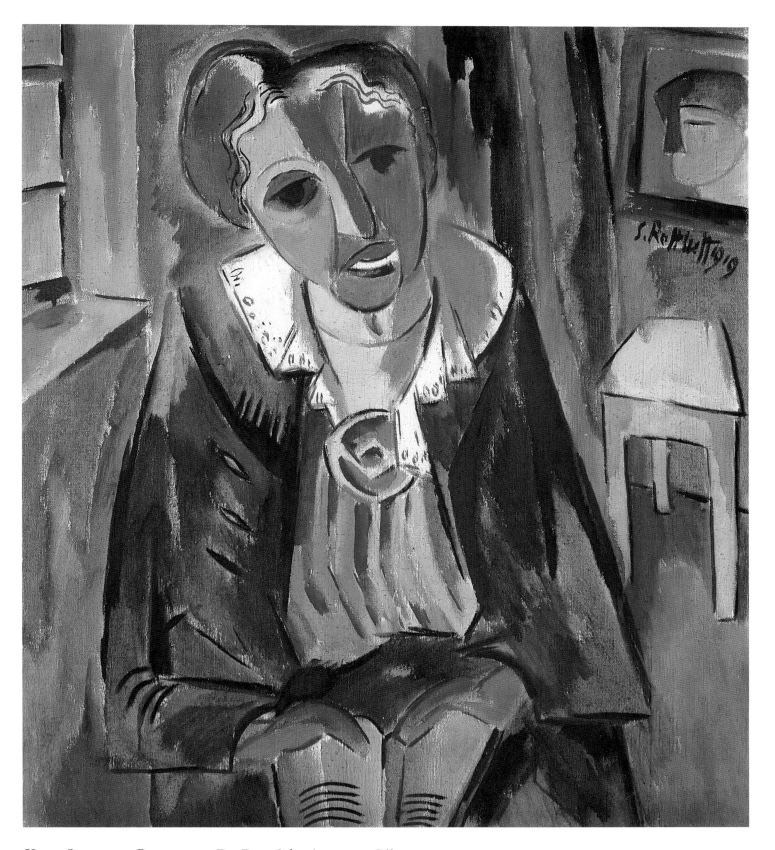

KARL SCHMIDT-ROTTLUFF. *Dr. Rosa Schapire*. 1919. Oil on canvas.
39 5/8 x 34 3/8 in. (100.5 x 87.5 cm). The Tate Gallery, London.

A founding member of Die Brücke, the German painter, printmaker, and sculptor Karl Schmidt-Rottluff combined bold, arbitrary color and Cubist forms in this portrait of his good friend, the art historian Dr. Rosa Schapire (1874–1954). A great supporter of Die Brücke, Schapire fled the Nazis in 1939, bringing to England works and letters by Schmidt-Rottluff and other German Expressionists.

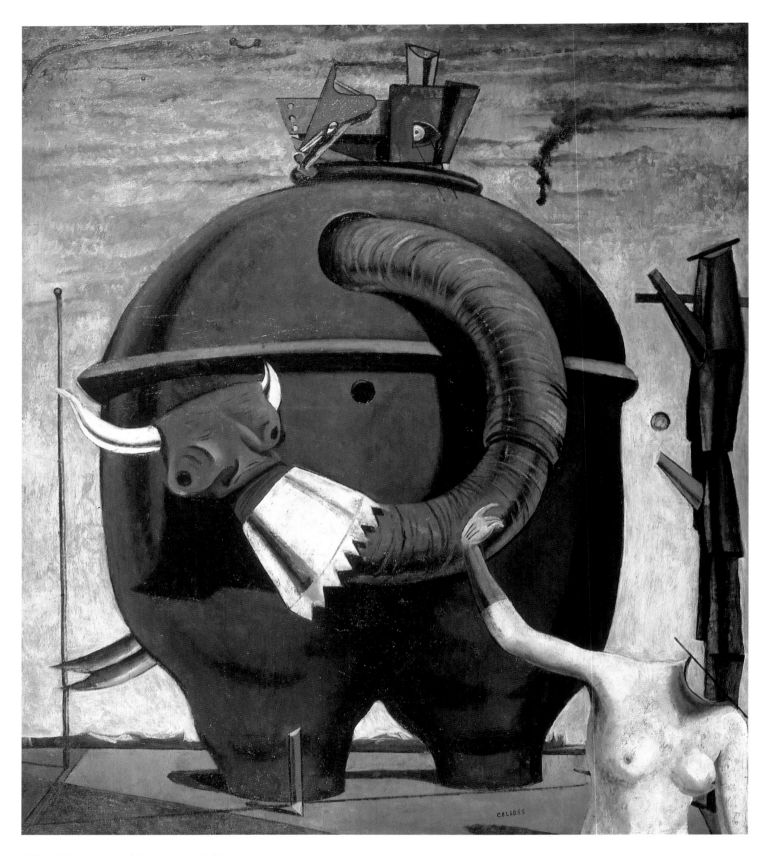

MAX ERNST. *Celebes*. 1921. Oil on canvas. 49 3/8 x 42 1/2 in. (125.4 x 108 cm). The Tate Gallery, London.

One of the first major Surrealist paintings, this bizarre and haunting image defies any attempt at rational interpretation. The pot-boiler–like monster resembles an elephant with a long, snail-like coil that ends in a horned, eyeless head. A female nude or mannequin seems to beckon this creature. The title *Celebes* was taken from some couplets popular among German schoolboys at the time, which begin: "The elephant of Celebes/has sticky, yellow bottom grease . . ."

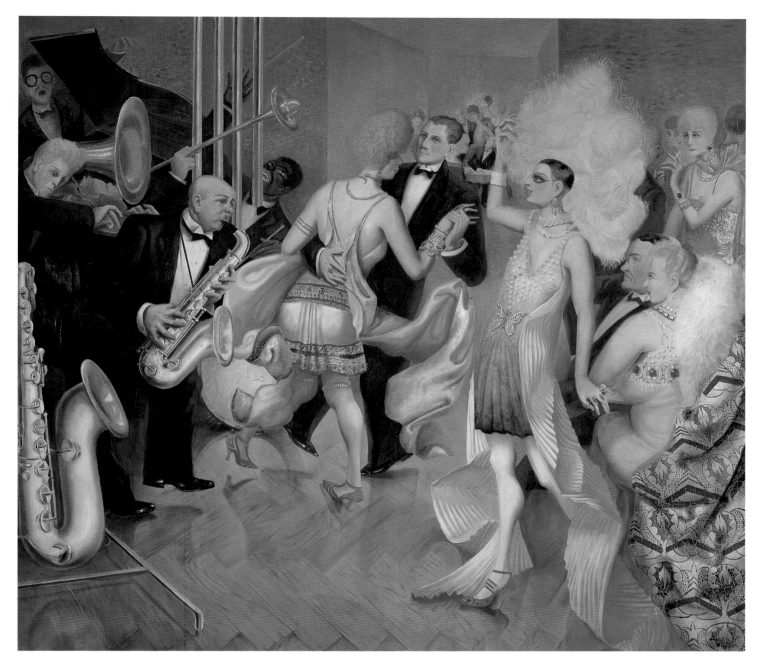

OTTO DIX. *Metropolis.* (central panel) 1927–28. Oil on canvas.
71 1/4 x 79 in. (181 x 201 cm). Galerie der Stadt Stuttgart, Stuttgart.

A proletarian by upbringing and conviction, Dix developed a form of magic realism known as "New Objectivity."
A current theme in his works of the 1920s is the social deprivation in Germany at that time. In this nightclub
scene, where prostitutes dance with their customers to the music of a jazz band, Dix confronts us with a morally
questionable aspect of postwar urban society.

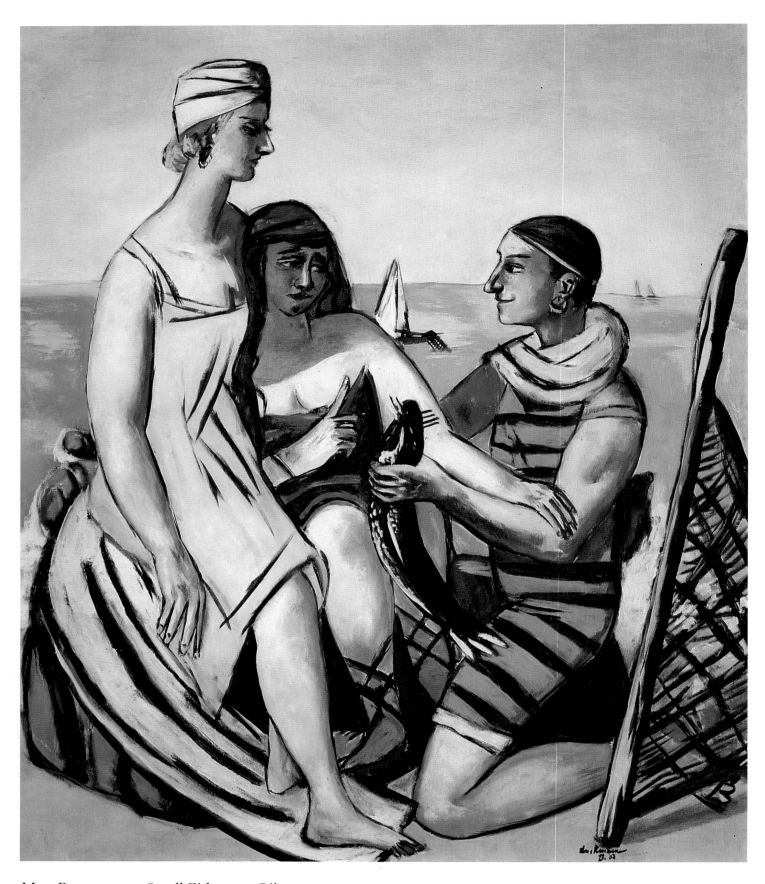

MAX BECKMANN. *Small Fish.* 1933. Oil on canvas.
53 x 45 1/2 in. (135 x 115.5 cm). Musée National d'Art Moderne, Paris.

Small Fish has all the charm and frivolity associated with a scene of an amorous courtship. A male bather proudly presents a freshly caught fish (a common sexual symbol) to the hesitating woman in the yellow dress, while her female companion lifts her hand in admonition. Beckmann has transformed this traditional subject into a language of monumental power not unlike Picasso a decade earlier. However, the spare means and characteristic use of black lines, which serve to define the shapes, are Beckmann's personal style.

PIET MONDRIAN. *Composition in Blue, Yellow, and White.* 1936. Oil on canvas.
17 x 13 in. (43.5 x 33.5 cm). Kunsthalle, Basel.

A founding member of the Dutch art group de Stijl, Mondrian developed a personal language using squares, rectangles, lines, and primary colors as the sole elements of his paintings. In a continuous search for harmony and balance, the artist produced numerous canvases based on these fundamental principles. This painting belongs to Mondrian's "classical" period in which the non-colors white and black assumed a weight equal to the primary colors blue and yellow.

PABLO PICASSO. *Guernica.* 1937. Oil on canvas.
137 3/4 x 307 7/8 in. (350 x 782 cm). Centro de Arte Reina Sofia, Madrid.

One of the great masterworks of the 20th century, this monumental painting was created in just two months to commemorate the bombing of the Basque town of Guernica, which was destroyed during the Spanish Civil War by German planes on April 26, 1937, acting on behalf of the Fascists. Its overpowering Surrealist imagery expresses the terror and suffering inflicted on people. At the center, the wounded horse with its open shrieking mouth stands for all innocent victims.

SALVADOR DALÍ. *Dream Caused by the Flight of a Bumblebee Around a Pomegranate a Second Before Awakening.*
1944. Oil on canvas. 20 x 16 in. (51 x 41 cm). Fundacion Colleccion Thyssen-Bornemisza, Madrid.

The tiny bumblebee hovering over a pomegranate at the bottom of this picture is the cause for the action in the
painting. The artist's wife, Gala, floats fast asleep and in her dream the bee's sting becomes the bursting of the
pomegranate from which emerge, threateningly, the fish, the tigers, and the bayonet. In Dalí's own words,
"The noise of the bee here causes the sting of the dart that will wake Gala." Translating Freud's theory on dreams into
surreal images, the artist expressed his experience with the unconscious.

JACKSON POLLOCK. *Watering Paths.* 1947. Oil on canvas.
44 7/8 x 33 7/8 in. (114 x 86 cm). Galleria Nazionale d'Arte Moderna, Rome.

Pollock is best known for producing totally abstract compositions by pouring, dripping, or throwing paint onto unstretched canvases, frequently putting the canvas on the floor and working on it from all four sides.

DIEGO RIVERA. *The Great City of Tenochtitlán*. 1945. Mural.
193 3/4 x 382 1/4 in. (492 x 971 cm). Patio Corridor, National Palace, Mexico City.

In order to revive the tradition of large-scale murals, Rivera was entrusted by the Mexican government to decorate numerous public buildings. Like the present scene, his subjects were usually taken from the history of Mexico or the Socialist spirit of the Mexican revolution. Tenochtitlán was the name of the former Aztec capital, today's Mexico City. Working with simple, monumental forms and bold areas of color, Rivera, who firmly held Marxist ideals, tried to reach his impoverished contemporaries.

PAUL CADMUS. *Bar Italia*. 1953–55. Tempera on pressed-wood panel.
637 1/2 x 45 1/2 in. (95.3 x 115.6 cm). National Museum of American Art, Washington, D.C.

A tumultuous array of characters, *Bar Italia* is transfixed by the clashes of cultures in postwar Italy: the American way of life versus the Italian tradition. In a setting inspired by Renaissance models, Cadmus confronts us with people of various backgrounds including American tourists, waiters, homosexuals, priests, and soldiers. A self-portrait appears somewhat hidden behind the prominent figure of the male hustler posing on the parapet.

MORRIS LOUIS. *Beta Upsilon*. 1960. Acrylic on canvas.
102 1/2 x 243 1/2 in. (260.4 x 618.5 cm). National Museum of American Art, Washington, D.C.

In the works of Morris Louis, color, soaked into the canvas, becomes an integral part of the expression. In *Beta Upsilon*, from the series *Unfurleds*, the artist has pushed the colors to the extreme edges of the painting, leaving the raw central expanse to command the viewer's attention. On the left, the streams of colors, which were poured onto the canvas, are generally darker hues, while those on the right are brighter, thus creating considerable tension across the wide blank space at the center.

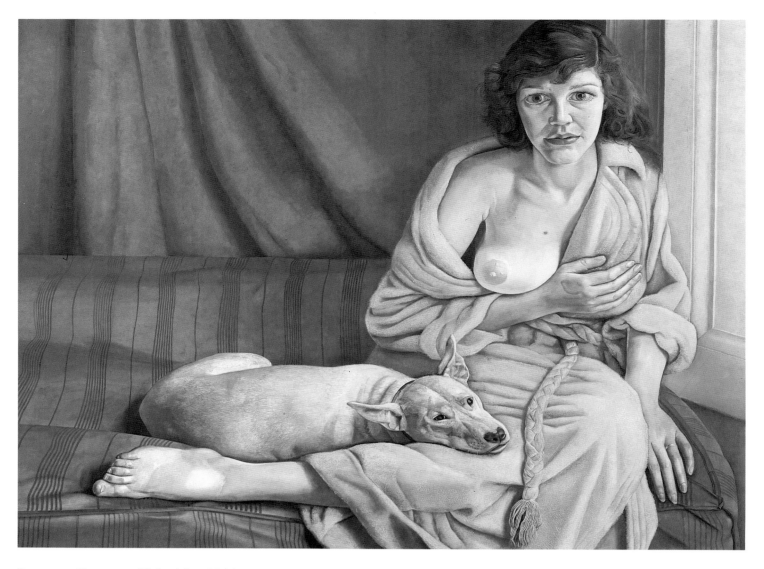

LUCIAN FREUD. *Girl with a White Dog*. 1950–51. Oil on canvas.
30 x 40 in. (76.2 x 101.6 cm). The Tate Gallery, London.

In the 1950s the artist, a grandson of Sigmund Freud, used a painstakingly precise, linear technique which
borders on hyper-realism. This seminude woman, caught in an embarrassing pose, looks out at the viewer with
an unmistakable presence and identity. Freud insisted on such directness with the result that the viewer feels
like an intruder into the private space of the sitter, in this case, the artist's wife.

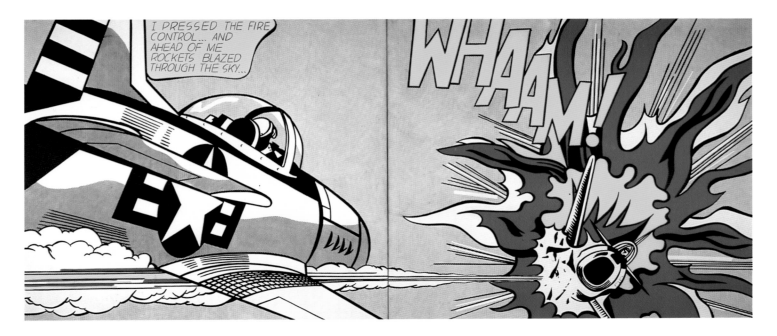

Roy Lichtenstein. *Whaam!* 1963. Acrylic on canvas.
68 x 160 in. (172.7 x 406.4 cm). The Tate Gallery, London.

One of the leading Pop artists, Lichtenstein often made use of comic-strip images. Simplified and enlarged to an enormous scale, the vehemence and brutality of *Whaam!* contrast with the detached, smooth rendering of the image. A war plane has just hit another plane with its missile, which is disintegrating in a powerful explosion. Developed initially as two separate panels, the humorous aspect of one panel shooting the other became somewhat of an afterthought.

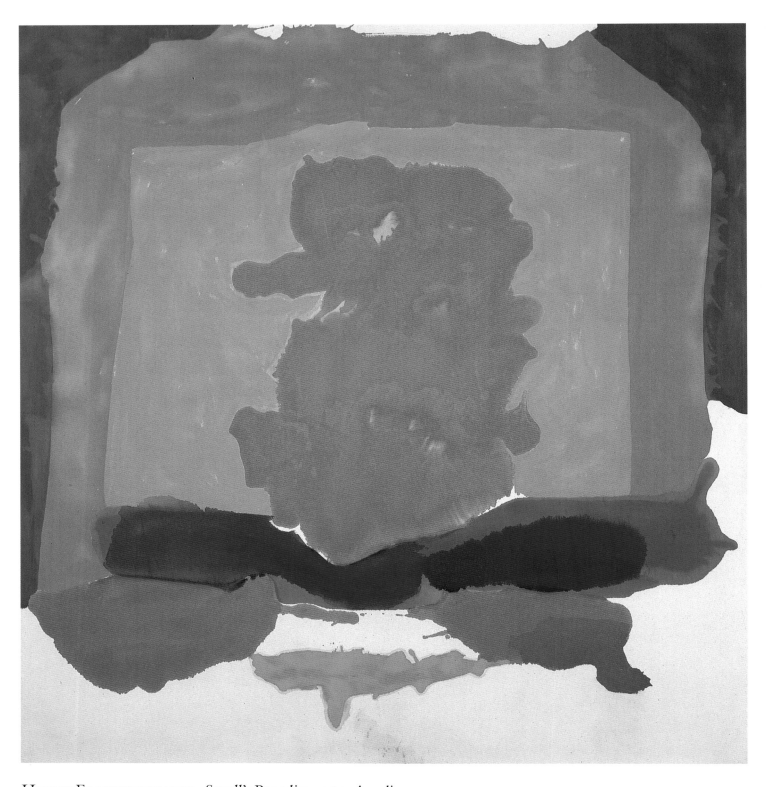

HELEN FRANKENTHALER. *Small's Paradise.* 1964. Acrylic on canvas.
100 x 93 5/8 in. (254 x 237.7 cm). National Museum of American Art, Washington D.C.

Traditionally, artists have prepared their canvases before painting by coating them with a glue sizing followed by a layer of primer paint. Forsaking tradition, the American painter Helen Frankenthaler is probably most well-known for her technique of pouring color (oil paints in her earlier works, acrylic in the later works) on unprimed canvas, thus creating her characteristic images of colorful, floating, amorphous forms. The painting illustrated here takes its name from a famous nightclub in Harlem.

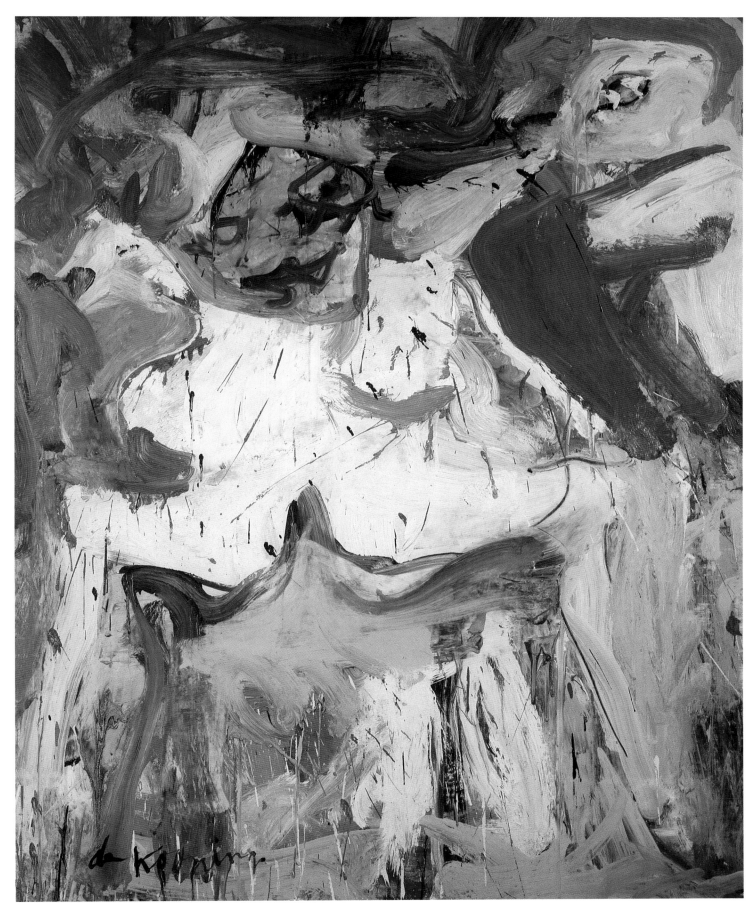

WILLEM DE KOONING. *The Visit.* 1966–67. Oil on canvas.
60 x 48 in. (152.4 x 121.9 cm). The Tate Gallery, London.

Dutch-born Willem de Kooning is a central figure in the history of Abstract Expressionism. Bold, spontaneous strokes of the paintbrush cover his canvases in an intensive mode of expression. Frequently, the artist included hypnotic evocations of female figures in threatening poses or with the quality of an erotic fertility symbol. Shapes and colors appear in no definable order, resulting in a conflict between sketch and finished picture.

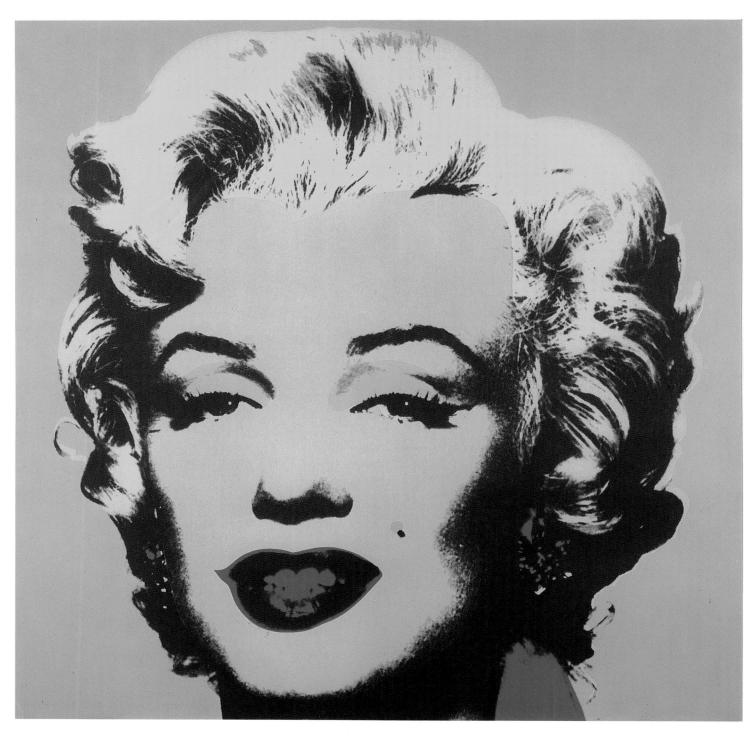

Andy Warhol. *Marilyn*. 1967. Silkscreen print. 36 x 36 in. (91.4 x 91.4 cm). The Tate Gallery, London.

More than any other artist, Andy Warhol personifies the idea of Pop art in the public imagination. His selection of popular images, which he frequently repeated using the silkscreen process for mechanical repetition, included commercial products as well as American folk heroes, such as Marilyn Monroe. Based on an actual photograph of the actress, Warhol varied the image by changes in the registration of the different colors.

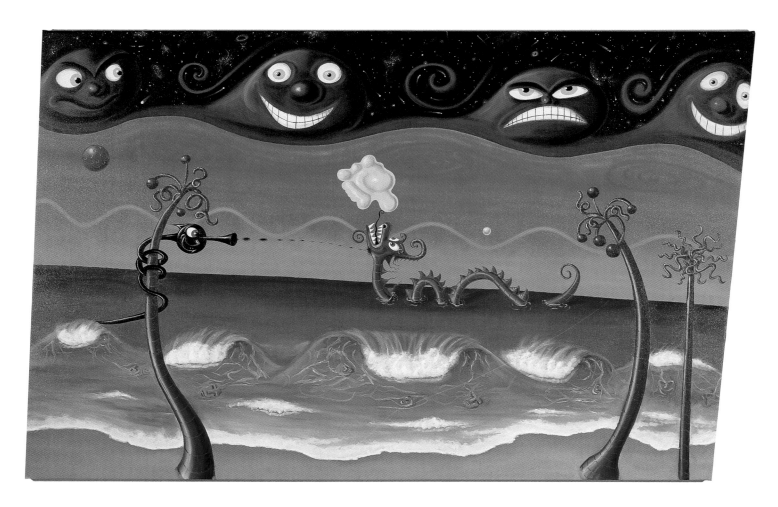

KENNY SCHARF. *Oceano Vista.* 1983. Oil and spray paint on canvas.
121 x 79 in. (307.3 x 200.7 cm). Private collection.

The whimsical and colorful art of Kenny Scharf appears as a renewed or continuous practice of the Pop art of the 1960s. In surreal compositions, the artist includes figures and other elements of contemporary popular culture, placing them into a new context.

PHOTO CREDITS

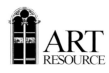 All photographs courtesy of Art Resource, New York.

ALINARI/ART RESOURCE, N.Y.
46, 108, 113, 157

ART RESOURCE, N.Y.
275 (top), 315

BRIDGEMAN/ART RESOURCE, N.Y.
61, 80, 192, 193, 220, 275 (bottom)

CAMERAPHOTO/ART RESOURCE, N.Y.
120, 281

ERICH LESSING/ART RESOURCE, N.Y.
11, 12, 15, 23, 24, 26, 29, 32, 34–35, 36, 37, 39, 40, 41, 43, 44, 45, 50, 58, 66, 77, 78, 91, 92, 96, 98, 99, 103, 107, 110 (top), 115, 124, 125, 128–129, 131, 140, 142, 146 (left), 148 (top), 164, 165, 166, 168, 169, 171, 172, 173, 174, 176, 177, 178, 180, 181, 183, 185, 188, 186, 191, 200, 201, 203, 205, 206, 209, 210, 211, 212, 218, 228, 230, 233, 234, 235, 237 (top), 238, 240, 241, 242, 243, 244, 245, 246, 247, 248-249, 250, 251, 252, 253, 256, 257, 258, 261, 262, 263, 264, 265, 266, 267, 268, 269, 270, 278, 279, 287, 292, 294, 296, 299, 300

GEORGE ROOS/ART RESOURCE, N.Y.
288

GIRAUDON/ART RESOURCE, N.Y.
25, 28, 31, 52, 62, 64, 65, 69, 70, 82, 88, 90, 94, 110 (bottom), 134, 135, 139, 148 (bottom), 149, 152, 163, 167, 189, 199, 202, 208, 219, 232, 244, 255, 293, 302–303

HERSCOVICI/ART RESOURCE, N.Y.
282

JEWISH MUSEUM/ART RESOURCE, N.Y.
71

NATIONAL MUSEUM OF AMERICAN ART/
ART RESOURCE, N.Y.
196, 197, 198, 221, 222, 223, 224, 225, 226, 227, 254, 260, 284, 308, 309, 312

NIMATALLAH/ART RESOURCE, N.Y.
16, 17, 42, 102, 277 (top), 304

THE PIERPONT MORGAN LIBRARY/
ART RESOURCE, N.Y.
63, 68, 85, 86, 89, 93, 95

SASSOONIAN/ART RESOURCE, N.Y.
141

SCALA/ART RESOURCE, N.Y.
8, 10, 19, 20, 21, 22 (bottom), 23 (top), 33, 38, 45, 47, 48, 49, 54, 55, 56, 57, 59, 72, 73, 74, 75, 76, 79, 81, 83, 84, 87, 101, 104, 106, 109, 114, 116, 117, 118, 119, 121, 122, 123, 126, 127, 130, 132, 133, 136, 137, 138, 145, 146 (right), 151, 153, 155, 156, 158–159, 160, 161, 162, 170, 175, 179, 184, 190, 204, 207, 231, 237 (bottom), 271, 272, 280, 289, 290, 291, 301

SCHALKWIJK/ART RESOURCE, N.Y.
306–307

THE TATE GALLERY, LONDON/
ART RESOURCE, N.Y.
194, 213, 214, 215, 216, 217, 259, 274, 285, 286, 295, 297, 298, 310, 311, 313, 314

VICTORIA AND ALBERT MUSEUM,
LONDON/ART RESOURCE, N.Y.
154

WERNER FORMAN ARCHIVE/ART
RESOURCE, N.Y.
13, 27

INDEX

Page numbers in italics indicate illustrations.